DEMOCRACY: AN ONGOING CHALLENGE

Democracy:
An Ongoing Challenge

Edited by NCCR Democracy
Hanspeter Kriesi
Lars Müller

LARS MÜLLER PUBLISHERS

Foreword

Some readers will still recall the fall of the Berlin Wall in 1989, the early 1990s and the election of Nelson Mandela as president of South Africa in 1994. The images of people dancing in the townships or celebrating atop the Berlin Wall shown on screens and printed in newspapers worldwide are burned into our minds and memories as though we ourselves had taken part in them. They are moments when the wish for freedom and self-determination became a reality, and they stand as symbols of hope and of change. Over the years, they have also found expression in stable legal relationships and in democracy.

Today, in a globalizing era, a more general and abstract idea of democracy is finding support worldwide. A subtle, cross-cultural understanding of democracy as freedom from despotic rule and as self-determination is even emerging, and it approximates the concept of liberal democracy. In that sense, democracy–despite great differences in the details–is a universal value today.

At the same time, democracy is a profoundly controversial concept, and it does not mean the same thing to everyone. It entails the pursuit of several basic principles at the same time, including the "liberty, equality, fraternity" called for by the famous rallying cry of the French Revolution. Even now, these principles are connected to the idea of democracy, though we might today speak of "solidarity" rather than "fraternity." Yet anyone who tries to put all these ideals into practice inevitably faces contradictions that cannot be resolved but only counterbalanced in varying ways. The pictures in this reader underscore this fact. They show the potential and possibilities of democracy but also the circumstances that must be present for democracy to exist at all. The images make clear that democracy is not a state that can be reached once and for all but instead requires dialogue and confrontation, time and time again, and poses an enduring challenge both for those who are governed and those who govern.

At the same time, democracy itself faces numerous challenges in the twenty-first century. One only needs to think about the incomplete process of democratization in countries around the world. Since the 1970s, democracy certainly has achieved unimagined triumphs. Starting in North America

and Europe, where democracy definitively prevailed only after the end of World War II, it was adopted as the system of government in Southern and Eastern Europe, Latin America, Asia and Africa. In the very recent past, Arab countries also have been caught up in the whirlwind of democratization.

Yet in many countries, democracy has been only partially accepted thus far. In some newly democratized countries, while elections are held, they are often not fair. In other places, top decision-makers, be they religious leaders, generals, or monarchs, are not required to stand for election. And even where the genuine decision-makers are freely elected, people themselves may not truly be free: A majority may try to prevail, ruthlessly, at the expense of minorities; civil rights and liberties are violated; not all are equal before the law.

Even if the process of democratization is underway worldwide, the consolidation of democracy will take quite some time. Constitutions can be amended in a matter of months and laws hammered out in a few years, but it takes generations for political elites and for the public to truly internalize democratic values. Democratization is a never-ending process. It affects both political decision-making processes as well as decisions in every sphere of life, whether in the family, in schools, in the workplace, in the healthcare system, in the military, and in associations and volunteer organizations. Let's try not to be too impatient!

Established democracies also face challenges, and the quality of democracy is not ensured permanently there either. Before the new, global wave of democratization set in, astute critics on both the right and the left in the 1970s saw a crisis of democracy looming in the West. They questioned the ability of democratic governments to meet public expectations that only seemed to increase. Today, the quality of established democracies is again being questioned, though at issue is no longer the excessive demands being placed on government.

Instead, the scope for action by democratically elected national governments is becoming increasingly limited, as a result both of globalization and of economic developments. To an increasing degree, supranational organizations and other actors (central banks, panels of experts, major enterprises) which are not democratically accountable call the shots. The resulting erosion of national democracies leads to populist responses that try to defend the ideal

of popular sovereignty from a rule by technocrats or by actors whose moves are not transparent. While these populist reactions may not be all that constructive, they nonetheless are expressions of a loss of trust that must be taken seriously. The response to that loss ought to be to take additional measures at the supranational level, as well as the level of the particular organizations under discussion, in order to democratize them.

The quality of established democracies is now also questioned by changes to the media landscape. Ultimately, the source of the legitimacy of democratic decisions does not lie in the decision itself, but in the opinion-formation process that precedes that democratic decision. Both classical Athenian democracy and the traditional Swiss *Landsgemeinde* were local assembly democracies. In modern forms of representative democracy, however, the public space for politics is no longer local. Political communication between electorate and representatives takes place primarily through the media, the character of which in recent decades has been radically altered by commercialization and technological innovation. It remains open whether, or to what extent, the new media and the possibilities they offer for direct communication will benefit democratic processes of opinion formation. In a media culture that is increasingly visual, content is conveyed differently than in an era dominated by print media. The moving image on a screen and the fixed image in the newspaper is increasing in importance, with all the ambivalence that carries with it. Images can generate followers and approval, and images can influence the outcome of an election. By the same token, images can also serve as evidence, arouse indignation, and inspire a desire for change.

Democracy: An Ongoing Challenge addresses the significance of images. Individual images as well as galleries of pictures allow seemingly abstract concepts like democratization, globalization, mediatization, and internationalization to become specific, localized and vivid. As addressed here, democracy is not just an abstraction. It is shown as well in its many and varied dimensions: as a utopia, as a challenge, as normalcy. The photos of Nelson Mandela as president and images of the fall of the Berlin Wall illustrate how once-utopian notions have become reality.

Hanspeter Kriesi, Lars Müller

In 2010, most (116) of the world's countries claimed to be democratic, and democracy is touted as the only legitimate form of government. Historically speaking, this situation is relatively new. But where did democracy start? And how did it spread?

The first example of democratic self-rule emerged in fifth-century BC Athens, though it existed in other ancient Greek city-states as well. The idea of self-rule was only revived during the Italian Renaissance in city-states like Venice and Florence. English (1688–1689), American (1763–1777), and French (1789) revolutions subsequently marked decisive steps toward a modern democratic understanding of government. Representative democracy as we know it came about through linking the idea of the nation-state as an "imagined community" (Benedict Anderson) to the notion of self-determination. Such a democracy is characterized by popular sovereignty, free and fair elections, the division of powers, the rule of law, and the securing of human and civil rights.

In Europe, uprisings in 1830 and 1848 were efforts to institutionally anchor democracy. However, almost everywhere in Europe, full citizenship rights were granted only to a small part of the (male) population until the early twentieth century. Only after World War I would universal suffrage begin to be granted in most of Europe. In the interwar period, democracy remained unstable in a majority of countries, but one can argue that it had stabilized worldwide by the second half of the twentieth century.

Globally speaking, democratic forms of government have proliferated. This development was not linear but instead proceeded in waves. We examine the third, and most significant, wave of democratization since 1975 in more detail. It has led to substantial progress toward democracy particularly in Latin America, in the former Eastern Bloc, and in sub-Saharan Africa.

THE DEVELOPMENT OF DEMOCRACY

A Long Road

Hanspeter Kriesi and Daniel Bochsler

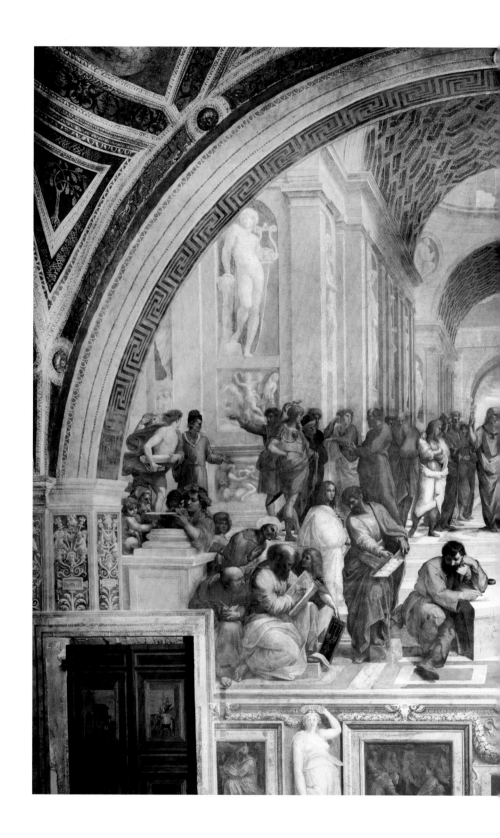

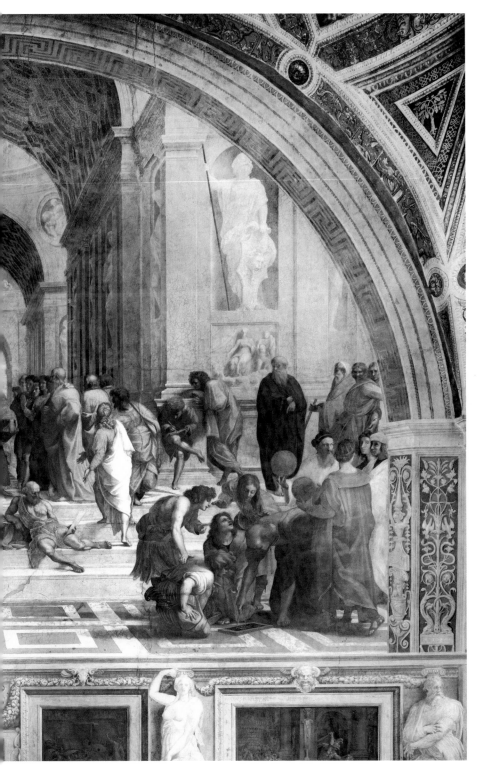

PRECURSORS OF MODERN DEMOCRACY Raphael, *The School of Athens* (1509–1511). The Greek city-state had the first democratically elected government, though only the male citizens of Athens had political rights. Raphael's masterpiece glorifies the ancient philosophers, as well as democracy, which was "rediscovered" during the Renaissance. akg-images/Erich Lessing

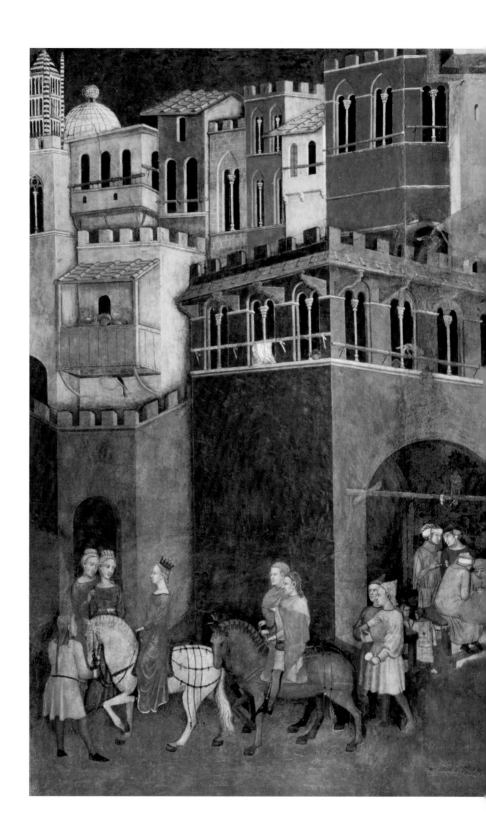

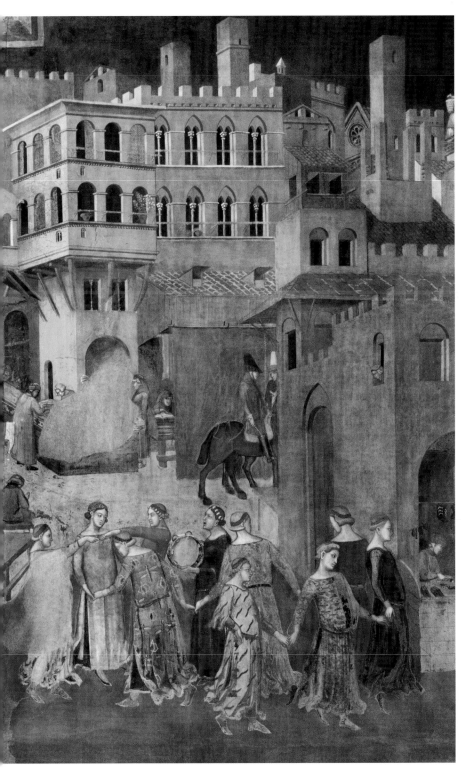

PRECURSORS OF MODERN DEMOCRACY Ambrogio Lorenzetti, *The Effects of Good Government* (1338–1339). Through a lottery that rotated political offices, as well as through freedom of speech and equalty before the law, the growing number of citizens in the city-states of northern Italy between the tenth and fifteenth centuries created democratic forms of government.

15

REVOLUTIONS AS THE CORNERSTONE OF DEMOCRACY Joseph Turner, *The Prince of Orange, William III* (1832). The English Revolution, 1688–1689: William on the way to England, whose Parliament offered him the throne but simultaneously ratified a Bill of Rights limiting the King's power. This marked the end of absolutist monarchical rule in England. Tate, London

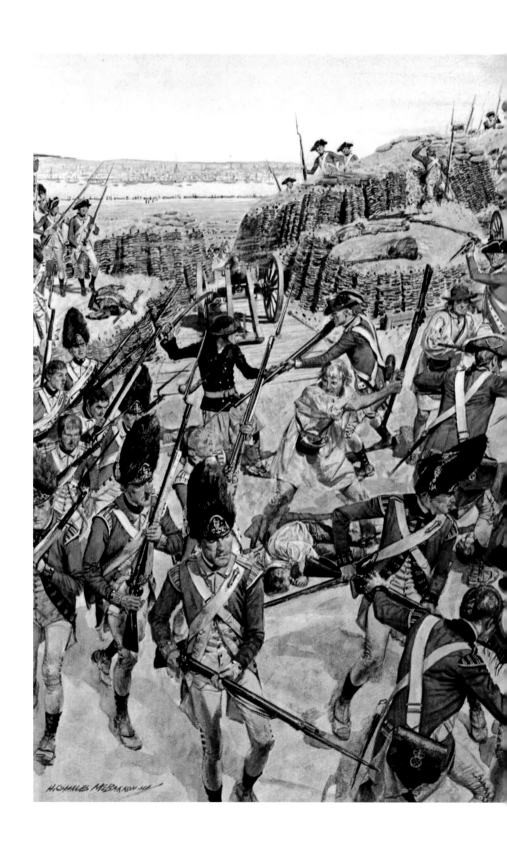

H. CHARLES McBARRON JR

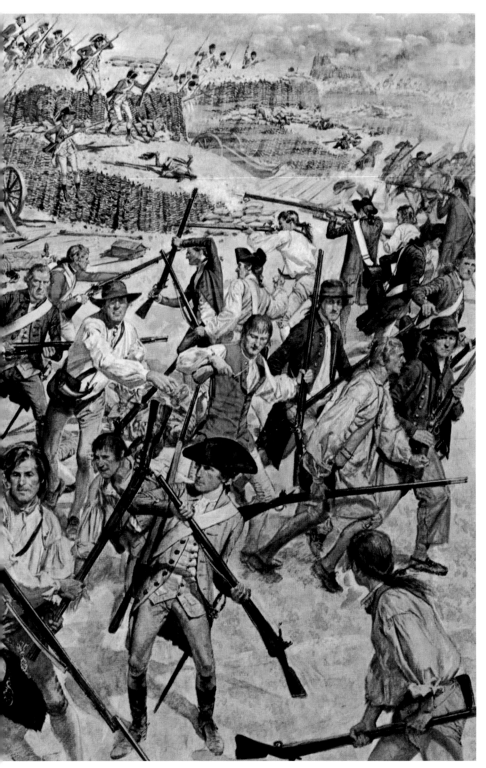

REVOLUTIONS AS THE CORNERSTONE OF DEMOCRACY H. Charles McBarron, *Soldiers of the American Revolution* (undated). The American Revolution, 1763–1766: Thirteen British colonies joined together to break from the British Crown and elect their own representives. The subsequent war against Great Britain resulted in American independence.

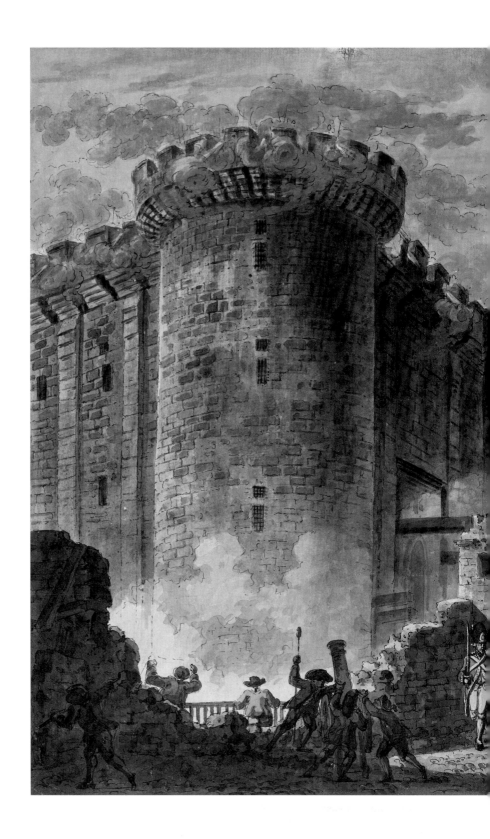

REVOLUTIONS AS THE CORNERSTONE OF DEMOCRACY Jean-Pierre Houël, *The Storming of the Bastille* (1789). The French Revolution, 1789: The Declaration of the Rights of Man and of the Citizen tied the state to upholding the law and declared all citizens to be equal before the law. The motto of the revolution was "Liberty, Equality, Fraternity."

At the beginning of the twenty-first century, democracy is the only legitimate form of government. Though its origins lie in Europe, today democracy is a universal value that has prevailed throughout the world. Its attractiveness lies in the fundamental importance of freedom and political participation for human life. It is also based on the notion that democratic processes give citizens an instrument by which they can hold their governments accountable for making responsible decisions that serve the common good. In addition, it strengthens the dedication of citizens to the common good and contributes to the acceptance of common rights and duties.

Democracy was not always this attractive. Most political thinkers, from ancient Athens to the present, have been very critical of the idea of democracy and of democratic practice. It has only been relatively recently that the idea of democracy has prevailed, and only in the twentieth century has democracy become the only acceptable form of government. What is understood by democracy, however, remains controversial, and notions differ considerably over what constitutes a well-functioning democracy. Since the twentieth century, the arguments in political theory have circled, in essence, around the meaning of democracy itself.

In the form of government we are familiar with today in nation-states, democracy has slowly spread throughout the world since the great modern revolutions—the English (1688/89), American (1776), and French (1789). As a rule, these are representative democracies. Before we turn to this modern form of democracy and its wave-like expansions, however, we first want to briefly discuss a few precursors. They were important sources of inspiration for modern political ideas, even if they do not correspond in any manner to the models of democracy common today.

CITIZEN PARTICIPATION:
THE ASSEMBLY DEMOCRACY OF THE GREEK CITY-STATES

The Greek city-states, and most particularly Athens, first put democratic ideas into practice in the fifth century BC. A democratic way of life had become possible with the emergence of an economically and militarily independent citizenry in relatively small and compact communities. The ancient city-state reached deep into the lives of its citizens, but included only a small part of the population. We should not forget that the economic independence of the Athenian citizens was based on a slave economy, which meant that most residents of Greek city-states were excluded from active citizenship. Only the approximately 30,000 men from long-resident, established families counted as active citizens. Slaves and those who had migrated to a city-state were thus just as barred from citizenship as were women.

The politically active citizens met at least forty times a year in open assemblies that reached decisions about all the key political questions the city-state faced. That assembly constituted a quorum of 6,000 participants, for it was of course not possible for all 30,000 men who possessed the right of citizenship to participate. The ideal was to reach unanimous decisions, but on contentious questions, the Assembly also reached decisions by majority vote. It was probably the Greeks who first used formal voting procedures to legitimize decisions on disputed issues.

An executive council of 500 was selected from the members of the Assembly in Athens, and their job was to prepare the legislation, in which they were supported by a smaller committee of fifty council members. This means that in the direct democracy practiced in the Athenian Assembly, the citizens gathered there did not have all the power. Smaller councils had considerable power, sometimes even more power than the Assembly itself. However, members of the executive council served only very briefly (usually only a year), could be re-elected only once, and basically came to their positions through a lottery. The characteristic aspect of modern representative democracies, namely elections, barely existed in that sense in the direct democracy practiced in ancient Greece. Determining the executive authority by chance, as well as the brief terms of office granted to the council, reflected the deep mistrust Greek democrats had of political professionalism. The determining of the decision-makers by lot, however, meant everyone who wanted to participate in the executive had the same chance of being selected.

In ancient Athens, a citizen was someone who actively participated in public affairs. From the ancient Athenian point of view, it is only elected representatives in modern democracies who, at best, could be regarded as citizens. Ancient Athenians would hardly have regarded modern democracies as democracies because of the minimal opportunities they offer to citizens to genuinely participate in them.

Ancient Greek democracy was sharply castigated by its contemporaries, with Plato's critique probably the best known. Disillusioned by the decline of Athens, the deteriorating quality of the political leaders, and the general moral decay that culminated in the trial and condemnation of Socrates (399 BC), Plato came to the conclusion that political rule should be transferred to a minority who had the abilities needed for ruling. Using arguments still cited today by critics of democracy, he argued for a "watchman state," meaning rule by experts, or as we would say today, by technocrats who have the necessary abilities to conduct the affairs of state.

Democracy as practiced in ancient Greek city-states did not survive. Its decline can be traced back to the instability of a slave-based economy as well as to the problem that the radically democratic manner of governing the state prevented the development of a professionally conducted administrative apparatus and thereby

hindered coordination within the branches of government. It made administering the economy, as well as the extensive territories the city-states had conquered, difficult and increased the vulnerability of such states to more centrally organized rivals.

LIBERTY, EQUALITY, AND ACTING IN THE PUBLIC INTEREST: THE ITALIAN CITY REPUBLICS AND ROUSSEAU

The idea of an active citizenry—meaning self-determination and popular sovereignty—was not revived again until the Renaissance, in certain Italian city-states. As in classical antiquity, active participation in self-rule in such city republics was limited to a small circle of well-to-do, established, qualified men. The government resembled an aristocratic club more than a democratically elected body. Florence, for example, was dominated by a patrician group of merchants for 250 years, starting in the late thirteenth century. Nevertheless, the 3,000 to 4,000 full citizens in Florence in 1494 amounted to about 18 percent of the male adults; in Venice, that figure reached only 6 percent.

As in antiquity, the key council members were selected by holding a lottery among the qualified, active citizens. This was seen as a means to undercut partisanship. A rapid replacement of officeholders, much as in antiquity, was seen as promoting a degree of equality among the qualified citizens. However, the political institutions in these city republics were often altered, making it difficult to generalize. The citizens themselves saw their basic political values particularly threatened by social tensions, often resolved violently, as well as by conflicts within the ruling stratum.

Nevertheless, these city republics were important precursors for modern democracy. Their constitutions aimed to establish freedom and equality among the citizens, with freedom meaning both the personal liberty of the citizens as well as independence externally and self-government internally. Initially, the freedom of the town was a corporate freedom, a protection provided by the community against the depredations of powerful aristocrats. A citizens' militia served as a means to defend the city's independence from attack. In terms of city self-government, the free and equal citizens succeeded one another as ruler and ruled, or could at least freely choose who the officeholders would be. Qualified citizens also had equal access to the political offices, with citizens represented by councils and the guild corporations by their own institutions. In addition, other fundamental values were upheld, in particular justice and equality before the law (legal equality and protection from arbitrariness on the part of the authorities and powerful citizens, provisions against the misuse of office), free speech, and the common good.

The city republics particularly relied on the virtue of their citizens, which is how the orientation toward the common good was understood. Without citizen virtue, there was no republic and no freedom—that was the basic message of this republicanism, regardless of its color. The heart of this Renaissance of the republics was the idea that the political community was responsible to no one but itself and that participating in political self-administration was a necessary condition for personal freedom.

This idea was expanded, later on, by Rousseau. Like many of his precursors in the Renaissance of the republics, Rousseau stands somewhere between the ancient and the modern notions of democracy. In the profoundly altered political environment of the eighteenth century, Rousseau tried to reformulate the republican idea of a self-determining popular assembly. He, too, imagined a kind of self-government by the citizenry, for those subject to the laws had, in his view, to also be the source of those laws. Every law to him was illegitimate if it had not been approved by the people. "The English people," Rousseau wrote in his treatise *The Social Contract* (1762), "thinks it is a free people; it is greatly mistaken; it is free only during the election of the members of parliament; as soon as they are elected, it is enslaved, it is nothing."

The people, in Rousseau's day, was still defined only as the propertied: Women, and the poor, were excluded. Rousseau continued to hold to a system of drawing lots for determining who would sit in the executive, because, as he argued, holding office in every true democracy is not an advantage but instead a heavy burden. In drawing lots, all were in the same situation, and no one particularly disadvantaged. Rousseau's core concern was to see to it that the future of democracy would be embedded in a community—like that of his native city-republic of Geneva, which he admired. Yet his vision of democracy was not systematically oriented to a world of nation-states, and the one he lived in, characterized by traditional community life, would soon vanish forever.

These precursors have inspired modern notions of representative liberal democracy, but modern ideas rely less on virtuous, responsible citizens who invest themselves in promoting the common good as a basis for the political community. Already by the early sixteenth century in Florence, Machiavelli broke with the optimistic image of the people promoted by republican humanists, along with their belief in the educative functions culture can perform, and suggested a far more pessimistic image of man in politics. In his wake, liberal political theory, since the time of the modern revolutions, has placed more emphasis on the careful circumscribing of the political sphere and its separation from the private sphere. Thus, the republicans of the American Revolution—in particular, James Madison—primarily tried

to protect the citizens from the state and to limit the power of the majority through suitable institutional barriers. Modern representative democracy, finally, replaces direct citizen participation with the delegation of political decisions to elected representatives. What characterizes modern democracy is no longer self-rule, meaning the direct participation of citizens in governmental affairs, but rather the principle that every exercise of legitimate authority requires the approval of those over whom this authority is exercised. This principle is perfectly illustrated by the call to arms ("no taxation without representation!") during the American Revolution. It is the election of representatives by those citizens affected by the decisions these representatives make that legitimizes the representatives' decisions.

MODERN REVOLUTIONS AND THE ASSERTION OF REPRESENTATIVE DEMOCRACY

The English, American, and French Revolutions mark the dawning of the modern age. They simultaneously created the first nations, the nation-state, and the modern, representative form democracy takes today. In the political awakening at the time, the nation was understood as the political community of all citizens. Thereby, the formation of the nation-state turns each and every member of the common people into a part of the sovereign. The contemporary idea of democracy, which is based on the fundamental principles of popular sovereignty and the equality of all citizens, therefore also contains the basic principles of the nation. This also means that the idea of democracy at the time was contained within the nation as the butterfly is contained within the caterpillar.

However, the nation-state goes beyond the limited proportions and size of the Greek and Italian city-states. The nation is thus no longer a small, compact community, whose members know one another. Rather, it is a merely "imagined community," as the American political scientist Benedict Anderson put it, a community of people who feel solidarity with one another even though they do not know one another and will never meet.

Among the basic elements of modern representative democracy, along with the democratic principle of a government chosen by the citizens (who have a general right both to vote and to be elected) in politically competitive free and fair elections, one also finds the liberal principles of guaranteeing human and civil rights, as well as the division of powers. Human and civil rights were first formulated by the French National Constituent Assembly in its Declaration of the Rights of Man on August 26, 1789. This declaration bound the state to uphold the law, declared all citizens were equal in their rights, guaranteed religious freedom, freedom of conscience, freedom of opinion, freedom to own property, the right to

personal security, and the right to resist oppression. In addition, it declared the people to be sovereign.

The introduction of the constitutional (or rule of law) state thus coincided with the introduction of democratic principles. It was augmented and strengthened by the principle of the separation of powers, which introduced the notion of mutual control (known as "checks and balances") of the differing branches: the executive (government), the legislature (parliament), and the judiciary (power of courts and the law). Each branch is independent of the others; they mutually control one another and thereby prevent any one of the branches from becoming tyrannical.

THE THREE WAVES OF DEMOCRATIZATION
The democratization of nation-states spread throughout the world in waves, of which three waves can be distinguished. Figure 1 illustrates this development.

The First Wave of Democratization: From the Age of Revolutions to the 1920s
The American and French Revolutions are regarded as the beginning of the first wave of democratization, but more significant for the spread of democracy were

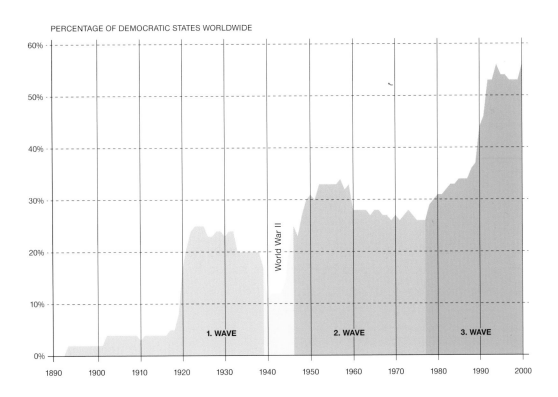

PERCENTAGE OF DEMOCRATIC STATES WORLDWIDE

1. WAVE 2. WAVE 3. WAVE

World War II

1 **THE THREE WAVES OF DEMOCRATIZATION** The percentage of democracies in the world to 2000. The minimal criterion for a democracy used here is the existence of general suffrage. The three waves of democratization are clearly visible.

Preamble

The representatives of the French People, organized as a National Assembly, believing that ignorance, neglect, or contempt of the rights of man are the sole cause of public calamities and of the corruption of governments, have resolved to set forth in a solemn declaration the natural, unalienable, and sacred rights of man, in order that this declaration, being constantly before all the members of the body politic, shall remind them continually of their rights and their duties; in order that the acts of the legislative power, as well as those of the executive power, may be compared at any moment with the objects and purposes of all political institutions and may thus be more respected, and in order that the grievances of the citizens, based hereafter upon simple and incontestable principles, shall always be directed to the maintenance of the constitution and redound to the happiness of all.

Therefore, the National Assembly recognizes and proclaims, in the presence and under the auspices of the Supreme Being, the following rights of man and of the citizen.

Article 1

Men are born and remain free and equal in rights. Social distinctions may be based only on the common good.

Article 2

The aim of every political association is the preservation of the natural and inviolable rights of man. These rights are liberty, property, security, and resistance to oppression.

Article 3

The principle of all sovereignty resides essentially in the nation. No body nor individual may exercise any authority which does not proceed directly from the nation.

Article 4

Liberty consists in the freedom to do everything which injures no one else; hence the exercise of the natural rights of each man has no limits except those which assure to the other members of the society the enjoyment of the same rights. These limits can only be determined by law.

Article 5

The law can only prohibit such actions that are harmful to society. Nothing can be prevented which is not forbidden by law, and no one can be forced to do anything which is not provided for by law.

Article 6

Law is the expression of the general will. Every citizen has a right to participate personally, or through his representative, in its foundation. It must be the same for all, whether it protects or punishes. As all citizens are equal in the eyes of the law, all are equally eligible to all dignities and to all public positions and occupations, according to their abilities, and without distinction except that of their virtues and talents.

Article 7

No person shall be accused, arrested, or imprisoned except in the cases and according to the forms prescribed by law. Anyone who solicits, transmits, executes, or causes any arbitrary order to be executed shall be punished. But any citizen summoned or arrested by virtue of the law shall submit without delay, as resistance constitutes an offense.

Article 8

The law shall provide for such punishments only as are strictly and obviously necessary, and no one shall suffer punishment except it be legally inflicted in virtue of a law passed and promulgated before the commission of the offense.

Article 9

As all persons are regarded as innocent until they shall have been declared guilty, if arrest is deemed indispensable, all harshness not essential to the securing of that person shall be severely punished by law.

Article 10

No one shall be prosecuted for their opinions, including their religious views, as long as the expression of those opinions does not disturb the public peace and order as established by law.

Article 11

The free expression of ideas and opinions is one of the most precious rights of man. Every citizen, accordingly, may speak, write, and publish freely, but shall be responsible for abuses of this freedom as they are defined in law.

Article 12

The guarantee of the rights of man and of the citizen requires the public use of force. Such force is used for the good of all and is not to the personal advantage of those to whom it is entrusted.

Article 13

A common contribution is essential for the maintenance of the public forces and for the cost of administration. This should be equitably distributed among all the citizens in proportion to their means.

Article 14

All the citizens have a right to decide, either personally or by their representatives, as to the necessity of the public contribution; to grant this freely; to know to what uses it is put; and to fix the proportion, the mode of assessment and of collection and the duration of the taxes.

Article 15

Society has the right to require of every public agent an account of his administration.

Article 16

A society in which the observance of the law is not assured, nor the separation of powers defined, has no constitution at all.

Article 17

Since property is an inviolable and sacred right, no one shall be deprived thereof except where public necessity, legally determined, shall clearly demand it, and then only on condition that the owner shall have been previously and equitably indemnified.

DECLARATION OF THE RIGHTS OF MAN AND OF THE CITIZEN adopted on 26 August 1789 by the French National Constituent Assembly

It is evident to all alike that a great democratic revolution is going on amongst us; but there are two opinions as to its nature and consequences. To some it appears to be a novel accident, which as such may still be checked; to others it seems irresistible, because it is the most uniform, the most ancient, and the most permanent tendency which is to be found in history.

Alexis de Tocqueville

Alexis de Tocqueville (1805–1859) was a French publicist, politician and historian.
In: *Democracy in America*, Vol. 1 (1835)

the uprisings in 1830 and 1848. In their wake, many West European countries introduced elected, representative institutions. However, at that time popular sovereignty did not yet mean political equality.

As in the ancient city-states and the Italian city republics, it was not just women who were excluded from exercising political rights. The rights of citizens were in fact limited more generally to those who were affluent (and tax-paying) and educated, and who had permanent residence. When such rights were extended, then it was as part of a reasoned calculation by those in power, seeking to ensure their own political survival and avoid revolts. It thus is no surprise that one consequence of the revolts in 1830 and 1848 was to see countries first either introduce or broaden general male suffrage. Great Britain, for example, at first granted only 2 percent of the population political rights, though it then extended them step by step.

Countries that immediately introduced universal or full male suffrage remained the exception. France was among them, though the universal male suffrage they introduced in the wake of the 1789 revolution would be restricted again only a few years later to a small part of the population. After 1849, Prussia had universal male suffrage, but its three-class franchise system depended on the amount of tax paid—with the result that the richest one-fifth of the population controlled two-thirds of the seats in parliament.

When the soldiers returned from the battlefields at the end of World War I, they had risked their lives for the state and yet often remained subjects of that state without rights. Well-trained in the use of weapons, they were therefore ready to organize uprisings. Under these circumstances, democratization was unavoidable, and most European countries moved to introduce universal suffrage, or at least universal male suffrage (see Figure 2). Women received the right to vote in the United States in 1920, but blacks living in southern states remained de facto excluded from suffrage into the 1970s. Switzerland was the laggard here, as it did not grant women full suffrage at the national level until 1971.

World War I led to the downfall of the four major continental powers that had ruled Europe to this point: the German, Hapsburg, Russian, and Turkish empires.

Australia	New Zealand	Denmark	Norway	Austria	Sweden	Germany	Finland	Canada	Great Britain	France	Italy	Belgium	Japan	USA	Switzerland
1903	1907	1915	1915	1918	1918	1919	1919	1920	1928	1946	1946	1948	1952	1970	1971

2 **INTRODUCTION OF UNIVERSAL SUFFRAGE IN WESTERN DEMOCRACIES** A Surprising Order: In southern states in the U.S., blacks were in practice only able to properly participate in elections after 1970. In Switzerland as well, a significant group, namely women, were only nationally enfranchised in 1971. For that reason, in these two countries, which are generally regarded as model democracies, universal suffrage has only existed since the second half of the twentieth century.

Their dynasties, as well as their claim of a divine right to political rule, vanished at this point in time as plausible reasons to legitimate the exercise of political power, and with them, the aristocracy was definitively deprived of its power. The downfall of these empires made possible the triumph of the nation-state, with its claims to self-determination. Simultaneously, democracy became the only legitimate form of government in the nation-states of Europe. World War I marked the high point of the first wave of democratization, but during the interwar period, most of these countries fell victim either to autocratic military coups or to fascist regimes.

The Second Wave of Democratization after World War II

Only after World War II did a new wave of democratization begin. The Western Allies introduced democracies in the areas they occupied, in particular West Germany, Austria, Italy, Japan, and Korea, usually as a continuation of earlier national traditions. Greece and Turkey soon joined this group, and in a number of Latin American countries democracies also emerged, though they were only of short duration. Beyond this, decolonization after the war created a large number of new states, though very few of them became democratic. India was among them, and since the passage of its constitution in 1950, it has been the largest democracy in the world.

In Western Europe after the war, the conviction grew that democracy should grant all its citizens not only the same freedoms and right to political co-determination, but the same social rights as well. On the other hand, equal political rights in societies that had large economic inequalities were regarded as a threat to the capitalist system. As a compromise, European countries created the welfare state, linking democracy to upholding minimum social standards.

The second wave of democratization was followed by a second retrenchment, which particularly affected Latin America. The military in Peru first came to power in 1962, when it looked as though the socialists might win the presidency. In the ensuing years, the military took over in numerous other Latin American nations. Such military coups often occurred when politics became increasingly radical: They were politically right-wing (with the important exception of Peru from 1968 to 1980) and oriented to the United States, a country that did everything it could during the Cold War to defend, if not extend, its sphere of influence.

Other examples of such retrenchment occurred in Asia, when President Marcos declared a state of siege in the Philippines in 1972, and when India's Indira Gandhi suspended democratic rule in 1975 and declared a state of emergency. In the Mediterranean, Greek democracy fell in the 1967 Colonels' Coup, and the army repeatedly intervened in civilian politics in Turkey after 1960. Since 1966,

Nigeria has been the scene of a number of military coups; across Africa, it is only Botswana that has become (at least to date) a stable democracy. However, some former British colonies—the islands of Malta, Jamaica, Trinidad, Barbados, and Mauritius—did become democracies during the 1960s.

The Third Wave of Democratization: From the 1970s to the present

A geopolitical shift in paradigm took place in the 1970s in both the United States and Western Europe. Up to that point, U.S. foreign policy had been focused on warding off left-wing overthrows of governments. But now it began to be more concerned about the protection of human rights and more interested in political democratization—even in countries where this would mean toppling anti-communist dictators. The European Community, in turn, now tied its expansion policy to the goal of democratization. In addition, the Organization for Security and Co-operation in Europe (OSCE), to which both Western and Eastern European countries belong, included "respect for human rights and fundamental freedoms" in the accords and declaration signed at their now-famous conference in Helsinki in 1975. The oil crises of the 1970s also broke the back of more than one autocratic regime.

The signal for the third and largest wave of democratization had been given. The Southern European dictatorships ended with the Carnation Revolution in Portugal (1974), the end of the Colonels' dictatorship in Greece (1974), and the death of General Franco in Spain (1975); these countries then started up accession negotiations with the European Community. As U.S. support for dictatorial regimes diminished, the wave of democratization washed first over Latin America, then East and Southeast Asia (the Philippines, Taiwan, South Korea, Thailand, Indonesia), and then the Eastern Bloc countries with the collapse of their communist regimes in 1989 and 1990. Since 2000, mass protests—called color revolutions—have toppled numerous autocratic regimes in Eastern Europe and in the successor countries of the former Soviet Union. Protests, dubbed the Arab Spring by the media, broke out in 2011 in the Arab world, a region up to that point regarded as particularly unreceptive to efforts at democratization.

However, this wave of democratization did not lead to democracy everywhere. Though elections have been held in nearly every country in the world since the 1990s, they are often anything but free, and initial efforts to hold multi-party elections in a number of countries have been followed by violent conflict or by new dictatorships. In Algeria during the 1990s, for example, a civil war broke out when an impending electoral victory of the Islamists was forcefully prevented.

In some former Soviet republics, but also in some African countries, power was transferred to autocratic presidents after elections that were only in part prop-

erly conducted. In other countries, elections remain a farce, with protests suppressed, as after the 2009 Iranian elections. There, the Green Revolution unsuccessfully protested against electoral fraud perpetrated by the mullahs in power. Yet even successful cases of democratization take considerable time for democracy to consolidate and become stable. With respect to civil rights, even established newer democracies do not live up to the standards of older Western European and English-speaking democracies. Still, those latter countries themselves would not have met the current criteria for an ideal democracy even a few decades ago.

One should not forget that many authoritarian regimes still exist in the world. The most important of them is certainly China, which brutally suppressed a democratization movement in 1989, and where the Communist Party continues its authoritarian rule. We assume the future of democracy will depend on the future of democracy in China. If we are to believe the results of opinion polls, there is a great demand for democracy in China. Yet for now there is no movement on the part of the Chinese government to respond to this demand.

DEMOCRACY AS A UNIVERSAL VALUE

Amartya Sen

[…]

In the summer of 1997, I was asked by a leading Japanese newspaper what I thought was the most important thing that had happened in the twentieth century. I found this to be an unusually thought-provoking question, since so many things of gravity have happened over the last hundred years. The European empires, especially the British and French ones that had so dominated the nineteenth century, came to an end. We witnessed two world wars. We saw the rise and fall of fascism and Nazism. The century witnessed the rise of communism, and its fall (as in the former Soviet bloc) or radical transformation (as in China). We also saw a shift from the economic dominance of the West to a new economic balance much more dominated by Japan and East and Southeast Asia. Even though that region is going through some financial and economic problems right now, this is not going to nullify the shift in the balance of the world economy that has occurred over many decades (in the case of Japan, through nearly the entire century). The past hundred years are not lacking in important events.

Nevertheless, among the great variety of developments that have occurred in the twentieth century, I did not, ultimately, have any difficulty in choosing one as the preeminent development of the period: the rise of democracy. This is not to deny that other occurrences have also been important, but I would argue that in the distant future, when people look back at what happened in this century, they will find it difficult not to accord primacy to the emergence of democracy as the preeminently acceptable form of governance.

[…]

Amartya Sen (b. 1933) is an Indian economist and philosopher. He was awarded the Nobel Prize in Economics in 1998.
Excerpt from *Journal of Democracy* 10, no. 3 (1999): 3–17

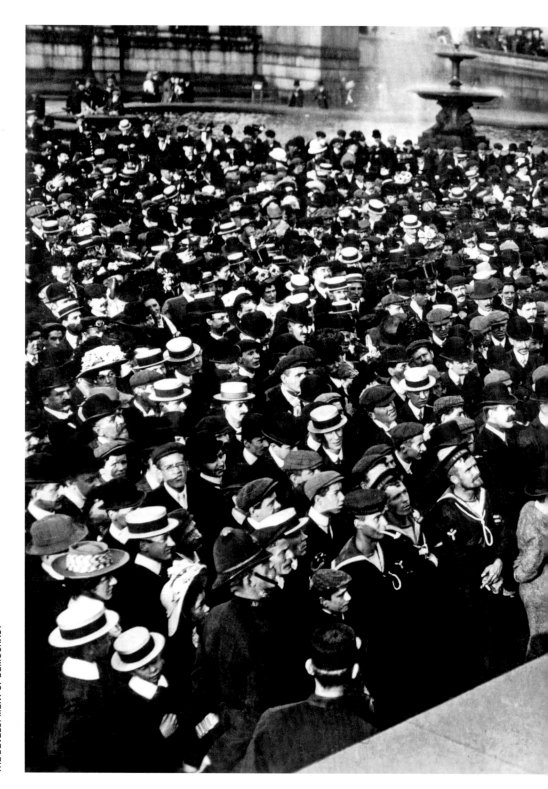

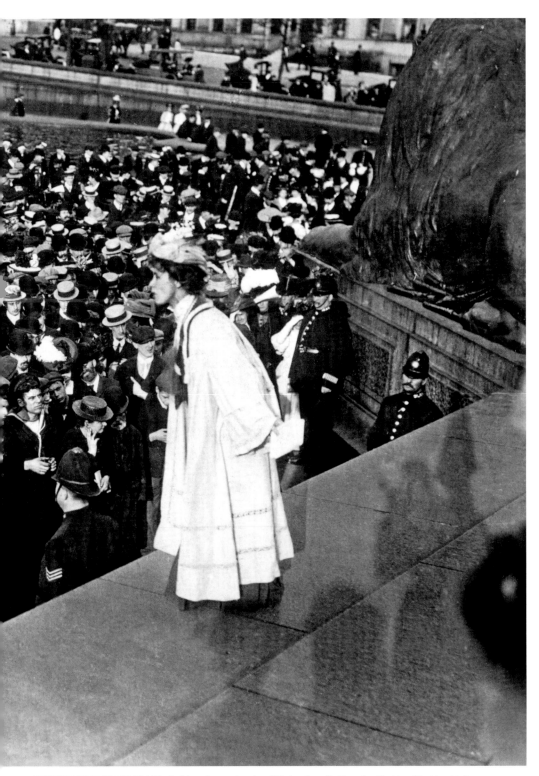

FIGHT FOR WOMEN'S SUFFRAGE Trafalgar Square, London: British suffragette Emmeline Pankhurst had fought since 1878 for the right of women to vote and for emancipation. In 1918, women aged 30 and older were enfranchised, and in 1928 the voting franchise was extended to all women on the same terms as men. Keystone

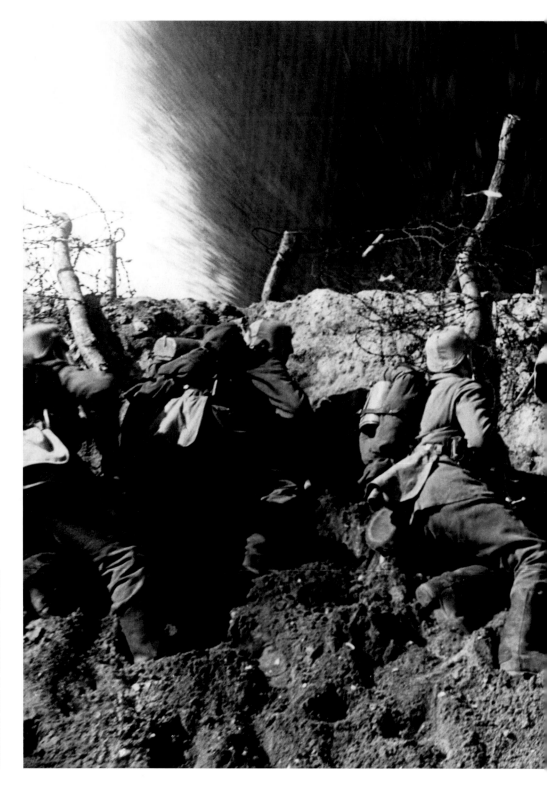

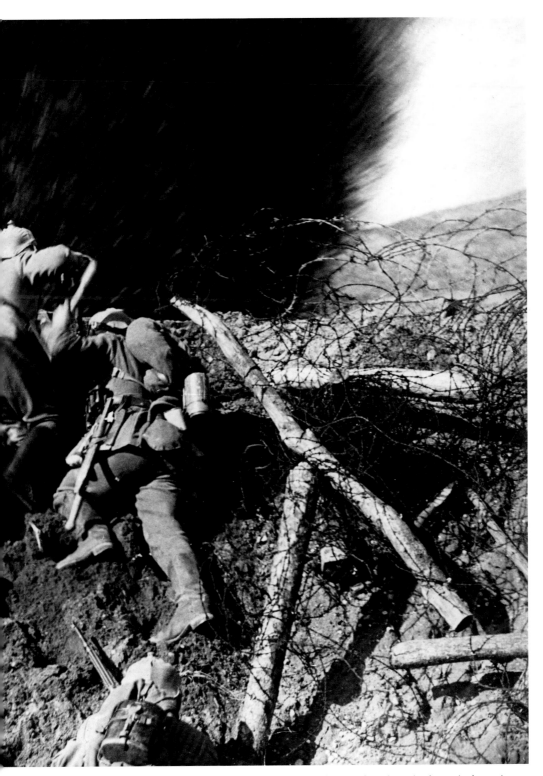

WORLD WAR I German soldiers in position: This conflict was fought largely from trenches; often only a few yards of ground might be won. Between 1914 and 1918, around 17 million people died. At the end of the war, the right to vote was expanded in many countries. In Germany, universal suffrage was introduced for women and men, on equal terms. (Scene from the documentary film *Der Weltkrieg*, 1928) Keystone/Scherl

END OF THE WAR Versailles, France, June 21, 1919: U.S. President Wilson after signing the Treaty of Versailles.
The treaty was later held partly responsible for the rise of National Socialism in Germany. Dukas/Bettmann

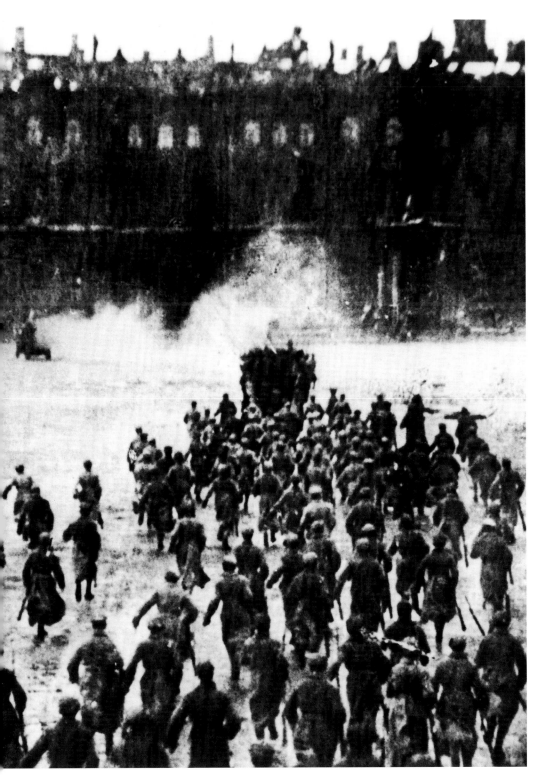

RUSSIAN REVOLUTION Petrograd, February 27, 1917: With the storming of the Winter Palace, the Bolsheviks seized power in Russia. The subsequent "dictatorship of the proletariat" claimed to speak for the people, but it deported millions of people. Many vanished into the Gulag or starved to death. Getty Images

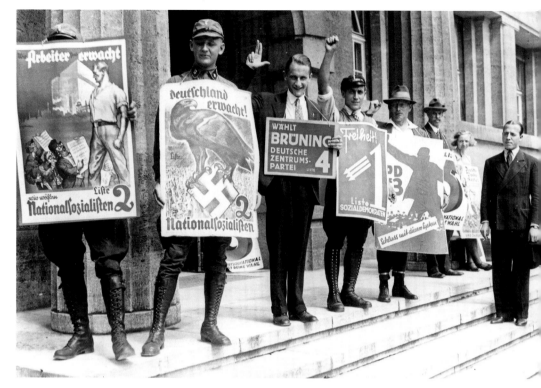

WEIMAR REPUBLIC Berlin, 1932: Campaign posters for the Reichstag election, in which the NSDAP obtained 37.7 percent of the vote in free elections. Bundesarchiv/Georg Pahl

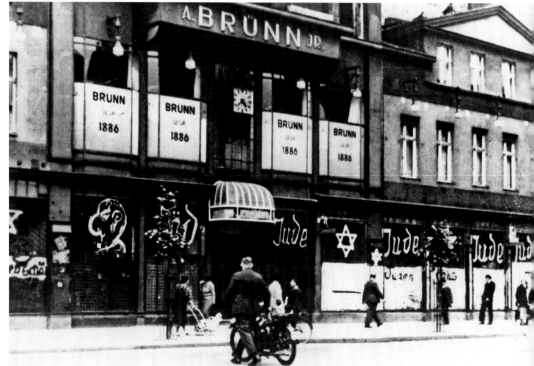

ANTISEMITISM Germany, 1933: Antisemitic symbols and images painted on the windows of a Jewish-owned shop. Keystone

FÜHRER CULT AND PROPAGANDA Schoolchildren start class with the Hitler salute. The curriculum was built around National Socialist ideology. The lesson plan included "the study of race," "the stab-in-the-back legend," and "German *lebensraum* in the East." Culver Pictures

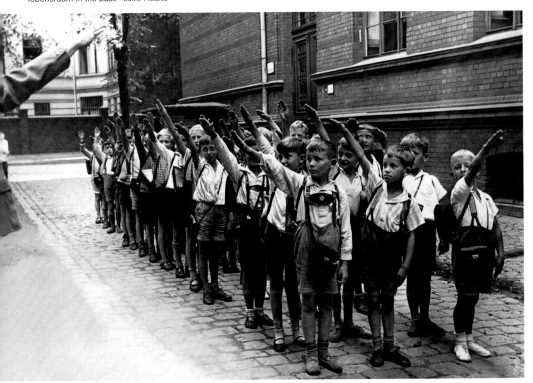

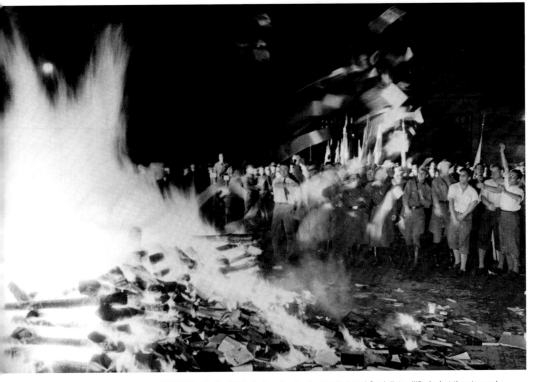

SUPPRESSION OF FREEDOM OF OPINION Berlin, 1933: By burning books, the National Socialists vilified what they termed "un-German" ideas. Many writers and artists left Germany. Imagno

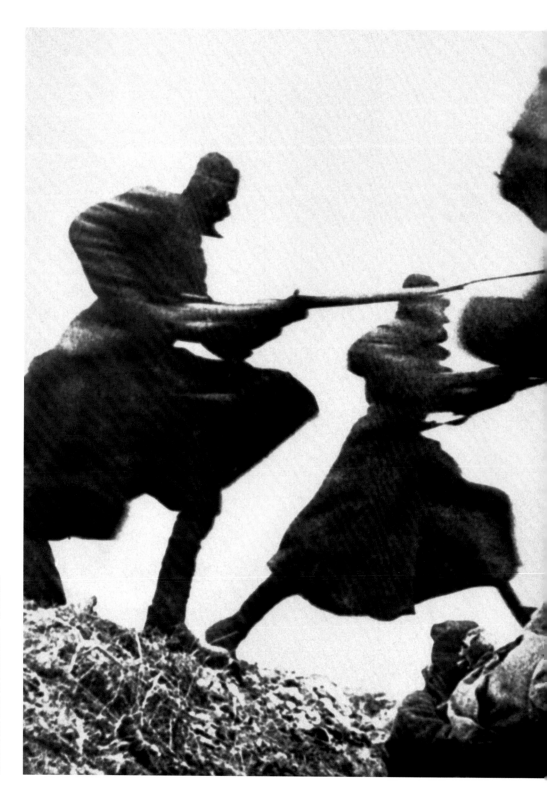

WORLD WAR II Eastern Front, 1941: To seize *lebensraum* in the East, Hitler invaded the Soviet Union on June 22, 1941. By the end of the war, the Soviet Union had lost 20 million citizens, including 6 million civilians. Dmitri Baltermants

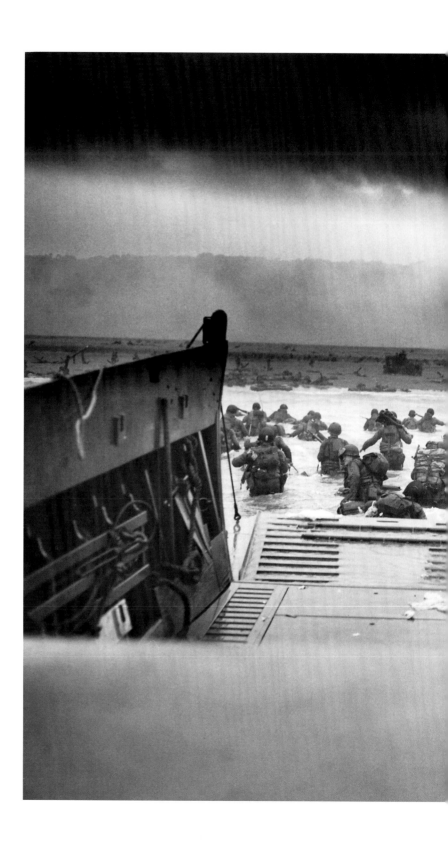

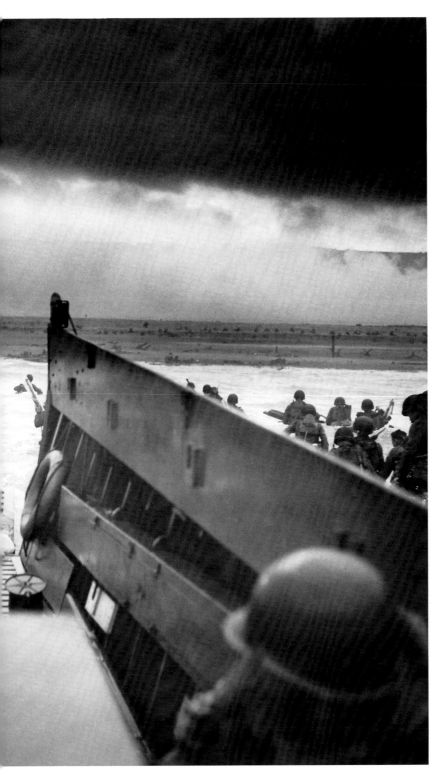

THE UNITED STATES ENTERS THE WAR France, 1944: American soldiers land at Normandy. Together with their allies, they freed Europe from Hitler's regime. On May 8 and 9, 1945, the Wehrmacht surrendered unconditionally. Robert F. Sargent

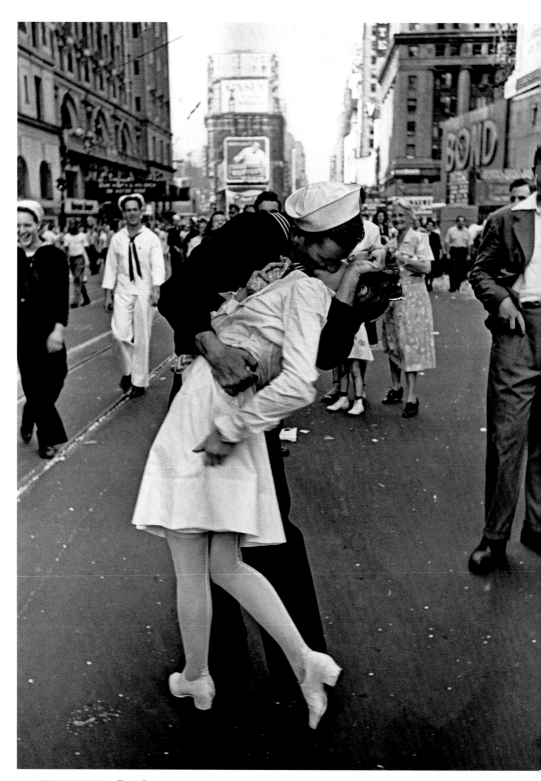

THE WAR IS OVER Times Square, New York, August 14, 1945: Victory celebration at the end of World War II.
Getty Images / Alfred Eisenstaedt

POST-WAR WORLD ORDER Stalin, Roosevelt, and Churchill at the Yalta Conference, the second of three conferences at which the Allies negotiated the post-war world order. Germany was divided in two and power was redistributed in Europe. While liberal democracies prevailed in Western Europe, the countries in the Eastern Bloc were dominated by the Soviet Union until 1989. Keystone/Leemage

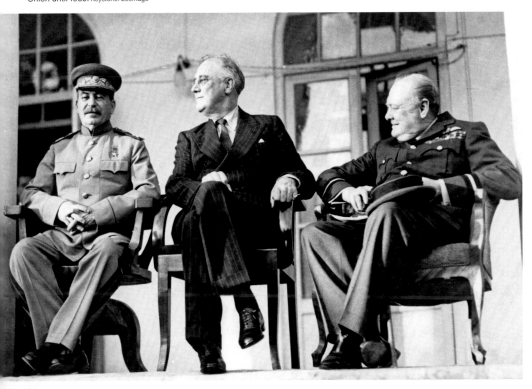

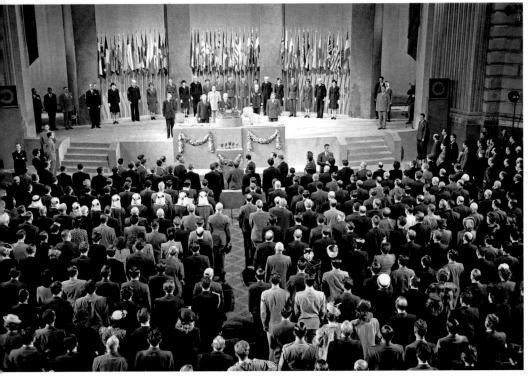

UNDER THE BANNER OF PEACE United Nations (UN) Charter Conference, San Francisco, 1945: The UN was meant to ensure the new world order held. In the Security Council, its most powerful body, the five victorious Allies of World War II continue to be the only permanent members with veto power. United Nations Photo

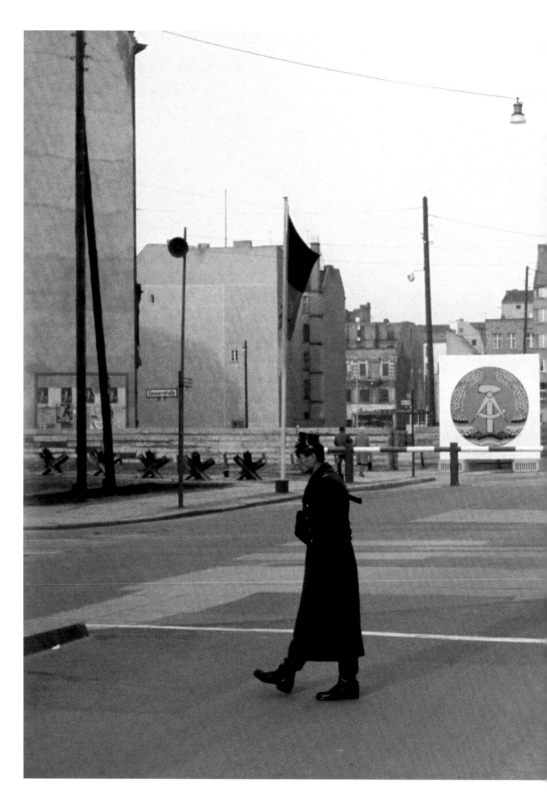

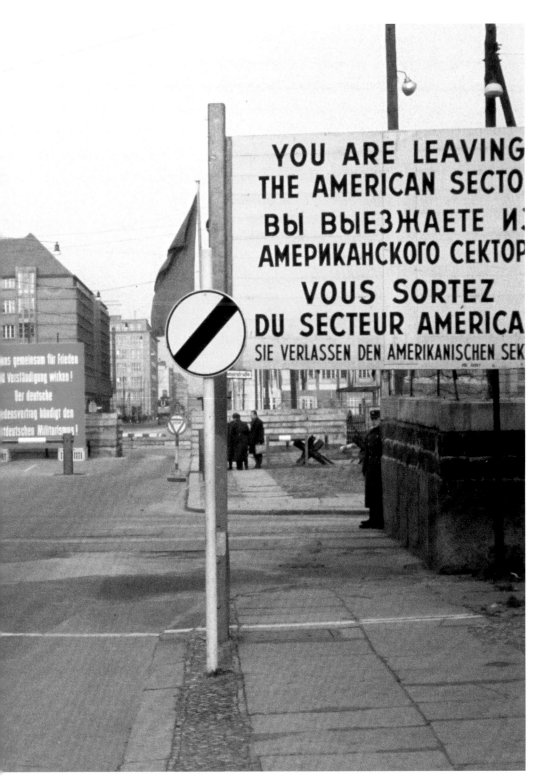

COLD WAR Checkpoint Charlie, Berlin, 1961: The building of the Berlin Wall closed the last gap in the Iron Curtain between East and West. ullsteinbild / Jung

The Third Wave in the Individual World Regions

Figure 3 shows the development of democratization in individual world regions during the third wave. This wave made great progress particularly in Latin America, in the former Eastern Bloc, and in sub-Saharan Africa. Not much changed in Western Europe (already at a high level) or in the Arab countries of North Africa and the Middle East (at a low level), by contrast, during the course of this wave of democratization. In this diagram, one can also see the considerable temporal differences within the larger democratization trends, depending on the region. There are also large variations with respect to the results. That suggests we should look more closely at specific democratization processes in four selected regions of the world.

Western Europe–Portugal, Greece, Spain

As already noted, the three Southern European countries of Portugal, Greece, and Spain democratized during the 1970s. The trigger in Portugal was an unwinnable colonial war that younger military officers had no interest in pursuing; in the spring of 1974, it led them to carry out a coup against the authoritarian regime. A war

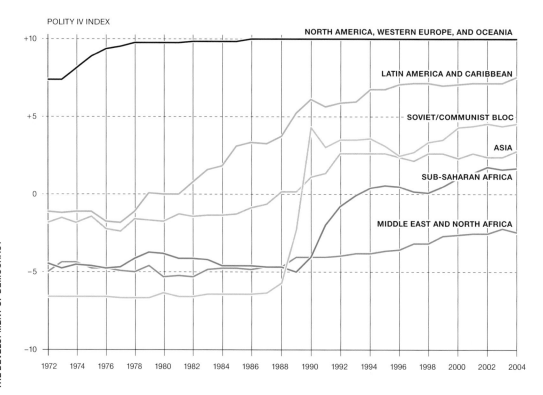

3 **DEVELOPMENT OF THE AVERAGE LEVEL OF DEMOCRACY, BY WORLD REGION (1972–2004)** The Polity IV Score index measures the quality of government based on a scale ranging from –10 (autocracy) to +10 (democracy). Democratic and non-democratic systems can be compared and contrasted using this scale.

THE DEVELOPMENT OF DEMOCRACY

with equally poor prospects that Greece was fighting with Turkey over the control of Cyprus led the Greek officers at the front, in the summer of 1974, to carry out a coup against the authoritarian Colonels' regime, and then to hand over power to a civilian government. The death of the Spanish dictator Franco in 1975, after nearly forty years of his rule, led to negotiations between the moderates in the Spanish government and the opposition, resulting in the democratization of the country.

The democratization of Spain is a model for a negotiated transition process from an authoritarian to a democratic regime. Under ideal preconditions—an international environment that supports the process, a developing economy pushing to be integrated into the (Western) European markets and into the European Community, a functioning civil service, and a lively civil society bent on introducing democracy—the decisive actors of the old regime were able to agree on a strategy for reforming the country and on a pact to do so. This pact made political (rather than economic) reforms the priority. To begin with, free elections were to be held at the national level, intended to establish who would be negotiating with whom. The existence of legitimized negotiating partners—political parties that had prevailed in national elections—provided the prerequisites for agreeing on the pact to democratize Spain.

Massive demonstrations and strikes of heretofore unknown dimensions in the spring of 1976 created an atmosphere of crisis, motivating the reform-minded forces of the old regime to move to a more inclusive strategy: They extended a hand to all the political forces. Even radical parties were allowed to take part in the decisive national election in June 1977, including the Communist Party of Spain, which had been banned up to that point. The vast majority of the electorate, however, chose the more moderate parties, and the army did not interfere in the democratic political process.

The major threat to the consolidation of democracy in Spain was the strong ethno-nationalism that existed in Catalonia and in the Basque Country. Yet because elections in Spain were first held nationally and only later regionally, the national institutions—parliament and government—had a legitimacy bonus that served them in good stead in the negotiations over the political future of these two provinces. The orderly, step-by-step democratization likely also contributed to the fact that not a single political actor ascribed responsibility for the Basque terror perpetrated by the ETA organization between 1978 and 1983 to the new Spanish democracy. On October 25, 1979, the majority of the electorate in Catalonia and in the Basque Country voted in favor of a regional autonomy statute, thus bringing the process of granting regional autonomy to an initial preliminary resolution. After the abor-

tive coup against democracy attempted by Colonel Tejero and General Milans del Bosch in February 1981, and after the first transfer of power in 1982 from the Conservatives to the Social Democrats, who had thus far been in opposition, Spanish democracy was finally and definitively consolidated.

The Communist Eastern Bloc: The Soviet Union and Central and Eastern Europe

The democratization of Europe continued in the East. Hardly anyone expected that the reforms introduced in the mid-1980s by the new General Secretary of the Communist Party of the Soviet Union, Mikhail Gorbachev, would lead to the dissolution of the Soviet Union, changes to the governments of the Eastern Bloc, or even to changes in Yugoslavia, Communist-run but independent of the Eastern Bloc.

The preconditions for democratization processes in this region were far less favorable than in Southern Europe. These were countries ruled by authoritarian regimes that had suppressed civil society efforts for decades. But their economies weakened substantially during the 1980s, and the ability of their political systems to cope declined along with it. The nuclear disaster in Chernobyl in 1986 was only the apex of other environmental catastrophes and comprehensive ecological degradation throughout the Soviet Union. Yugoslavia, too, fell into economic difficulties as the result of a debt crisis.

The reforms Gorbachev introduced were partly oriented to establishing transparency and openness (*glasnost*), and partly to reducing the horrendous defense expenditures, as well as to bringing about economic and political reforms (*perestroika*). In the course of this new orientation in Russia's leadership, Gorbachev made it clear that Moscow would no longer militarily intervene to prevent reforms or upheavals in the Eastern Bloc countries.

The sudden absence of Soviet tutelage led to dramatic political changes in the Eastern Bloc countries, and the process of reform there took on its own dynamics. Gorbachev's reforms, which had been introduced from above in the Soviet Union, made revolutions from below possible in large parts of the former Eastern Bloc. Environmental movements arose in the small Baltic Soviet republics to protest against the pollution created by Soviet industry, as well as to oppose the construction of a nuclear power plant in Lithuania. But above all, these movements allowed nationalist and anti-Soviet forces to develop independence movements under the guise of a green umbrella movement.

Outside the Soviet Union, the change began first in Poland, the Eastern Bloc country with the strongest civil society and the weakest regime. Toward the end of the 1980s, a conflict developed on two levels in Poland. The conflict between

party and society was augmented by internal fights within the Communist Party between moderate reformers and hardliners, as well as by internal fights within the oppositional union movement Solidarność between the moderates around Lech Wałęsa and the radicals. By fall 1988, the leaders of Solidarność were no longer able to control the increasing mobilization of their base. As in Spain, reformers in the opposition and reformers in the regime moved toward one another, thus allowing the key steps to be taken, namely the Round Table talks that led to the transition to democracy.

Protests soon spread across the entire region. When the police, too, refused to halt street protests in Czechoslovakia, the Communist Party collapsed. In East Germany, civil rights activists gathered for Monday demonstrations in Leipzig, which were soon copied in other cities. On a state visit to East Germany, Mikhail Gorbachev said to its then-leader Erich Honecker, "I think dangers await only those who do not react to life." But Honecker, a hardliner, did not react to the signs of the times, and was stripped of power in an internal revolt within the East German Communist Party. Once the Berlin Wall fell, the way to reunifying Germany also was paved. The last of the international protest dominoes brought down Todor Zhivkov in Bulgaria and Nicolae Ceauşescu in Romania. And though protesters in the streets exerted pressure in some countries, the actual reforms were usually hammered out at the negotiating table or in back rooms—especially in Hungary and Poland—under the guidance of respected religious figures or academics. By the beginning of the twenty-first century, all the countries in the former Eastern Bloc had developed fairly consolidated democracies.

While events in the Eastern Bloc followed one another in rapid succession, power in the Soviet Union was rapidly slipping from Gorbachev's hands. Liberalization here too had led to street protests and to conflicts among the party elite, both leading to national elections to the Congress of People's Deputies that were held in March 1989. However, only candidates for the Communist Party and independents were eligible to stand for election. A year later, when the parliaments of the Soviet Union's fifteen republics were elected, independence movements or reform organizations had only partly been formed.

Yet these elections were the trigger for very differentiated political developments in the various republics, as they created institutions of varying democratic quality. Popular protests, additionally, were organized regionally and barely coordinated at the national level. The Baltic states, Moldova, and the republics in the Caucasus were the first to push for independence, with the central organs of the Soviet Union simply unprepared to respond to the developments. Gorbachev had to defend himself in the Kremlin against opponents of his reforms, and was

even blocked by a coup launched by hardliners on August 19, 1991. Boris Yeltsin, a reformer and President of the Russian republic, hastened to his aid in Moscow, an act that brought a massive increase in his own power. Though the attempted coup came to an end after three days, it made clear that power was no longer in the hands of the Kremlin and instead had shifted to the institutions of the individual republics, particularly to those of the Russian Federation. By the end of 1991, the Soviet Union officially ceased to exist.

While the three Baltic states sought their future in closer ties to Western Europe, democratization did not proceed smoothly elsewhere in the former Soviet Union. Former party cadres created new authoritarian regimes in the five Central Asian republics, and Russia, Ukraine, and Belarus, after some fitful moves toward democracy, once again fell into the hands of presidents who ruled with a strong, authoritarian hand.

The end of communism in some places led ethnic diversity to turn into violent conflict, with nationalist leaders coming to power in some of the former Soviet and Yugoslav republics. Even after twenty years, conflicts over secession remain unresolved in the Caucasus and Moldova and hinder the development of democracy. In the former Yugoslavia, Europe also experienced its bloodiest conflict since World War II. In 1989, at Kosovo Polje—the Field of Blackbirds—in Kosovo, Serbian Communist leader Slobodan Milošević gave a speech that sparked nationalist Serbian policy, which would draw numerous neighboring ex-Yugoslav republics into war. Only with the end of the war, the death of the Croatian autocrat Franjo Tuđman, and the end of the Milošević regime in Serbia was it possible to begin democratizing the region.

After Milošević's defeat in the conflict over Kosovo, the opposition in Serbia was able to unify sufficiently to participate in the 2000 presidential elections. During state television coverage of Milošević's re-election, the results of which were likely manipulated, the opposition broadcast information showing the dictator losing the election, and after twelve days of mass public protests, the government finally resigned. The Serbian revolution initiated a series of other color revolutions sparked by fraudulent elections in Georgia (2003), Ukraine (2004), and Kyrgyzstan (2005).

Sub-Saharan Africa

Sub-Saharan Africa has no fewer than forty-nine countries. These countries have made notable progress toward democracy in the course of the third wave of democratization, though admittedly starting from a very low level. Democratic institutions in Africa, in the immediate period after decolonization, proved to be

not viable. In the newly independent states, multi-party governments were rapidly supplanted by one-party regimes, or replaced in coups by a military junta. In the 1960s, that meant Africa had the largest number of independent countries ruled by dictators that had ever been measured.

Various African countries have held elections since the end of the Cold War, not least under pressure from the international community. Yet they are rarely held regularly and are often little more than democratic window dressing: Even at the outset, the governing party is so strongly favored that the opposition stands no chance of winning the election. Sham parliaments are often elected, but the real power remains in the hands of the autocratic president. Frequently the autocrat in power is his own successor, too, legitimized through pseudo-democratic elections. Occasionally, those in power have also refused to vacate their positions even when they have lost elections, which in Kenya, Zimbabwe, and the Ivory Coast then led to bloody conflicts. The hope has thus been dashed in most African countries that holding elections can or will usher in further steps toward political liberalization, and one cannot really speak of a democratization of Africa. According to Freedom House in 2012, only nine smaller African countries can be regarded as democratic.

Yet because Africa has many faces, to generalize about it is nearly impossible, and the variation can be illustrated with four country cases. South Africa is likely the best-known example of a successful democratization. Until 1992, the country was ruled by the so-called apartheid regime, a government run by the white minority in the country. This regime excluded the black majority of the population from power. The ruling National Party (NP) had banned the black opposition party (ANC) and had thrown its leader, Nelson Mandela, into jail in 1962. Intransigence on both sides increased during the 1970s and 1980s, and a bloodbath seemed inevitable. Yet under international pressure exerted on the apartheid regime, as well as owing to a decline in the share of whites in the population over time, a rapprochement became possible. The newly elected white president, Willem de Klerk, released Mandela from prison in 1990, and together with other parties, the ANC and the NP began negotiations to democratize the country. In 1992, elections were held to create a constitutional assembly, and the pact agreed upon between blacks and whites ultimately guaranteed white property rights in exchange for political power for the black majority. In 1992, de Klerk and Mandela were jointly awarded the Nobel Peace Prize.

That democracy need not be confined to rich countries can be shown by the example of Mali. This multi-ethnic country, with an illiteracy rate of 75 percent, is among the poorest in the world. As in other African states like Benin or the Congo,

the Malian opposition was able to bring about a multi-party national conference after a series of protests, as well as a military coup in 1991. This conference worked out a new constitution, which led to free elections that the opposition won. Though not perfect, Malian democracy remained remarkably stable even during periods of miserable economic development and armed conflicts. Yet as a consequence of the war in Libya, a military coup took place in Mali in 2011, followed by renewed armed conflict. Only after international troops intervened to support the government was political order at least provisionally restored in early 2013.

Ghana is one of the rare examples of how a country that starts with unfree elections can gradually develop into a democracy. Under Kwame Nkrumah's leadership, the former Gold Coast became one of the first colonies to develop a militant, nationalist movement, and its efforts would lead the British colonial government to withdraw from the country in 1957. After a short democratic phase, Nkrumah created a repressive one-party state, and was removed from office in a 1966 military coup. After various other military coups, a radical, populist young lieutenant named Jerry Rawlings took power in 1981. At the beginning of the 1990s, he surprised everyone by releasing political prisoners and announcing free and fair multi-party elections. Though the first elections were heavily manipulated, access to politics by the opposition gradually improved. When the incumbent was no longer permitted to stand for office in 2000, the opposition party candidate won for the first time. The advent of genuine party competition means Ghana can today be regarded as democratic.

The final example is Nigeria, a country with the largest population in Africa and, after South Africa, the second-largest economy. It is also the dominant state in West Africa. After taking some encouraging initial steps toward democratization, it then fell into the hands of military rulers from 1966 to 1999. The ethnic diversity in the country creates enormous challenges for its governments. The first challenge, after independence was achieved in 1960, was a devastating civil war fought between the separatist Ibo people and the government from 1967 to 1970. Since that time, the government has experimented with federalist structures. Also problematic for the democratization of the country has been the discovery of oil fields in the Niger River delta. That has brought wealth but has also worsened the corruption of the political elite. The last military regime, which ruled Nigeria until 1999 under the command of General Sani Abacha, was marked by the spectacular personal enrichment of the head of the government and his family.

Nigeria has seen four presidential and parliamentary elections since 1999, marked, or marred, each time by manipulation, swindles, corruption, and violence, though there were cases in which parts of the electorate successfully orga-

nized themselves to protect their votes. Politics is wholly controlled by former military officers. This elite has brought a military structure of orders, command, and obedience into politics, depriving the citizens of any substantive rights and of political participation rights.

In sum, one can regard the steps taken toward democracy in Africa as a combination of various factors. Economic deprivations over a longer time period have led to unrest in the population and calls for greater political participation by the people. International factors such as the end of the Cold War or the ongoing economic crisis also played a role. In the case of the latter, authoritarian regimes in Africa could no longer count on the support of the superpowers to prop up their rule. In the case of the former, a worsening crisis is undermining the possibilities these regimes have to keep their client group satisfied by providing gifts and privileges.

However, and against this background, the strategies the political actors have adopted have proven decisive, as the examples of de Klerk and Mandela in South Africa, Jerry Rawlings in Ghana, or the Nigerian ex-generals illustrate. As in the past, there are also structural factors that make further steps toward democratization in Africa difficult. Among them, one can include the great cultural and ethnic diversity that exists in individual countries (on this, see pp. 233–4), widespread poverty, a personalized political culture, as well as the new role China, a country that works closely with authoritarian regimes, is playing in Africa. As far as the state is concerned, in many parts of Africa it has not been able to establish itself as the legitimate political power or to work well with existing, traditional social structures.

North Africa and the Middle East

The Arab countries of North Africa and the Middle East have shown themselves historically to be particularly resistant to democratization. This is unlikely to have been due to a lack of democratic values in the population. If anything, the Arab Spring of 2011 clearly proved the exact opposite yet again. Nor is Islam a hindrance to democratization, if one considers countries with heavily Islamic populations such as Turkey, Indonesia, Bangladesh, or Malaysia. To differing degrees, they have each established democratic institutions.

Instead, two factors in particular have likely slowed democratization in the Arab world: The international context and natural resources, especially oil and gas. Rather than increasing the pressure to democratize, the international community has often provided economic and military support for authoritarian regimes. In the eyes of the West, such governments helped ensure the stability of the region and could control or curb feared Islamist movements.

A prime example of the role the international context played was the failure to consolidate democracy in Algeria. After the liberalization of the regime in 1989, Algeria experienced an efflorescence in its civil society and in multi-party political competition. In local elections in 1990 and in national elections in 1991, both of which were somewhat free, the newly founded Islamist FIS (*Front Islamique du Salut*) party celebrated an overwhelming victory. Its accession to power, however, was prevented by a military coup. The military intervened in politics under the pressure brought by liberal and secular circles. As a result, Algeria was swallowed up in a bloody civil war lasting for years. Rather than responding to the military coup with sharp critique and sanctions, the international community, under French leadership, instead supported the return to authoritarianism as well as the new regime. Some claim military leaders in Algeria had even been provoked into intervening by French authorities.

The second factor long hindering democratization in the Arab states has been their resources, especially oil. Its availability has allowed the authoritarian regimes of these countries to buy off their populations and control them. With natural resources at its disposal, the state becomes the largest employer in the country and can at the same time free the citizens from practically every tax, thereby subsidizing affluence. It is the reverse, one might say, of the call to arms in the American Revolution: No representation without taxation. In addition, enough means are available to maintain a large state security apparatus and use it to intimidate and suppress critics of the regime. Overall, therefore, the state can exercise extensive control over its population, and the global increase in oil and natural gas prices in the twenty-first century has made it much easier for the authoritarian regimes in this region to survive.

But the Arab Spring of 2011 has now brought democratization efforts to this part of the world as well, starting with Tunisia. Since 2008, living conditions have worsened as a result of the global economic crisis, and the country was already plagued by high and increasing youth unemployment rates. In a social context that was already tense, Mohamed Bouazizi, a street vendor, immolated himself on December 17, 2010, in the town of Sidi Bouzid. This act triggered spontaneous protests, which rapidly spread across the entire county and were soon supported by the largest unions and professional organizations. Initially the regime tried to suppress these revolts, but when the army made it clear that it would not participate in the crackdown, Tunisia's dictator Ben Ali fled abroad on January 14, 2011. A transition government was installed within a few days, and it organized elections for a constitutional assembly in October 2011 that were won by a moderate Islamist party, Al-Nahda, which thereupon created a coalition government.

Events in Tunisia had an inspiring effect on Egypt, the most important Arab country, with the first demonstrations taking place there on January 25, 2011. In the ensuing days, they grew into mass protests demanding the resignation of President Mubarak. Illegal strikes soon followed. When the police withdrew from the streets, the army, greeted enthusiastically by the demonstrators, took over the task of trying to maintain public order. The Supreme Council of the Armed Forces declared its support for the legitimate demands of the demonstrators, and after Mubarak resigned on February 11, it assumed power over the country. On March 19, constitutional referendums to limit the terms in office of the president, limit emergency powers, and increase judicial oversight of elections were approved. Yet hopes of a rapid and comprehensive democratization were soon dashed. The military leaders soon turned against a too-rapid liberalization, massively increased repressions, and did little to halt conflicts over religion. Elections, as in Tunisia, resulted in a victory for the moderate Islamists (the Muslim Brotherhood), who received 47 percent of the votes, as well as for the more radical Islamists (the Salafists), who received an additional 25 percent. These parties thereupon passed a new constitution, which not only has great deficiencies with respect to the protection of basic rights and the rights of minorities, but also removes the military from civilian control.

Events in Tunisia and Egypt resonated in a wave of protests that spread across nearly the entire Arab world. In Libya, it led to a civil war that ended with the victory of the rebels, supported by NATO, over the regime long run by Muammar Gaddafi. Protests broke out in mid-February in Bahrain, where a political conflict had long simmered between minority Sunni leaders and the majority Shiite population, but they were decisively quashed a month later with the help of Saudi Arabian troops. After Ben Ali fled Tunisia in mid-January, demonstrations took place in Yemen, demanding that the country's long-serving president, Ali Saleh, be deposed. Despite strong repression, these protests escalated, and the pressure exerted by protesting citizens led, a year later, to the President's willingness to go into exile abroad. Protests against President Assad's government in Syria, despite enormous repression, has led to a situation of near civil war. Thanks to concessions made by their leaders, both Morocco and Jordan were able to keep the revolts under control. Various other governments, including those of the United Arab Emirates, Lebanon, and Saudi Arabia, responded by further limiting liberties or by persecuting specific segments of the population to prevent protests from arising. There were no noteworthy protests either in Algeria or in the Gulf States, with the exception of Bahrain.

There are two, only partly satisfactory, answers to the question why these revolts broke out in 2011. One points to a strengthened civil society in those coun-

tries where the revolts have thus far had the greatest success. The other points to the role of the media. Thus, the Qatari satellite television station Al Jazeera played a decisive role in continuing to report on the protests despite efforts by the Tunisian and Egyptian governments to halt the broadcasts. The television station itself used information supplied by protestors through the Internet and sent on mobile telephones.

It is easier to answer the question why some protests were more successful than others: The survival of regimes was decisively dependent on the support of the government by the military and by other allies. In Egypt, for example, the army had increasingly distanced itself from the Mubarak regime. As in Tunisia, it had refused to intervene to stop the demonstrators. This was quite different in Syria, where the army is closely linked to the government, and where the army has (thus far) used massive violence against the civilian population and in support of the government. The army in both Yemen and Libya was divided, as well as being a relatively weak institution. Finally, quite different segments of the population joined in protest against the government in Tunisia and in Egypt, while governments in Libya, Bahrain, Yemen, and Syria were able to profit from or to strategically exploit divisions in their populations to prop up their rule.

But sustainable steps toward liberalization stemming from the Arab Spring have been very limited. The former dictators of Tunisia and Egypt have been toppled and initial elections held, but both countries are far from being democratized. Whether the region as a whole can be democratized despite its unfavorable context, meaning in particular its oil-dependent economy, remains open.

The fact that the dynamism of the Arab Spring has slowed and that democratization has also not advanced as much as one might like in other countries once again underscores that it is a process that takes time. The triumph of democracy as the only legitimate form of government is, for now, only an apparent success. Thus, many countries that formally democratized during the third wave hold elections, but they do not take place under conditions in which all participants have equal opportunities. Democracies in the third wave generally remain less liberal than the Western democracies that established themselves during the second wave. That democracy has been only partly realized in the third wave is not an argument against its attractiveness as a universal value shared by people around the world. Rather, it points to the fact that opposition by rulers to democracy remains unbroken in the respective countries.

My notion of democracy is that under it the weakest should have the same opportunity as the strongest.

Mahatma Gandhi

Mahatma Gandhi (1869–1948) led the movement for Indian independence from British colonial rule.

DECOLONIALIZATION Bombay, India, 1944: Mahatma Gandhi, the leader of India's independence movement, was the embodiment of non-violent resistance to British colonial power; Jawaharlal Nehru (left) became the first prime minister of independent India in 1947. Keystone/Max Desfor

DECOLONIALIZATION Congo, 1960: During the ceremony marking the handing over of power, Belgian King Baudouin's sword is torn from his hand by a Congolese. Within a few months, the initial attempts at democracy gave way to coups and armed violence—with the previous colonial rulers playing a role as well. Between 1945 and 1968, 43 new states came into being on the African continent. Keystone/Robert Lebeck

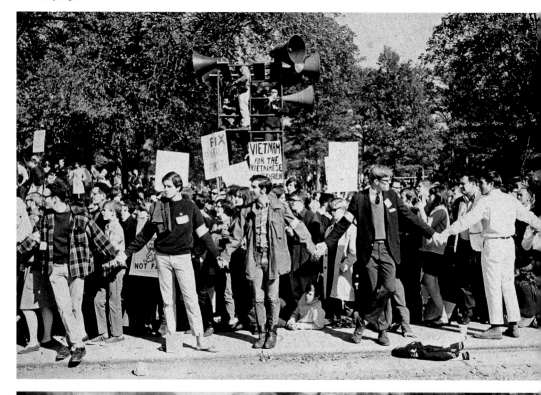

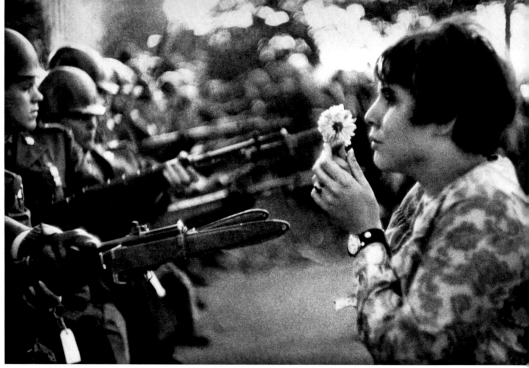

VIETNAM WAR PROTESTS Washington, D.C., 1967: Across the country, protests erupt against United States military involvement in Vietnam. Magnum Photos/Marc Riboud

THE 1968 MOVEMENT Paris: For a few days in May 1968, students and striking workers took over the city. In 1968, civil rights and student movements began in many European and U.S. cities. Keystone/Bettmann

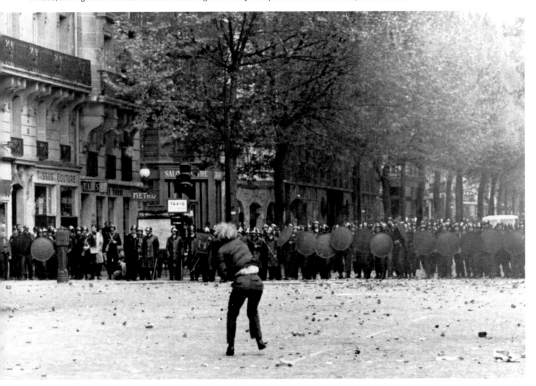

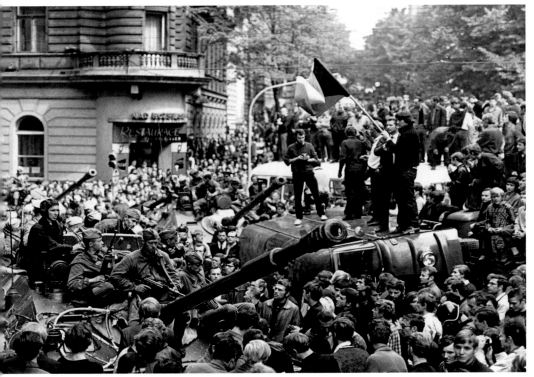

PRAGUE SPRING Prague, 1968: The invasion of Soviet troops put a stop to the Czechoslovak experiment in "socialism with a human face." This ended the tentative steps toward liberalization taken by Alexander Dubček, the newly elected General Secretary of the Communist Party of Czechoslovakia. AFP Photo/Libor Hajsky

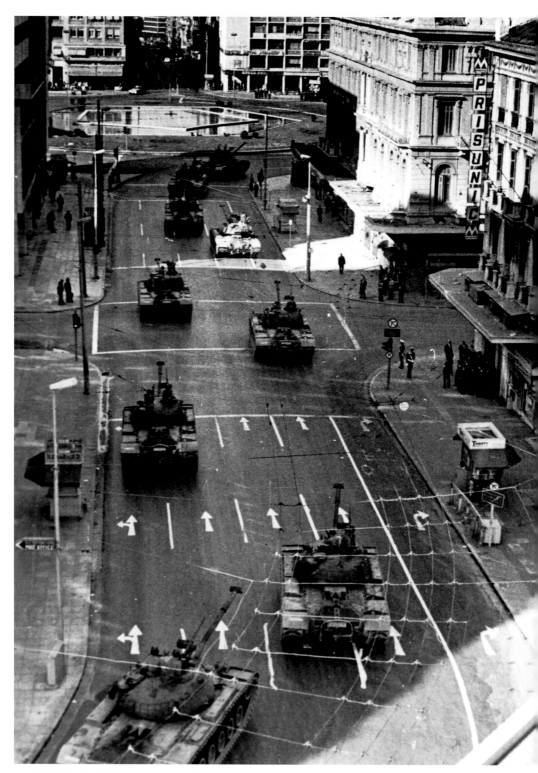

MILITARY DICTATORSHIP IN GREECE Athens, 1973: The Colonels' junta rendered democracy inoperative in Greece between 1967 and 1974. The 1967 coup was the result of a thirty-year conflict between left-wing and right-wing forces.
Keystone/Vassilis Karamanolis

MILITARY DICTATORSHIP IN CHILE Chile, 1973: The National Stadium in Santiago de Chile. After the coup against democratically-elected socialist President Salvador Allende by the military junta under Augusto Pinochet, as many as 40,000 members of the opposition were held, interrogated, and tortured here. The coup was supported by the United States. Dukas/Bettmann

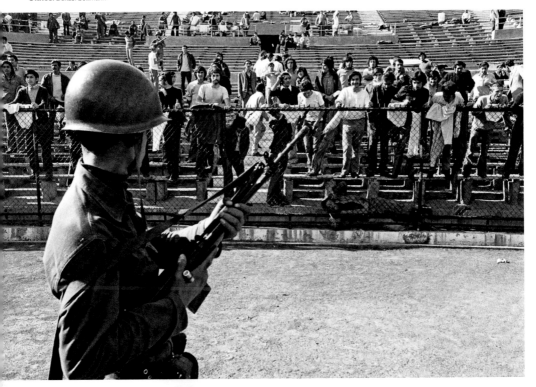

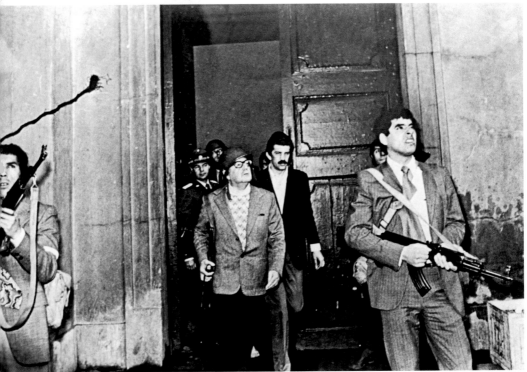

THE TOPPLED PRESIDENT Santiago de Chile, September 11, 1973: Salvador Allende on the day of the coup at La Moneda Palace, the seat of government, which the rebels bombed and finally stormed. Allende then took his own life.
Dukas/Orlando Lagos

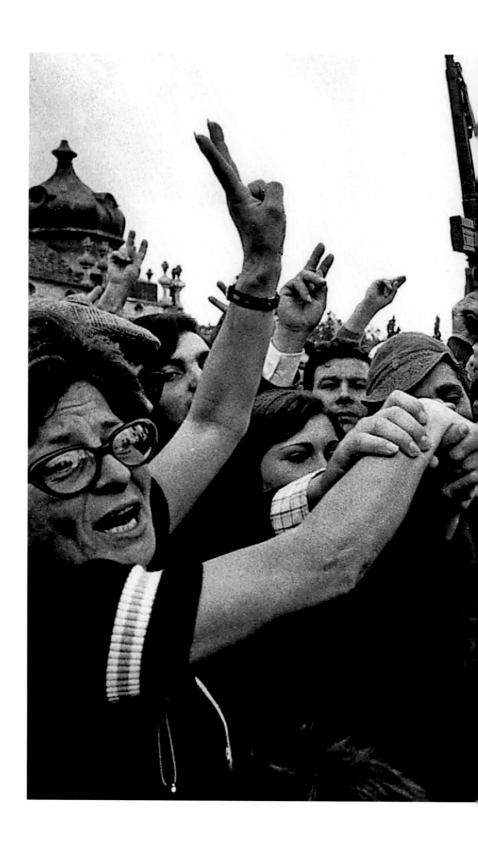

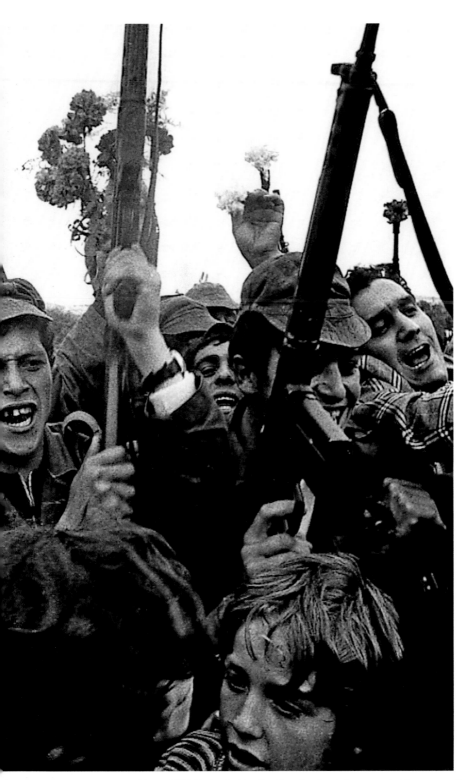

CARNATION REVOLUTION Portugal, 1974: During the bloodless Carnation Revolution, one part of the army overthrew the authoritarian dictatorship that had ruled for forty-eight years. Portugal granted independence to its colonies, elected a constitutional assembly the following year, embraced modernization, and joined the European Union in 1986. Reuters

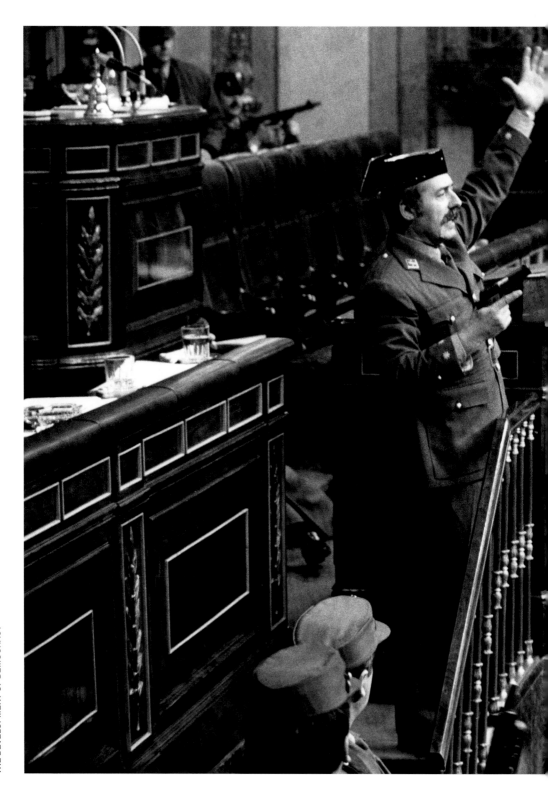

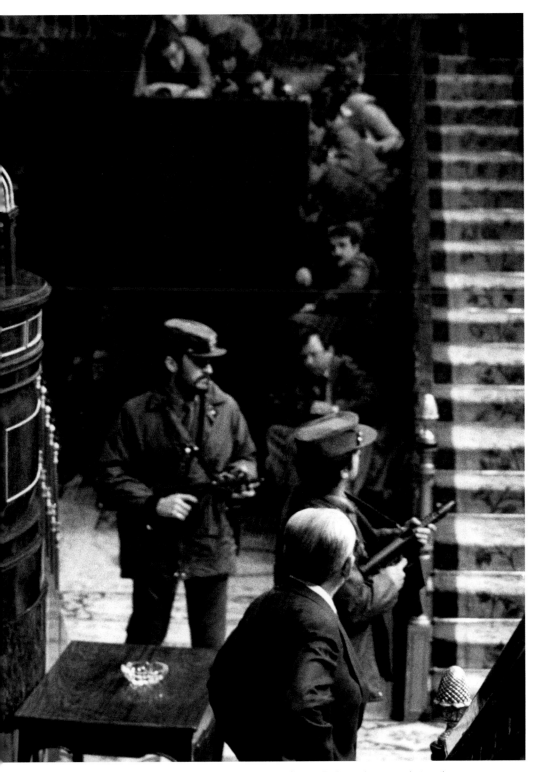

FAILED COUP Madrid, 1981: Antonio Tejero taking members of the Spanish Parliament hostage and attempting a coup, trying to stop democracy from being introduced in Spain after the end of the Franco regime. In a bold intervention, Spain's King Juan Carlos I spoke on television, asking citizens to stay calm and to support the democratically elected government.
Manuel Pérez Barriopedro

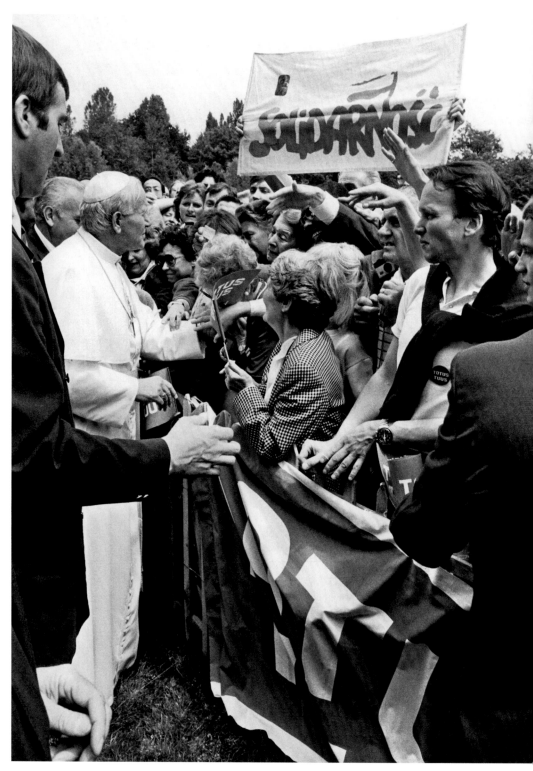

BEARER OF HOPE Geneva, 1982: Pope John Paul II on a visit to Switzerland. While the election of Pole Karol Wojtyła as Pope in 1978 raised hope for change in his native country, elsewhere the Catholic Church backed military regimes and nationalists who ruled in an authoritarian manner. Keystone

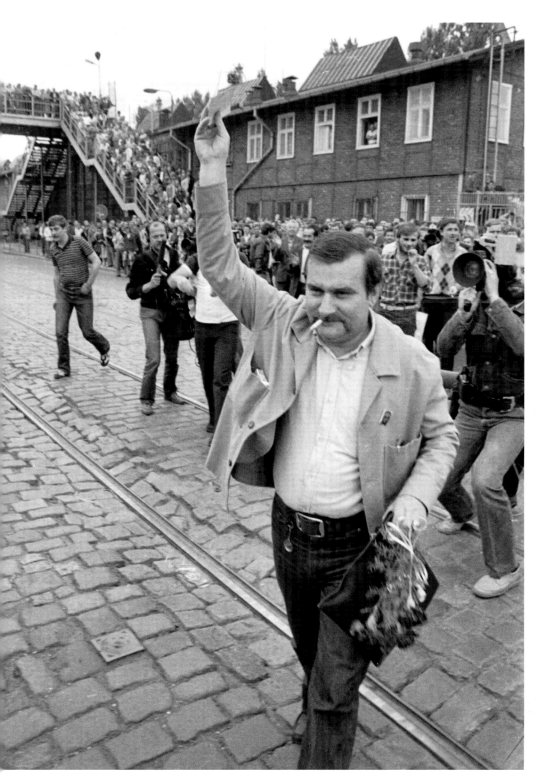

STIRRINGS IN EASTERN EUROPE Gdansk, Poland, 1983: Union leader Lech Wałęsa came to symbolize resistance to communism in Poland and Eastern Europe. In Solidarność, he founded the first free union in the Eastern Bloc. After repeated protests six years later, and through the Round Table discussions, the union brought about the introduction of the first partially free elections. Dukas/Bettmann

THAW Washington, D.C., 1987: Ronald Reagan and Mikhail Gorbachev sign the Intermediate-Range Nuclear Forces Treaty to destroy all medium range nuclear weapons in Europe and Asia. Dukas/Bettmann

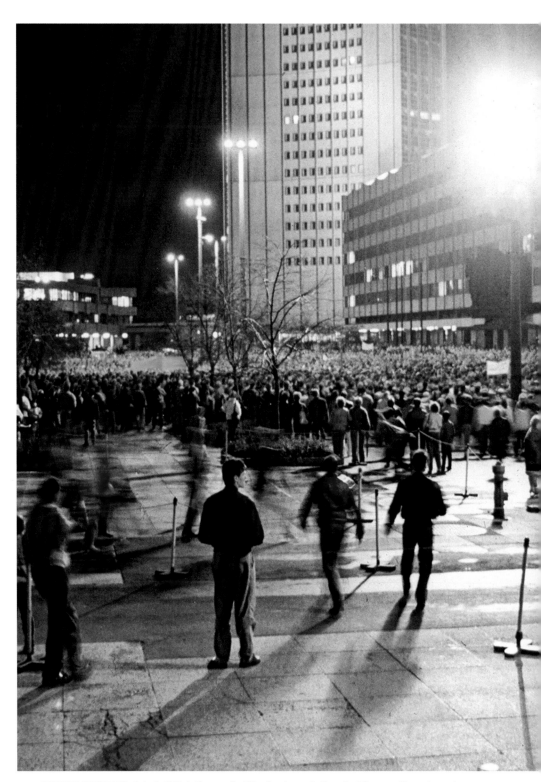

THE WALL CRUMBLES Leipzig, 1989: In the so-called Monday demonstrations, East German citizens demand more freedom and political rights, chanting the slogan "we are the people." One year later, the reunification of Germany took place.
Keystone

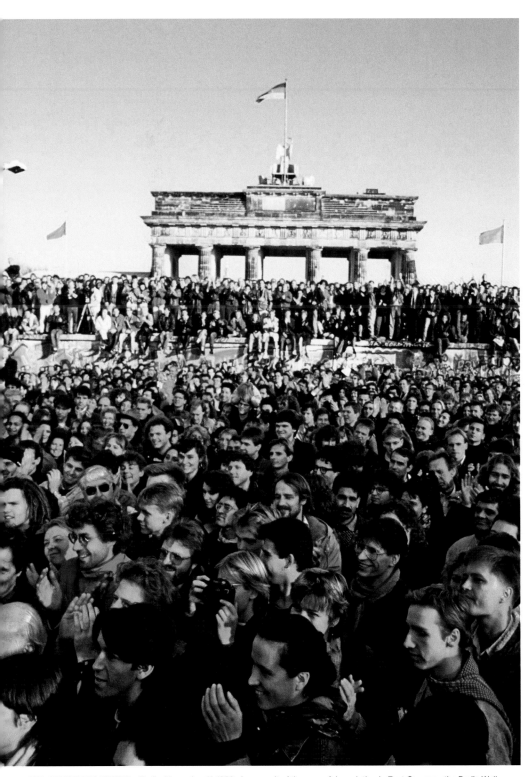

FALL OF THE BERLIN WALL Berlin, November 11, 1989: As a result of the peaceful revolution in East Germany, the Berlin Wall fell on November 9. After numerous East Germans fled via Hungary to the West, the SED regime yielded and opened the inner-German border crossings. Panos/Robert Wallis

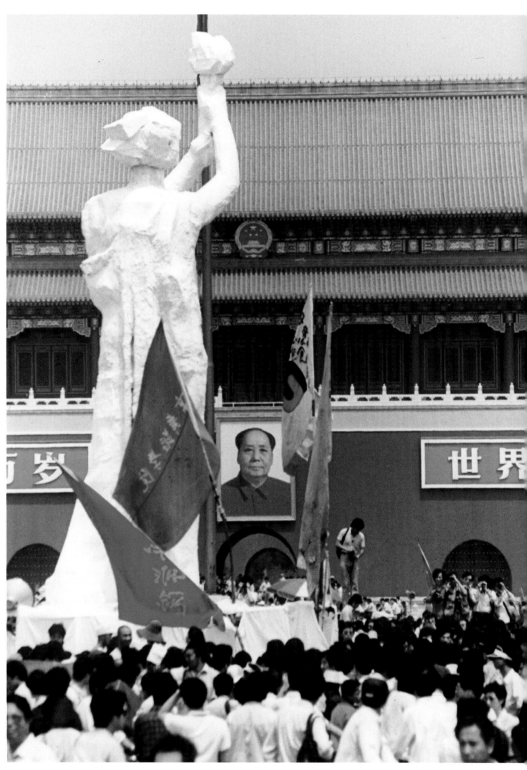

SUPPRESSION OF THE REFORM MOVEMENT　Tiananmen Square, Beijing, 1989: Student protests in China, calling for political freedoms. They were forcibly broken up by the Chinese military. Since then, there has been liberalization of the Chinese economy–but dominance by the single-party government has been unaffected thus far, and more political freedoms are not being granted. AFP/Catherine Henriette

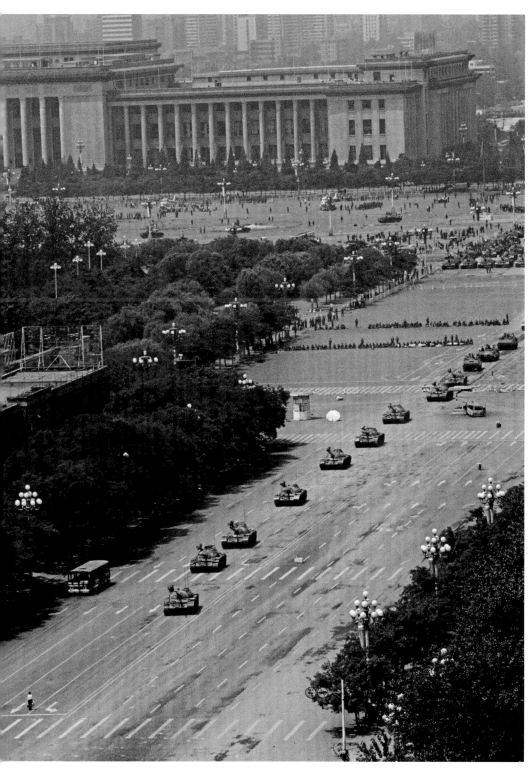

Magnum Photos/Stuart Franklin

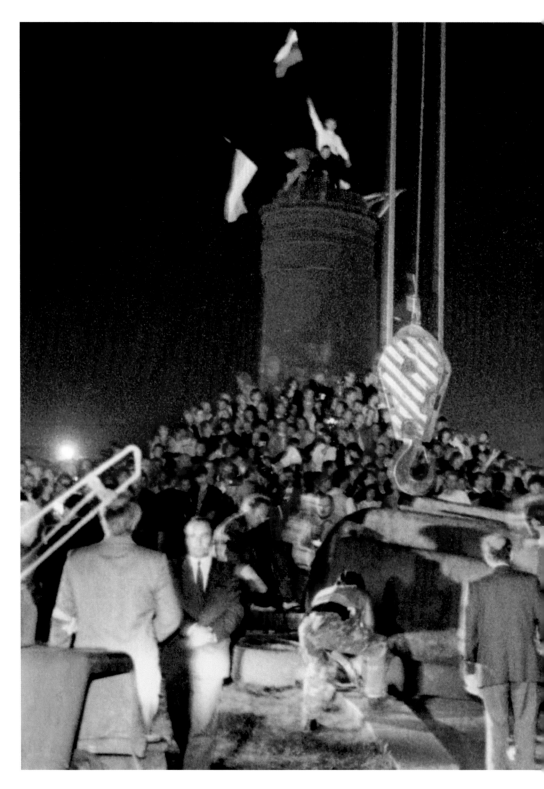

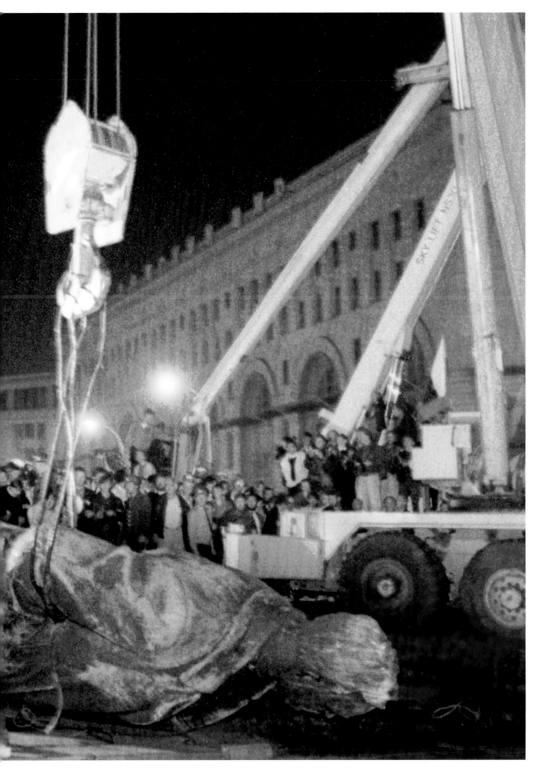

ATTEMPTED COUP AGAINST PERESTROIKA AND GLASNOST Moscow, August 23, 1991 : Standing on the base of the toppled monument to Felix Dzerzhinsky, the hated chief of the KGB security agency, a young man waves the Russian flag. The attempted coup against President Mikhail Gorbachev and his policy of openness failed; the country's fifteen republics became independent when the Soviet Union was dissolved on December 31, 1991. Keystone/Alexander Zemlianichenko

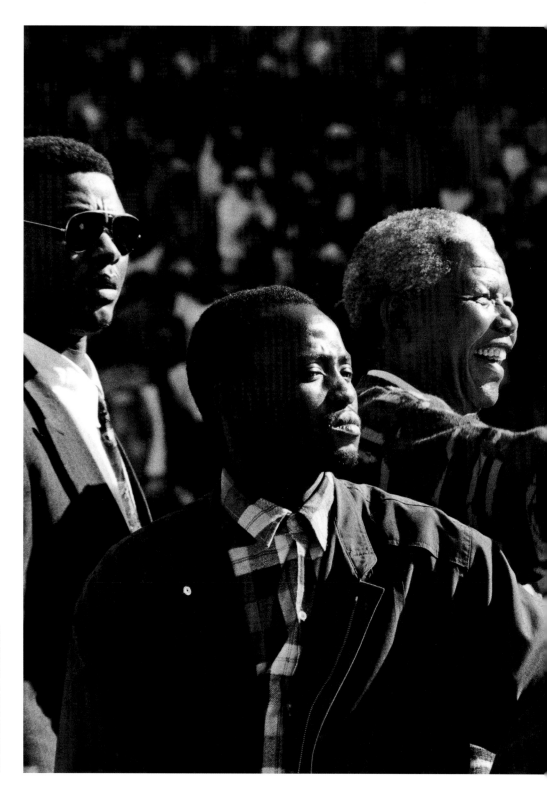

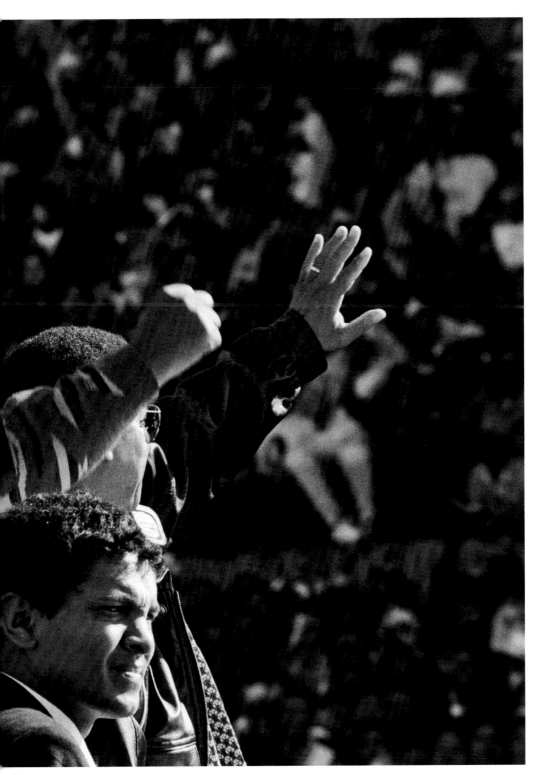

END OF APARTHEID South Africa, 1994: In the early 1990s, President Frederik Willem de Klerk launched political reforms and negotiations that included all population groups. Apartheid was abolished. For the first time, blacks could also take part in elections, and they elected Nelson Mandela president. George Hallett

*If democracy is to be viable,
then the population must as much
as possible be free from hatred
and destructive impulses, and just
as free of fear and servility.*

Bertrand Russell

Bertrand Russell (1872–1970) was a British philosopher, mathematician and logician.

WAR IN THE MIDST OF EUROPE Starting in 1991, Yugoslavia's member republics gradually declared independence from Yugoslavia, but the Yugoslav People's Army forced them to fight to gain that independence. The reciprocal ethnic cleansings culminated in genocide in 1995, with Bosnian Muslims murdered in Srebrenica, in eastern Bosnia, by Bosnian Serbs. Not until 2001, after the Ohrid Peace Accord was signed in Macedonia, did the armed conflict come to an end. Thomas Kern

INTERNATIONAL JUSTICE The Hague, February 2002: Former Yugoslav and Serbian President Slobodan Milošević stands trial before the UN International Criminal Tribunal in The Hague, accused of genocide. The International Criminal Tribunal for the Former Yugoslavia was the first UN court to take action against war crimes. Keystone/Robin Utrecht

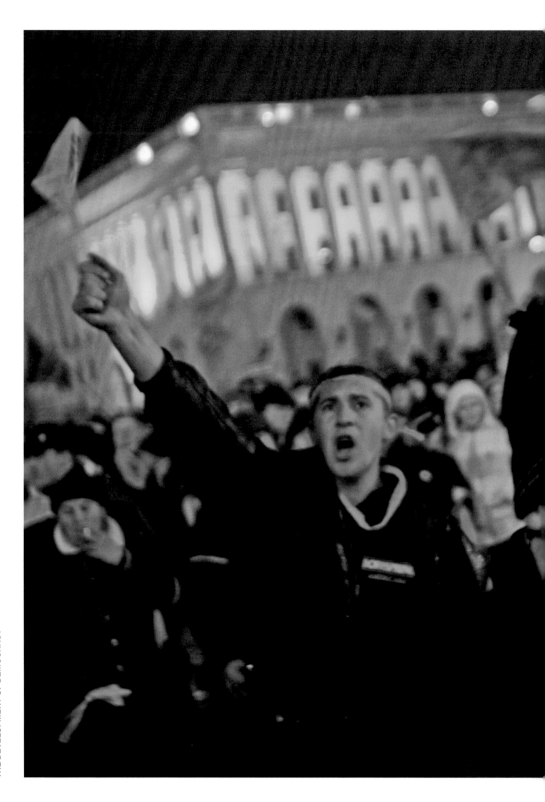

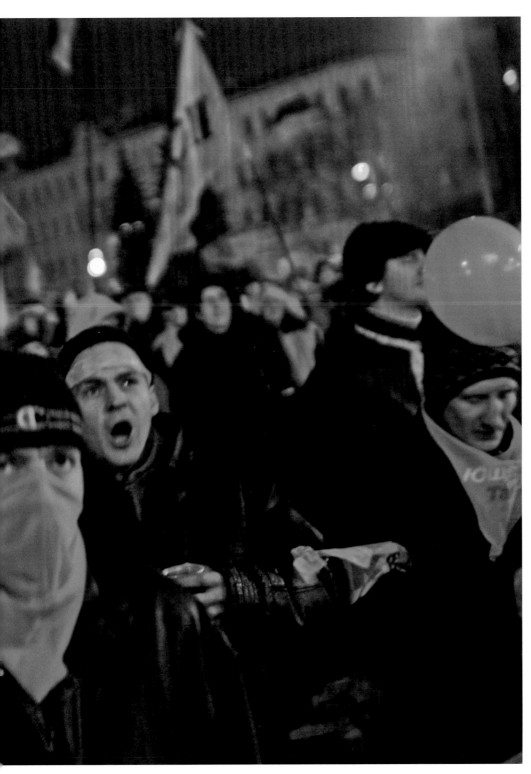

ORANGE REVOLUTION Kiev, 2004: After the elections in Ukraine, the defeated opposition mobilized for prolonged street protests. The apparently manipulated outcome of the runoff was declared invalid by the Supreme Court. When a new runoff was held, opposition candidate Yushchenko was elected president. Magnum Photos/Thomas Dworzak

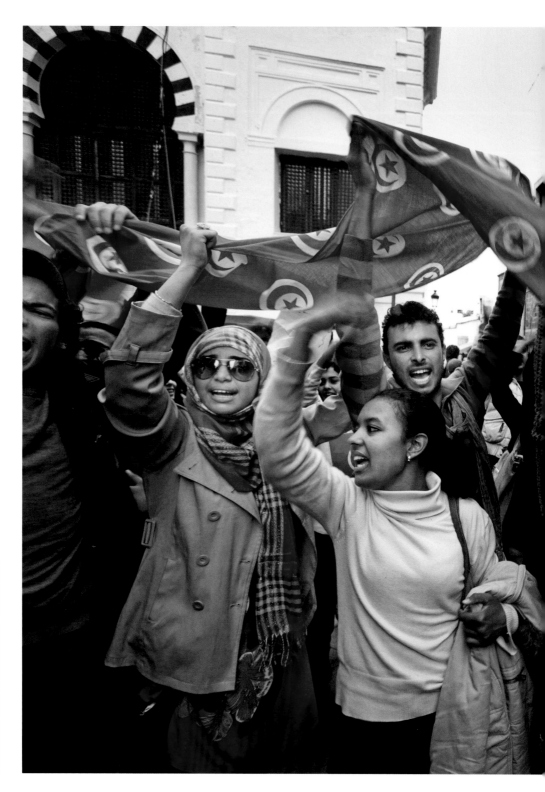

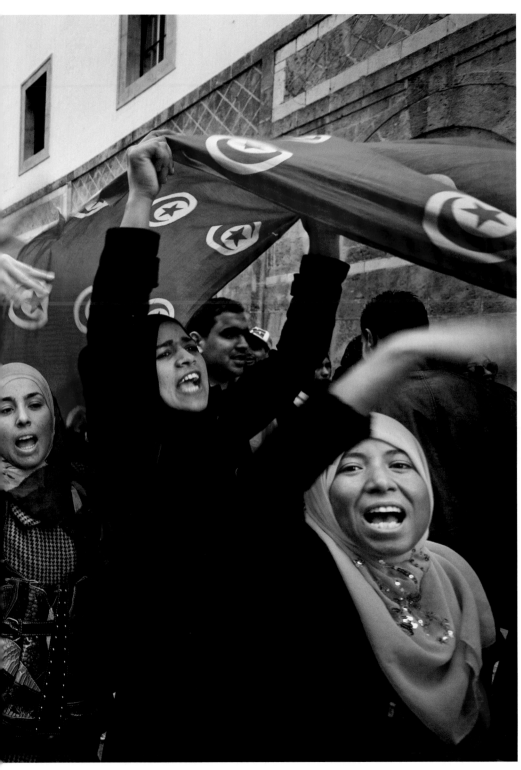

UPRISING IN TUNISIA Tunis, February 2011 : The Arab Spring began with uprisings against the corrupt regime of President Ben Ali. The revolt was triggered by the self-immolation of Mohamed Bouazizi, a vegetable vendor, on December 17, 2011, in protest against humiliating treatment by the government. With the flight of the autocratic President from the country, twenty-three years of rule came to an end. Panos/Alfredo D'Amato

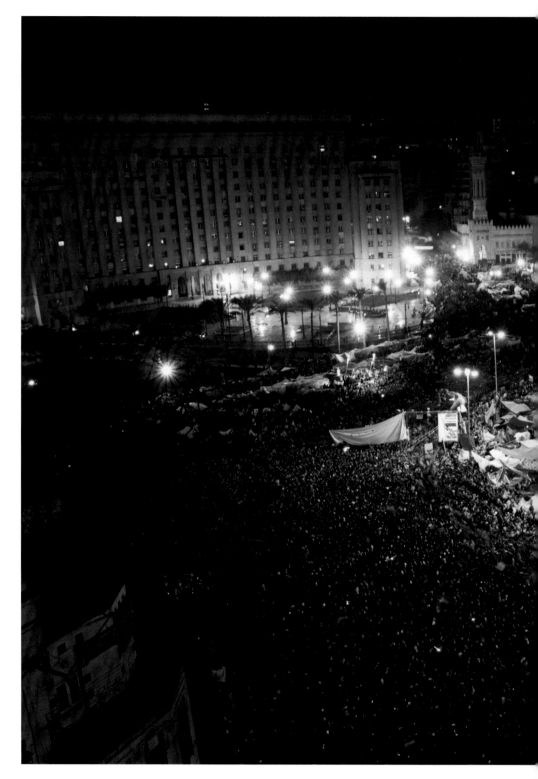

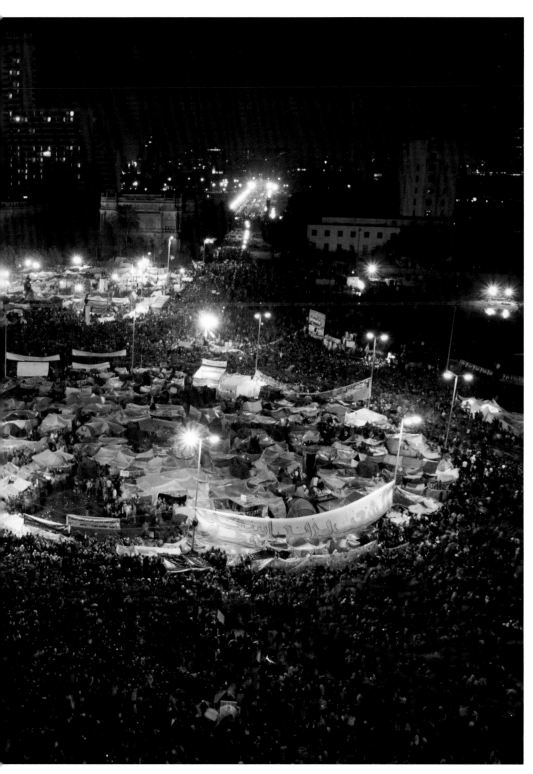

UPRISING IN EGYPT Cairo, 2011: The crowd in Tahrir Square awaits Mubarak's announcement he is resigning after thirty years of authoritarian rule. Disillusionment two years on: Mohamed Morsi, the democratically elected president, is removed from office in 2013. It will take many more years to establish a stable democracy in Egypt. LUZphoto/Lindsay Mackenzie

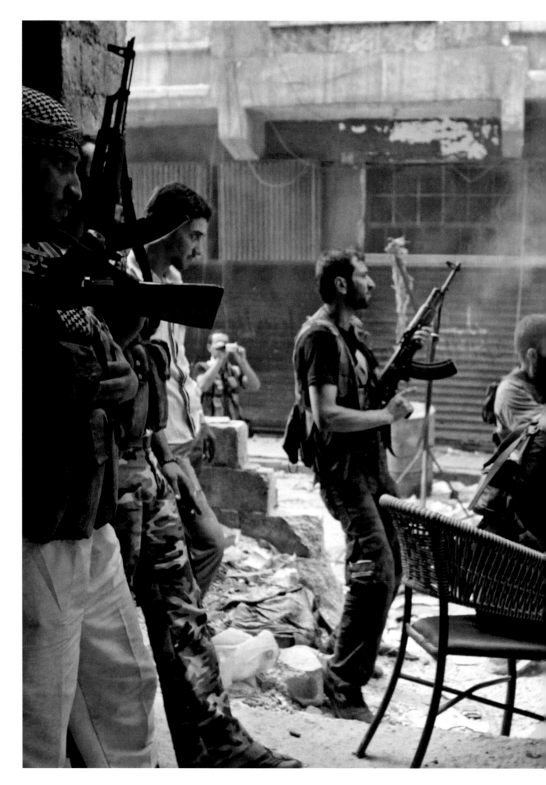

CIVIL WAR IN SYRIA Aleppo, Syria, 2012: Soldiers of the Free Syrian Army fight the troops of autocrat Bashar Assad. Protests against the regime, beginning in March 2011, finally led to a civil war, which, according to UN estimates, has claimed 100,000 lives in the first two years, and has forced more than one million people to flee the country. Reuters/Zain Karam

MASTERS OF THEIR OWN DESTINY

Shirin Ebadi

[…] Allow me to say a little about my country, region, culture, and faith.

I am an Iranian. A descendant of Cyrus the Great. The very emperor who proclaimed at the pinnacle of power 2500 years ago that "…he would not reign over the people if they did not wish it." And [he] promised not to force any person to change his religion and faith and guaranteed freedom for all. The Charter of Cyrus the Great is one of the most important documents that should be studied in the history of human rights.

I am a Muslim. In the Koran the Prophet of Islam has been cited as saying: "Thou shalt believe in thine faith and I in my religion." That same divine book sees the mission of all prophets as that of inviting all human beings to uphold justice. Since the advent of Islam, too, Iran's civilization and culture has become imbued and infused with humanitarianism, respect for the life, belief, and faith of others, propagation of tolerance and compromise, and avoidance of violence, bloodshed, and war. The luminaries of Iranian literature, in particular our Gnostic literature, from Hafiz, Mowlavi [better known in the West as Rumi], and Attar to Saadi, Sanaei, Naser Khosrow, and Nezami, are emissaries of this humanitarian culture. Their message manifests itself in this poem by Saadi:

The sons of Adam are limbs of one another
Having been created of one essence.
When the calamity of time afflicts one limb
The other limbs cannot remain at rest.

The people of Iran have been battling against consecutive conflicts between tradition and modernity for over 100 years. By resorting to ancient traditions, some have tried and are trying to see the world through the eyes of their predecessors and to deal with the problems and difficulties of the existing world by virtue of the values of the ancients. But, many others, while respecting their historical and cultural past and their religion and faith, seek to go forth in step with world develop-ments and not lag behind the caravan of civilization, development and progress. The people of Iran, particularly in the recent years, have shown that they deem participation in public affairs to be their right, and that they want to be masters of their own destiny.

This conflict is observed not merely in Iran, but also in many Muslim states. Some Muslims, under the pretext that democracy and human rights are not compatible with Islamic teachings and the traditional structure of Islamic societies, have justified despotic governments, and continue to do so. In fact, it is not so easy to rule over a people who are aware of their rights, using traditional, patriarchal, and paternalistic methods.

Islam is a religion whose first sermon to the Prophet begins with the word "Recite!" The Koran swears by the pen and what it writes. Such a sermon and message cannot be in conflict with awareness, knowledge, wisdom, freedom of opinion and expression, and cultural pluralism.

The discriminatory plight of women in Islamic states, too, whether in the sphere of civil law or in the realm of social, political, and cultural justice, has its roots in the patriarchal and male-dominated culture prevailing in these societies, not in Islam. This culture does not tolerate freedom and democracy, just as it does not believe in the equal rights of men and women, and the liberation of women from male domination (fathers, husbands, brothers …), because it would threaten the historical and traditional position of the rulers and guardians of that culture.

One has to say to those who have mooted the idea of a clash of civilizations, or prescribed war and military intervention for this region, and resorted to social, cultural, economic, and political sluggishness of the South in a bid to justify their actions and opinions, that if you consider international human rights laws, including the nations' right to determine their own destinies, to be universal, and if you believe in the priority and superiority of parliamentary democracy over other political systems, then you cannot think only of your own security and comfort, selfishly and contemptuously. A quest for new means and ideas to enable the countries of the South, too, to enjoy human rights and democracy, while maintaining their political independence and territorial integrity of their respective countries, must be given top priority by the United Nations in respect of future developments and international relations.

Shirin Ebadi (b. 1947) is an Iranian lawyer who became the first female judge in her country. A human rights activist, she was awarded the Nobel Peace Prize in 2003.
Excerpt from Shirin Ebadi's Nobel Peace Prize Lecture "In the Name of the God of Creation and Wisdom,"
© The Nobel Foundation (2003)

Both the idea of democracy and the term itself can be traced back to antiquity. The Greek word *demokratia* is composed of *demos* (people) and *kratein* (ruling) and thus means "rule by the people." In a democracy, the people are both the rulers and the ruled.

In actually implementing its principles, however, various questions arise. How is the *demos* defined? Who counts as part of the eligible electorate? Who is excluded, and why? Which procedures and institutions can establish the "identity" of rulers and ruled? Isn't this "identity" just a fiction?

In the ancient Greek city-states, as well as in the Renaissance city-states, citizens (though only few of them) participated directly in making political decisions. For larger political territories, the idea of politically representing the citizens emerged in the course of the seventeenth and eighteenth centuries. In this "second-best" version of democracy, the people would not become the rulers but, through elections, would at least be the referees of who, for a limited time, would be allowed to rule. The cornerstone of modern democracy as we know it was thereby laid.

What is needed for a good democracy has been the subject of debate at various levels. In terms of democratic theory, one can ask which elements are necessary: Is it just the existence of plebiscites? Or are features such as the rule of law and the division of powers necessary as well? Or are there still other criteria, such as a catalogue of rights or rules of procedure? Recent empirical investigations have tried to measure the quality of democracy based on specific criteria such as freedom, equality, and the limits placed on the exercise of power. These studies show a differentiated picture and the existence of varying forms, but above all make it possible to compare the strengths and weaknesses of various democracies.

WHAT IS DEMOCRACY?

Rule by the People

Wolfgang Merkel

There are innumerable definitions of democracy. To simply list them would bring little enlightenment. But one can describe democracy, at heart, as a form of political rule in which those who formulate the institutional rules also live under them, and are at once both ruler and ruled. The basic idea of democracy is thus "self-rule" or "self-legislation." Ruler and ruled must be identical, and the ruled also must be able to think of themselves as rulers. To the Austrian constitutional law professor Hans Kelsen (1881–1973), democracy and autocracy primarily differ because in democratic regimes the laws are made by those to whom those laws apply (autonomous norms), while in autocracies (dictatorships), lawmakers and those to whom the laws apply are different (heteronomous norms).

Admittedly, this is a relatively abstract definition. It is probably for that reason most theoreticians and practitioners (politicians) approve of democracy. But the more specifically democracy is defined in institutional or procedural terms, or its precise contents are established, the more contested it becomes. Normative convictions come into play, lending a special weight to particular principles and values while discounting others. As the great French democratic theorist Alexis de Tocqueville trenchantly formulated it as early as 1835, the assumed tension between the two basic democratic principles of "liberty" and "equality" repeatedly kindles controversy and debate.

It is also necessary to explain just why the ruled also understand themselves to be the rulers. Which democratic institutions and procedures can generate this identity? Can they actually do so, or is the claimed identity between the people and their government a myth that, though it legitimizes democracy, in fact obscures the genuine relationships of rule?

DEMOCRACY: THE TERM

Democracy is not a modern invention. Both its content and the term itself have their origins in ancient Greece. Etymologically, the word *demokratia* is composed of the two terms *demos* (people) and *kratein* (ruling), with the term itself dating back to the fifth century BC. Democracy thus means rule by the people, or popular sovereignty. The people are sovereign and thereby the ultimate authority for both decisions and legitimation. This sounds simpler than it is, for who are the people? Who belongs to this group? What does rule mean, and who exercises it? How should it be exercised? Which principles underlie rule? Which procedures and institutions should be used to transform these normative principles into political, legal and social reality? What does "the ultimate authority" actually mean?

In Greek antiquity, *demos* meant both "all" (meaning the people, particularly the popular assembly) as well as "the many" (meaning the majority at the popular

assembly). All and many, however, are two different things, and this ambiguity has persisted right up to the present. For if only many but not all rule, then popular sovereignty might in fact be a myth, or at least no more than a guiding principle, which neither theoretical formulation nor practical implementation could ever quite live up to.

The problems start with the constitutional determination of who "the people" are. In no democracy of the world are "the people" of a state, or rather the citizens, "all" of those humans who live within a politically defined territory. What is important here is to distinguish between a political definition of who the people are (*demos*) and an ethnic definition (*ethnos*). Nevertheless, ethnic criteria (language, origin, culture) played an important role in defining membership of the *demos* in ancient Greece, and they continue to play a role in many democratic societies even today. Because of this political definition, who counts as a member of the nation-state remains an open question, answered in various ways even today.

In ancient Athenian democracy, only male full citizens belonged to the *demos,* yet full citizens were less than one-third of the resident population. When this *demos* is held up as the exemplar of direct democracy, one cannot ignore that fact. This democracy was direct yet also exclusive, categorically shutting out slaves, metics (resident aliens), and women. Even Aristotle, Alexander the Great's highly educated teacher, did not possess the full rights of citizenship as he had not been born in Athens.

These and other forms of "democratic" exclusion were maintained during the Roman Republic, as well as in Italian city-states during the Renaissance. Even in economically advanced countries during the eighteenth and nineteenth centuries, only male citizens with a defined income were counted as members of the *demos.* Full rights of citizenship were granted only to owners of property (and, of course, to the aristocracy), meaning that citizenship was tied to a certain level of wealth and income. It was only in the course of the twentieth century that women were gradually given the right to vote and thereby made into fully empowered citizens of the state. The income census, which was used as a criterion for granting full political rights, was also abolished, and with these two changes, the minimum criteria for an inclusive democracy, meaning "rule by all," were fulfilled.

At least since the mid-twentieth century, it has been uncontested in existing democracies that women and the less well-off should be equally counted as belonging to the *demos.* What remains contested is which immigrants might be counted, and when, as belonging to the people of a nation-state with full rights of citizenship. Liberal immigration countries such as Canada, Australia, or the United States have consistently been more generous about this than continental European countries

like Germany or Switzerland, which have always been more restrictive about granting full political rights.

Even within democratic societies, no consensus exists as to who should be counted as belonging to "the people." In the twenty-first century, this question divides liberals from conservatives and cosmopolites from communitarians. Generally speaking, the farther right political parties, groups, or political opinions are (culturally) positioned on the political spectrum in a democracy, the more (ethnically) exclusive they want to make the right to membership in the *demos*. The right-wing populist political parties that have emerged during the last three decades in Europe, in particular, want to define the *demos* as much as possible by the *ethnos,* that is, from descent and following the *jus sanguinis* principle, which asserts that a citizen is a person descended from citizens.

However, from a modern, open, cosmopolitan, democratic perspective, the *jus soli* principle should be operative. That principle asserts that a citizen is a person who was born in the territory of the nation-state. In addition, immigrants should have a fair chance at naturalization after a not-overlong period of permanent residence, and this fair chance should be independent of the ethnic identity, religion,

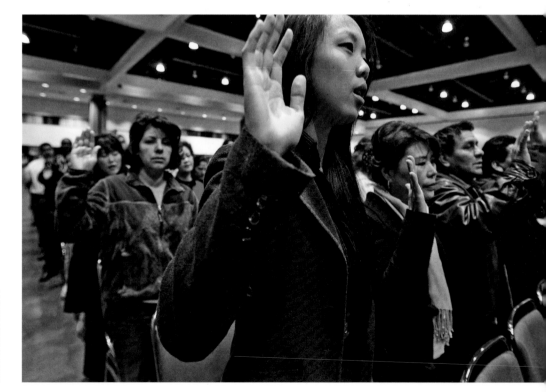

IMMIGRATION Los Angeles, USA, 2008: Immigrants at a naturalization ceremony. Every year, an average of 680,000 people become naturalized U.S. citizens. As a classic country of immigration, the United States has a more liberal attitude toward immigration than European countries, for example. AFP Photo/Robyn Beck

or gender of the immigrant. If that does not happen, then for this reason alone, the democratic precept that the ruled must also be able to understand themselves as the rulers remains a fiction.

RULE BY THE PEOPLE?

How, then, should democratic popular sovereignty be exercised so that the people can simultaneously understand themselves as both ruled and rulers? In Greek antiquity, *demokratia* was used in a manner synonymous with *isonomia*, which meant something like "equality before the law." In Attic democracy, such legal equality was regarded as being best ensured by the majority. Without democratic participation, equality before the law was therefore unthinkable. The popular assembly was to provide the institutional guarantee for *isonomia*.

The relationship among legal equality, a constitutional or rule-of-law state, and democratic participation was much disputed during the nineteenth and twentieth centuries. While the main currents in German jurisprudence regarded it as possible to have a constitutional state that was not a democracy—the example cited was Prussia—this is disputed, and with good reason, in much of contemporary political philosophy. The German philosopher Jürgen Habermas, for example, talks of the "dual-track" aspect of legal equality and political participation. Over the longer term, one cannot have the one without the other. A democracy that lacks a functioning constitution (or a rule of law) does not deserve the name, nor can one guarantee the existence of a constitutional (or rule-of-law) state that lacks political participation rights.

Yet is the democratic order the best way to govern every territorially organized nation-state? Is it just as good for small countries like Denmark, Slovenia, or Luxembourg as for Russia, India, or China? In the past, this question was far more controversial in both theory and practice than it is today.

In Greek antiquity, the "democratic" system of rule was limited to small-scale city-states that doubtless were more city than state. Even at the time, such rule was unsuited for the Persian Empire. Because ancient democracy was exclusive and possible to implement only in small city-states, it could take a direct democratic form: Political participation and political decisions were not separated by representative institutions and organizations. At least for those who were full citizens, one could therefore speak of an identity of rulers and ruled, as all citizens could go to the popular assembly and were empowered both to speak and to make decisions. But in Athenian democracy, only a small proportion of the approximately 30,000 eligible citizens ordinarily took part in the Assembly, so even there not all citizens always participated in every decision.

While various forms of republican government were practiced in a number of Italian city-states during the Renaissance, the most significant political philosophers of the seventeenth and eighteenth centuries, including John Locke, Baron de La Brède et de Montesquieu, Immanuel Kant, and even Jean-Jacques Rousseau, regarded direct democracy as a form of rule unsuited for large territories. The American democratic theorist Robert Dahl calls this the first large territorial transformation of democracy: Nation-states with large territories and large populations are unsuited for direct popular sovereignty and instead require representation. The beginnings of modern democracy in the United States, England, Australia, New Zealand, and the European continent can be traced back more to the modern idea of representation than to ancient notions of democracy.

Contrary to what is often believed, modern democracy is by no means a direct import from Greek antiquity. Even during the Roman Republic, the term democracy itself was no longer used, and it had a negative connotation well into the nineteenth century. In the judgment of James Madison—one of America's founding fathers and its fourth president—writing in the *Federalist Papers* (No. 55), "had every Athenian citizen been a Socrates, every Athenian assembly would still have been a mob." The idea of democracy, as for Aristotle, had a negative connotation, as it was equated with the rule of the rabble. Not equality but rather individual liberty became the central political value, yet the liberty of each individual could be logically anchored in a "republican constitution" (Immanuel Kant) only if the laws were made, or authorized, by all. Individual liberty, legal equality, and self-rule were now to be ensured through indirect popular sovereignty provided by representative institutions.

This created a problem for democratic theory, since only a very few could represent the many. How could the people then rule, give themselves laws, and feel that they ruled? Both theoretically and practically, this was to be guaranteed through elections. To the degree that the people could select their representatives as well as vote them out of office again, they could understand themselves, at least indirectly, as the proper sovereign. The possibility of removal from office, in particular, contains a mechanism of control, since the political elites, meaning the government, must always fear being removed from office if they do not adequately represent the interests of "the people."

However, interests varied considerably in societies organized into estates, and they remain so in developed capitalist societies as well. It is not infrequent that interests are in conflict with one another. The democratic and philosophical fiction that a unitary, substantive, "popular will" exists cannot be maintained. It is therefore not the will of the people as a whole that is expressed through elections and

that legitimates a government, but rather the will of the majority of the people. More precisely, one would have to argue that it is not the people who rule in a democracy, but only a majority of the people. As this is always rule for only a limited period, and because the minority that loses in an election might be the majority in the next election, limited democratic rule is bearable. It does not make the people into rulers over the people, but it does make them into the judges of who will rule.

Representative democracy is therefore a second-best solution, and likely the only realistic one for mass societies. Beyond this, representative democracy is open to including direct democratic elements, as practiced currently, for example, in the political systems of Switzerland, California, Italy, and in other places. Yet every representative democracy has certain preconditions it must meet if it is to deserve the name. The most important are that:

– Elections must be general, equal, free, and fair. "General" means no limitations legitimized by arguments based on gender, race, ethnicity, religion, or education can be placed on the franchise of adult citizens. Switzerland (until 1971: no national franchise for women), southern states in the United States (until 1965)

WOMEN EXCLUDED Stans, Switzerland, undated: Politics just among men. In the *Landsgemeinde,* a meeting of all the eligible voters in a canton, women were long excluded. Women only obtained the right to vote in Switzerland at the federal level in 1971, making it the last country in Europe to introduce national women's suffrage. In two cantons, women had to wait about another twenty years until they were also finally granted the right to vote at the cantonal level. Keystone

and South Africa (until 1993; limitations on the franchise for blacks), Latvia (after 2000; limitations based on ethnicity for Russians), and Thailand (limitations based on education) have all infringed on this precept with greater or lesser intensity, and for that reason cannot be called fully developed democracies before these dates. "Equal" means individuals cannot be given either a lesser or a greater weight to their vote due to particular characteristics such as wealth, status, and education. "Free" means that the state, and in particular the executive, may not (arbitrarily) exclude political parties from political competition. Even banning political parties judged anti-constitutional by constitutional courts (as in Germany) can be regarded as problematic from the point of view of democratic theory, as it restricts party pluralism and excludes those members of the population from representation who voted, or would have voted, for these political parties. The paradox here is that democracy protects itself with the use of democratically questionable procedures. The "fairness" precept is the most imprecisely defined. Even if corresponding fairness indicators are set out in fat codebooks used by international election observers, the boundaries are unclear and open to differing interpretations. The elections in Russia under Putin can certainly no longer be regarded as fair, and the same is true for Venezuela under Hugo Chávez and his successor. But is this also true for Berlusconi's Italy, at a time when he controlled the most important private and public television stations? Would it even be applicable to the United States, where money politics influences elections in a manner unheard of in any other OECD country? Opinions here are divided, and gray areas prevail.
– The differing interests must be represented in a pluralistic and free political party and association system. Political parties are the most important, if not indispensable, organizations for representative democracy. In the nineteenth century, when many of the first political parties came into being, political parties and party governments had a negative image. This lasted into the twentieth century, with a prime example being the Weimar Republic. Political parties were regarded as detrimental to national unity, particularly in conservative and nationalist circles, because they divided society and put particular interests ahead of the good of the whole. Today, after a short hiatus in the 1950s and 1960s when they were held in high regard, political parties have once again gotten a bad reputation. Contempt for parties is regarded as trendy and has been increasing, particularly in the media but also in society in general. Yet it is not possible to have a genuinely representative democracy without strong, legitimated political parties. Political parties present programs and to a great degree tie their work in government to such programs. If they don't abide by these

commitments (or election programs), they can be called to account by voters and not re-elected. Civil society associations or even individuals cannot supplant political parties, because they do not (and cannot) engage in such programmatic obligations. A strong civil society can augment party government or correct it, but can never replace it. This sometimes goes unrecognized by those who have enthusiastically rediscovered civil society.

– All citizens must be given the same chance to influence political decisions and the election of the political decision-making elites. Liberal democracy theorists therefore insist on the importance of legal equality, political equality, and formally equal educational opportunities. Socioeconomic equality as a precondition for actual political equality of opportunity, however, has no place in such thinking. A state that wanted to establish greater socioeconomic equality would be accused of limiting the (economic) liberty of its citizens and flouting the property rights of the individual. Social democrats like Eduard Bernstein (1850–1932) or Hermann Heller (1891–1933), by contrast, regarded a degree of social homogeneity as a condition for equal political rights.

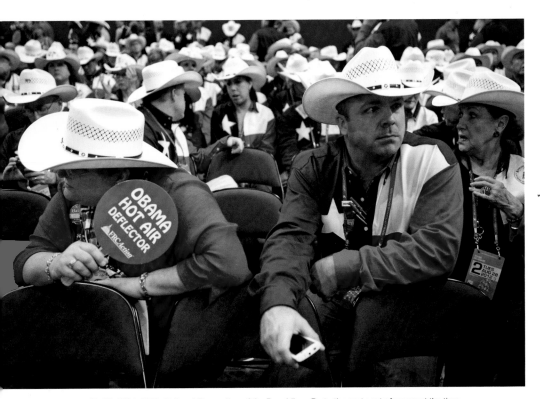

OPPOSITION Florida, USA, 2012: National Convention of the Republican Party, the party out of power at the time. The existence of an opposition and the real opportunity for a change in which party (or who) rules are among the most important hallmarks of a functioning democracy. Keystone/Darcy Padilla

– The interplay between government and opposition must also function. The opposition must have a fair chance to participate, at some point, in governing. Only then can it effectively fulfill its role of oversight as a supervisory body of the ruling government in parliament. If free elections repeatedly relegate certain political parties to the opposition, however, and the same party rules for decades, then such permanent exclusion of a political minority from governing is no longer compatible with the principle of the rule of all over all. In addition, democratic systems pay for the dominance of permanent governing parties with a lack of transparency, corruption, and weak political innovation. The examples of Italy (Christian Democratic Party rule from 1948 to 1992), Japan (Liberal Democratic Party rule from 1955 to 1993), and more recently, South Africa (African National Congress rule since 1994) are well known. Because Swiss consensus democracy also has no real opposition and thus no genuine alternation in its governing parties, a different corrective for its lack of institutionalized opposition is needed, and it can be found, at least in part, in aspects of direct democracy such as referendums.

The normative as well as political dispute over what makes a good democracy, what it either needs or does not need, where the boundary line runs between democracy and economy, and how far the government can, should, or must use its democratic mandate to intervene and shape the economy and the society, has been conducted ever since democracy began.

MINIMALISTS VERSUS MAXIMALISTS: DIFFERING DEFINITIONS OF "GOOD DEMOCRACY"

The normative discourse about (good) democracy is as old as democracy itself, and it intensified again particularly during the twentieth century. It is nearly impossible today to survey the many existing democratic theories, though one can at least try to arrange them in categories, such as historical or chronological, ideological, and procedural or institutional, or by who first suggested them. What often emerges are mixed classifications of democracies, under labels such as conservative, liberal, social, pluralist, elite, decisionist, communitarian, cosmopolitan, republican, deliberative, participatory, feminist, critical, postmodern, or multiculturalist, to name just a few of the more significant. Even experts lose their way at times in this thicket, so a simplified classification is needed. In the never-ending fight over definitional authority when it comes to defining democracy, as well as what it contains and what its boundaries are, one can distinguish between three groups of democratic theories: Minimalist, midrange (proceduralist), and maximalist.

The Minimalist Model–Elections are the core of democracy

Minimalists such as the influential economist and democratic theorist Joseph Schumpeter (1883–1950) start from the position that free, equal, and secret elections not only form the core of democracy but are democracy itself. In Schumpeter's model, elections are regarded as being like a marketplace, and in that marketplace, political entrepreneurs–political parties, for example–offer their (programmatic) products. Voters can demand, examine, select, or reject these products. The offering that is most highly demanded wins the day, and therefore gives the successful entrepreneur the right, for a time, to represent the preferences and interests of the voters. In recurring rhythms, the represented are given the opportunity to call their representatives to account for the just-ended legislative session, and depending on their judgment, choose to either re-elect or not re-elect them.

The minimalists, who style themselves as realists, thereby consciously limit the essence of democracy to the "vertical responsiveness" between ruled and rulers. This model is called an "elitist" theory of democracy, not without reason, as it is the elites who rule: In the process of governing, they are not to be bothered by the people. Schumpeter's "realistic" theory, expounded in *Capitalism, Socialism*

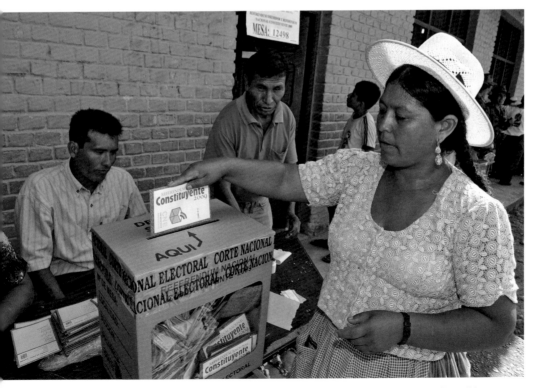

THE EXISTENCE OF ELECTIONS AS A MINIMAL CRITERION El Chapare, Bolivia, 2009: Voting. In the minimalist model, democracy exists once elections are held in a country. No other conditions have to be met. AFP Photo/Aizar Raldes

and Democracy (1942), is the classic exposition of the minimalist model of democracy. Minimalists certainly also regard human rights or a constitutional state as important preconditions for democracy, but not as inherently necessary elements. Civil society's controls over those who govern, or even direct democratic intervention on the part of the people through referendums, are regarded as incompatible with this rationalist-realist democratic theory.

The Midrange, Proceduralist Model—
Elections alone do not make a democracy

The proponents of a midrange democratic concept regard such a minimalist understanding of democracy as inadequate. They add the aspects of a constitutional (or rule-of-law) state and horizontal checks on power to the holding of free, general, equal, and fair elections, which they do not contest is the core aspect of democracy. They also do not want to restrict citizen political participation just to elections. For formal democratic elections are genuinely democratically effective only when embedded in guaranteed human, basic, and civil rights, in binding norms that have developed in society in a democratically legitimated fashion, and when there is

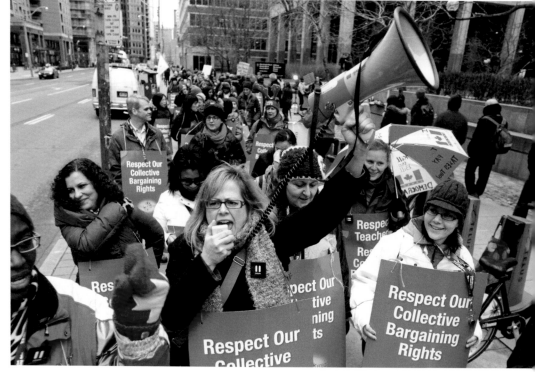

A RULE-OF-LAW STATE AS GUARANTOR OF DEMOCRACY Toronto, Canada, 2012: Demonstrating teachers. According to the midrange, proceduralist model, aside from elections, it is essential to have a functioning state under the rule of law for a democracy to exist. Other than elections, citizens must have opportunities for futher involvement in politics, such as through referendums, strikes, and demonstrations. Reuters/Fred Thornhill

reciprocal control and an interweaving between executive, legislative, and judiciary powers. This model is primarily based on procedural rules, and its proponents, including Jürgen Habermas, argue that constitutional (or rule-of-law) democracy is characterized by a fundamentally simultaneous origin of the protection of civil rights and of the rights of political participation. That means the constitutional (or rule-of-law) state is not a constraint on democracy, but one of its core elements.

Given this procedural understanding, political participation should not amount to just casting one's vote. Additional opportunities to participate, including referendums, civil society activities, and public discourse, are meant to prevent the bundling, and articulation, of interests in society from being left solely to the political parties. Rather, a vital civil society is to invigorate the participatory potential of democracy and to protect it from being appropriated by an aloof "political class."

Participatory notions of democracy are part of this midrange model, one that goes beyond a concept of democracy that is limited to constitutional considerations, and which demands the democratization of larger societal and economic realms. A strong civil society based on the active cooperation by citizens, and on deliberative processes in small groups, communities, or neighborhoods is meant to contribute to the further democratization of political decisions. These, along with direct democratic plebiscites—with whatever intensity they are institutionalized—are certainly compatible with the midrange, procedural model of democracy. Proponents of this model range from liberal pluralists such as Noberto Bobbio to advocates of strong deliberative participation such as Jürgen Habermas or Benjamin Barber.

What the minimalist and the midrange models of democracy have in common is their limitation to norms, principles, and procedures that lie at the heart of the democratic decision-making process. One can also call this the performance of democratic institutions. Yet to maximalists, this procedural limitation placed on the "input dimension" and to the participatory extension of democratic procedures is inadequate.

The Maximalist Model—
A democracy needs a welfare state to reduce inequalities

Maximalists include an "output dimension," by which they mean the results of politics, in their definition of democracy. This can include collective goods such as domestic and international security, economic prosperity, welfare state guarantees, and recognizable fairness in the distribution of basic goods, income, social security, and even life opportunities. The core of this model is avoiding extreme inequality in the distribution of income as well as of primary and social goods,

for only a "social democracy" can ensure the political principle of equality. Proponents of such a position include the social democrat Eduard Bernstein (1850–1932), the Weimar constitutional law expert Hermann Heller (1891–1933), and nowadays, Thomas Meyer (2005). Some Latin American democratic theorists also stand in this tradition. North American democratic theory rejects such maximalism both normatively and analytically as being too all-encompassing. However, three decades of continually increasing inequality in the developed OECD member states have renewed attention in democratic theory to the question of socioeconomic distribution.

Still, one can object that some of these output measures and political results are not specific to democracy and can also be provided in dictatorships. One can point here to economic growth in China and Vietnam, social and economic welfare in Singapore's soft autocracy, or socioeconomic equality in Cuba. For this reason, it is problematic to include the output dimension directly in a definition of democracy. At the same time, the performance record of democracy also says something about its vulnerability to crises. If a democracy cannot resolve key problems and fails to deliver what citizens expect, then its output legitimacy sinks

THE STATE AS LEVELER Lovagny, France, 2012: Advocates of the maximalist model argue that democracy does not exist until the state also ensures a fair distribution of goods and income, as well as social welfare benefits, because only in this manner are equal opportunities and political participation possible for all. AFP Photo/Philippe Desmazes

and its stability is put in question. Even if one does not wish to include questions of socioeconomic inequality in defining democracy, one cannot understand the actual development, stability, and quality of democracy without taking this central constraint into account.

THE EMPIRICAL DEBATE:
HOW CAN ONE MEASURE THE QUALITY OF A DEMOCRACY?

After the third major wave of democratization in the twentieth century, the North American NGO Freedom House counted, in 1995, a record number of 121 "electoral democracies." Among them, one finds such differing democratic nation-states as Finland, Switzerland, Italy, Bolivia, Thailand, Russia, and Mali. Other NGOs, foundations, and research institutions have also tried to measure the quality of democracy, including the North American Polity Project, the Worldwide Governance Indicators (WGI) of the World Bank, the Bertelsmann Stiftung's Transformation Index (BTI), and the Swiss NCCR project Democracy Barometer. While the former indices try to compare the quality of as many of the world's democracies as possible, the Democracy Barometer has confined itself to the subtle distinctions among the (for now) thirty "best" democracies on the planet.

Measurements of democracy must define the normative as well as theoretical basis of their concept of democracy. The Democracy Barometer chose a midrange conceptualization, one that follows neither the democratic minimalists, who argue free and general elections are sufficient to define democracy, nor the maximalists, who want to include political outcomes, such as progress toward achieving social justice, in their definition.

Thus the formal legal bases, institutions, and procedures are taken into account, as well as how they are politically implemented. It is thus not only relevant that an election is free, general and fair, but it is of considerable democratic significance as well who votes, who abstains from voting, and, if relevant, which patterns of social exclusion can be discerned. If the lower strata, women, or ethnic and religious minorities consistently participate less in elections and other forms of political participation, or if they are greatly underrepresented in parliament and government, then this has a negative impact because it effectively impairs political equality.

Three basic principles serve as the starting point for the conceptualization of democracy: Liberty, (political) equality, and control. Democratic systems must strike a balance between the principles of "liberty" and "equality," and also make use of a third principle, that of control. Control exercised over rulers is one of the cardinal aspects distinguishing democracy from autocracy, as the latter tends toward an uncontrolled exercise of power.

Criteria for the Quality of a Democracy
Liberty

Liberty—understood as negative liberty (thus not the freedom to do something but rather the freedom *from* something)—first of all means the protection of an individual from the illegitimate encroachments of third persons, but particularly also encroachment by government. The most historically significant examples of such defensive rights are the right to life and physical integrity, freedom of opinion, and religious freedom, as well as—though this is certainly more controversial—the right to property.

The list of freedoms has grown over time: Free speech, the freedom of assembly, and the freedom of information, as well as their constitutionally guaranteed protection, are by now regarded as minimum conditions for democratic regimes. Documented, or constitutional, liberties are a precondition of democracy, for if they are not guaranteed, citizens cannot adequately realize their political participation rights. The guarantee such rights will be protected cannot result solely from a decision made by the political majority, but needs permanent safeguarding by the constitutional state.

FREEDOM OF SPEECH London, 2011: At Speakers' Corner in Hyde Park, everyone has the right to speak publicly on any subject, without having to sign up for it somewhere in advance. Freedom of speech is one of several freedoms that are regarded as basic prerequisites in a democracy, to protect the individual against infringement and arbitrariness on the part of the government. Gregor Young

Equality

In modern philosophy and politics, equality and liberty are indissolubly linked. Liberty requires an equality component, for without it, equal individual autonomy cannot be realized. Political equality primarily means all individuals are treated equally in the political process. All citizens must be given the same rights to influence democratic decisions. Beyond this, the entire citizenry must have the same opportunities for access to political power.

Political equality is particularly effective when all individual preferences are taken into account as far as possible, and when individuals are equally involved. In a representative democracy, free, fair, and competitive elections that permit the equal involvement of interests are key to this. Political participation, both conventional and unconventional, should be perceived as identical, to prevent certain social groups from being systematically shut out of the political process. An important precondition for the equal realization of political rights, finally, is that the political decision-making process be equally visible to all and thus be characterized by a high degree of transparency.

EQUALITY OF OPPORTUNITY School in Bangladesh, 2009: With an illiteracy rate of about 50 percent, the country is one of the world's poorest. Access to elementary education for all, particularly for girls, is a key step in the democratization of a country. In most cases, however, the ideal of equal opportunity remains unattainable. This applies equally to both rich and poor countries. Panos/Sven Torfinn

Control

A third principle serves to maintain the fragile balance between liberty and equality: Control, or in other words, limitation of the power wielded by those in positions of power. This occurs both vertically, through elections, as well as horizontally, through constitutionally based mechanisms enabling the powers in a democracy to oversee and limit one another. Elections guarantee vertical control by permitting citizens to re-elect, or replace, their political representatives. Effective elections must be as free, fair, and competitive as possible.

Liberty, equality, and control are the three fundamental principles of a democracy. For a regime to be called a democracy, it must guarantee and protect liberty and equality. Both principles must be balanced against one another with the help of vertical and horizontal controls. The three basic principles dictate which functions a democracy must fulfill. Each of the three basic principles is assigned three basic functions, and this yields a total of nine basic democratic functions: Individual liberty, the rule of law, openness, competition, control of powers, ability to rule, transparency, participation, and representation (see Figure 1).

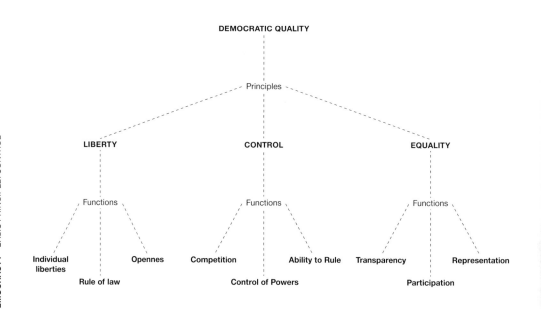

1 **THE CONCEPTUAL TREE OF THE DEMOCRACY BAROMETER** The Democracy Barometer was constructed to measure the quality of democracies. The conceptual tree shows the criteria that were used.

Components and subcomponents are derived in turn from these nine functions, all of which are subsequently measured using various indicators. Overall, the Democracy Barometer consists of three principles, nine functions, eighteen components, fifty-one subcomponents, and one hundred indicators. The quality of democracy, ultimately, is measured empirically by more than one hundred indicators, including social selectivity in general elections, referendums, or political protest activity by gender, social class, and education. Other indicators measure how strongly a civil society is voluntarily organized into unions or human rights associations, and examine whether a state is centralistic or whether it allows citizens more opportunities to participate through federalist structures. Further, indicators look at how well women are represented in parliaments, whether minorities are discriminated against, how extensive party competition is, whether the media landscape is pluralist in nature, and how equality before the law, judicial independence, religious freedom, and the guaranteeing of various civil rights are realized. These individual indicators permit a differentiated insight into the diverse realms of a democratic system, but can also be summarized in a single index.

INDEPENDENT JUDICIARY Karlsruhe, Germany, 2012: The Federal Constitutional Court oversees the actions of the other government bodies, that is, of the government and the representatives of the people. If a law violates the civil rights of the citizens, the Court can demand that it be amended or reformulated. Such control mechanisms ensure that none of the government bodies possesses unconditional power. Reuters/Kai Pfaffenbach

Country	1990	2000	2007	1990–2007
Denmark	1	1	1	1 (87.17)
Switzerland	4	2	2	2 (81.42)
Sweden	2	3	3	3 (81.32)
Norway	3	6	4	4 (79.53)
Finland	5	5	5	5 (79.00)
Belgium	11	4	10	6 (77.66)
Netherlands	7	7	9	7 (77.26)
Germany	6	9	7	8 (74.93)
Iceland	9	8	6	9 (73.88)
Canada	13	10	8	10 (73.52)
Austria	8	12	11	11 (72.62)
Australia	12	11	12	12 (71.68)
Italy	10	13	16	13 (67.57)
Spain	14	14	14	14 (65.94)
USA	16	15	21	15 (59.66)
New Zealand	18	16	15	16 (59.22)
Hungary	24	17	22	17 (58.62)
Slovenia	n.a.	18	13	18 (58.45)
Czech Republic	22	19	18	19 (55.89)
Luxembourg	15	22	24	20 (53.59)
France	17	21	19	21 (52.43)
Ireland	21	20	23	22 (50.33)
Poland	25	24	20	23 (49.86)
Great Britain	20	23	17	24 (46.85)
Japan	19	25	25	25 (44.78)
Portugal	23	26	26	26 (42.88)
South Africa	29	27	28	27 (26.10)
Cyprus	26	28	27	28 (25.24)
Costa Rica	27	29	29	29 (20.28)
Malta	28	30	30	30 (14.28)

2 **THE QUALITY OF ESTABLISHED DEMOCRACIES (1990–2007)** The ranking of the best democracies combines the results from one hundred indicators. Beginning with the three foundational democratic principles of liberty, equality and control, the indicators were successively derived based on their key democratic functions, their components and their subcomponents. A list of all the indicators and the steps used to derive them can be found at: www.democracybarometer.org.

Established Democracies in International Comparison

If one compares the quality of democracy, across countries, using a single comprehensive index, then one finds the following for the period from 1990 to 2007 (see Figure 2): In this ranking of the thirty best democracies worldwide, Scandinavian countries occupy four of the five top spots. These are small, relatively homogenous countries with an almost unbroken democratic tradition throughout the twentieth century. These are also the countries with the least socioeconomic inequality and a particularly high density of societies, associations, and other civil society organizations. Switzerland, with its strong tradition of federalism and its dense network of referendums at local, cantonal, and national levels, reached second place based on the 18-year average from 1990 to 2007. At the other end of the spectrum, one finds Malta, Costa Rica, Cyprus, and South Africa. The range of countries in which one may observe many deficiencies in democracy stretches from rank 15 (the U.S.) to rank 26 (Portugal). The exact figures, meaning all one hundred assessment indicators, can be examined at www.democracybarometer. org.

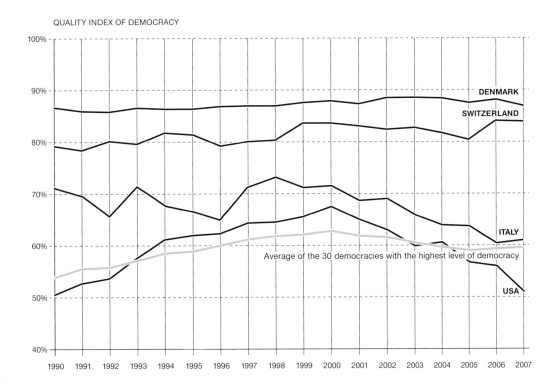

3 **THE DEVELOPMENT OF DEMOCRATIC QUALITY** The figure shows how Denmark, Switzerland, Italy and the U.S. developed from 1990 to 2007, as compared with the average of the thirty countries with the highest levels of democratic quality.

The development of democratic quality since 1990 can be followed with some precision with the help of the Democracy Barometer. The widespread thesis of the decline of democracy and the ongoing crisis in democracy can thereby be subjected to an empirical test. The cyan line in Figure 3 shows the course the overall index of democratic quality has taken among the thirty best democracies, while the four black lines show how democracy has developed from 1990 to 2007 in four select countries. When one systematically examines the empirical indicators, a crisis of, or in, democracy, meaning a steady decline in the quality of democracy as is sometimes suggested in the press, the media, or even by some democratic theorists, cannot be found. On the contrary: The average quality in all thirty countries was actually higher in 2007 than in 1990. While Denmark, as the best democracy, consistently and stably remained above average, the quality of democracy visibly declined in Italy before 2000 and in the United States after 2000. This decline paralleled changes in government, with the governments of Berlusconi in Italy and Bush in the United States having particularly negative effects.

CURRENT CHALLENGES TO DEMOCRACY

No matter how good such an empirical examination of the quality of democracy might be, it is only a snapshot that reflects the surface and does not recognize developments taking place in the deep structures of the democratic system. One should also be careful with cheap talk about crises, as this would logically mean things were better before the crisis and that a healthy democracy existed earlier, perhaps even during a lost Golden Age. This cannot be empirically substantiated for "democracy" in general, or for the older democracies in particular, as a first look at the Democracy Barometer shows. One should instead, speak of the challenges democracy faces at the beginning of the twenty-first century, and of its vulnerabilities.

One can draw a distinction between challenges to democracy that grow from within (endogenous) and from without (exogenous). For established Western democracies, the key endogenous challenges at present are:
– the hollowing-out of core democratic functions
– inclusion in heterogeneous societies
– the social preconditions for democracy

The major exogenous challenge, without doubt, is globalization, and this is discussed in greater detail on pages 460–91.

The Hollowing-out of Core Democratic Functions

Since the early 1970s, a fixed canon of crisis diagnoses has held that core functions of democracy such as participation, representation, and inclusion are being hol-

lowed out: Participation declines, representation breaks down, inclusion fails. Democracy loses its participatory core and degenerates into an elitist spectator democracy. But is this true? An examination of Germany, which among OECD countries can be found more or less in the middle (Democracy Barometer 2011), appears to support this "hollowing-out" thesis.

The Challenge of Participation: Who takes part in elections?

In Germany, as in most Western democracies, the critique has it, voting participation is dropping, members are leaving the mass political parties, and what remains behind is a citizenry that has retreated into private life and leaves questions of how to pursue the common good to the political elites. A more systematic examination of voting participation rates throughout Western Europe from 1950 to 2009 indicates, at least by this measure, that the decline has been quite moderate, falling from 83 percent in 1950 to 75 percent in 2009. The picture in Eastern Europe's new democracies has been more dramatic (though over a shorter time period). There, voting participation fell from 72 percent in 1994 to 55 percent in 2009.

Yet does the voting participation rate say anything about the quality of a democracy? Is 72 percent worse than 91 percent? The higher the participation rate, the better? This is controversial not just in empirical studies of democracy but in democratic theory as well. English-speaking analysts of democracy, in particular, even warn of over-participation, and of an "overheated" democracy if voting participation rises too much. Yet one need not lend credence to such a conservatively colored value judgment. The fact is that satisfaction with democracy in the EU, as measured by opinion polls, shows no correlation whatsoever with voting participation rates. Not only that, but in the last two decades, Switzerland (45 percent) and the United States (52 percent in presidential elections and 33 percent in midterm elections) show the lowest voting participation rates among OECD countries, though subjective satisfaction with democracy in both countries lies markedly over the OECD average.

However, voting participation rates do correlate with the degree of social selectivity: The lower the voting participation, the higher the social selection of the electorate. But if voting participation depends on membership in a social class, or in an ethnic or religious minority, or on gender, or level of education, democracy loses representativeness. A democracy whose distinguishing adjective is "representative" but in reality is selective loses credibility.

Social selectivity in voting participation is less strong in Germany than it is in Switzerland or in the United States, and it has developed differently during the last three decades. While education- and class-specific selectivity has intensified—the

lower the educational and social level, the lower the voting participation—gender-based selection has vanished and women vote at rates equal to men. The problem is far more a recurrence of the class-based character of political participation.

On the other hand, one should balance the decline in conventional political participation against the increasing involvement in unconventional political activity not associated with political parties. Compared with the supposed Golden Age of democracy in the 1950s and 1960s, such active forms of participation and involvement have increased substantially. The difficulty is that this development has only intensified the problem of social selection, as it is primarily young, well-educated people who engage in democratic activities in civil society associations like Amnesty International, Human Rights Watch, Attac, Transparency International, or environmental groups. One seldom finds workers, immigrants, or those from the educationally deprived lower classes in such organizations.

The Challenge of Representation:
The growing gulf between politics and society

During the twentieth century, political parties became the most important intermediaries, within the mechanism of representation, between society and government. Yet members are deserting the political parties, and the parties threaten to become member-poor cartels that have lost their social moorings yet have established a monopoly claim to fill important political posts. The loss of members can be seen across Europe, but is most evident in the mass (or popular) political parties.

This membership loss is not only seen in political parties but is also true of clubs and associations. *Bowling Alone* was what the American political scientist Robert Putnam called this collective loss of bonding in individualized societies of the post-industrial age. Societies undergo change—and with it, their readiness to organize collectively. In that sense, the loss of political party members is primarily a social phenomenon and only secondarily a consequence of party failure. The classic mass parties, with their many members and catch-all programs, threaten to become anachronisms in individualized societies, and over the longer term, this is likely to create more problems than benefits.

In the past, the large mass parties were castigated, and not without reason, as overly bureaucratic, hierarchical, and programmatically amorphous. Their erosion and the resulting proliferation of other political parties means voters are given greater choice between alternate programs. Pluralism and the intensity of competition thereby increase, and this, at least in the short term, is good news for democracy. There is less good news over the longer term, for with the erosion of mass popular parties, the political "integration engine" of the postwar era loses steam.

Left by the wayside, again, are the lower classes who had been politically mobilized, organized, and represented by such parties in the 1950s, 1960s, and even into the 1970s. They seldom find a home in the ecological, right-wing populist, or left-wing socialist political parties. The social selectivity of democratic participation and representation will increase further if mass parties continue to erode.

A still more troubling finding should be added. In public opinion polls in nearly every country, despite their considerable differences, parliaments and political parties receive the least support of all national institutions. The police, the military, the church, and the constitutional courts, which are important though not necessarily democratic and certainly not representative institutions, receive the highest marks. One might say that the further public institutions are from the core political business of pluralistic organization, representation, and conflict resolution, the better their polling results. The converse is also true: The closer organizations and institutions such as parliaments, political parties, and political elites stand to the center of democratic representation, the lower their rates of approval.

Causes for the Loss of Trust in Politics

Is the low degree of trust due to politics and political elites, or does it stem from the societal environment? Both are true, though there is an interplay at work here. Newly emerging, external problems are not adequately dealt with in domestic politics, not least because politicians and political parties, in competition with one another, often claim an ability to resolve problems that they do not actually possess. Political opposition and the laws of media orchestration tempt them to make such claims, though. But if the results fall short of citizens' expectations, which have been inflated by the media and politicians, it can only lead to disappointment and, over the long term, to mistrusting the political elites.

A further reason for the increasing mistrust of politics and political elites has been found in the empirical research on democracy. Owing to increasing levels of education as well as the greater availability of political information, a type of "critical citizen" has emerged in large numbers. Citizens today, this research suggests, are far more critical than forty or fifty years ago, so the reason for the loss of trust lies more among citizens (demand-side) than among politicians (supply-side). The supply has not worsened, but the demands have become, well, more demanding. Seen this way, the growing mistrust citizens show towards politics and political elites would even have to be seen as an increase in democracy. If one also takes into consideration that a degree of mistrust of political representatives on the part of the politically represented is not only normal but even helpful in supporting the control principle in a democracy, then this news is more good than bad.

Has the bond between representatives and those they represent ruptured? The diagnosis says: No, but in most democracies it has grown thinner and more complex, and requires more maintenance. The supply from the political world has not kept pace with demands that have become more exacting. Owing to an increased demand on the part of citizens for political solutions, and the disappointment effects thereby generated, democracy has actually become more vulnerable to crises. One aspect that has clearly worsened is the increasing exclusion of the lower strata from participation and representation.

The Challenge of Inclusion: Minority group participation

The question of inclusion is inextricably linked to the question of representation. Democracies are that much more democratic the more comprehensively their resident citizens are integrated into the system of political representation and decision-making. Inclusion does not only have political dimensions, but economic, social, and cultural dimensions as well. The more comprehensively all classes, ethnic groups, religious communities, and genders are integrated economically, socially, and culturally, the better they can participate politically—and vice versa.

UNEMPLOYMENT Madrid, Spain, 2010: Waiting in line in front of a job center. In Western European countries, unemployment is an unresolved structural problem. Those with few qualifications have only slight chances, depending on the country, of finding a job. Because the children of poor parents do not have the same opportunities as the children of well-to-do parents, democracies are confronted with a massive problem of social equity. Keystone/Paul White

The better they can participate, the more readily their interests will be represented. The more inclusively all the relevant and legitimate interests are equally represented, the higher the quality of the democracy. The higher democratic quality becomes, the more crisis-resistant the democracy will be.

If one compares this democratic logic of inclusion today with the situation in the 1960s and 1970s, one can ask whether there really has been a decline in democracy over the last forty years. Is the inclusion and exclusion situation a reason to speak of a crisis? To answer this, one should examine four central variables: Class, ethnic group, gender, and sexual orientation.

Class Affiliation: The disconnected underclass

Economic inequality has increased visibly in Western societies over the last two decades. This is due partly to the sharp increase in income among the top three percent of the society, and partly to the increase in the numbers of those counted as members of the lowest classes. In addition, the character of the lower classes has changed. It is no longer composed, as in the 1960s, of workers who, though unskilled, were nevertheless integrated into the workforce. Instead, it is now primarily

ETHNICITY Fylakio, Greece, 2010: Refugees at a reception camp near the Greek-Turkish border. Since the 1960s, immigration has been an influential and controversial issue in Europe. In most countries, integration has not been satisfactorily accomplished. As a result, a disproportionate number of people whose parents and grandparents were immigrants live in difficult social and economic circumstances. Panos/Jeroen Oerlemans

made up of those who stand outside the labor market. While unskilled workers in Western Europe were still integrated into society and participated politically during the first three decades after World War II, the lower classes that stand outside the labor market today are increasingly losing their connection to politics and society. They are ostracized and marginalized, and pass on this social status, inexorably, to their children. The lower strata have long since become an underclass, one increasingly ethnically colored. In terms of education, immigration, integration, and employment, democratic politics have failed, and the degree of inclusion is worse than in the 1960s. This is true of nearly all the countries in Western Europe.

Ethnic Affiliation: The challenge of integration

Immigration has made Western European societies more heterogeneous since the 1960s, and ethnic diversity has increased. This is not the place to answer the question whether inadequate integration should be ascribed primarily to the immigrants themselves or to the receiver society and its policies. The fact is that the integration of many of the immigrants and their descendants has been suboptimal, whether economically, socially, or politically. Immigrants, and those with a migra-

GENDER Kuwait, 2000: The first women to work in the country's oil industry: Even in a non-democratic state with a Muslim majority, emancipation advances are changing role models. In Western countries, the situation for women has improved markedly in recent decades, though complete equality has yet to be reached. That gap is illustrated by the different average pay women receive for the same work done by men, or by the smaller number of women in managerial positions. Panos/Penny Tweedie

tion background, are disproportionately represented among school dropouts, the unemployed, and those on welfare, or in other words, among the lower classes. Western European democracies tend to be more ethnically exclusive than inclusive, and this situation reduces the quality of democracy and creates a growing group of people and citizens who are indifferent or even hostile to democracy.

Gender: The way towards the equality of men and women

Nowadays, women participate in elections just as often as men do, and their representation in parliaments has increased substantially. Female government ministers have long ceased to be uncommon and even female chancellors or prime ministers are no longer a rarity. Scandinavian countries have largely established gender parity in the representative organs of democracy, but both Germany and Switzerland still have some way to go.

Nevertheless, progress in promoting equality between women and men in Western Europe and the United States has been considerable. Policy areas of special concern to women, such as gender equality and how to reconcile family and career, have increasingly moved to the center of political discourse and decisions.

SEXUAL ORIENTATION Moscow, Russia, 2013: Homosexuals protesting at the Duma, the Russian parliament. While there has been a general liberalization in Western countries with respect to same-sex partnerships, homosexuals in Russia continue to face discriminatory laws. Keystone/Ivan Sekretaev

Even though full equality between men and women has yet to be achieved, women today are in a better position legally, politically, and even economically than at any time in the past.

Sexual Orientation: Increasingly equal treatment of homosexuals

If one asks a homosexual whether he or she would prefer to live in the alleged heyday of democracy in the 1960s and 1970s or today, in an allegedly "post-democratic" age, the answer is clear: Today! The criminalization and prosecution of homosexuality has been abolished, political discrimination is a thing of the past, and even social ostracism has reduced considerably. Western democracies have become exceptionally sensitive toward a minority that does not pursue the hetero-sexual life of the majority.

Yet the picture of inclusion in Western democracies during the last decades is mixed. Considerable success can be noted for certain minorities and in the increase in gender equality that benefits women, but ethnic inclusion has not been adequate or wholly successful, and the class question, in a new guise, has returned to democracy. Ethnic integration, too, is overlain with the question of class. In a country like Germany, it is not the Muslim lawyer and the Turkish doctor who are excluded but their coreligionists and countrymen in the lower classes who are poorly integrated into the economy and labor market.

THE CRISIS OF DEMOCRACY: A MYTH?

If one understands a crisis to mean a situation that threatens continued existence, then the advanced democracies in the OECD have barely been affected. The myth of a Golden Age of democracy during the 1950s and 1960s is as persistent as it is untenable. Democracy wasn't golden in Germany's rigid society during Konrad Adenauer's chancellorship, nor was it in Switzerland, where women lacked the right to vote. Italy, under the control of the Democrazia Cristiana party, was illiberal and corrupt, and in the Kennedy years in the United States, naked racism kept the black population in the southern states from being able to vote or exercise their other civil rights.

Theories of crisis are oddly ambivalent. On the one hand, they are not infrequently propagated by the best-known commentators of the age. With theory-driven astuteness, they ferret out important aporia, dilemmas, and "dysfunctions" of democracy. On the other hand, these theories have unmistakable weaknesses, including:

- Talk of *the* crisis of democracy simplifies and obscures. It abstracts from core differences in democracies even though those differences are precisely what differentiates a crisis from a non-crisis. Denmark isn't Italy, Switzerland isn't Greece, France isn't Argentina.
- Individual trends that seem crisis-like, such as a decline in voting participation, the social selectivity of such participation, globalization, crises within (financial) capitalism, or the loss of traditional values and ties, are exaggerated and applied indiscriminately to the democratic order.
- Diagnoses of crises often suffer from a one-dimensional notion of time, one incapable of recognizing the non-simultaneity of events. With discernment, challenges and tendencies toward crisis may be described, but aspects of democratization that run counter, or that compensate, stabilize, or optimize, are excluded from the analysis. Thus, while social selectivity has increased in the last decades, so has transparency in government, and the legal, political, and societal situation of women and minorities has distinctly improved. This is no small thing, particularly if one has a demanding understanding of a tolerant democracy. Of course the crises of capitalism haven't vanished, and of course they continue to pose a challenge to democratic rule. Still, the concerted international efforts that were made after the 2008 crisis in the global financial markets showed that the major democracies remain capable of acting when it is a matter of ensuring their own future existence. Yet that the burdens of this crisis must once again be borne by the less privileged should not be lost from sight. It worsens the social imbalance of many democratically constituted societies, but does not drive them to the brink.

All this does not mean that weaknesses, deficits, or even defects cannot or do not exist in important realms of democratic politics. The distance that has grown between rulers and ruled is one of them. The loss of trust that political elites, political parties, and parliaments increasingly must endure cannot be lessened by noting that the number of enlightened and critical citizens has increased, too. It seems far more to be due to a particular asynchrony that advanced democracies currently face. Endogenous and exogenous challenges have increased faster during the decades than has the ability of democracies to cope or keep up with them. Changes to democratic institutions and processes have not kept pace with the changes to their environment. Whether the democratic institutions and the learning mechanisms built into them are elastic enough to prevent the gap between supply and demand from widening further cannot, for the moment, be foreseen.

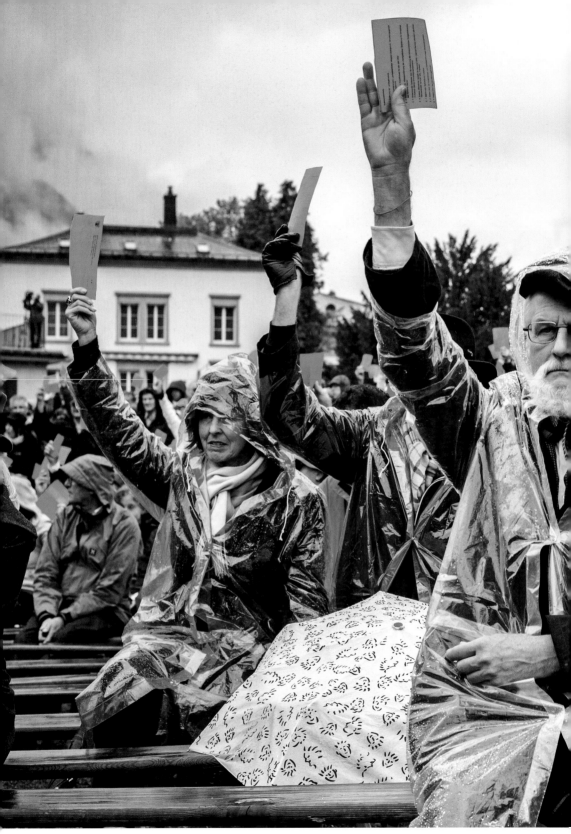

ATTRIBUTES OF DEMOCRACY

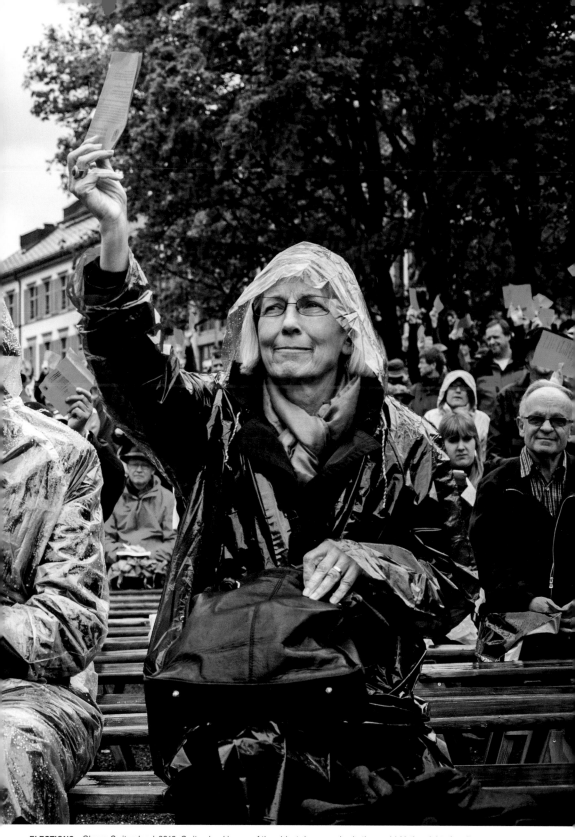

ELECTIONS Glarus, Switzerland, 2012: Switzerland is one of the oldest democracies in the world. Voting rights for all, including women, were not introduced at the federal level until 1971, however. Only since 1990, when the last holdout among the cantons, Appenzell-Innerrhoden, gave women the right to vote, has Switzerland had universal suffrage at all levels. In some cantons, however, elections are not secret! Pascal Mora

ATTRIBUTES OF DEMOCRACY

FREEDOM OF THE PRESS Kaduna, Nigeria, 2011: Newspaper vendors in the run-up to the presidential elections.
Are appearances deceiving? In a 2009 report, Freedom House claimed this country, which has had unstable governments
and military dictatorships since independence, had a "partially free" press. The press, as the "fourth estate," is absolutely
necessary if public debates and diversity of opinion is to be possible. Keystone/Sunday Alamba

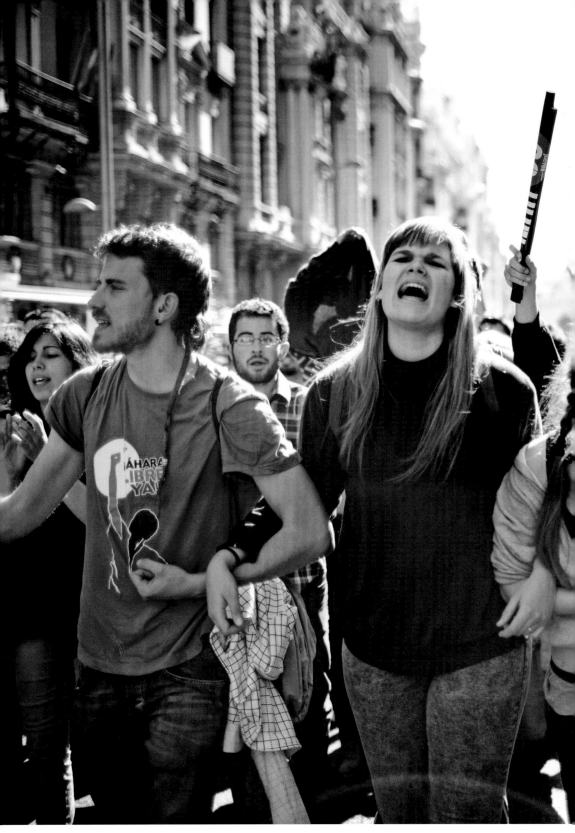

ATTRIBUTES OF DEMOCRACY

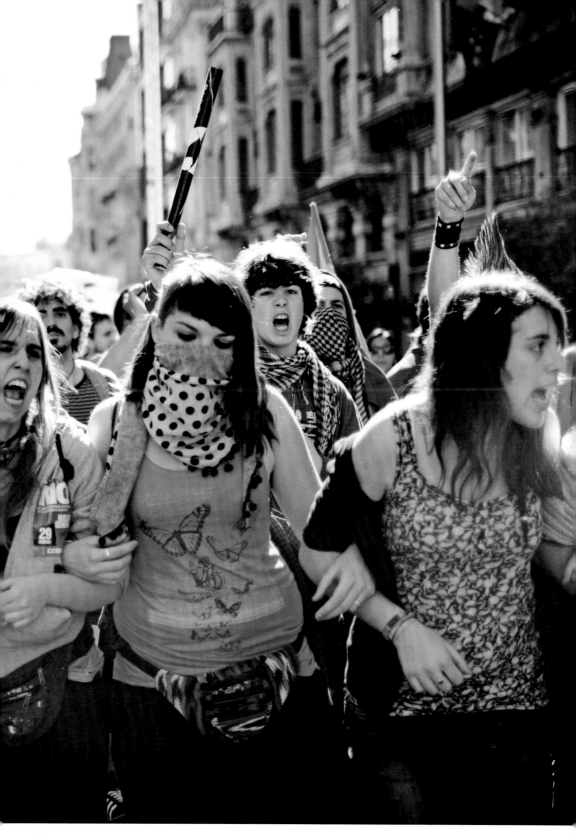

FREEDOM OF OPINION AND FREEDOM OF ASSEMBLY Madrid, Spain, March 29, 2012: National strike in Spain.
Unemployed youths demonstrate against the government's austerity measures. The right of free assembly is often one
of the first freedoms to be curtailed by authoritarian regimes. Panos/Christian Als

ATTRIBUTES OF DEMOCRACY

EQUALITY BEFORE THE LAW Tallahassee, USA, 2009: Equality before the law is guaranteed in the U.S. Constitution. Nevertheless, there is evidence that minorities are at a disadvantage in the U.S. system of justice. The number of minority inmates in the country's prisons is disproportionate. Furthermore, sensational acquittals of whites accused of crimes against blacks have repeatedly led to discussions about ethnically motivated unequal treatment in the United States. Laif/Daron Dean

ATTRIBUTES OF DEMOCRACY

SEPARATION OF POWERS Washington, USA, 2009: President Obama speaks before Congress. In the United States, the Supreme Court passes judgments on the lawfulness or constitutionality of laws passed by Congress and on the actions of the President. In this manner, all three branches – Supreme Court, Congress and President – can check and balance each other's actions. AFP Photo / Jewel Samad

ATTRIBUTES OF DEMOCRACY

SAFETY AND PROTECTION OF PROPERTY London, Great Britain, 2009: Police guard the Royal Bank of Scotland to protect it from demonstrators. The bank had become insolvent in the course of the financial crisis and had to be bailed out by the government at the taxpayers' expense. Panos/Tom Pilston

143

ATTRIBUTES OF DEMOCRACY

EQUAL RIGHTS School in South Africa: Under international pressure, the country ended its official policy of discrimination in 1994. Despite the persistence of great differences between ethnic groups with regard to social and economic status, political equality prevails. Panos/Giacomo Pirozzi

ATTRIBUTES OF DEMOCRACY

EQUAL OPPORTUNITY Youth orchestra in Caracas, Venezuela, 2008: Equality of opportunity in life is created largely through equal access to education. Peter Dammann

ATTRIBUTES OF DEMOCRACY

SOCIAL RIGHTS Bastia, France, 2001: Carefree in old age. Well-organized societies have a contributory component. Those who are economically weaker (the elderly, the poor, the sick) are supported by those who are strong. In studies of democracy, one school of thought argues social security should be a part of the definition of what a democracy is.

ATTRIBUTES OF DEMOCRACY

FREEDOM OF BELIEF, FREEDOM OF RELIGION Hyderabad, India, 2010: Even though religiously motivated conflicts continue to occur, India, as the world's biggest democracy, guarantees freedom of belief and freedom of worship in its constitution. AFP Photo/Noah Seelam

As a form of rule, democracy has been spreading across the globe since the nineteenth century. However, this process has been uneven, taking place at different points in time in different regions and cultures, with not every democratization resulting in a stable democracy. This observation raises a question about which prerequisites are necessary for democracy. What form must states and societies take for the seed of democracy to fall on fruitful soil and take root?

The literature on democracy and democratization discusses the prerequisites for democracy in terms of identity, culture, economics, and the international setting. In a nationalist age, ethnic identity has come to be seen as the most significant characteristic of the *demos*. For that reason, ethnically homogenous societies have had an advantage in becoming democratic, more so than have multi-ethnic societies. In the latter case, democratization carries the danger of erupting into violent conflict, as well as into lasting discrimination against specific groups. In such cases, having procedures for divided rule (such as federalism and consensual decision-making) is a prerequisite for stable democracy. The idea that democracy is a Western or even a Protestant form of rule is obsolete, however. A far more important prerequisite is that a people comes to cherish freedom—understood as individual self-expression—as an indispensable value.

That occurs especially in societies which have reached a certain degree of prosperity. Wealth is one of the best-researched and established prerequisites for democracy, especially when combined with a reduction in economic inequality. Finally, a favorable international environment helps. Successful democratic states in the international neighborhood, along with international organizations that promote democracy, increase the pressure on undemocratic states to change their ways, and also help to stabilize new democracies.

THE PREREQUISITES FOR DEMOCRACY

The State
and the People—
What Else?

Frank Schimmelfennig and Manuel Vogt

If only they show the will and determination to topple an undemocratic regime, can all people then live as democrats? There is an influential strand in the study of democracies that believes democracy is possible everywhere, regardless of a people's ethnic composition, culture, religion, level of economic development, or the international context. All that is necessary is a situation favorable to revolution—a weakened and divided regime, such as after a lost war or during a deep economic crisis, an unhappy or even desperate population, ready to take on the risks of a rebellion, and a revolutionary leadership that has support in the population and demonstrates strategic skill.

In point of fact, democratic revolutions have occurred again and again in countries and places where such revolutions were thought unlikely. In the last several decades, starting with Soviet-dominated Eastern Europe and extending to the latest upheavals in the Arab world, and including several African and Asian countries, such democratic upheavals have surprised even the experts.

Still, it is also true that successfully overthrowing an old regime, by democratic means, does not necessarily result in a stable democracy afterwards. At the end of each wave of democratization, some countries have reverted to being ruled by the old regime. Other countries have halted midway in their democratization, have degenerated into civil war, or have established a new, but undemocratic, regime. Overthrowing the communist regimes of Central and Eastern Europe, for example, led many countries to establish stable, consolidated, democratic governments afterwards. But it also led to a quasi-communist regime in Belarus, unstable and defective democracies in Albania and Ukraine, as well as civil war in ex-Yugoslavia and non-communist dictatorships in Russia and Central Asia.

So the question is, what conditions are necessary for establishing a *stable* democracy? What is necessary so that the will of the people not only sweeps a regime out of office but then also leads to a consolidated, stable new regime that functions, and functions reliably, according to the democratic rules of the game? What gives the new regime broad recognition and acceptance among the people?

The aspects discussed below should by no means be understood as necessary or sufficient conditions for a stable democracy. Instead, they are factors that can favorably influence the likelihood that such a democracy will be successfully established or consolidated.

WHO ARE THE PEOPLE?
DEFINING A STATE'S PEOPLE AS A PREREQUISITE FOR DEMOCRACY

A fundamental, but often overlooked, prerequisite for a functioning democracy is determining who a state's people actually are. If governmental rule and authority

are in the hands of the people of a state—if, so to speak, the people rule themselves—then one necessarily needs rules and criteria determining who is meant when one refers to "the people." At issue, thus, is the definition of the *demos*. Before the people can rule, there must be agreement over who deserves and who remains excluded from political rights.

Many modern democratic theories address this question only in passing. Democratic participation by the people and government accountability are generally regarded as the two fundamental pillars of democracy. Yet the former is often treated just as confirmation of an already generally accepted condition, or as a characteristic that helps distinguish democracies from dictatorships, where the population cannot themselves elect their ruler. If democratic participation nevertheless is mentioned, then it usually is only to discuss specific criteria for exclusion (age, mental capacity) in the context of the people's general right to vote. So the assumption is that a defined people of a state already exist. However, this is not always the case. Ethnic discrimination, for example, can be found even in some apparently exemplary democracies.

Two Concepts of Citizenship: Jus sanguinis and jus soli

Beginning with the French Revolution, nationality became the decisive criterion for determining the *demos*. Nationality, meaning belonging to or being a member of a nation, is usually determined by one of two principles: *jus sanguinis* (Latin for "right of blood") and *jus soli* (Latin for "right of soil"). As the term "blood" suggests, the first principle sees the nation as organic, a closed cultural community that is based on lineage in which membership of that nation is transferred from parent to child. In the case of *jus soli*, by contrast, it is the place of birth that is decisive for a person's nationality. The second principle, to an increased degree, uncouples nationality from the notion of a cultural community and instead sees the *demos* as a strictly political community, one in which "strangers" can, through legal procedures, become integrated as citizens.

The *jus sanguinis* principle is closely tied to the rise of nationalism, particularly in the nineteenth century. As a formative political ideology, nationalism lent a new political significance to the idea of the nation. Nationalism can be described as a principle of political legitimation, which starts from the proposition that ethnic or cultural boundaries should be congruent with political borders. Every people should have its state and be ruled by "its own" people. Ethnic identity refers to innate or acquired characteristics that point to a person's origin, which can include skin color, hair type or other physical characteristics, language, and religion. An ethnic group, therefore, is a group of human beings who understand themselves

(or are seen by others) as a group that belongs together culturally, based on such characteristics.

The ideology of nationalism hence directly ties the legitimacy of political rule to ethnic and cultural identity. In that perspective, the people of a state is explicitly equated with an ethnically defined community. Only those who belong to a particular linguistic or religious group are part of the nation and can enjoy political rights. This can become problematic when political reality is not congruent with the "cultural map," and differing ethnic groups live in the same territorially defined state.

Historical events in Western Europe led to a situation in which most states in this region now can be seen as ethnically homogenous. Purges during the religious wars fought between the fifteenth and seventeenth centuries, and the later (more or less) voluntary adoption of a dominant national language and culture by linguistic minorities, are responsible for the fact that most West European states—Portugal, England, France, Sweden, and so forth—are associated with only one language and one religion. It is not least for this reason that the dimension of ethnic identity and of ethnic definition of the *demos* is mentioned only in passing in many standard theories of democracy. Instruments used to measure the level of democracy in various countries around the world also give little weight to the question of ethnic equality, so we turn to this issue next.

Multi-ethnic States: The need for consensus and the risk of the tyranny of the majority over minorities

The fact is that most of the world's countries today are multi-ethnic. This is especially true of ex-colonies in Africa and Asia, but many countries in Eastern Europe also have groups that differ in language, religion, and culture. There are also groups like the Kurds, who live scattered across several countries but have no state of their own. In such cases, ethnic identity as a way to determine who belongs to a state takes on enormous significance.

For democracy to function in the manner democratic theorists think it should, people who live together in a territorially defined state must be able to think of themselves as a political entity or unit. In multi-ethnic societies, this means all the different groups need to see themselves as belonging to a single national people, and this identity must stand above membership in any particular ethnic or religious group. Switzerland is a model of such a multi-ethnic nationalism, and it is a country that strongly demarcates itself outwardly, but has an extremely integrative character inwardly. The various language groups—and later the religious groups as well—came together to create *one* political community, a Swiss nation under the roof of a common state.

But when a society is multi-ethnic, there can be grave consequences if the *demos* is equated with one particular ethnic group. The result can be anything from political exclusion along ethnically set boundaries to genocide. In asking how one determines who the people of a state are—and thus whether there is democratic rule—issues of ethnic discrimination arise. South Africa's apartheid regime, as well as racial segregation and discriminatory election laws in the southern U.S. states, for example, were based on an extremely ethno-nationalist vision of who the people of the state were. Blacks, for racial reasons, were excluded from the *demos* and the rights associated with it. The precursors of such race-based regimes can be found in European colonial rule in Africa and Asia (and earlier, in Latin America). The people of the state at that time were defined as only the small group of colonial occupiers—who, for reasons they claimed had to do with racial and cultural superiority, ruled over subject, and native, peoples.

Discrimination and political exclusion need not be based only on formal laws or rules. Particularly in countries with a majority group, the entanglement of democracy and nationalism can lead to the oppression of ethnic groups. As "rule by the people" in practice usually means "rule by the majority," democratic rules and procedures that emphasize simple majorities can lead to a "tyrannical" rule by the dominant group. They electorally overwhelm the ethnic minorities and turn them into "eternal" minorities. In this case, simple majority democracy turns undemocratic.

In principle, the assumption is that political majorities continually change. But if certain groups permanently remain in the minority, they lose their political rights for all intents and purposes and remain, so to speak, excluded from the *demos*. In the worst case, politically depriving minorities of their rights can end in a genocide like that carried out in Rwanda in 1994, when the majority Hutu wanted to secure their supremacy by physically annihilating the minority Tutsi.

Yet ethnic discrimination can be found even in what are otherwise regarded as exemplary democracies, as in the case of Israel with its de facto occupation of the Gaza Strip and the West Bank, or in Latvia or Estonia. Precisely because—or perhaps despite the fact that—these countries function according to formally proper democratic processes, significant minorities (Arabs and Russians, respectively) are shut out of the political community in these countries. A telling example is a referendum recently held in Latvia on introducing Russian as a second official language. The Latvian electorate rejected the proposal by a large majority. Russians account for about 30 percent of Latvia's population, but owing to Latvia's rigid language policy, Russians are disadvantaged both politically and economically.

The discriminatory electoral laws that existed in Latin America in earlier times, a number of which linked suffrage to mastery of the Spanish language, have faded

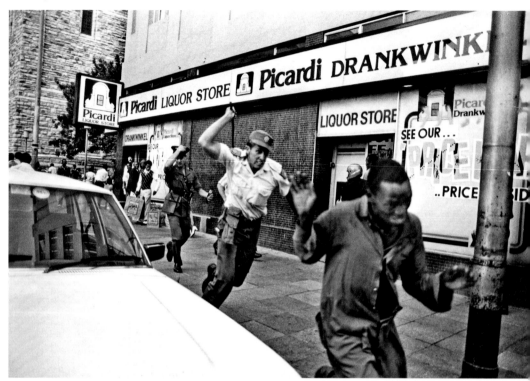

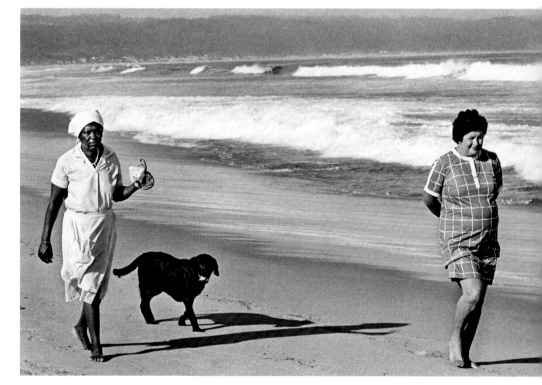

Durban, 1987: A "whites only" beach. The black woman can walk on it only as the servant of a white woman.
Panos/Gisele Wulfsohn

Johannesburg, 1984: Racial discrimination in every area of life. Panos/Eric Miller

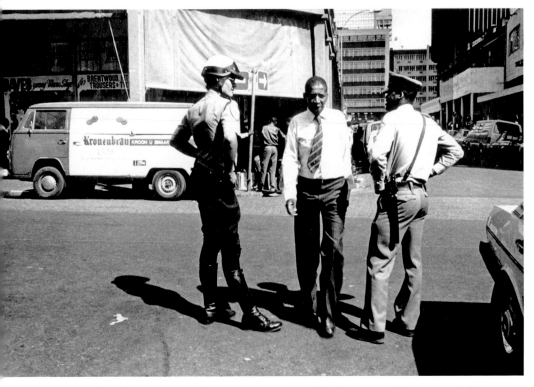

Johannesburg, 1982: Arbitrary treatment and harassment are part of daily life for the black population under apartheid.
Panos/Nancy Durrell-Mckenna

RACIAL DISCRIMINATION AND THE CIVIL RIGHTS MOVEMENT IN THE UNITED STATES Martin Luther King Jr. during a speech in Washington, D.C., 1957. As the leading figure in the American civil rights movement, Martin Luther King Jr. fought for equal rights for the black population of the United States. With the 1964 Civil Rights Act and the 1965 Voting Rights Act, black Americans obtained legal equality. Magnum Photos/Bob Henriques

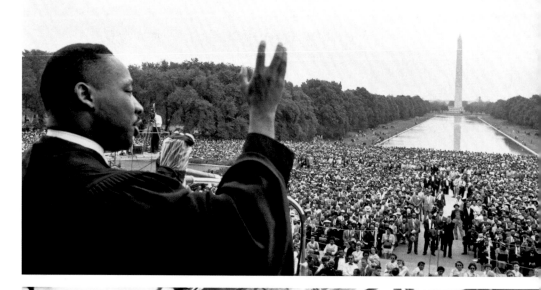

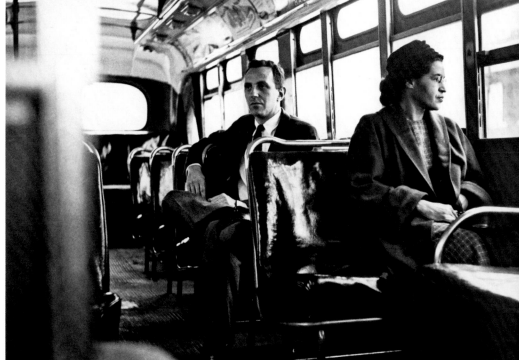

Rosa Parks's refusal to surrender her seat on a bus to a white passenger and thus submit to racial discrimination led to widespread boycotts in Montgomery, Alabama in 1955. After a 381-day bus boycott by the black population, Montgomery abandoned segregation on public transport. The photo shows Parks on December 21, 1956, the day the U.S. Supreme Court declared racial segregation on public buses unconstitutional. Dukas/Bettmann

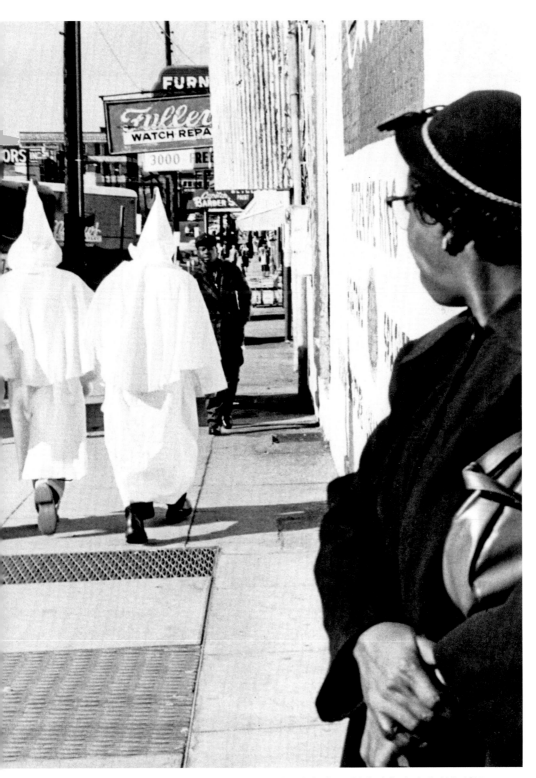

Alabama, 1956: With extreme brutality, the Ku Klux Klan fought against eliminating racial discrimination in the United States. Its members believe in the dominance of the white race. Keystone

I HAVE A DREAM

Martin Luther King Jr.

When Martin Luther King Jr. delivered his speech during the March on Washington for Jobs and Freedom on August 28, 1963, he articulated a vision of utopia that moved millions of people. It was a utopia that has taken shape over the course of the past decades. Even if, in the day-to-day reality of Americans, minorities still have to contend with prejudice and disadvantage, they nevertheless have legal and social equality and can participate in political life. The election of Barack Obama in 2008 as the first black president of the United States is evidence that the promise of the utopia outlined in 1963 was honored less than fifty years later.

I am happy to join with you today in what will go down in history as the greatest demonstration for freedom in the history of our nation.

Five score years ago, a great American, in whose symbolic shadow we stand today, signed the Emancipation Proclamation. This momentous decree came as a great beacon light of hope to millions of Negro slaves who had been seared in the flames of withering injustice. It came as a joyous daybreak to end the long night of their captivity.

But one hundred years later, the Negro still is not free. One hundred years later, the life of the Negro is still sadly crippled by the manacles of segregation and the chains of discrimination. One hundred years later, the Negro lives on a lonely island of poverty in the midst of a vast ocean of material prosperity. One hundred years later, the Negro is still languishing in the corners of American society and finds himself an exile in his own land. So we have come here today to dramatize a shameful condition.

In a sense we have come to our nation's capital to cash a check. When the architects of our republic wrote the magnificent words of the Constitution and the Declaration of Independence, they were signing a promissory note to which every American was to fall heir. This note was a promise that all men, yes, black men as well as white men, would be guaranteed the unalienable rights of life, liberty, and the pursuit of happiness.

It is obvious today that America has defaulted on this promissory note insofar as her citizens of color are concerned. Instead of honoring this sacred obligation, America has given the Negro people a bad check, a check which has come back marked "insufficient funds." But we refuse to believe that the bank of justice is bankrupt. We refuse to believe that there are insufficient funds in the great vaults of opportunity of this nation.

[…] I say to you today, my friends, so even though we face the difficulties of today and tomorrow, I still have a dream. It is a dream deeply rooted in the American dream.

I have a dream that one day this nation will rise up and live out the true meaning of its creed: "We hold these truths to be self-evident: that all men are created equal."

I have a dream that one day on the red hills of Georgia the sons of former slaves and the sons of former slave owners will be able to sit down together at the table of brotherhood.

I have a dream that one day even the state of Mississippi, a state sweltering with the heat of injustice, sweltering with the heat of oppression, will be transformed into an oasis of freedom and justice.

I have a dream that my four little children will one day live in a nation where they will not be judged by the color of their skin but by the content of their character.

I have a dream today.

I have a dream that one day, down in Alabama, with its vicious racists, with its governor having his lips dripping with the words of interposition and nullification; one day right there in Alabama, little black boys and black girls will be able to join hands with little white boys and white girls as sisters and brothers.

I have a dream today.

I have a dream that one day every valley shall be exalted, every hill and mountain shall be made low, the rough places will be made plain, and the crooked places will be made straight, and the glory of the Lord shall be revealed, and all flesh shall see it together.

This is our hope. This is the faith that I go back to the South with. With this faith we will be able to hew out of the mountain of despair a stone of hope. With this faith we will be able to transform the jangling discords of our nation into a beautiful symphony of brotherhood. With this faith we will be able to work together, to pray together, to struggle together, to go to jail together, to stand up for freedom together, knowing that we will be free one day.

This will be the day when all of God's children will be able to sing with a new meaning, "My country, 'tis of thee, sweet land of liberty, of thee I sing. Land where my fathers died, land of the pilgrim's pride, from every mountainside, let freedom ring."

And if America is to be a great nation this must become true. So let freedom ring from the prodigious hilltops of New Hampshire. Let freedom ring from the mighty mountains of New York.

Let freedom ring from the heightening Alleghenies of Pennsylvania!

Let freedom ring from the snowcapped Rockies of Colorado!

Let freedom ring from the curvaceous slopes of California!

But not only that; let freedom ring from Stone Mountain of Georgia!

Let freedom ring from Lookout Mountain of Tennessee!

Let freedom ring from every hill and molehill of Mississippi. From every mountainside, let freedom ring.

And when this happens, when we allow freedom to ring, when we let it ring from every village and every hamlet, from every state and every city, we will be able to speed up that day when all of God's children, black men and white men, Jews and Gentiles, Protestants and Catholics, will be able to join hands and sing in the words of the old Negro spiritual, "Free at last! free at last! thank God Almighty, we are free at last!"

Martin Luther King Jr. (1929–1968) was an American clergyman and civil rights activist. He was awarded the Nobel Peace Prize in 1964.
Excerpt from the speech held at Washington, D.C., August 28, 1963

into history. But extreme social and economic inequalities persist, particularly among those of indigenous and African background. De facto, this means members of these groups usually are excluded from politics, even in countries like Guatemala, where indigenous peoples form the majority of the population.

Latin American societies, with their extreme and historically rooted inequalities, can be regarded as hierarchical. Social class *and* access to political rights. as well as to political power, are directly and permanently tied to ethnic identity. Ethnic discrimination emerges here from a kind of "graded" *demos* that is composed of different classes of citizens who have unequal political opportunities.

When a State's People are Divided

In multi-ethnic countries that lack a clear majority group, there is often conflict with regard to determining to whom the state "belongs," or deciding which group the state should serve. Particularly in African countries where economic resources and wealth are directly linked to the state and to possessing political power, countries in which wealth and power are often distributed through clientelistic networks based on ethnic ties, different groups fight over the distribution of privileges and valued resources. The economic situations of entire villages, groups, and regions depend on the political position of their elites and the access these elites have to political power. Subtler forms of exclusion may be at play in this competition, as when public investment in infrastructure, education, or other public goods is overwhelmingly to the benefit of particular groups—and other groups remain economically and politically disadvantaged. Ethnically motivated violence that accompanied elections in Kenya (2007–2008), Guinea (late 2010), and northern Nigeria (2011) bears witness to the unresolved "problem of the *demos*" in these divided countries. Democratic elections here often decide whether entire population segments will be excluded from, or will have access to and benefit from, political power.

Many political conflicts thus turn on the *definition* of the democratic community, meaning on defining the people of a state. Though criteria such as age or gender could, in principle, also serve as a basis for political exclusion, nationalism, as the political ideology that has shaped the modern world, has meant ethnic identity has become the key element. States are not tied to gender or age groups but instead to (often ethnically and culturally defined) nations. If there is ethnic discrimination or competition between different groups over who will hold power in and over the state, we can speak of a divided *demos*.

It is especially during democratization phases that these divisions and the question of who belongs become key. Multi-ethnic societies that have not yet reached a clear and integrative definition of the people of a state, and this often means

KURDISH CONFLICT Zahko, Iraq, 1981: Kurdish refugees. The Kurds are an ethnic minority in Iraq, Iran, Turkey, and Syria. For decades they have demanded cultural and political rights. The PKK, the Kurdistan Workers' Party, has waged an armed campaign since 1984, demanding an independent Kurdish state. VII/Ed Kashi

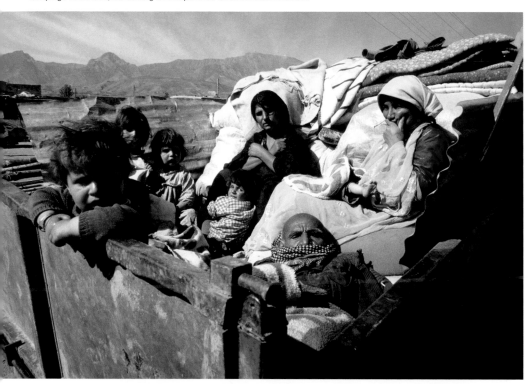

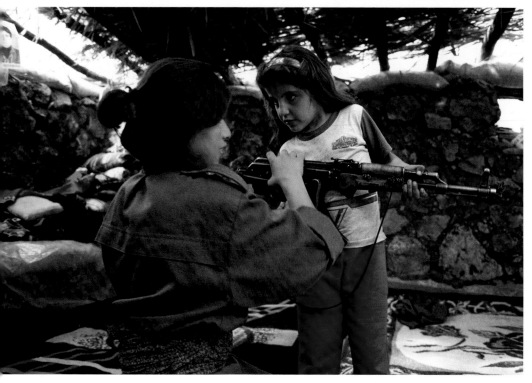

Kurdistan, Iraq, 2005: A young PKK fighter shows her little sister how to hold a Kalashnikov. VII/Anastasia Taylor-Lind

countries that lack any democratic past, are in danger of falling into violent internal conflicts.

Currently, this is a problem particularly in North African and Middle Eastern states. The *demos* question was not at all resolved in the wake of the Arab Spring, and ethnic or religious discrimination remains widespread. "Liberated" Egypt has already seen outbreaks of religiously motivated violence, and Syria, torn by violence and suffering under repression, threatens, like Iraq, to split apart along its ethnic and religious lines if democratization is introduced too hastily. These countries first need to clarify their *demos* question before they can become stable democracies.

That means, in particular, the various groups must show themselves ready to recognize one another as equally entitled partners in a superordinated democratic community. The example of the Ivory Coast can serve to some degree as an object lesson for the current and future Arab world. In the wake of democratization in the 1990s, the question arose of what genuine *Ivoirité*, membership of and belonging to the Ivorian people, actually consisted of. The result was discrimination against the Muslim population in the north, which in turn led to a protracted civil war.

The basic question, then, is how capable democracy is of surviving in ethnically divided societies. In most parts of the world, multi-ethnicity is an unalterable fact and the ethnic "homogenization" of a country—as the ideology of nationalism prescribes—is not an option. The exchange of populations that was internationally mandated, such as in Eastern Europe after the World Wars, is no longer being considered nowadays. And the "gentler" process of assimilating minorities into a dominant national culture can no longer be expected to occur either. So there is no alternative but for democracies to accommodate to a multi-ethnic *demos*.

Strategies for Dealing with Heterogeneous Peoples in a State

But how can state authority be anchored in the people when the *demos* itself is divided? That differing ethnic groups can grow together to become a superordinate national community is hardly possible—at least in the short term. When the Swiss state was founded in 1848, immediately after a brief civil war fought between liberal Protestant and conservative Catholic cantons, it was not realistic to conceive of a unified Swiss people just then. Yet this example illustrates that if one can find appropriate institutional solutions, "rule by the people" can become a reality even among a divided people.

There are four basic strategies for dealing with multi-ethnicity, of which two have already been mentioned: Dominance, universalism or "de-ethnification," dividing up the state, and sharing power.

CIVIL WAR IN GUATEMALA Solola, 1992: Guatemalan Nobel Peace Prize winner Rigoberta Menchú at a demonstration.
In Latin America, historically rooted inequalities often mean indigenous groups remain excluded from political power.
AFP Photo/Gonzalez

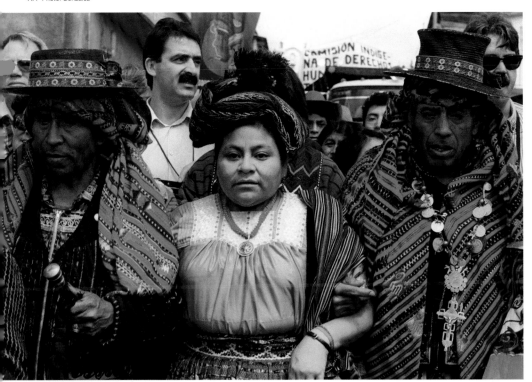

Chimaltenago, 1997: Members of the Mayan population visit the graves of relatives killed by the Guatemalan army in
a massacre. The army's violence against the Maya peoples during the civil war (1960–1996) was classified by the official
truth commission as genocide. Since the end of hostilities the country has started a process of democratization.
Magnum Photos/Thomas Hoepker

The Dominance of one Group over Another

The dominance of one group over all others in a state is historically by far the most common strategy. The goal is to avoid conflict over the identity of a state's people by having one particular group claim the leading role and force minorities into a political system dominated by this particular group. More specifically, that means executive power, the higher civil service, and the upper echelons of the military and police apparatus (at least) are staffed by members of the dominant group. The centralized rule exercised by General Franco in Spain at the expense of Catalans, Basques, and other minorities is a prominent European example of such dominance. Banning the use of minority languages, in this case Catalan and Basque, is typical of such a system.

Over the longer term, however, there are considerable drawbacks to pursuing such a strategy of dominance. In addition to the aforementioned normative problems, it also holds enormous potential for conflict. Such systems can survive for a while—sometimes even for decades—with the help of a repressive state apparatus, but scientific studies clearly show the risk of civil war is distinctly higher in such situations than in countries where ethnic groups are not being oppressed. The Basque conflict in Spain, the Kurdish uprising in Turkey, the lengthy (and ultimately successful) rebellions against the Amharic-dominated military government in Ethiopia, and numerous other examples clearly show the long-term risk in pursuing this repressive course.

Universalism or De-ethnifying

The second strategy consciously tries to block ethnic identities out of the political process by emphasizing individual rights. A legal framework "blind to ethnicity," which places individual liberties at its core, is intended to guarantee a universal equality independent of ethnic group membership. One could call this a liberal universalist or "de-ethnifying" strategy. The U.S. Constitution is often cited as a model for such a political order oriented toward the individual. However, in reality this is often little more than a "better disguised" version of dominance. Equality and "blindness to ethnicity" in the law are used in political discourse as a way to hide the supremacy of one particularly strong group (demographically, economically), thereby consolidating its power. The "color-blind" U.S. Constitution, for example, long tolerated the political and economic marginalization of the country's black population, particularly in its southern states. The hierarchical systems of Latin America, too, are often based on a similar policy of formal yet superficial equality that goes hand in hand with underlying discrimination. Thus, the constitution in Guatemala is often cited as proof that everyone, both those of indigenous

GENOCIDE IN RWANDA Rwanda, 1994: Tutsi refugees on the way to Kabgayi. After independence, the majority Hutu took over power in Rwanda from the previously dominant minority Tutsi. In 1994, government-organized extermination of the Tutsi was meant to ensure the dominance of the Hutu.

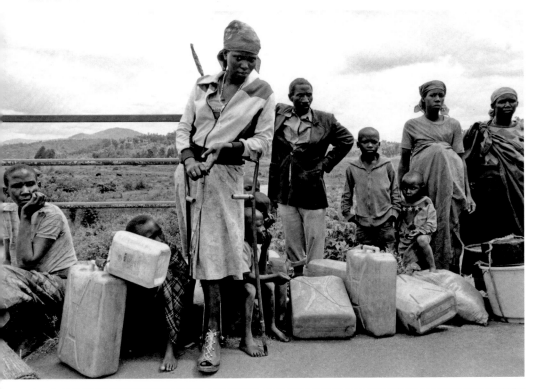

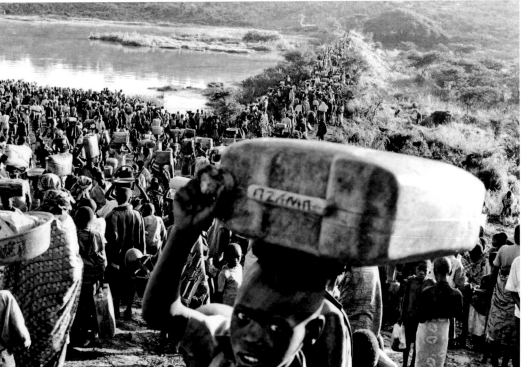

Ngara, Tanzania, 1994: Rwandan refugee camp. According to Human Rights Watch, in only 100 days in 1994, more than 500,000 people were killed. Other estimates speak of as many as 1,000,000 dead. Both images: Magnum Photos/Gilles Peress

ETHNIC CONFLICT AFTER PRESIDENTIAL ELECTIONS Kenya, 2007: Electoral irregularities and manipulation lead to serious ethnic conflicts. After two months of serious rioting, with up to 1,500 dead and more than 200,000 displaced from their homes, a coalition government was formed with former President Mwai Kibaki re-elected to office, while his opponent Raila Odinga became Prime Minister. Keystone/Till Muellenmeister

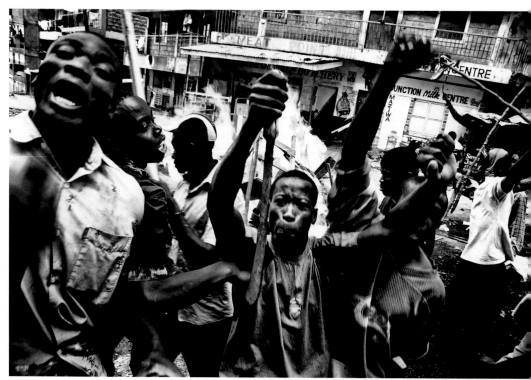

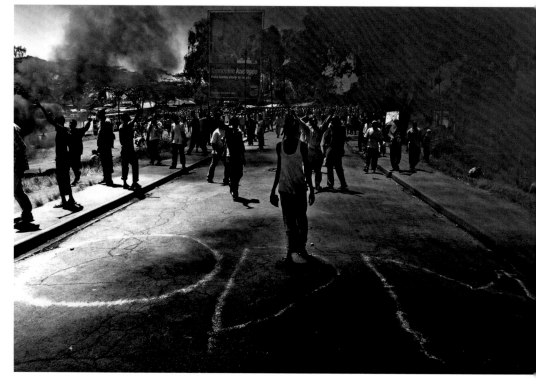

Ethnic conflicts following elections still happen frequently in today's Africa, most recently in Zimbabwe in July 2013.
Keystone/Mike Berube

THE PREREQUISITES FOR DEMOCRACY WHO ARE THE PEOPLE?

and those of "Ladino" (European) background, possesses the same rights. But though indigenous people form the majority of the country's population, they in fact hold less than 10 percent of the seats in parliament. If they are represented at all in the Cabinet, then it is ordinarily in positions of limited power, such as culture or sports ministers, and the poverty rate of the indigenous people is twice as high as among members of the Ladino group.

In hierarchical societies, the opposite, or alternative, version of this "de-ethnification" or "color-blind" universalist strategy is to have quotas for ethnic minorities in parliament and/or in the Cabinet. Countries like Brazil or the United States, meanwhile, practice societal versions of this strategy, for example at universities, by having "Affirmative Action" programs to explicitly assist members of minority groups.

Dividing the Country

The most radical answer to having a divided people is to divide the country itself, or to split off a part of the territory populated by a particular group. This "two-state solution" has long been discussed as a way out of the conflict between Israel and the Palestinians in the Middle East. But the difficult path to a Palestinian state also shows that though conflicts over secession are widespread, they almost never lead to officially dividing and founding a new state. The most recent examples of South Sudan and Kosovo and the (renewed) founding of Eritrea are clear exceptions to the rule. On the one hand, the international community is quite concerned to maintain existing borders and very reluctant to address the issue of minority-group self-determination. Many states—even powerful ones like China and Russia—themselves have ethnic minorities in certain regions, such as Tibet or Chechnya, and are not interested in setting precedents that might encourage potential independence efforts by these minority groups.

On the other hand, weighty reasons also speak against dividing a country. First, there is the danger it will simply trigger further secessions on the "ethnic matryoshka doll" principle: every newly founded state itself will likely contain ethnic minorities which then will want to assert their own right of self-determination, forcing the newly founded state to further self-divide. The same conflicts are set in motion, now just on a smaller scale. The civil war that broke out in newly founded South Sudan thus came as no surprise. Kosovo, recently independent of Serbia, also has its own Serbian minority that clamors for independence.

Second, homogeneity does not necessarily provide protection against further conflict. The example of Somalia speaks volumes. As one of the very few African countries one can call a genuine nation-state, it has become a textbook example of a failed state. Of course, like most other ethnic groups in Africa and Asia, the

Somalis are highly fragmented into clans and sub-clans, but in principle one should regard the Somali people as a macro-ethnicity composed of various sub-groups. This shows anew that in the end, nowadays, one cannot avoid multi-ethnic democracy.

Dividing and Sharing Power

Perhaps the most promising strategy for adapting democracy to modern multi-ethnic conditions is to divide and share power by officially recognizing ethnic differences and guaranteeing equal rights to the various identified groups. Such a division of powers needs to occur at the highest political level, in the central state. The elites of all relevant groups need to be integrated into a ruling coalition and all such groups should have equal access to the administration of that state. The second aspect in such a system of divided power is "ethno-federalism," meaning autonomy for the various groups in their own regions. The guarantee of cantonal sovereignty, as a concession to the Catholic cantons when Switzerland was founded as a modern nation-state, rests precisely on this consideration. Switzerland's further political development, it is fair to say, would have been far more turbulent had not the losers of the Sonderbund War in 1847 been assured cultural autonomy, especially to maintain their Catholic faith, in their cantons.

Still, for a long time the Swiss national government was not one that genuinely divided power: For decades, the national government was dominated by Protestant liberals, and only later would a genuine division of power come about between Catholics and Protestants. The integration of all the language groups so much discussed today was a far more organic process that became a significant political topic only in the course of the World Wars. Nevertheless, it too is an important element in the successful sharing of power in the country today. Similar power-sharing systems were introduced in Bosnia and Ethiopia, though under far more difficult political circumstances. In the former case, one can almost regard it as a de facto division of the state, because the three different parts or groups seem to function almost wholly independently of one another.

Given the existence of a divided people, such institutional adjustments to democracy, ranging from pure majority rule to an equal rule of all major segments in the population (which one might call a "democracy in the safe mode"), often appear sensible or even, at times, inescapable. It is a matter of institutional answers to the question how "popular sovereignty" can be achieved among a divided people—and thus a matter of the fundamental prerequisite for the definition, or the configuration, of a democratic community.

SEPARATISM IN EUROPE Calahorra, March 21, 2008: After a bomb exploded near a police station. The ETA, an armed underground organization, has been fighting for a separate Basque state since 1959. Ceasefire agreements have been repeatedly broken by ETA. Reuters

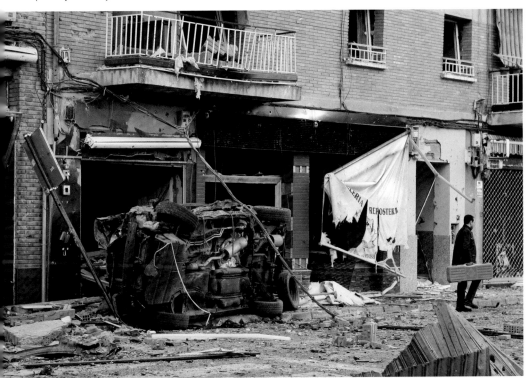

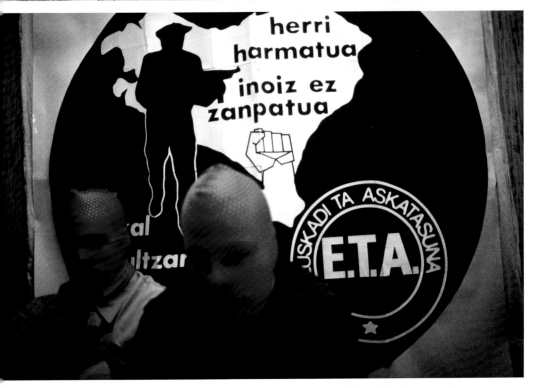

France, 1982: Members of the Basque underground organization ETA. After the armistice of 2011, the organization agreed to its own dissolution and disarmament. Since November 2011, there have been no more attacks. But disarmament still hasn't taken place yet. Magnum Photos/HG

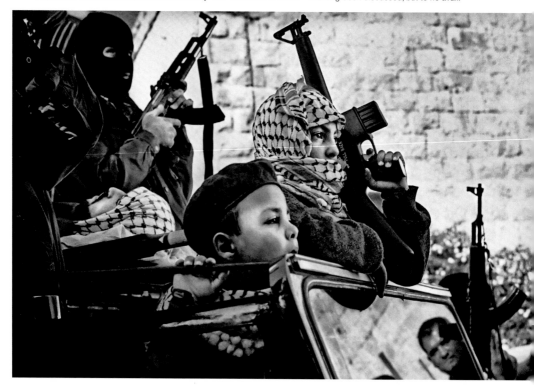

Hebron, West Bank, 2002: Jewish boys at the Purim parade in Hebron, an event traditionally used by ultra-right nationalists in Israel to demonstrate their power. Many Jewish settlers are vehemently opposed to a two-state solution, because they believe the biblical Land of Israel—including the territories now inhabited by the Palestinians—was given to them by God. Therefore they do not approve of the political negotiations between the Israeli government and the Palestinians. Both images: Laif/Jan Grarup

THE CULTURAL AND ECONOMIC PREREQUISITES FOR DEMOCRACY
Cultural Prerequisites:
Which values are needed in a society for a democracy to emerge?

Is democracy "Western"? Clearly, modern democracy had its origins in the West and was long confined to the West. In the course of the nineteenth century, stable democracies gradually developed in the United States, Great Britain, the Netherlands, and Scandinavia. This took place without violent revolution—with the exception of the American Revolution, whose character was primarily anti-colonial—and without counterrevolution. Yet in France, the homeland of democratic revolution in Europe, democratic institutions proved highly unstable. That immediately suggests one see the cultural prerequisites of democracy not only in the cultural achievements of the West—human rights, the Enlightenment, the market economy—but also in Protestantism.

The spread of democracy in the second half of the twentieth century forced repeated re-evaluations of this narrow view of democracy's cultural prerequisites, as the wave of democratization in Latin American and southern European nations in the 1970s largely took place in countries that were predominantly Catholic. As democratization took hold in non-Christian countries such as Japan, South Korea, or Taiwan, the argument shifted: Now only Islam remained hostile to democracy. Yet the successful democratization of Indonesia, or the examples of Turkey and Malaysia, rather undermine this supposition as well.

Still, these examples do not wholly refute the proposition that democracy does require certain cultural prerequisites. Rather than being concerned with the basic differences that exist between various civilizations and cultures, it is more relevant here to consider how individual values change within the cultural areas.

One prerequisite for democratization, a number of authors believe, is the development and spread of post-material values. Unlike material values, which are oriented to satisfying basic needs or to pursuing wealth, post-material values include the expansion of individual freedoms. The focus is on individual self-expression rather than on individual self-preservation, and self-expression calls for institutions and processes that take individual rights and freedoms into account, and protect and expand them. Fundamentally, the more the values of a society shift in the direction of individual self-expression, the stronger the demand, and support, for democracy will be. But where does this drive to self-expression arise in a society? This question leads us to the economic prerequisites for democracy.

CHANGE IN BOLIVIA Oruro, 2011: Bolivian President Evo Morales raises the flag on an official occasion. Morales was first elected in 2006 and is the first indigenous president of Bolivia. One of the main goals of his Movement for Socialism is the emancipation of the indigenous population; however, indigenous groups continue to struggle against historically rooted poverty.

La Paz, 2010: A news anchor in traditional dress. Bolivia has 36 indigenous groups, and they have been marginalized and discriminated against since the colonial era. Both images: Pietro Paolini/Terra Project

Economic Prerequisites:
First satisfy basic needs, then worry about larger issues?

Affluence is the best-researched prerequisite for democracy. As the political sociologist Seymour Martin Lipset put it as long ago as the late 1950s, "the more well-to-do a nation, the greater the chances that it will sustain democracy." Affluence promotes the creation of democracies and helps underscore their stability. Democratic states that have reached a certain degree of affluence remain democratic, and the return to an undemocratic form of rule is highly unlikely. Yet why do prosperous states both become and remain democratic?

One reason is the striving for self-expression. The more affluent a society is, the less people need to be concerned with meeting their basic needs. Food, clothing, and shelter are taken care of, and social security systems provide protection in case of unemployment, illness, or needs in old age. That means people have the requisite scope to pursue their own self-expression.

The level of education also rises with increasing affluence in a society, further supporting striving for self-expression, as well as diversity in lifestyles. The path from affluence to democracy thus involves a change to individual values in a developed society. Those who no longer need to struggle to survive can pursue other goals, including self-expressive ones, and those who seek greater self-expression support and help promote democracy. The obverse is also true: Societies in crisis over their futures, or societies at war, or societies in severe economic difficulties, focus on their basic societal needs—and the corresponding support for democracy declines.

A further reason why affluent societies tend to remain democratic is that their economic inequalities diminish, and that trend favors democratization in a variety of ways. On the one hand, prosperity strengthens the bargaining position of the corresponding segments of the population. In the course of industrialization, for example, the state offers more political participation rights to a broader, newly affluent middle class in return for payment of higher taxes. In addition, ruling elites fear for their positions less as inequality diminishes, since the more equally wealth is distributed in a society, the less radical the popular demands for the redistribution of wealth become. The existence of a large, affluent middle class leads to centrist majorities in government, because members of this class are satisfied with their standard of living and would themselves also suffer if wealth were radically redistributed.

There is also a change in the economic foundations of wealth in developed societies. In traditional, agriculturally oriented societies, affluence depends on land ownership. In modern industrial and service-providing societies, affluence is based

instead on capital. Capital is more mobile and can be transported abroad, and for that reason landowners often fear democratization more than do the owners of capital. Landowners can protect their holdings less well from redistribution or expropriation, and landowners have less success in bringing decision-makers to moderate their orientations by threatening to leave the country.

Under some circumstances, too much equality can also hurt democratization. If citizens to a large extent already profit from prosperity to a similar degree as the elites, then they no longer have a strong economic incentive to bring their own interests to bear in the political process or even rebel against the authorities. In this manner, one can explain why Singapore is not a democracy despite its high level of affluence. The ruling elite understood how to skillfully introduce welfare state policies in a manner that undercut broad popular mobilization in favor of democratization. The oil monarchs of the Persian Gulf show, in an even more extreme fashion, that the enormous profits they have realized through exploiting their major resource can be used to keep the population politically disenfranchised, despite rising national affluence. If the society is religiously fragmented or its tribal groups are powerful, as in Bahrain or Libya, however, this oil wealth-based political strategy also reaches its limits.

THE INFLUENCE OF THE INTERNATIONAL ENVIRONMENT
ON THE DEMOCRATIZATION OF A COUNTRY

Political regimes do not develop in a manner cut off from their international environment. In many ways, that environment encourages or hinders the development of democracy. One important indicator for this can be seen in the successive waves of democratization (see pp. 27–62). These waves can be explained in part by the fact that many states were affected simultaneously by the same international events: The collapse of monarchies during World War I, the defeat of fascist states and right-wing dictatorships during World War II, and the decline of, and changes to, the Soviet Union at the end of the Cold War.

Demonstration and snowball effects also exist. If the people of one country watch how the people in another country with a similar political environment successfully topple their autocratic rulers, they are encouraged to try to do the same in their own country. The more countries that do so, the more difficult it becomes to halt this process. The spark of rebellion has repeatedly leapt borders and inflamed anew—from Tunisia to the rest of the Arab world during the Arab Spring; from Serbia to the color revolutions in Ukraine and Georgia; from Poland in 1989 to the rest of Central and Eastern Europe—and in earlier centuries, from the French or Russian Revolutions to throughout the world.

Globalization and the technologies that engender it reinforce such demonstration effects. The older media, including television and radio, provide images and reports of democratic revolutions around the globe. Where, as part of democratization the media gain greater freedom, they can help the new democratic government consolidate its gains. Where radio and television are state-controlled or censored, they cannot be deployed in this way—on the contrary. In this context, the new media can play an important role, as seen by the fact that the color revolutions in Eastern Europe and the Arab Spring uprisings are already being referred to as Internet or Twitter revolutions. However, it is doubtful that these new media technologies can also contribute to strengthening or consolidating democracies.

Globalization also accelerates the modernization and industrialization of societies, and increases capital mobility, thereby supporting the economic prerequisites of democracy. The balance of global and regional power is also important for the survival chances of newer democracies. Where the great powers, both globally and regionally, are democratic, they support newer democracies. That was true of Europe after World War I, in Western Europe after World War II, and in Eastern Europe after the end of the Cold War. On the other hand, new, unstable democracies have a difficult time when undemocratic powers refuse to support them or even support their opponents. One can think here of the Holy Alliance in the nineteenth century, or Eastern Europe after the end of World War II, or the states that are neighbors of today's Russia. Beyond the role of the great powers, however, it matters whether neighboring countries are mostly democratic or not. Neighbors promote international exchange, and the more intensive this is economically— boundary-crossing communication and direct contact with democratic countries that takes place through travel, study trips, or work stays—the more favorable the conditions for democratization and for consolidating democracy are.

International, and in particular, regional organizations are a further important institution supporting democratization processes. Political conditionality is one way to do so. International organizations may offer nation-states attractive benefits including financial aid, access to markets, or political participation rights. If these benefits are made dependent on a participating nation-state being democratic, or at least in the process of introducing democratic reforms, it creates a domestic incentive to democratize. Democratic regional organizations like the EU or NATO have, through such accession conditionality, helped support democratic consolidation in the formerly communist states of Eastern Europe. This was especially true in countries where illiberal tendencies, such as discrimination against minorities, weak constitutional guarantees, or a weak enforcement of the rule of law, have blocked the democratization process.

A further means of spreading democratic norms is through networks that exist between governments, which are also supported by international organizations. Here it is also important that such networks be largely composed of democratic states, as this magnifies their effect. Such networks can help change the anti-democratic orientation of elites in democratizing countries, or can stabilize democratic orientations. They may help in word and deed to build democratic systems. They will criticize undemocratic developments in the states that belong to the network, and they will voice their approval of democratic developments. In such ways, membership in democratic organizations and policy networks helps both to establish and to stabilize new democracies. Yet this can take place only under favorable conditions: The respective elites in such new democracies must see an advantage to membership and must be open to the ideas these networks promulgate. But anti-Western dictatorships are ordinarily little impressed by such international organizations and networks.

Democracy cannot succeed unless those who express their choice are prepared to choose wisely. The real safeguard of democracy, therefore, is education.

Franklin D. Roosevelt

Franklin D. Roosevelt (1882–1945) was President of the United States from 1933 to 1945.

FREEDOM, DEVELOPMENT, AND HUMAN WORTH

Aung San Suu Kyi

[…] It is often in the name of cultural integrity as well as social stability and national security that democratic reforms based on human rights are resisted by authoritarian governments. It is insinuated that some of the worst ills of Western society are the result of democracy, which is seen as the progenitor of unbridled freedom and selfish individualism. It is claimed, usually without adequate evidence, that democratic values and human rights run counter to the national culture, and therefore to be beneficial they need to be modified–perhaps to the extent that they are barely recognizable. The people are said to be as yet unfit for democracy; therefore, an indefinite length of time has to pass before democratic reforms can be instituted.

The first form of attack is often based on the premise, so universally accepted that it is seldom challenged or even noticed, that the United States of America is the supreme example of democratic culture. What tends to be overlooked is that although the United States is certainly the most important representative of democratic culture, it also represents many other cultures, often indelicately enmeshed. Among these are the "I-want-it-all" consumer culture, megacity culture, superpower culture, frontier culture, immigrant culture. There is also a strong media culture which constantly exposes the myriad problems of American society, from large issues such as street violence and drug abuse to the matrimonial difficulties of minor celebrities. Many of the worst ills of American society, increasingly to be found in varying degrees in other developed countries, can be traced not to the democratic legacy but to the demands of modern materialism. Gross individualism and cut-throat morality arise when political and intellectual freedoms are curbed on the one hand while on the other hand fierce economic competitiveness is encouraged by making material success the measure of prestige and progress. The result is a society where cultural and human values are set aside and money value reigns supreme. No political or social system is perfect. But could such a powerful and powerfully diverse nation as the United States have been prevented from disintegrating if it had not been sustained by democratic institutions guaranteed by a constitution based on the assumption that "man's capacity for reason and justice … makes free government possible," while "his capacity for passion and injustice … makes it necessary"?

It is precisely because of the cultural diversity of the world that it is necessary for different nations and peoples to agree on those basic human values which will act as a unifying factor. When democracy and human rights are said to run counter to non-Western culture, such culture is usually defined narrowly and presented as monolithic. In fact the values that democracy and human rights seek to promote can be found in many cultures. Human beings the world over need freedom and security that they may be able to realize their full potential. The longing for a form of governance that provides security without destroying freedom goes back a long way. Support for the desirability of strong government and dictatorship can also be found in all cultures, both Eastern and Western: the desire to dominate and the tendency to adulate the powerful are also common human traits arising out of a desire for security. A nation may choose a system that leaves the protection of the freedom and security of the many dependent on the inclinations of the empowered few, or it may choose institutions and practices that will sufficiently empower individuals and organizations to protect their own freedom and security. The choice will decide how far a nation will progress along the road to peace and human development. […]

Aung San Suu Kyi (b. 1945) is a Burmese opposition politician. She was awarded the Nobel Peace Prize in 1991.
Excerpt from *Journal of Democracy* 6, no. 2 (1995): 11–9

DEMOCRACY IS A GOOD THING

Yu Keping

The author of the following below is the director of the Center for Chinese Government Innovations at Beida University in Beijing and an influential policy advisor. His pro-democracy manifesto, published in 2008, gives great weight to democracy as the most appropriate political system for humankind. At the same time, he expresses reservations about the claim of democracy to be universally valid. According to Yu Keping, certain economic, cultural, social, and political conditions must be met before democratic forms of government can function. This position stands in contrast to a liberal concept of democracy, which assumes democratic norms are unconditionally and universally valid and that every nation should determine its own fate. That liberal concept is defended in this book, for example, by Shirin Ebadi (p. 98), Aung San Suu Kyi (p. 182), and Wole Soyinka (p. 382).

Democracy is a good thing. This is true not only for individuals or certain officials but also for the entire nation and for all the people of China. Simply put, for those officials who care more about their own interests than about the national interest, democracy is not a good thing; in fact, it is a troublesome thing, even a bad thing. Under conditions of democratic rule, officials must be elected by the citizens, gaining the endorsement and support of the majority of the people. Officials' powers can be curtailed by the citizens; officials cannot simply do whatever they want. They must sit along with the citizens and negotiate with them. Just these two points alone already make many officials dislike democracy. Therefore, democracy cannot operate on its own; it requires citizens themselves and government officials who represent the interests of the people to promote and implement it.

Democracy is a good thing, but that does not mean that everything about democracy is good. Democracy is definitely not 100 percent perfect; it has many internal inadequacies and contra- dictions. Democracy allows the citizens to go into the streets, hold assemblies, and engage in actions that can fuel political instability. Democracy can make certain matters that are very simple under undemocratic conditions overly complicated and frivolous, thereby increasing the politi- cal and administrative costs. Democracy often involves repeated negotiations and discussions, occasionally causing a delay in making timely decisions and thereby decreasing administrative efficiency. Democracy often affords opportunities for certain sweet-talking politicians to mislead the people, and so on. But among all the political systems that have been invented and imple- mented, democracy is the one with the fewest number of flaws. Relatively speaking, democracy is the best political system for humankind.

Democracy is a good thing, but this does not mean that democracy can do everything. Democracy is a political system that holds that sovereignty belongs to the people, but it is only one of many systems that govern human societies. Democracy mainly regulates the political lives of people, but it cannot replace the other systems and it cannot regulate everything in people's lives. Democracy has its internal limitations; it is not a panacea and it cannot solve all of humankind's problems. But democracy guarantees basic human rights, offers equal opportunity to all people, and represents

a basic human value. Not only is democracy a means for solving people's livelihood issues, but it is also a goal of human development. A tool for achieving other goals, democracy is also in accord with human nature. Even if food and housing are widely available or even guaranteed to all, the human character is incomplete without democratic rights.

Democracy is a good thing, but that does not mean that democracy comes without a price. Democracy can destroy the legal system, cause the social and political order to go out of control, and even prevent economic development during certain periods. Democracy can disrupt international peace and cause political divisions within the nation; the democratic process can also propel dictators onto the political stage. All of these have already occurred in human history, and they will likely continue to occur. Therefore, the price of democracy is sometimes high to the point of being unacceptable. At their roots, however, these faults are not the faults of democracy as a system but rather the faults of the politicians and statesmen in particular democracies. Certain politicians do not understand the objective rules of democratic government; they ignore the social and historical conditions of the times in which they live; they go beyond the stage of historical development and promote democracy in an impractical manner; and therefore they end up with the opposite consequences. Certain politicians treat democracy as their tool for seizing power, using the idea of "democracy" to win popularity only to end up misleading the people. With them, democracy is only a cover for populism and dictatorship; democracy is the pretense and power is the substance.

Democracy is a good thing, but this is not to say that democracy comes unconditionally. Implementing democracy requires the presence of economic, cultural, and political preconditions; the unconditional promotion of democracy will bring disastrous consequences to the nation and its people. Political democracy is the trend of history, and it is the inevitable trend for all nations of the world to move toward democracy. But the timing and speed of the development of democracy and the choice of the form and system of democracy are conditional. An ideal democratic system must be related to the economic level of development of society, the regional politics, and the international environment, and it must also be intimately related to the national tradition of political culture, the quality of the politicians and the people, and the daily customs of the people. It requires the wisdom of the politicians and the people to determine how to pay the minimum political and social price in order to obtain the maximum democratic effects. In that sense, democratic politics is a political art. To promote democratic politics, one should have an elaborate system design and excellent political techniques.

Democracy is a good thing, but that does not mean that democracy can force the people to do things. The most concrete meaning of democracy is that it is government by the people who get to make choices. Even though democracy is a good thing, no person or political organization has the right to regard itself as the embodiment of democracy and therefore able to force the people to do this and not to do that in the name of democracy. Democracy requires enlightenment; it requires the rule of law, authority, and sometimes even coercion to maintain social order. The basic approach to developing democracy is not the forceful imposition of a democratic order by the government, but rather the emergence of such an order from among the people. Since democracy is rule by the people, it should respect the people's own choice. If a national government employs forceful means to make the people accept a system that they did not choose, then this is national autocracy and national tyranny masquerading as democracy. When one country uses mostly violent

methods to force the people in other countries to accept their so-called democratic system, then this is international autocracy and international tyranny. National tyranny and international tyranny are both contrary to the nature of democracy.

We Chinese are presently building a strong, modern socialist nation with unique Chinese characteristics. For us, democracy is not only a good thing but an essential one. The classical authors of Marxism said, "There is no socialism without democracy." Recently Chairman Hu Jintao pointed out further, "There is no modernization without democracy." Of course, we are building a socialist democracy with unique Chinese characteristics. On the one hand, we want to absorb the best aspects of human political culture from around the world, including the best of democratic politics; on the other hand, we will not import wholesale an overseas political model. Our construction of political democracy must be closely integrated with the history, culture, traditions, and existing social conditions in our nation. Only in this way can the people of China truly enjoy the sweet fruits of political democracy.

Yu Keping is a Chinese political scientist and the director of the Center for Chinese Government Innovations at Beida University in Beijing.
From Yu Keping, *Democracy is a Good Thing,* Brookings, Washington, D.C. 2009, pp. 3–5

Is Small Beautiful?

Andreas Ladner

How important is the size of a community, city, or country for the functioning of democracy? The question is neither new nor easy to answer. Both theorists and practicing politicians have tried throughout history to find an optimal territorial size, but have proven unable to come to a conclusive, universally valid answer. On the one hand, there is a lack of consensus over how to determine the quality of democracy. On the other hand, structural, cultural, and historical circumstances make evaluative comparisons anything but easy. Nevertheless, as will be argued here, the question itself generates valuable insights into the history of democracy, and the question posed above can be partly answered, at least for clearly delimited areas of inquiry.

THE SIZE OF THE CITY IN ANCIENT GREECE: LARGE ENOUGH TO BE INDEPENDENT BUT SMALL ENOUGH FOR CITIZENS TO KNOW ONE ANOTHER

What the ideal size of a city might be was a question that already preoccupied the philosophers of ancient Greece. After power shifted in Greece from the hereditary kingdoms, which had exercised a feudal form of rule over an extensive territory, to the city-states, in which a select group of male inhabitants had political rights, the question soon arose as to what size of the *polis* would be ideal to best organize and realize their political self-determination.

Plato, for example, thought the citizenry should be small enough that one could still know everyone else personally, and be kindly disposed to one another. In his view, it was even possible to calculate an upper limit: 5,040 heads of families (see his *The Laws*, fifth and sixth books). Aristotle, in turn, thought the *polis* ideally should be small enough that its members would still know each other's characters. Furthermore, it should be possible for every-one to gather in a square and yet still be able to hear each speaker in a discussion. The minimum size, to Aristotle, should be determined by the community's ability to provide for itself (see his *Politics*, second and seventh books).

Beyond the practical question of how many people could gather together in a square and be able to debate among one another, two important challenges to democracy arise here. Democratic self-determination presupposes a degree of economic independence, and it requires a degree of familiarity with the nature of other citizens, and with how they think.

FROM ASSEMBLY DEMOCRACY TO REPRESENTATIVE DEMOCRACY

The modern era, as a consequence of the Enlightenment and the abolition of absolutism, has once again grappled with the question of the optimal size for a democracy. However, the challenges are fundamentally different. Evolving nation-states are now the focus, and no longer the Greek city-state. For that reason, the issue is no longer assembly democracy but instead how to represent the people, and in some cases also represent the various regions of a country, in a democratically legitimated parliament. On the one hand, the ability of a government to act needed to be ensured, and on the other hand there was a desire to prevent the emergence of an overly powerful, no longer controllable central authority. This problem could not be readily resolved.

Rousseau, in his *Social Contract*, bemoans that the ability of citizens to effectively participate in politics stands in inverse proportion to the size of the state. Put another way, the more citizens there are living in a nation-state, the smaller the share any specific individual has in a political decision. Equality, political participation, control of the government, political rationality, friendliness, and consen-

sus among citizens decrease, in this view, in proportion to the degree the population and territory of a nation-state increase.

Yet greater size was desirable if a political entity was to survive or play a role on the international political stage, at least for Montesquieu, even when that carried dangers: "If a republic be small, it is destroyed by a foreign force; if it be large, it is ruined by an internal imperfection" (see his *The Spirit of Laws*, Book 9, Chapter 1). From this perspective, the separation of powers, federalism, and representative democracy are in the end nothing more than institutional provisions intended to give a democracy leverage in larger contexts. Yet the ideas of the Greek philosophers, as well as Rousseau and Montesquieu's musings, on "true," small-scale democracies in manageable structures have never entirely gone out of fashion.

THE QUESTION OF IDEAL SIZE AND ITS INFLUENCE ON THE QUALITY OF DEMOCRACY

The ideal size of a community, following democratic premises, has been repeatedly discussed in recent years. The 1970s saw predictions of a sharply rising global population and fears of the limits to growth. Increasing urbanization and the trend towards megacities also led to renewed attention to ideal size. What effects enlargement of the local unit will have on the quality of democracy is also a question in land reform or when the fusion of communities is contemplated. A return to the grassroots, to smaller organizational units, is often called for, especially to encourage political participation and to draw more citizens into the process of making political decisions, not least to try to stem increasing disenchantment with politics and halt falling voter turnout. Decentralization trends observable in various countries are heading in the same direction. They can be understood as a reaction to the tendency to increasingly make decisions in international and supranational organizations, one consequence of globalization. Here, too, there are questions about the limits to, or possibilities for, exercising democracy in larger contexts.

VILLAGE MEETING Curva, Bolivia: Philosophers from Plato to Rousseau, and political scientists even today, have asked how many people can or should participate in democratic decision-making. Should all who make such decisions also know one another? Panos/Arabella Cecil

WHAT CAN RESEARCH CONTRIBUTE? DIFFERENT APPROACHES TO THE RELATIONSHIP BETWEEN SIZE AND THE QUALITY OF DEMOCRACY

Political science has repeatedly raised questions about the influence size has on the quality and functioning of democratic institutions. Robert Dahl and Edward Tufte published their classic study *Size and Democracy* in 1972, and it remains a standard work, even though they did not and could not come to a conclusive, and more importantly, an empirically-based, answer to the question of what the ideal size of a democracy might be.

There are various reasons why the question is difficult to answer. One is the difficulty in measuring. Should one measure a political unit by the physical size of the territory it occupies or instead by its number of residents? Another difficulty is how to measure the quality of democracy. If one considers only voting participation rates, that neglects other significant aspects. Yet which aspects should, or must, be taken into consideration? There is also a question how, and where, one can measure and compare differences in quality. There are numerous, and at times striking, institutional and cultural differences between countries, which makes comparison anything but easy. Participating in an election, to take just one example, may simply not have the same significance everywhere.

Speaking theoretically, one can address the relationship between size and democracy in three ways. A first group of approaches assumes increasing community size has a negative effect on the functioning of democracy. Closely related to this is the idea that "true democracy" can only be practiced in small, readily grasped units, as anything larger will lead to a diminished sense of community. A second group of approaches thinks size can have a positive effect, for only above a certain community size are structured political discussions—where organized political actors mobilize and inform the citizens— even possible. The first approach is called the *decline of community* model, the second the *mobilization* model. A third group of explanations takes the stance that there simply is no connection between the size of a community and the quality of democracy.

Four arguments can be discerned in this discussion. The first is that small size is associated with a closeness between residents, or also between residents and political authorities, and such closeness is assumed to have either a direct or an indirect effect on the quality and functioning of that democracy. Hence, politics in small communities is more readily understood and community ties and social control are greater, this argument has it. The second argument circles around the degree of politicization. Larger communities have more political competition because more actors participate, and in that sense political differences are also greater. The media also highlight these political differences and make them more interesting and more transparent. The third argument focuses on the composition of the population. Here the assumption is that social heterogeneity increases with increasing community size. Social problems increase particularly in the cities, which in turn has an effect on the intensity of political debates. The final argument emphasizes the range of government services. Larger communities must, or can, offer more services. That leads to more political decisions on the one hand, but also awakens more expectations of politics on the other.

However, as noted, some studies suggest size effects might not exist at all. Thus, one can show, among other things, that what is key to the ability to take part in political decisions is not community size but education. If the size of the community itself does not have a direct influence on the quality of democracy, but it is instead other factors that directly, if to a larger or smaller extent, connect to size that matter, then it becomes still more difficult to answer our question. Even if we find differences between large and small communities, that does not yet mean the community's size is the reason. Instead it is possible, and not wholly implausible, that there are more people with systematically diverging views and interests who live in large communities than who live in small ones.

AN INTERNATIONAL COMPARISON

In the context of a large, internationally comparative study, researchers from the Netherlands, Norway, Denmark, and Switzerland tried to establish what influence the size of a political unit had on democratic quality, and investigated communities of differing sizes in all four countries. The advantage of this approach is that the cultural and institutional differences within the individual countries are rela-

tively small, and it is possible to investigate whether interconnections found in one country are also evident in the others. Efforts were made to control for other potential influences and confounding factors, such as the differing composition of the population in large and small communities, the varying social and political challenges, and differing lifestyles and attitudes.

No general indicator of quality was used to measure the quality of democracy. Rather, various preconditions for a well-functioning democracy were investigated, ranging from political interest, to how satisfied residents were with the local authorities, to participation in local elections.

The main findings of the investigation can be readily summarized. There was no empirical evidence that the quality of democracy increases with increasing community size. The notion that democracy functions better in smaller communities, by contrast, did receive at least some support, though it was limited to a few of the indicators investigated.

The direct (and negative) effects of size were seen in contacts with local authorities and in involvement in local parties, both of which shrank as community size increased. Also, people in small communities tend more to feel they have enough personal skills and the needed information to participate in local political decisions. Their trust in local politicians was also greater, and satisfaction with the performance of local government tended to fall as community size increased. The observed size effects were greatest in small communities; differing numbers of inhabitants have hardly any effect in the cities.

The willingness to participate in local elections, interest in local politics, or knowledge about politics was unrelated to community size in most of the countries studied. People in larger communities, despite better media coverage, are no more interested in local political issues, and also no better informed about them, than those who live in smaller communities.

EVERYONE IN THE SAME BOAT? Lütschental, Switzerland, 2008: In the global era, numerous decisions are made at international or national levels, far from the individual citizen. But local problems are usually adddressed locally. In communities whose size permits direct interpersonal communication, citizen engagement and political participation is easier than in communities where people do not know one another personally. Keystone/Rainer Drexel

Finally, the study showed that the quality of democracy increases primarily through social integration. Membership in clubs and associations, ties and bonds to the community of residence, neighborhood integration, and trust in fellow citizens is greater in small communities, and that has positive effects on most of the other indicators used to measure the quality of democracy.

OVERALL, RESPONSIVENESS TO CITIZENS CREATES TRUST IN POLITICS

So what practical lessons can one draw from the results of this research project? One can hardly argue that by creating larger communities through fusion one will also create better preconditions for a well-functioning local democracy. There may be other good reasons for amalgamating communities, such as because tasks can be addressed more efficiently, because one can better take account of changed habits among the population, or because larger units allow for more sensible regional planning and development. Yet if one undertakes such fusions, then an effort should be made to prevent the loss of trust, as

well as loss of closeness, to officials and decision-makers. By the same token, efforts should be made to maintain the attachment of the population to their community of residence and to the social networks they belong to.

More generally, in this globalizing era, more efforts should be made to make political decisions that involve citizens as much as possible, and to do the utmost to strengthen trust in politics and politicians. Transparency and comprehensive information are just as important as integrating those affected by decisions into the process of making those decisions, or even letting them make their own choices. In that sense, it is worth remembering the ancient Greeks, who were convinced that a degree of familiarity with the characters and lifestyles of others is necessary in order to understand their issues and demands. A democracy can function only when it is not just the benefit of individuals but also the benefit of an entire community that determines the guidelines.

Yet what was found at community level in this study cannot be simply transferred to other con-

NEIGHBORS Great Britain, 2003: Whether democracy functions better in small or large communities cannot be determined for all areas of life. However, citizens trust the local authorities and politicians more in smaller communities, and the knowledge of local problems is also greater. Magnum Photos/Chris Steele-Perkins

texts: Further research is necessary. It also is not possible to start from scratch with the world, and one must deal with the entire world as it is. Finally, one should not simply judge democratic systems as better or worse, but instead keep in mind that particular goals can be reached in quite different ways. There are conflicts between the goals pursued by the various aspects inherent to democracy, so it is not possible to improve all its aspects simultaneously. Nevertheless, we believe the attempt to investigate the connection between community size and the quality of democracy has led to important insights into how democracy functions.

Democracy is ... the recognition that we, speaking socially, are all responsible for one another.

Heinrich Mann

Heinrich Mann (1871–1950) was a German writer.

Democracies differ strongly from one another, and hence the understanding of what counts as democratic differs as well. Depending upon the country, the most significant actors and institutions may occupy differing roles.

In most democracies, parliament stands at the heart of political life. Great Britain is the exemplar of parliamentary democracy, a country where a government remains in power only as long as a parliamentary majority supports it. Yet parliamentary authority, in a growing number of countries, is increasingly coming under fire by the populace. In countries that have direct democratic instruments—which have become popular far beyond Switzerland—citizens, with the help of popular plebiscites, can make decisions about laws or may even be able to dismiss a government. Such direct democratic tools feature frequently in the newer democracies in Latin America or in Central and Eastern Europe, but exist as well in some U.S. states. At the local level, forms of still more direct participation also exist, as in the public budgeting process used in Porto Alegre, Brazil.

The president is more than a mere symbol of the country in other places. In presidential democracies, as in the United States, but particularly in Latin America, the president is wholly independent of parliament, is directly elected by the citizens, and conducts foreign and security policy. No other institution could play such a weighty role and counterbalance the power of parliament. Yet presidential democracies are no guarantee for a mutual control of governmental institutions. Presidential systems make it possible for popular leaders—including those who have taken unusual paths into politics such as Vladimir Putin in Russia or Corazon Aquino in the Philippines—to rise rapidly to positions of considerable power.

The variety of models of democracy can be illustrated using five dimensions. These concern the differentiation between majority democracies and consensus democracies, the latter of which in turn rest on cooperation between the most important political actors and on their willingness to compromise. They also concern liberal rights, which are not guaranteed in equal measure everywhere, as well as the question of how inclusive and egalitarian a democracy should be. The consensual model and an inclusive form of democracy are often essential, particularly in countries with multi-ethnic populations, for only in that manner can all the various groups in the population participate equally in politics.

How Do
the People Rule?

Daniel Bochsler and Hanspeter Kriesi

PRESIDENTIALISM Washington, D.C., USA, 2010: The considerable powers of the American president are offset
by a system of checks and balances. For example, the U.S. Congress, if it can muster a two-thirds majority, can override
a president's veto. Keystone/Pete Sonza

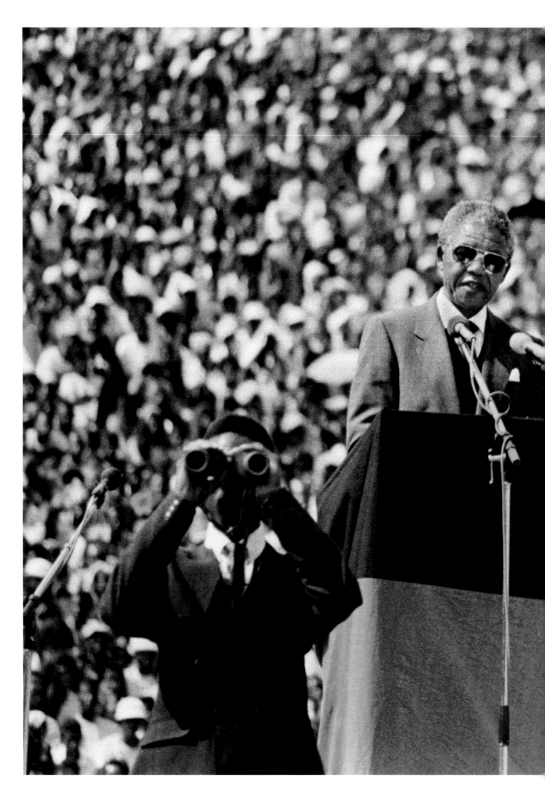

CONSENSUS DEMOCRACY Johannesburg, South Africa, 1990: Nelson Mandela, shortly after being released from prison, where he had spent twenty-seven years. After apartheid was abolished, blacks were allowed to vote for the first time in April 1994. Nelson Mandela was the first president elected by all South Africans. Panos/Graeme Williams

PARLIAMENTARISM Budapest, Hungary, 2012: The right-wing, nationalist, conservative government of Prime Minister Viktor Orbán has been sharply criticized for limiting the rights of the political opposition and for wanting to bring both courts and media under its control. Keystone/Lajos Soos

CONSENSUS DEMOCRACY Bern, Switzerland, 2013: The Swiss government consists of seven federal councillors who are responsible for conducting the business of government. They act collegially, each has equal rights, and decisions the Federal Council makes are presented collectively to the Swiss people. The federal councillors are elected by the Swiss parliament for four years. Once elected, the Swiss parliament cannot declare it has no confidence in the Federal Council. Keystone/Ulrich Liechti

PRESIDENTIALISM Tyva Republic, Russian Federation, 2010: Vladimir Putin has governed Russia since 2000, either as president or as prime minister. Thanks to various maneuvers, a constitutional amendment, and a re-election in 2012 – widely viewed as rigged – he will have been in power for eighteen years by the time his third term ends. Thus, the principle of government turnover, which embodies the essence of a democratic system, will have been negated. AFP Photo/Alexey Druzhinin

SEMI-PRESIDENTIALISM Nicolas Sarkozy in Colleville-sur-Mer, France, 2009: The French president is responsible for the country's foreign and security policy. Moreover, he appoints the prime minister as head of government. If the president's party lacks a majority in parliament, "cohabitation" occurs, and the president must work together with a prime minister acceptable to the majority party. In this case, his capacity to govern is restricted. Reuters/Larry Downing

SUMMIT MEETING Paris, France, 2013: Within the European Union, the German chancellor (head of government) and the French president (head of state) are particularly important.

As universal as the principle of democracy is, it is put into practice in widely differing ways. Depending on the political and social practices of a given country, democracy may be interpreted quite differently. The spectrum ranges from the power-sharing characteristic of multicultural countries such as South Africa or Bosnia and Herzegovina, to the concentration of power accorded to a British prime minister. We also sketch out models of direct and of representative democracy.

Political systems have a variety of problems. Among them is the failure of the Weimar Republic and subsequent rise of Adolf Hitler in Germany. In the post World War I course of democratization, Germany switched to a proportional representation electoral system, and in doing so, failed to set a minimum threshold for representation in parliament; hence even very small parties could be elected into the German Reichstag. As a result, the party structure fragmented, and the party landscape polarized ideologically at the same time. After 1930 governing became more difficult because it became impossible to form a governing majority in the Reichstag. By 1932 the majority of the parliament seats were occupied by representatives of extreme parties (National Socialists and Communists). As a result, the moderate parties could no longer form a majority. President Paul von Hindenburg saw no alternative to the situation in early 1933 but to ask the Nazis to take power. To what extent proportional representation or the role of the president in Weimar's semi-presidential system contributed to Hitler's seizure of power remains a matter of controversy.

PRESIDENTIALISM:
THE POWER TO RULE IN THE HANDS OF A SINGLE PERSON

The election of former secret service agent Vladimir Putin to the presidency in 2000 was the beginning of the end of Russia's democratization. To increase his power, Putin curtailed the rights of regional governors. As part of a 2004 reform, they were no longer directly elected but instead were appointed by the president, by which means Putin further reduced the autonomy of the regions. He also gained control over parliament by founding the United Russia party, which is regarded as an extension of the president's power. With it, he had (after some changes in affiliation by representatives after the 2003 elections) a two-thirds majority in the Duma (the lower house of parliament), which was maintained until 2011. Because this majority is sufficient to change the constitution, few options remained to the opposition to exert influence. In response to the color revolutions that led to toppling the governments in various formerly communist countries (see pp. 33, 54–6), Putin declared war on civil society organizations, and made it virtually impossible to finance them through foreign donors. In addition, he took action

against media outlets that disagreed with the government. Along with this, the Russian president's authorities to exert power have been expanded, and members of the secret services have been brought into politics.

In the literature, presidential systems are controversial, and with good reason. Of the thirty-one presidential systems established since World War II, including in all seventeen Latin American countries, democracy collapsed within a relatively short time in no fewer than twenty-four (see pp. 32–3). Yet the best-known presidential system, that of the United States, is also one of the most stable democracies.

U.S. presidents enjoy special legitimacy owing to their election by the people. It is thus not surprising that every four years the focus of the U.S. public, as of the entire world, is on the campaign for the presidency. That attention lasts for ten months before the nominations, in a series of primary elections and caucuses from January until the first Tuesday in November, when the president is finally elected. The elections of the legislature at the same time are overshadowed by the presidential election. The power of a U.S. president rests not only on the legitimacy his election confers but also on his broad powers as head of government and on his independence from Congress.

Only when government is grounded in the rule of law—fairly and consistently applied—can society rest on a solid foundation. Leaders must ensure that the rules are respected—that they protect the rights and property of individual citizens. Leaders must also hold themselves to the same rules, the same restraints— never above them.

Kofi Annan

A good leader can engage in a debate frankly and thoroughly, knowing that at the end he and the other side must be closer, and thus emerge stronger.

Nelson Mandela

Kofi Annan (b.1938) was Secretary-General of the United Nations from 1997 to 2006.

Nelson Mandela (b.1918) is a South African politician who fought against apartheid. He was President of South Africa from 1994 to 1999.

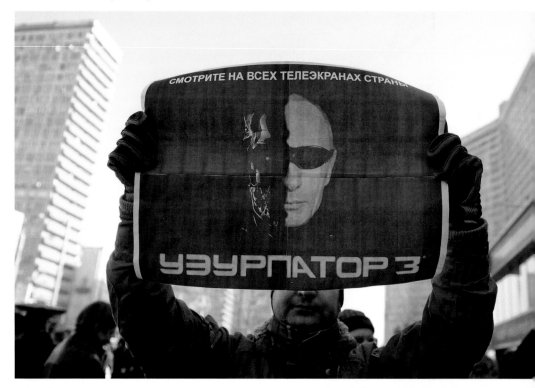

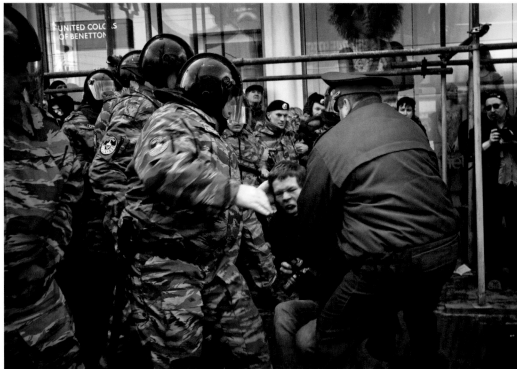

Moscow, 2007: A "Dissenters' March" protests against Putin's authoritarian governing style and the increasing limitations placed on civil society. Thomas Peters, a photographer for Reuters, is shown here being manhandled by security personnel.
Panos/Justin Jin

In a presidential system, executive power lies in the hands of a single person—and not in a council or a cabinet. The president nominates his cabinet (the government), and in the United States its members eventually must be confirmed by the legislature. Final decisions in the executive branch lie in the hands of the president. The constitutions in presidential systems usually grant the president a veto power over the law-making process as well as the possibility of introducing legislation or of blocking laws through referenda. Presidents also have a prominent role in foreign and security policy, and often have budget responsibilities, the possibility of ruling by decree, and the right to exercise emergency powers.

The U.S. president, however, is wholly independent of the legislature, which means its elected representatives cannot remove him from office for political reasons. In 1998, when the Republican-dominated Congress wanted to remove Democrat Bill Clinton (1993–2001) from the presidency during his second term (though it ultimately failed to do so), it had to make a private matter into an affair of state. The impeachment effort turned on Clinton's perjury with regard to his affair with White House intern Monica Lewinsky, because impeachment itself is quite explicitly not a political but a legal process.

Noteworthy in presidential systems is the side-by-side existence of two powerful yet independently legitimated institutions. Both the legislature (parliament) and the executive (president) are directly elected by the people for a specific term of office and cannot mutually dismiss each other. The two organs control each other through various checks and balances. This system perfects the separation of powers between executive and legislative.

Though both organs stand side-by-side, meaning neither depends on the other, in practice they can make each other's lives difficult. The complete deadlock of government policy during Clinton's first term was much more politically significant than the Lewinsky affair. Since a U.S. president can neither pass laws nor exert ultimate control over the budget, he needs to cooperate with Congress. But Clinton was not even two years into his term when the Democrats lost their majority in both House and Senate at the end of 1994. This led the Republicans to refuse to cooperate with him, whereupon Clinton vetoed the funding for the Republicans' budget, with the result that Clinton governed for seven months without a budget. The conflict came to a head in fall 1995, when Congress still had not passed a budget for the new fiscal year, which begins on October 1 in the United States. At issue was the long-term reduction of the deficit. The Republicans demanded bigger cuts in the budget, but simultaneously wanted to lower the taxes for the rich—by the same amount that they wanted to cut health benefits for the poor, the handicapped, and retirees, which was in turn unacceptable to Clinton. A compromise could not

LOCAL CAMPAIGNING Detroit, Michigan, USA, 2008: Barack Obama during his first presidential campaign. He was the first black to be elected president of the United States. Panos/Christian Burkert

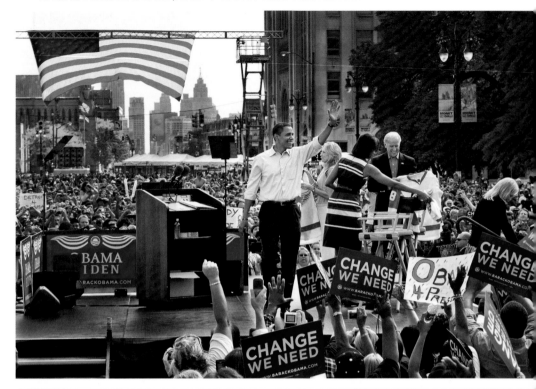

MEDIA CAMPAIGNING Lake Worth, Florida, USA, 2012: Barack Obama's second presidential campaign. Television debates between presidential candidates are an important part of the American presidential election campaign. The legitimacy of the president rests on his direct election by the people and on his independence from the legislature. Panos/Robert Wallis

PRIMARIES: THE FIGHT TO BECOME A PARTY'S CANDIDATE Manchester, New Hampshire, 2007: Barack Obama's first run for the presidency was supported by an unprecedented number of volunteers. He was also able to collect a large number of campaign contributions and as a result had an immense campaign budget. Panos/Jacob Silberberg

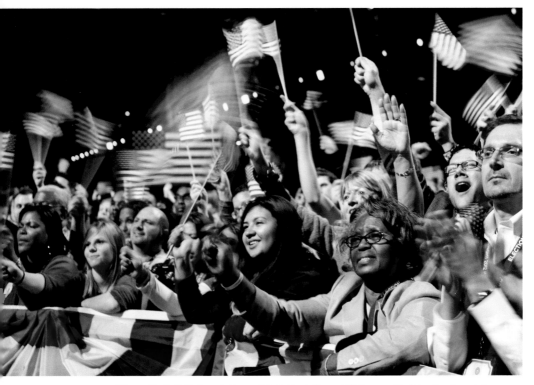

ELECTION VICTORY Chicago, Illinois, 2012: Barack Obama defeats his challenger Mitt Romney. His victory is not greeted with as much enthusiasm as in 2008. The high expectations placed on Obama in his first term were exemplified by awarding him the Nobel Peace Prize in 2009. Reuters/Jason Reed

be reached until April 1996. Because Congress in turn also refused to pass a short-term continuing appropriations resolution, the U.S. federal government in essence shut down in part for nearly a month in 1995 and 1996.

The U.S. president is head of government, head of state, commander-in-chief of the armed forces, head of his party, and a very powerful world leader. He is not only the "voice of the people" but also has impressive veto rights over legislation and can put pressure on the legislature by mobilizing the public. He has an extensive personal and administrative staff of several thousand civil servants at his disposal. Nevertheless, his power is checked not just by a strong legislature but also by a strong judiciary whose highest court, the Supreme Court, can and does rule on whether his actions are in conformity with the U.S. Constitution (through judicial review).

As long as the president can count on a majority of representatives of his own party in Congress, he can govern effectively. If there is a divided government, however, as when a Democratic president faces a Republican-dominated Congress (or vice versa), the system functions only with difficulty. It is only through constant negotiations between the various factions, a pragmatic orientation, and ideological flexibility that such a system of government can function at all. Negotiations between

THE IMPORTANCE OF THE ECONOMY Washington, D.C., USA, 2001: The best-known quip of Bill Clinton's presidency was: "It's the economy, stupid!" In his campaign, Clinton had successfully shifted the focus onto the economic issues the country faced. Reuters/William Philpott

(and within) the parties allow for more or less stable cross-party coalitions that support the president on a case-by-case basis. But in a divided government where the parties are intransigent, as was true of President Obama's or President Clinton's first terms, the president's hands are tied, and there is a threat of immobility looms. The presidential system of the United States seems more threatened by immobility now than in the past. In the last decades, narrow majorities in Congress frequently have meant a divided government, and growing ideological polarization both in Congress and in the population at large has made it more difficult to reach an understanding between the parties. With polarization, party discipline has also increased, and bipartisan coalitions have become more infrequent.

At the same time, when government crises occur, presidential systems are more likely to collapse. In parliamentary systems, a government can be replaced in a crisis. But presidents, even if they have become unpopular, cannot be so readily removed from office. The danger, particularly in more fragile democracies, is that the democratic system as a whole begins to totter, and such crises become acute especially when a president can no longer count on the support of the legislature and the two institutions mutually obstruct each other.

PARLIAMENTARY SYSTEMS: THE MUTUAL DEPENDENCE OF GOVERNMENT AND REPRESENTATIVES OF THE PEOPLE

Such obstruction is unthinkable in a parliamentary system, because government and parliament mutually depend on each other. Yet even if a government is dependent on a parliament, that certainly does not mean it is weak.

If one thinks of unchecked power, then many are reminded of Great Britain's Margaret Thatcher, prime minister from 1979 to 1990. She ruled with an iron fist, in a manner some felt reckless or inconsiderate, earning her the moniker "the Iron Lady." The Thatcher era is regarded as the epitome of an unrestricted neoliberal program aimed not only at reforming but also at radically transforming the country. She had a lasting impact on both its labor market and its welfare state. Barely, having arrived in office, Thatcher abrogated cooperation with employers and unions and instead worked to tame the trade unions. With respect to Europe, she embarked on a new course aimed at limiting the power of the European Community, and in particular, at limiting what Britain contributed to it.

Great Britain is regarded as the classic example of parliamentary democracy, the model for the mutual dependence of legislature and executive on one another. In presidential systems, the president elected by the people and can continue to govern even without a majority in parliament. In a parliamentary system, the government is answerable and accountable to parliament.

ADAMANT 1982: British Army helicopters landing on the *Queen Elizabeth II* cruise ship during the Falklands War. The ship transported British troops to the theater of war in the South Atlantic. This war became a symbol of Thatcher's iron will. Keystone

STRIKING MINEWORKERS Warwickshire, Great Britain, 1984: Margaret Thatcher did not allow herself to be swayed by strikes. During the 1980s, she reduced the power of the unions and pursued a neoliberal program of reforms. Keystone

EN ROUTE Margaret Thatcher, 1984: At home at 10 Downing Street, she did not need to tolerate a navigator next to her. In Britain's majority system, the head of government has largely unbridled power. Keystone/Bill Rowntree

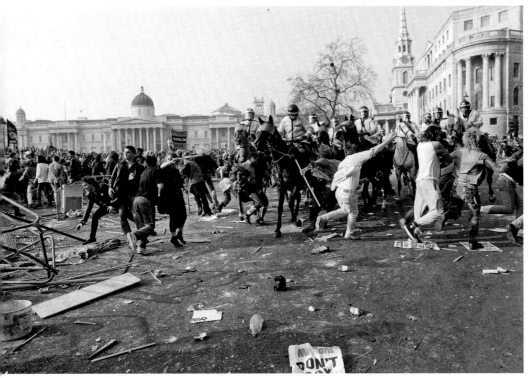

PROTESTS AGAINST A FLAT TAX Trafalgar Square, London, 1990: The introduction of a poll tax in 1990, a local flat tax that every citizen, rich or poor, had to pay, led to Thatcher's downfall. Protests and demonstrations erupted and her own party withdrew its confidence in her, stripping her of her power virtually overnight. It is striking in Great Britain how much the ruling government depends on maintaining its support in Parliament. David Hoffmann

This mutual dependence is most visible when parliament is asked by the seated government for a vote of confidence in its leadership. Should the executive ask and parliament answer that it no longer has confidence in the government, then not only does the current government fall, but with it the seated parliament as well, and new elections must be called.

The House of Commons can at any time thus confront the government with a motion of no confidence, and if successful, force new elections. In other countries, parliaments may even be able to directly select a new government. Germany's "constructive vote of no confidence," for example, permits withdrawal of confidence in the current government only when there is a parliamentary majority that supports a named successor government. Conversely, a seated government in a parliamentary system can arrange for new elections to be held by taking advantage of its power to dissolve a seated parliament. Because forcing the resignation of a government through a parliamentary vote of no confidence also means simultaneously dissolving parliament and scheduling new elections, members of the majority party in parliament risk losing their seats if they vote against their own government. They will thus think twice about whether they want to endanger the government and thereby risk being sanctioned by the voters for having done so. Instead of jeopardizing the government, therefore, they will tend to vote in its favor. This mutual dependence is very evident in House of Commons votes, where practically all legislation proposed by the government is approved without further ado. In practice, the Parliament of the United Kingdom serves as a kind of echo chamber for government proposals. Formally speaking, parliament is sovereign, but the system functions only if this particular sovereign rules neither in fact nor in deed but instead remains muzzled.

At the same time, the prime minister depends on his or her parliamentary party. As long as the party holds together, has confidence in the head of government, and holds an absolute majority of seats in parliament, then power in Westminster—the part of London where the Houses of Parliament are located—remains in the hands of the government. As soon as this confidence and unity is lost, the government falls.

Margaret Thatcher, who long enjoyed near-unlimited power, learned bitterly just how important it was to have the confidence of her party. In 1990, factions within her party began to distance themselves from her. New leaders wanted to finally dethrone the Iron Lady. Her own party declared it no longer had confidence in her rule, pushed her out of office nearly overnight, and placed its confidence instead in her fellow Conservative Party member John Major.

HEADS OF GOVERNMENT AND PARTIES IN PARLIAMENTARY SYSTEMS: THE INDEPENDENCE OF REPRESENTATIVES

Political parties play a key role in parliamentary systems, and it is decisive whether parliamentary seats are distributed according to a majority or a proportional representation electoral system. Great Britain is an exemplary case of a majority electoral system. There, the prime minister, supported by the effects the majoritarian electoral system has, as a rule possesses a great deal of power because two major parties, Labour and the Conservatives, face one another, and one almost always creates or has a parliamentary majority. In this manner, the respective majority party controls parliament and provides the head of government. This leads to clear responsibility, but also occasionally to what seem paradoxical situations.

This paradox was well illustrated by the Thatcher era, for though her government had a free hand to engage in drastic reforms, at no time did her policies enjoy the support of a majority of the voters. Thatcher was first elected in 1979, with her Conservative Party receiving a respectable 44 percent of the votes. Owing to the majority electoral system, however, this translated into 339 of the 622 seats in the House of Commons, giving her government a comfortable 55 percent majority. Though she lost votes to the opposition in her first re-election in 1983, she was able to gain an additional fifty-eight seats: With only 42 percent of the vote, her party now had 61 percent of the seats. The Social Democratic Party–Liberal Alliance massively improved its vote, but despite receiving fully 25 percent of the vote it won only 4 percent of the seats in the UK Parliament. In some places where the Alliance did well, this meant a loss to Labour, to the benefit of the Conservatives. In a majoritarian system, a ruling party can profit massively from a divided opposition.

The election of Thatcher with a minority of the votes is not an exception. It is normal in a majoritarian system for the largest party to be supported by only a minority of the voters, yet still obtain the majority of the seats. The result is artificial governing majorities. In some elections it can even happen that the party with the second-largest number of votes nevertheless receives a majority of the seats and can, in a sense, rule despite the will of the people. In addition to Great Britain, majoritarian electoral systems are found largely in its former colonies.

It is no surprise that midsized and smaller parties press for switching to a proportional representation voting system. In a majoritarian system they have barely any chance to increase their number of seats, and for that reason both politicians and voters soon turn away from midsized parties. Proportional representation systems, by contrast, more or less accurately reflect the actual number of votes cast in the seats a party obtains in parliament. On the other hand, proportional representation in parliamentary systems also means a single party rarely can win a majority

of the seats, and governments for that reason instead must be crafted out of (shifting) coalitions.

Multiparty coalition governments are based on a coalition agreement. The exercise of power at the top then depends on cooperation between two or more parties, and negotiations form the basis for the creation of a government. A typical example was postwar West Germany, where the small liberal party of Free Democrats (FDP) tipped the scales between the two large parties, the Christian Democrats (CDU) and the Social Democrats (SPD). With few exceptions, the FDP able, alternately, to form a coalition with either the CDU or the SPD.

Yet when governments are formed as the result of coalition negotiations, voters no longer know whom they should vote for in the end. Here, too, Germany provides an illustrative example. In 1982, in the middle of a legislative term, the FDP declared its coalition with the SPD under Chancellor Helmut Schmidt to be at an end, and instead formed a coalition with the CDU and its smaller Bavarian sister party, the CSU, with Helmut Kohl as chancellor. German politics thereby shifted 180 degrees without a single voter having changed his or her vote.

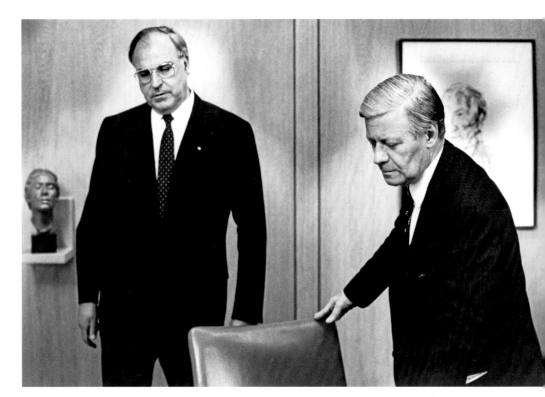

A CHANGE IN GOVERNMENT WITHOUT THE PARTICIPATION OF THE PEOPLE Bonn, Germany, 1982: The German people had no say in the change in government from Chancellor Helmut Schmidt to Helmut Kohl. In systems with proportional representation, the form government takes comes about as a result of party coalition-building. In this case, the shift in coalition on the part of a small party – the FDP, liberals – spelled the end of the Schmidt chancellorship. J.H.Darchinger/Friedrich-Ebert-Stiftung

ELECTIONS IN PRESIDENTIAL SYSTEMS:
THE MAJORITY PRINCIPLE AND THE DANGER OF POPULISM

If one compares presidential with parliamentary systems, then presidential systems also have their advantages. First, the responsibility of the government to the voters in a presidential system is especially high. Voters know exactly which candidate they are dealing with, and also know who is to be made responsible for deficiencies or maladministration. Similar clarity exists in a parliamentary system only when, as in the British case, clear majorities emerge as a result of the majoritarian electoral and two-party system. Second, legislatures are more independent in presidential systems and therefore freer in their decision-making processes. On the other hand, it is precisely this independence from the ruling government that can lead to immobility. Third, if one criticizes the rigidity of fixed terms of office in presidential systems, one can equally well find fault with the potential instability of the governments in parliamentary systems. Fourth, parliamentary systems can lead to a strong concentration of political power; in a British-style parliamentary system, such concentration can be even greater than in a presidential system.

The strong majoritarian element in presidential systems is also criticized. In a parliamentary system, election losers take their seats on the opposition benches. But the loser in a presidential election has no function to play in the political system when the election is over. In addition, there is a risk in presidential systems that outsiders with virtually no ties to the party system or to parliamentary politics will be elected. The danger that such a president will then engage in unconstitutional acts is greatest if he or she has been elected in explicit opposition to the established parties. This is not an exceptional case, for it often happens that an outsider who appeals to the people and turns in a populist manner against the political classes is elected president. The list of well-known examples is long and includes Alberto Fujimori (Peru), Hugo Chávez (Venezuela), General António Ramalho Eanes (Portugal), the former Catholic priest Jean-Bertrand Aristide (Haiti), General Charles de Gaulle (France), General Dwight D. Eisenhower (United States), Field Marshall Paul von Hindenburg (Germany), and the widow Corazon Aquino (Philippines). Russian President Vladimir Putin (2000–2008; 2012–) was supported by his predecessor Boris Yeltsin, but pursued a career in the administration rather than a traditional political career, and was prime minister for only five months before becoming president.

SEMI-PRESIDENTIALISM AS A MIDDLE COURSE BETWEEN PRESIDENTIAL AND PARLIAMENTARY SYSTEMS

A third way between the extremes of presidential and parliamentary systems has become increasingly popular. In particular, a number of post-communist countries have followed the hybrid example of France and introduced semi-presidential systems.

One should not underestimate the might of the French president, as he personifies what was once a great power. He commands the use of French nuclear weapons and exercises France's veto power in the UN Security Council, and that not merely symbolically. In the French system, it is the president rather than the prime minister and cabinet who determines foreign and security policy, and he can exercise emergency powers as well. He is independent of parliament, as in a presidential system, though the business of government is in the hands of a prime minister formally selected by parliament. It is in the power of the French president to nominate the prime minister, but the prime minister is answerable to parliament.

François Mitterrand, president of France from 1981 to 1995, learned the pitfalls of this system at his cost. He is remembered not just for the solidarity he showed

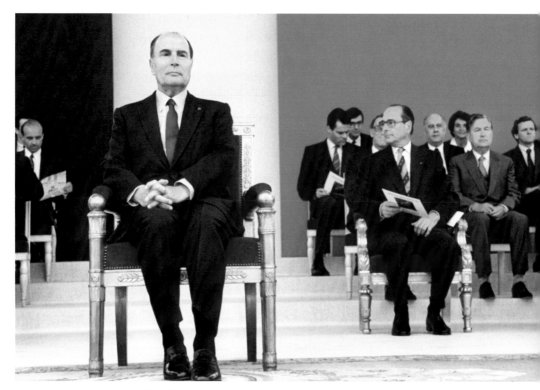

SHARED POWER OR NOT? Paris, France,1986: Semi-presidentialism is a middle path in which the president is directly elected by the people, while the government is elected by parliament. If president and government are from different parties, it creates what has been dubbed "cohabitation." President Mitterrand experienced this situation twice, from 1986 to 1988 and from 1993 to 1995. Keystone

with German Chancellor Helmut Kohl (CDU) and for his commitment to a more fully integrated Europe. At a time when Thatcher was smashing the welfare state in Great Britain, Mitterrand was reducing the workweek in France, expanding the social safety net, not least by imposing a solidarity tax on the rich, abolishing the death penalty, and increasing the role of the state in the economy. But his power over domestic policy was sharply reduced in the 1986 elections when the Socialists lost their majority in parliament to parties of the center-right. Mitterrand saw himself forced to name Jacques Chirac, a center-right Gaullist, as prime minister. The president's powers were reduced, and he now experienced the principle of having power divided between two executive organs, both legitimated by the people.

With a center-right majority in parliament, Mitterrand could do little in terms of domestic policy-making, so a cohabitation arrangement was worked out. Mitterrand, the Socialist president, was responsible for foreign and security policy, while Chirac, the Gaullist prime minister, and his cabinet dealt with all other areas of government. This arrangement illustrates that in the end, the power of the French president strongly depends on whether his party has a majority in parliament. Unlike Clinton's problems in his presidential system, which were noted above, the government did not shut down even though the French president lacked a legislative majority. This, however, depends heavily on the ability of parties in parliament to create a majority. In a majoritarian electoral system and when parties maintain voting discipline in parliament, as in France, stable majorities are possible.

Other countries that have introduced semi-presidential systems, particularly in Central and Eastern Europe, vary considerably in the powers they give their presidents. Limiting the concentration of power is a particularly important element in preventing authoritarian tendencies from emerging. By contrast, when the president is given the role of arbiter over institutional conflicts in semi-presidential systems, this can stabilize democracy.

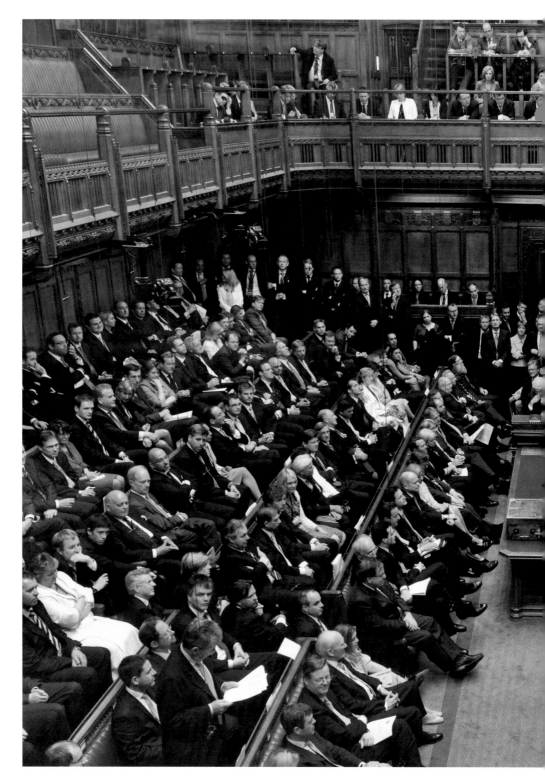

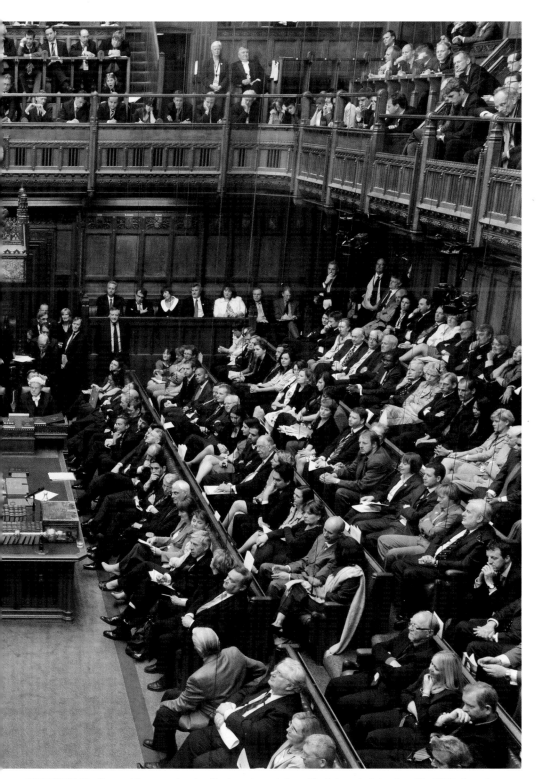

THE EXEMPLAR *House of Commons*, London: The lower house is the politically important chamber of the UK Parliament. It is responsible for making laws and for the national budget. Members of the governing party and the opposition sit opposite one another.

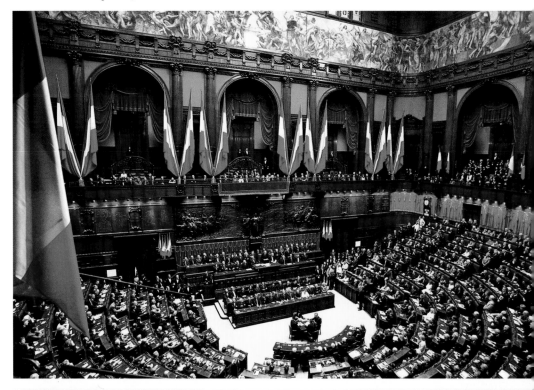

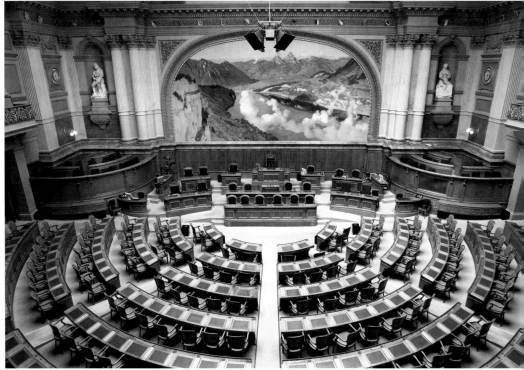

Chamber of the National Council, Federal Palace, Bern: The Swiss National Council, which represents the Swiss people, and the Council of States, which represents the cantons, have identical powers and are of equal weight. Keystone/Peter Mosimann

Reichstag building, Berlin: The Bundestag, the German national parliament, has met in the Reichstag building in Berlin since Germany reunified in 1990. Laws affecting the individual federal states also require the assent of the German Bundesrat (Federal Council), the upper house, where the governments of the sixteen federal states are represented. Panos/Stefan Boness

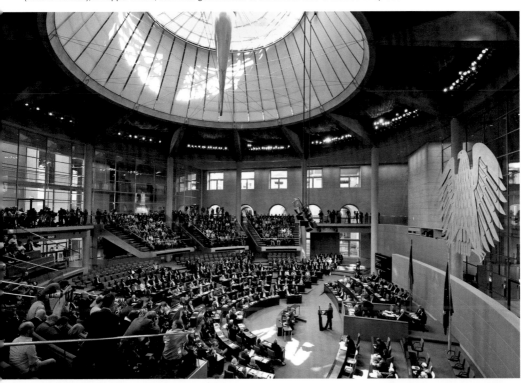

Assemblée nationale, Paris: The French National Assembly, the lower house, has the key legislative powers for passing laws or budgets. The Senate, the upper house, plays a less prominent role. Getty Images/Laurent Zabulon

OUTSTANDING ARCHITECTURE, FRAGILE DEMOCRACY *Jatiyo Sangsad*, Dhaka: The parliament of Bangladesh has only one chamber, the National Assembly. Majority World/Shahidul Alam

NEW DEMOCRACIES *Cámara de Diputados*, La Paz: The Bolivian parliament, also known as the National Congress, consists of the Chamber of Senators and the Chamber of Deputies. Panos/Dermot Tatlow Bolivia

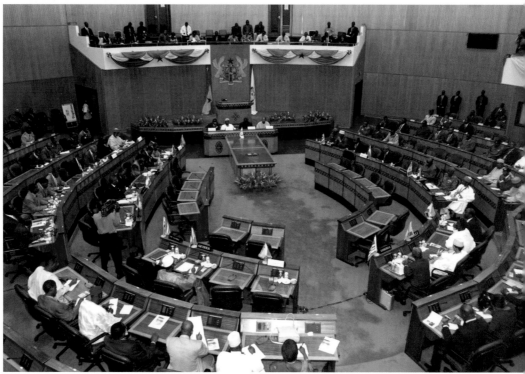

Parliament of Ghana, Accra: Each electoral district in Ghana elects a single representative. AFP Photos/Issouf Sanogo

Camera Deputatilor, Bucharest: Romania has a bicameral parliament, consisting of the Chamber of Deputies and the Senate.
Reuters/Bogdan Cristel

Seimas, Vilnius: the parliament of Lithuania. Reuters/Ints Kalnins

INTERNATIONAL The General Assembly of the United Nations, New York: This is not a parliament, as it is not composed of elected representatives. Nevertheless, it is an important institution, as it provides a venue for discussion of internationally relevant issues among states, each of which participates on equal terms. Anzenberger/Luca Zanier

THE INVOLVEMENT OF THE MANY VERSUS ONE-SIDED MAJORITY DECISIONS: MODELS OF CONSENSUS AND MAJORITARIAN DEMOCRACY

Strong presidents or prime ministers who lead their countries with an iron hand and with a single-party coalition would be unthinkable in many countries—and devastating.

The Difficult Consensus: The example of Bosnia and Herzegovina

In 1992, Serbs in Bosnia and Herzegovina took up arms in a war that was the most devastating visited on Europe since World War II. Bosnia and Herzegovina had been multicultural, a country in which Muslim Bosniaks, Orthodox Serbs, Catholic Croats, and smaller ethnic minority groups like Jews and Roma had coexisted in multi-ethnic communities for centuries. With the collapse of Yugoslavia, however, the Milošević government in Serbia wanted to extend its influence over broad parts of what had been Yugoslavia. Concurrently, Bosnian Serbs warned that should Bosnia and Herzegovina become independent, Serbs would become a minority constantly outvoted by the Bosniaks, the largest population group. The Bosnian Serbs called for a Serbian republic in Bosnia and Herzegovina and went

A DIFFICULT CONSENSUS Sarajevo, 2010: U.S. Secretary of State Hillary Clinton meets the three (!) presidents of Bosnia and Herzegovina. Consensus democracies are appropriate in multi-ethnic states, but as each ethnic group in this particular case can exercise its veto, making political decisions becomes a complicated, lengthy process. Keystone/Amel Emrić

to war, one that would end up costing the lives of at least 100,000 people, including the genocide of thousands of Bosniaks in the east Bosnian town of Srebrenica. The war would end only with the signing of the Dayton Peace Accords in November 1995.

Today, all the participants feel the Dayton Accords have stalemated the country politically. The government in Sarajevo is virtually powerless, as it lacks both the authority and the financial means to govern effectively. The country is fragmented into two entities, an autonomous Federation of Bosnia and Herzegovina dominated by Bosniaks and Croatians and itself fragmented into ten cantons, and an autonomous, Serb-dominated "Republika Srpska" created through the ethnic cleansing carried out during the war. The de facto power is at the regional level. In Dayton, the Bosnian Serbs achieved what they had fought for: The creation of an autonomous, Serb-controlled partial republic that uses symbols of an independent republic and enjoys privileged treatment and protection from neighboring Serbia. Bosniaks and Croats divide power in the ten cantons of the Federation. As indispensable as even minimal centralization would be, not least for taking the first steps toward integration into the EU, it is politically obstructed. All the institutions—parliaments, governments, courts, even the presidency—are made up of representatives from all three ethnic groups, and there are numerous ways to veto every decision-making process. Elections are held in separated districts, and votes largely go to the ethnically defined parties of the three groups, which is why the elections are often criticized as "ethnic censuses." In day-to-day politics, this means Bosnian Serb politicians routinely veto practically all proposed laws, irrespective of whether their purpose is to establish a national anthem or create a national police force—and that frustrates all efforts to strengthen what is today a largely irrelevant national government.

Bosnia and Herzegovina thus is a tragic example of what consensus democracies can suffer from: An insufficient consensus.

Democratization by Consensus: The example of South Africa

South Africa in the post-apartheid era provides the counterexample. Its institutions, in the transition period after 1993, were drafted to reflect the consensus model. Its core elements included a particularly inclusive proportional representation system for electing the constitutional convention to ensure that all minorities would be appropriately represented. The transitional constitution called for a government of national unity in which every party receiving at least 5 percent of the vote would automatically be represented, and which was to make decisions in a consensual manner. In the constitutional convention, a two-thirds majority was also required

to approve the final version of the constitution, thereby forcing convention representatives to make decisions, if at all possible, by consensus. In addition, nine autonomous regions were created to represent, at least in part, the linguistic and ethnic multiplicity of the country. For that reason as well, safeguards were introduced (the guaranteeing of private property, constitutional jurisdiction), intended to protect minorities from arbitrary decisions made by the political majority.

With 60 percent of the vote, the African National Congress (ANC), a mass organization that had fought for decades against anti-black discrimination in the country, became the largest party, and its president, Nelson Mandela, became head of the South African government in 1994. Frederik Willem de Klerk, head of the National Party and the president who brought an end to the apartheid regime and the dominance of the white minority, received the post of deputy president in the national unity government. His party voluntarily withdrew from it in 1996, having gained confidence in the new institutions, and now wanted to play the role of a constructive opposition. With its overwhelming majority—it has won two-thirds or more of the seats in every election since 1994—the ANC could rule on its own, but it is a broadly based party, which guarantees a broad consensus. After a devastating defeat at the polls, what remained of the National Party joined the ANC in 2004, so there is a danger South Africa may functionally turn into a one-party state.

Consensus and Majoritarian Democracies Compared

Consensus democracies come particularly into play in nations with both cultural majorities and cultural minorities. Though quite differently constituted in each case, they can thus be found in Northern Ireland, long marked by a deep rift between Catholics and Protestants, in quadrilingual Switzerland, in Lebanon, Belgium, Kosovo, and Macedonia. In a consensus democracy, politics is a matter of negotiating balanced compromises rather than making one-sided majority decisions. The governments are broadly constituted but not all-powerful, and are forced to closely coordinate their actions with other political organs.

Consensus democracies thus differ in a variety of dimensions from *majoritarian democracies,* which concentrate power in the hands of a president or prime minister and his or her majority party. The Dutch-American political scientist Arend Lijphart has proposed that one can identify no fewer than ten such institutional differences, and they encompass the most significant rules and practices of modern democracies. He summarizes these differences as falling into two dimensions. The *executives–parties dimension* focuses primarily on the power relations between government and parliament as well as between parties and associations, while the *federal–unitary dimension* focuses on the division of power among institutions—

THE EXECUTIVES-PARTIES DIMENSION:

1 Concentration of executive power
M: single party government
C: coalition government

2 Relationship between the executive and the legislative power
M: executive dominance
C: separation of powers between the executive and the legislature

3 Party system
M: two-party system
C: multiparty system

4 Electoral system
M: plurality system of elections
C: proportional system

5 System of interest associations
M: pluralism
C: corporatism

THE FEDERAL-UNITARY DIMENSION:

6 State structure
M: unitary, centralized state
C: federal, decentralized state

7 Concentration of power in the legislature
M: unicameralism
C: bicameralism

8 Constitution
M: flexible
C: rigid – minority vetoes

9 Judicial Review
M: no judicial review
C: elaborate judicial review

10 Central bank
M: independent
C: dependent on government

THE TEN ASPECTS OF PURE MAJORITARIAN (M) AND CONSENSUS (C) MODELS BY AREND LIJPHART.

central state and regional states, the two chambers in parliament, the constitutional court, and the central bank (see the Ten Aspects of Majoritarian and Consensus Principles, p. 235).

Where governments can rule only in coalitions, the ability to govern a country depends on the readiness of the various actors to cooperate and find compromises, aspects one can call a culture of consensus. Contemporary examples of the lack of a consensus culture can be found not only in Bosnia and Herzegovina but also in Belgium. Since the 1970s, the political parties, which are organized by language community, but also by region in Belgium, have found it increasingly difficult to form ruling coalitions. However, there are more successful examples, such as Northern Ireland, Macedonia, or Switzerland, which give hope that the institutions of consensual democracy can help promote the development of a culture of consensus.

If one combines the two dimensions, one arrives at four possible models of representative democracy: A federalist and a unitary consensus democracy, and a federalist and a unitary majoritarian democracy. We have placed fifty established democracies, based on various indicators, within these four models, as one can see in the figure on pp. 248–9. Great Britain is a typical example of a majoritarian democracy in a unitary state. While this is where unitary democracy had its beginnings, one finds it in former British colonies such as New Zealand or Barbados as well. It can be found in centralized unitary states such as France, with its majoritarian democracy, or in Hungary, Turkey, and South Korea, which also tend toward a majoritarian system. The federalist consensus model, on the other hand, is exemplified by Switzerland, Belgium, and Germany, and the democracies of South Africa, Brazil, and Mexico also correspond to this model.

At the same time, Figure 1 shows federalism certainly can be combined with a majoritarian model, as in the United States, Australia, Canada, Argentina, Colombia, the Philippines, and India. By contrast, we find the centralized consensus model in, among other places, Scandinavia, the Netherlands, and Austria, as well as in Central European states such as Slovenia, the Czech Republic, or Slovakia. The EU's political system, interestingly enough, also has many characteristics of a consensus model.

Consensus democracies are characterized by proportional representation electoral systems and by a broad spectrum of political parties. New parties have an easier time becoming established in the political landscape in such countries, and the electoral system thereby guarantees that all relevant societal groups are adequately represented in parliament. Yet it also leads to a situation where it is nearly impossible for one party alone to form the government; instead, party coalitions

are the rule. In these countries, one often finds rules of the game that broadly disperse power. The disadvantage is that political responsibility cannot be clearly assigned, and the coalition character of government can mean that even parties that lose an election may—so to speak, through the back door—end up as members of a ruling coalition.

Two countries particularly stand out in this conflict of goals: The United States and India. Because small parties do not stand a chance in majoritarian democracies, they usually receive barely any votes, or do not even stand for election. This can lead to the impression that a majority in Congress is broadly anchored in the population. Yet the price for this is, as for example in the United States, no party has been able to establish itself as a representative of ecological issues. Many voters do not find their interests reflected in the two parties and stay home, as can be seen in the electoral participation rate of about 60 percent. The particularity of India, by contrast, lies in its strongly regionalized party landscape, and regional parties are elected in the respective regional strongholds. Despite a majoritarian electoral system, therefore, a multiparty system exists.

While multicultural countries tend toward the consensus model, the Indian exception can be explained by the fact that nearly all the countries with an Anglo-Saxon heritage have adopted the British system of majoritarian democracy. The only exceptions are Malta, South Africa, and Ireland, all of which have adopted the consensus democracy model.

The size of a country plays a significant role with respect to the federal–unitary dimension. The largest democracies—the United States, India, and Brazil—tend to be more federalist, which is hardly surprising since decisions made in federal substates are closer to the citizens as such than those made for the entire country in distant Washington, D.C., Delhi, or Brasilia. In economically, socially, or culturally heterogeneous countries, federalism gives differing regions a face and makes politics more strongly oriented to local needs. Yet it is precisely the post-communist democracies that are an exception here, inasmuch as they are strongly centralized despite their ethnically diverse societies. After all the federalist countries in the region (Czechoslovakia, Yugoslavia, the Soviet Union) broke apart with the fall of communism, federalism and regional autonomy for minority regions were misunderstood as the first steps toward disintegration, and thus they became taboo as political options.

LIBERAL AND ILLIBERAL DEMOCRACIES: FINDING A BALANCE BETWEEN DECISIONS BY MAJORITY AND CONTROL THROUGH THE RULE OF LAW?

Consensus democracy, or the principle of sharing political power, is a way for minorities to be protected against the "tyranny of the majority" (James Madison). The other means are the rights and liberties of the individual, which also contain protection against arbitrary decisions.

When the successor countries to Yugoslavia began organizing elections in the early 1990s, the American diplomat Richard Holbrooke made a very skeptical observation: "Suppose the elections are free and fair, but those elected are racists, fascists, separatists...." A democracy in which the majority has unlimited power is a "populist democracy," which may well disregard the rights of minorities and the rule of law. Yet even referendums held in established democracies can reveal the limits of majoritarian democracy. Swiss voters in 2009, for example, decided to ban the construction of minarets, thus sparking a debate about the relationship of plebiscitary democracy to minorities. An unlimited majoritarian democracy cares little about the principles of international law and regards popular sovereignty as absolute.

LIBERAL PRINCIPLES VS. DECISIONS BY A DEMOCRATIC MAJORITY Zurich, Switzerland, 2009: Liberal democacies protect civil and human rights, as well as guarantee the protection of minorities. In 2009, Swiss voters adopted a referendum banning the construction of minarets – and thus violated the religious freedom of the Muslim minority. Panos / Mark Henley

On the one hand, liberal principles limit the majoritarian principle, inasmuch as citizens can exercise their majoritarian decisions only within the limits placed by the constitutional or rule-of-law state. Thus a constitutional state protects certain minorities, and protects property. A liberal democracy that honors liberal principles therefore tries to protect minorities from the "tyranny of the majority." On the other hand, democratic principles also set certain limits to liberal principles.

Figure 1 shows the fifty consensus and majoritarian democracies with respect to their position vis-à-vis liberal principles. Here the figure is divided into four quadrants corresponding to the four models of democracy: The liberal consensus democracies, the liberal majoritarian democracies, the illiberal consensus democracies, and the illiberal majoritarian democracies. All fifty countries are democracies, but they are more or less consensual, and more or less liberal.

Immediately noticeable is the more pronounced liberalism of the long-established democracies in Western Europe and in the English-speaking world. The newer democracies of Latin America (Peru, Columbia, Venezuela, Mexico) and Southeastern Europe (Bulgaria, Romania, Croatia) are by contrast less liberal than the democracies of longer standing. The same is true, if to a lesser degree, of the

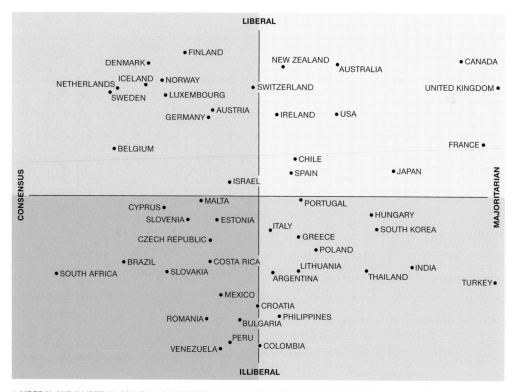

1 **LIBERAL AND ILLIBERAL, AS WELL AS CONSENSUS AND MAJORITARIAN, DEMOCRACIES COMPARED** The figure distinguishes between more liberal (above) and less liberal democracies (below). It also distinguishes between consensus (left) and majoritarian (right) democracies.

southern European (Spain, Italy, Portugal, Cyprus, Malta) and Central European democracies (Hungary, Czech Republic, Poland, Slovenia, Slovakia), as well as of the democracies in Africa (South Africa).

Among the liberal democracies, one finds a clear division between the English-speaking majoritarian democracies (Great Britain, United States of America, Canada, Australia, New Zealand) and the consensus democracies of Scandinavia (Denmark, Finland, Iceland, Norway, Sweden) and of Northwestern Europe (Belgium, Germany, Luxembourg, Netherlands). Among the consensus democracies, the most liberal are Denmark and Finland. The most liberal of the majoritarian democracies are Australia, Canada, and New Zealand. All these countries are characterized by pronounced legal equality and government capacity (low levels of corruption) as well as guaranteed property rights.

Among newer, generally less liberal, democracies, we find many countries searching for a middle way between the consensual model and the majoritarian model. Only Turkey, with its weak unions and a uniquely high barrier to representation in parliament of 10 percent in national elections, is a strongly majoritarian democracy.

DIRECT AND REPRESENTATIVE DEMOCRACY: CO-DETERMINATION OR DELEGATION?

A wave of democratization swept over the world in the late twentieth century. Somewhat unexpectedly, it revived the classic republican notion of self-determination by the citizenry, lending it new life (see pp. 33–4). Thanks to the success representative democracy has enjoyed, these models had been nearly forgotten. Today, participatory democracy, as an alternative to representative democracy, has made up lost ground, if only modestly.

In participatory democracy, citizens are included in decision-making processes to the greatest extent possible, not just in the political system but also in other key social institutions, such as the workplace or the local community. Participatory democracy is "strong democracy," more self-government by the citizens than representation in the name of the citizens. In this model, active citizens rule themselves, not necessarily at every level or in every respect but often enough. This self-rule by the citizens is made possible by institutions that allow for participation in determining the political agenda, in public deliberations, in law-making, and in executing the laws. As long as self-determination applies only to the political context, it will have only a limited effect on the quality of life of the citizens. For self-determination to be genuinely meaningful, it needs to extend beyond politics into all areas of life, especially the economy and occupational life.

Proponents of the participative model concede that many central aspects of representative democracy—party competition, political representation, periodic elections—will be unavoidable elements of a participatory society as well. That does not mean it should be confined strictly to this. To begin with, proponents feel citizens can obtain genuine control over their own lives only if they have an opportunity to directly participate in local decisions. Beyond this, they assume that the possibility of participating directly in realms such as occupational life would radically transform the environment of national politics. Citizens would have numerous ways to gain experience in making decisions about the distribution of resources and the regulation of coexistence. On this basis, they would be much better prepared to evaluate national political questions, and better able to assess the performance of their political representatives and play a part in decisions of national import and impact. Finally, proponents of participatory democracy assume that active participation would have an educational as well as a politically empowering effect. Active participation not only increases the feeling citizens have that their actions can have a political effect, but also contributes to their acceptance of political decisions. Active participation, in other words, contributes to the stability and legitimacy of a democratic system. The idea that active participation makes for better citizens goes back to Alexis de Tocqueville (1835) and was first used as a central argument for democracy by John Stuart Mill in 1861. Though the idea had a brief renaissance among the New Left in the 1960s and 1970s, it has lain largely dormant since then.

In the limited framework of the political system, one can partly realize the ideals of participatory democracy theory by giving citizens the opportunity to place specific issues on the political agenda through initiatives and contribute to deciding central decisions through referendums. These possibilities exist in some countries, at differing levels of the political system. They are most fully articulated in Switzerland, where citizens have the right at local, cantonal, and national levels to make direct substantive decisions about important political topics. These direct democratic mechanisms augment Switzerland's representative democracy. They are built into representative democracy inasmuch as they are guided and controlled by parties and associations and their representatives. Various other countries employ comparable direct democratic instruments, though they can differ strongly from the Swiss-style mechanisms. Some Latin American countries interpret direct democracy to mean having the right to depose the ruling government by popular plebiscite. And in a number of Latin American and Central and Eastern European countries, whether and when certain substantive decisions are made is within the power of the government or the president to determine. In this way, a government can strategically use—or not use—the mechanisms of direct

Bern, 2007: Switzerland has the strongest direct democracy. To launch an initiative at the federal level, 100,000 signatures must be collected. Swiss citizens can participate directly in political events at the municipal, cantonal, and federal levels. Reuters/Pascal Lavener

Bern, 2007: Political engagement with an issue does not end with passage of a popular initiative. The "Alpine initiative," for example, sought support in the Swiss parliament for their demand that heavy goods transiting the country be transported by rail. If a demand is supported by a popular majority, parliament and government must still implement it. Ex-Press/Nadja Frey

Basel, 2009: Demonstration against adopting the "anti-minaret initiative." The right of a minority was curtailed by the decision of the majority. Roland Schmid

Morges, near Lausanne, 2010: The Swiss People's Party (SVP) has launched a number of popular initiatives with xenophobic undertones, including those "against an uncontrolled influx of foreigners and overcrowding in Switzerland." Voters approved of two of them: The "minaret ban" and the "deportation of criminal foreigners" initiatives. Reuters/Valentin Flauraud

243

democracy, and does not need to fear that the people will block issues they do not like at the polls.

Switzerland's uniqueness is evident if we compare the fifty established democracies with one another with respect to their use of direct democratic instruments. Nowhere else, at the national level, can one find such an extensive use of direct democracy. But this carries a price: Representative democracy is weaker in Switzerland than in the other countries. This means elections in Switzerland, when compared with other democracies, are of low significance. There are also very large social differences: Democracy is primarily practiced by the educated classes.

The special status of Switzerland is reinforced by the numerous possibilities of exerting influence through direct democratic means at the cantonal and local levels. Citizens of Bern, the capital city, for example, vote every year on the city's budget. Where direct votes on public spending can be decided by referendums, public spending is lower than in purely representative systems. Evidently, when citizens can have a determining influence, they are more careful about spending their own tax revenues than their elected representatives are. Regions (cantons) with greater direct democratic participation also have lower levels of public debt, better tax compliance rates, and better public services.

Finally, direct democratic processes serve a legitimizing and integrative function, and they increase general citizen satisfaction. This is due not only to the higher level of governmental performance such practice of direct democracy brings about. It also is a direct consequence of the increased legitimacy of political decisions associated with such practices.

Based on Swiss experience, direct democratic processes seem very attractive overall. Public opinion research indicates that citizens do not seem overburdened by the tasks associated with such practices, primarily because the decisions to be taken are prestructured by political elites through existing institutions and through the mobilization and communication strategies used. The costs of direct democracy are borne by those minorities that are unpopular—such as immigrants or sexual minorities, and in some places, ethnic minorities. Their rights are often restricted through direct democratic decisions. However, even citizens who stand on the winning side in a plebiscite discover they depend on representative democratic organs for implementing their choice. They may discover that such institutions find ways around or simply avoid implementing the expressed will of the people.

Direct Citizen Involvement: Latin American examples

Switzerland is by no means the only country in which citizens directly take part in political decisions. Interesting new modes of participation have been developed in recent years, particularly in Brazil. The city of Porto Alegre, one of Brazil's ten largest cities (1.5 million inhabitants), has been a pioneer here. Citizens have been systematically involved in a "participative budget" process ever since the Partido dos Trabalhadores, a left-wing workers' party, won the mayor's office in 1988, and in a manner that goes beyond even what is possible for Swiss citizens. From 15 to 25 percent of the infrastructure investments are decided upon through such direct citizen participation, and the Porto Alegre model has spread quickly throughout Brazil.

Public budgeting in Porto Alegre takes place in phases. The city is divided into sixteen sections, and they are further subdivided into neighborhoods. Meetings are first held, between March and June, at the neighborhood level, where participants set local priorities and discuss both existing and new plans. They also elect those who are to bring these priorities to the city section meetings. From July to November, in a second round of neighborhood and city section meetings, advantages and disadvantages of the various proposals are discussed. Votes are taken on the proposals, oversight committees are formed, and representatives to the city's budget council are selected. This council, in turn, guides the public budgeting process and votes on the final proposed budget, which is then presented to the city council.

It would not be entirely accurate to call Brazilian participative budgeting pure direct democracy, as citizens who participate in the discussion forums at the neighborhood level also elect representatives to present their priorities at the next higher level. On the other hand, participation goes far beyond merely electing representatives, because citizens discuss, argue, and vote on specific priorities and projects. Between 2000 and 2003 in Porto Alegre, no fewer than 35,000 citizens from all walks of life took part in this process, on average. The result of citizen participation has been to increase investment in poorer neighborhoods, improve the quality of public services, and reduce at least some clientelism.

Citizen participation in public budgeting in Brazil always lies in the hands of the city's executive, and its success depends heavily on how committed that executive is. Its commitment, in turn, is bound to the political program of the party governing that particular city, and is also linked to strategic political considerations. Part of the political platform of the Partido dos Trabalhadores is to fight clientelism and to introduce direct ways for citizens to participate. Yet this is no longer the only party promoting such issues. Some mayoral candidates thus may think their support of such processes will increase their chances at the next election.

On the other hand, the success of such processes depends on the strength, autonomy, and attitude of civil society organizations. They need to be numerous, independent, have many members, and must themselves be convinced that mobilizing citizens to participate will improve the general public welfare. Unlike ordinary interest groups, these organizations need to not only promote their own agendas, but also support direct citizen involvement in the decision-making process. The Brazilian experience indicates that civil society itself is also strengthened by having citizens participate in the public budgeting process.

Brazil is not the only Latin American country in which such innovative participatory processes have been introduced: Other examples come from cities in Mexico, Argentina, Chile, and Bolivia. In all such cases, what is decisive for success is the combination of a committed city government and engaged civil society organizations.

HAVING A SAY WHEN IT COMES TO MONEY: A "PARTICIPATORY BUDGET" Citizen's meeting in Porto Alegre, Brazil, 2009: The city's residents can play a direct role in the budgeting process. Through this direct democratic process, they are closely involved in political decision-making and can express their priorities and ideas. IDB/Arlette Pedraglio

CONCLUSION

It would certainly be problematic to identify the "best" form of democracy. Democracy must meet quite diverse demands, but can never fulfill all of them. The goals associated with individual forms of democracy often cancel one another out: Direct forms of participation allow citizens a highly unmediated influence on politics, but are at the same time quite demanding. Majoritarian democracy creates clear responsibilities and allows for simple decision paths, but it excludes large parts of society from power. Presidential systems have perfected the separation of powers, but are susceptible to crises. The model of direct citizen participation is difficult to realize when the questions are complex, when the country lacks experience with democracy, or when levels of education are low. Presidential systems may serve to exacerbate political instability. Unlimited majoritarian democracy may only inflame ethnically divided societies. There is thus no one "genuine" democracy. Nevertheless, different models of democracy can provide more or less good solutions, depending on the social and political context.

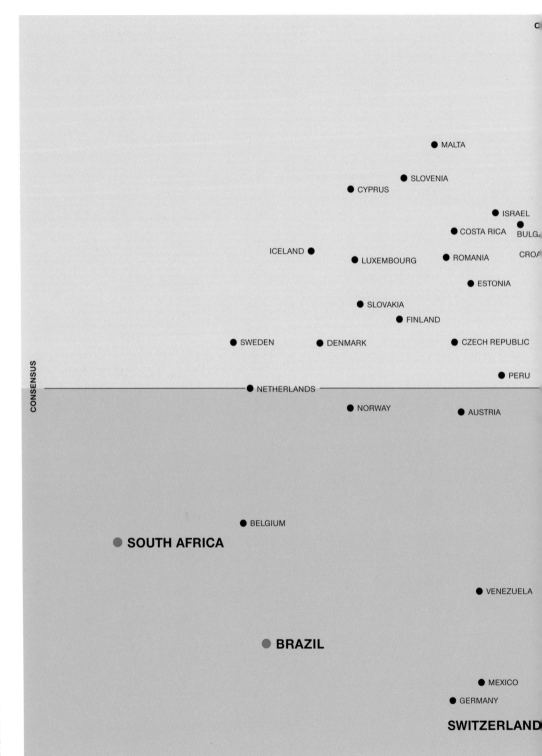

CONSENSUS

MALTA
SLOVENIA
CYPRUS
ISRAEL
COSTA RICA
BULG.
ICELAND
LUXEMBOURG
ROMANIA
CROA
ESTONIA
SLOVAKIA
FINLAND
SWEDEN
DENMARK
CZECH REPUBLIC
PERU
NETHERLANDS
NORWAY
AUSTRIA

BELGIUM
SOUTH AFRICA

VENEZUELA

BRAZIL

MEXICO
GERMANY
SWITZERLAND

DIFFERING FORMS OF DEMOCRACY

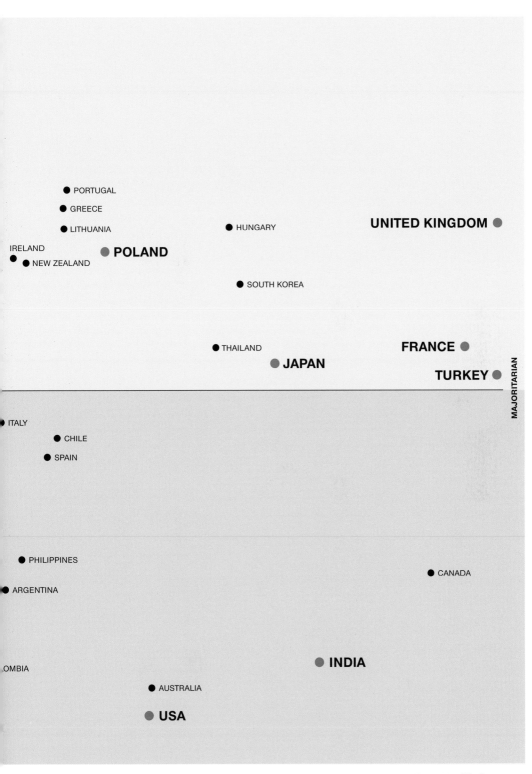

MAJORITARIAN

CONSENSUS AND MAJORITARIAN, AS WELL AS FEDERALIST AND CENTRALIZED, DEMOCRACIES COMPARED The figure shows majoritarian (right) as well as consensus (left) democracies. It also distinguishes between strongly centralized (above) and federalist (below) countries. Each of the countries more emphasized here are briefly portrayed on pages 250–69.

SOUTH AFRICA

The foundation for the so-called *apartheid* regime was laid in South Africa when the National Party took power in 1948, launching a long-lived program to ensure the power of the white minority by limiting the rights of the black majority. Owing to both international and domestic pressure, this regime could not be sustained forever, and when Frederik Willem de Klerk became president in 1989, he introduced the first liberalization measures. These became increasingly difficult to control and finally led to the democratization of the country. The key event was the release of Nelson Mandela, leader of the African National Congress (ANC, the black opposition movement), who had been imprisoned for decades in the regime's jails. South Africa's democratization was negotiated between representatives of the *apartheid* regime and the ANC. The process of democratization foresaw a transitional period in which a government of national unity would include all the relevant political actors. The first democratic elections, held in April 1994, gave the ANC an overwhelming victory and led to electing Nelson Mandela the first president of the new South Africa.

The transition period came to an end in 1996 when the final version of the constitution came into effect. It was one of the most progressive constitutions in the world, and in addition to the usual civil and political rights of citizenship, it also guaranteed a broad array of basic social and economic rights. With its inception, there was no longer a need for an all-party, unity government, but the principle of consensus remained in effect at an informal level. The ANC dominates the new South Africa: In all the elections held thus far, it has won about two-thirds of the seats in the national parliament. The ANC makes the claim it is not race-based, so it has been very careful, in the composition of its governments, to mirror the ethnic composition of the country. Hence, four of the thirty-five national ministers are white, as are nine of the ninety-nine ministers in the provincial governments. The largest opposition party is the Democratic Alliance, followed by the Inkatha Freedom Party, which represents the Zulus. The Zulus had vehemently opposed the ANC's dominance even during the transition phase, and argued for the largest possible measure of federalist autonomy in the country. It is a longer-term problem for South African democracy to have only one party rule, even if, as compared with every other African liberationist party, the ANC has distinguished itself in consolidating liberal democracy in South Africa.

THE END OF RACIAL DISCRIMINATION Nelson Mandela, after spending 27 years as a political prisoner of South Africa's apartheid regime, spoke out in favor of national reconcilliation and for a transition to democracy after being released. Mandela became South African president in the first free elections held in 1994. He has become a global symbol for the peaceful transition to democracy. Panos/Graeme Williams

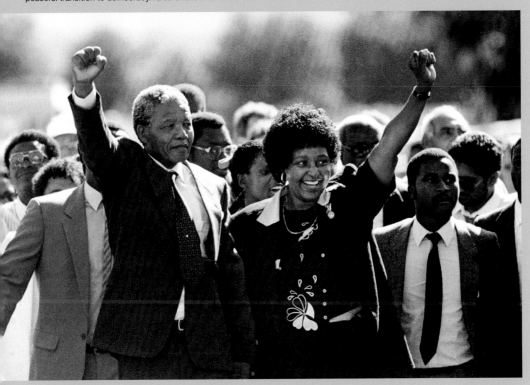

APARTHEID South Africa, 1977: The black and "colored" majority is massively oppressed by the white minority. International pressure and sanctions finally brought about the end of the apartheid regime in the early 1990s. Keystone/Sven-Erik Sjöberg

INDIA

India is the world's largest democracy. The country became independent from Great Britain after World War II, and its democratic constitution dates from January 1950. While many ex-colonies began their independent existence as democratic nation-states, India is one of the few in which sustainable democracy was consolidated. The country profited in the 1950s and 1960s from Jawaharlal Nehru, a political leader who stood fully behind democracy. It also profited from a well-functioning civil service, from a popular, dominant party (the Congress Party), and from low levels of political conflict. But under Nehru's successor, his daughter Indira Gandhi, Indian politics became more turbulent during the 1970s and 1980s. Indira Gandhi's personalized and populist course weakened the country's democratic institutions, the Congress Party became an instrument of her personal power, and the civil service became politicized. That Gandhi was removed from office in a democratic election, however, also indicates the ability of Indian democracy to resist such tendencies: The dominance of the Congress Party was broken in the process. The rise of the Bharatiya Janata Party (BJP), which primarily mobilized the Hindu majority, created a second large political party. Though originally a nationalist party tending toward religious extremism, the BJP found itself forced to moderate its stance and govern in coalition with other parties.

India, an enormous country with deep cultural divides, inherited majoritarian institutions from its former British colonial rulers. Indian democracy was able to survive, despite a majority-based electoral system, only because it functioned more like a consensus democracy. Thus, the dominant Congress Party always included the most varied factions, each representing different cultural minorities. In addition, both Congress and the BJP, the two large parties that have dominated Indian government, always depended on coalition partners to rule. Those partners, representing regional minorities, ensured the Hindu majority could not simply have its way and ignore minorities. Finally, India is also a federal country in which regional cultural minorities have considerable autonomy and possess special rights protected by the Indian constitution.

FATHER AND DAUGHTER Jawaharlal Nehru was both a founder of India and its first prime minister. His daughter Indira Gandhi and her son Rajiv were also prime ministers. Rajiv's widow Sonia Gandhi took over leadership of the Congress Party after her husband was assassinated. Keystone

FRANCE

The French Revolution (1789) toppled the monarchy and created the French Republic, but it would take more than a century for democracy to become fully established in the country. Universal suffrage for men was introduced in 1884 and for women only in 1946.

The French Revolution and France's further political development also strengthened its already strong centralism. Even today, France has a strong, centralist state that intervenes in the economy and society at will, and is the embodiment of the common good in the eyes of the French. The strong state corresponds to a weakly organized society: Measured by number of members, French unions, for example, are the weakest in Europe.

France's Fifth Republic was founded in 1958. The weak, unstable governments of the Fourth Republic, introduced after the Allies liberated France during World War II, proved unable to successfully address decolonization, France's key problem in the 1950s. Events in Indochina had already strongly undermined the French political system, but it would be the Algerian war of independence that would lead to replacing the Fourth Republic with the semi-presidential system of the Fifth Republic. Since then, France has appeared to have two centers of power: The president and a government responsible to parliament. Both president and parliament are elected by the people through a majority voting system, which has led to a concentration of power.

When the people elect a president who also has a parliamentary majority of his own party, the two power centers coincide and the president becomes the central wielder of power. This was not always the case in the past, as the terms in office of parliament and president were not equally long. As a result, *cohabitation* existed three times, meaning the president and the prime minister belonged to different parties and had to share power. Owing to a change in the constitution, since 2002 the two elections have been held in immediate succession, drastically reducing the possibilities of a future *cohabitation*.

Charles de Gaulle (1958–1969) was the first president of the Fifth Republic, and was followed by Georges Pompidou (1969–1974), Valérie Giscard d'Estaing (1974–1981), François Mitterrand (1981–1995), Jacques Chirac (1995–2007), Nicolas Sarkozy (2007–2012), and François Hollande (2012–).

SEMI-PRESIDENTIAL DEMOCRACY Military parade on the Champs-Elysées in Paris. On July 14, its national holiday, France celebrates its Revolution and the 1789 storming of the Bastille. These events led to abolishing the monarchy and establishing the country's First Republic. VII/Alexandra Boulat

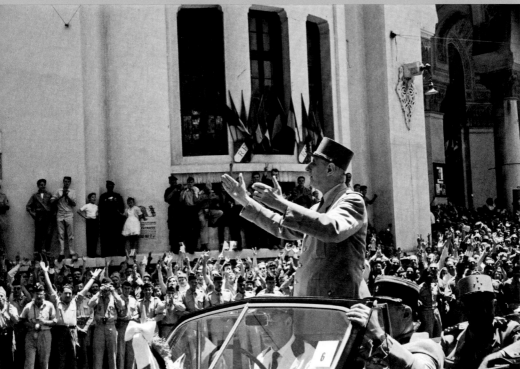

DECOLONIZATION Algeria, 1958: During the Second World War, Charles de Gaulle was the supreme commander of the Free French. The governmental crisis provoked in France by the uprising in Algeria only came to an end when de Gaulle returned to politics and ushered in the semi-presidential Fifth Republic. De Gaulle was French President from 1959 to 1969; Algeria became independent in 1962. Getty Images

POLAND

It is no accident that the chain reaction leading to the collapse of the Eastern Bloc began in Poland. It was the country in the bloc with the strongest civil society and the weakest government. The Catholic Church and Solidarność, the union movement, provided the dual basis for societal opposition to the communist regime. Toward the end of the 1980s, a conflict developed in Poland at two levels. The struggle between party and society was reinforced on the one hand by a struggle within the Communist Party between reformers and conservatives, and on the other hand by a struggle inside Solidarność between the moderates (Lech Wałęsa) and the radicals. In the fall of 1988, the regime brought the Solidarność moderates together with the party reformers in Round Table talks that would lead to decisive steps being taken towards democratization. The USSR under Mikhail Gorbachev played a key role, as Gorbachev was willing to accept the end of the Eastern Bloc and of socialism. By accepting the transition to democracy in Poland, he also signaled to the rest of Eastern Europe that he was secure in his power and supported the reform process.

The result of the Round Table talks was the introduction of a semi-presidential system in Poland, with a strong president who had a great deal of scope to interpret what his powers and responsibilities as leader were. Lech Wałęsa, former leader of Solidarność, was elected the first president of democratic Poland in 1990. No fewer than 111 political parties participated in the first free elections to the Polish parliament (Sejm), of which 29 then took seats. It was initially difficult to govern, given such severe party fragmentation, and with an unclear division of powers between parliament and president. Reforms to the electoral system that began in 1993 led to reducing the number of parties in parliament, and passage of a new constitution in 1997 both diminished the president's power and consolidated Poland's parliamentary democracy.

Since that time, the party landscape has coalesced around the same two basic conflicts that had shaped party constellations in Western Europe: Class and religion. While the social democratic successor party to the former communists was able to still win a clear victory in the 2001 parliamentary elections, a subsequent major corruption scandal weakened it to such a degree that it has not been able to recover since. The party constellation since the 2005 parliamentary elections has been marked by the opposition between the secular liberal Civic Platform party (PO) of Donald Tusk (prime minister since 2007) and Bronisław Komorowski (president since 2010) on the one hand, and the religious conservatives from the Law and Justice party (PiS) of the twin Kaczyński brothers on the other. One twin, Jarosław, was prime minister in 2006–2007; his twin brother, Lech (president since 2005), died in an airplane crash in 2010. In the eastward enlargement of 2004, Poland became the largest Central and Eastern European country in the EU.

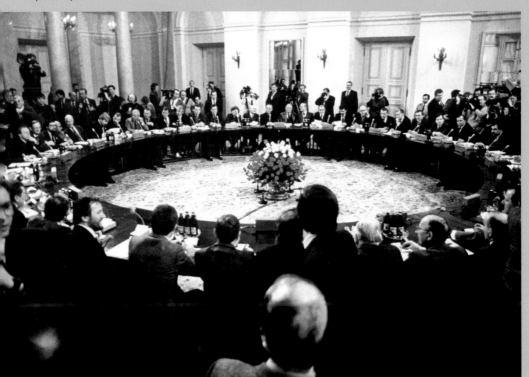

CHANGE IN GOVERNMENT Warsaw, 1989: Representatives of the Communist regime and the opposition negotiate for the first time at the Round Table, the latter led by the independent Solidarność union. The result of these meetings would be that Poland held its first free elections in 1989, and that Lech Walesa was elected, in 1990, as the first president of the Third Republic. Keystone

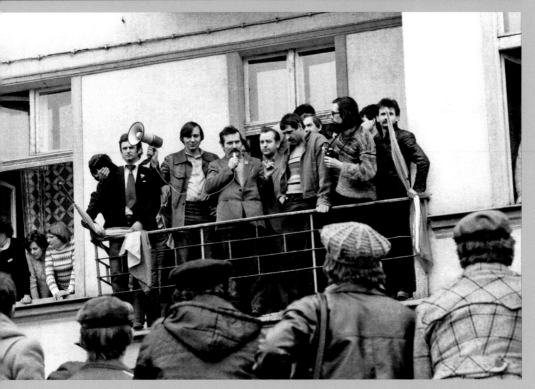

THE BEGINNINGS Bydgoszcz, 1981: Lech Walesa speaks from the balcony. In 1980, this union leader was able to obtain the right to found Solidarność, the first free union in the communist Eastern Bloc. In doing so, he set a chain of events in motion which first led to the government declaring a state of emergency. Yet by 1989, it led to negotiations with the government that ultimately resulted in free and democratic elections. Keystone/Ludomil Zolnowski

GREAT BRITAIN

Great Britain is the mother of all democracies. Democracy developed here before it did anywhere else–though in very small, incremental steps over many centuries. In the course of the nineteenth century, the right to vote was gradually extended to ever wider circles of the population, culminating finally in universal suffrage for men in 1918 and for women in 1928.

Great Britain is also the classic example of a democracy where parliament stands at the center of power. The citizens elect Members of Parliament (the representatives), who then select a Prime Minister and Cabinet that will govern the country. Since World War I, two major parties, the Conservatives and Labour, which stand opposed to one another, have provided the Prime Minister in turn. This concentration of votes on two large parties is the result of the British majoritarian electoral system. Members of Parliament are elected in single-member districts in which a representative of each party stands for election. The person who amasses the most votes is then the elected representative and takes a seat in Parliament. Smaller parties also exist in Great Britain but they generally have little influence. The manner in which British democracy is organized leads to a concentration of power in the hands of the Prime Minister.

This power concentration is reinforced by two factors characteristic of British democracy. The first is that Great Britain does not have a written constitution. Instead, its "constitution" consists of the manner in which the institutions that constitute the British state are understood and employed. The other is the fact that Great Britain is unitary, with power concentrated in the hands of the government in London. For that reason, its democracy has been called an "elective dictatorship" of the Prime Minister. Recent holders of that position include Margaret Thatcher (1979–1990), John Major (1990–1997), Tony Blair (1997–2007), Gordon Brown (2007–2010), and David Cameron (2010–).

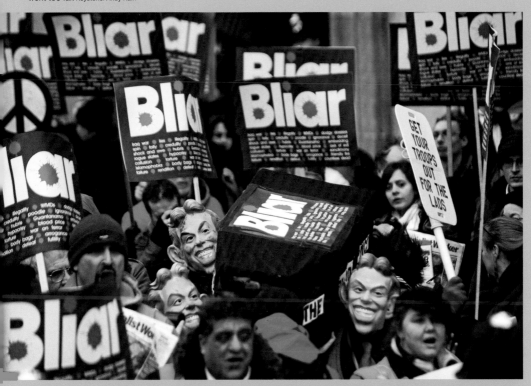

PARLIAMENTARY DEMOCRACY London, 2003: Demonstration against Great Britain's participation in the war against Iraq. Former Prime Minister Tony Blair is castigated as "Bliar" (Blair + liar) and as U.S. president George W. Bush's "poodle." Opponents of the war feel that in the course of the Iraq war, the "special relationship" between Great Britain and the U.S. went too far. Keystone/Andy Rain

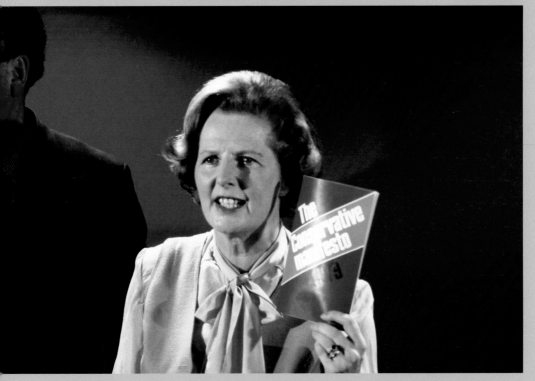

THE "IRON LADY" London, 1979: Margaret Thatcher presenting the campaign program for the Conservative Party, shortly before she became British Prime Minister. Thatcher epitomized the strong government leader. Nevertheless, she was toppled from power in 1990 by a vote of no confidence from within her own party in Parliament. Dukas

JAPAN

While the roots of Japanese democracy go back to the nineteenth-century Meiji Restoration, its current democracy was introduced, under American supervision, after Japan's defeat in World War II. Despite its non-Western cultural tradition, Japan's democracy and its political behavior are very similar to what one finds in Western parliamentary democracies. What is unique to Japanese democracy is the single-party dominance of the Liberal Democratic Party (LDP). It has ruled the country since 1955 with only two short interruptions (1993 to 1996; 2009 to 2012), and is a center-right party whose strongest support comes from the rural areas. The election of Junichiro Koizumi as prime minister in 2001, an outsider yet a reformer within the LDP, brought the party landslide victories and great popularity. The center-left Democratic Party, founded in 1998, whose support is largely urban, has been the largest opposition party since the 2000 elections. Though in power from 2009 to 2012, it was unlucky enough to have to deal both with the consequences of the economic crisis and with the disaster at the Fukushima nuclear power plant.

There are three key actors which determine Japanese politics: The major business enterprises, the state bureaucracy, and the LDP. The economy and the bureaucracy, of course, are also central to the political decision-making process in Western democracies. As far as the LDP's power is concerned, decisions are implemented only once the various internal party factions have reached a consensus. However, Japan has quite strong cultural and behavioral norms that prevent a "tyranny of the majority" from developing. As a rule, efforts are made in Japan to find nonpartisan compromises that the political opposition can also support. In the past, these kinds of compromises were sought particularly when the LDP held only a slim majority. The Japanese government is also often sensitive to protests that emerge from social movements.

CLEAR STATEMENTS Mass protests, unusual in Japan, after the Fukushima nuclear disaster in 2011 led the Japanese government to declare it would cease using nuclear power by 2040. Yet under pressure from industry, this decision was watered down soon afterwards. Panos/Adam Dean

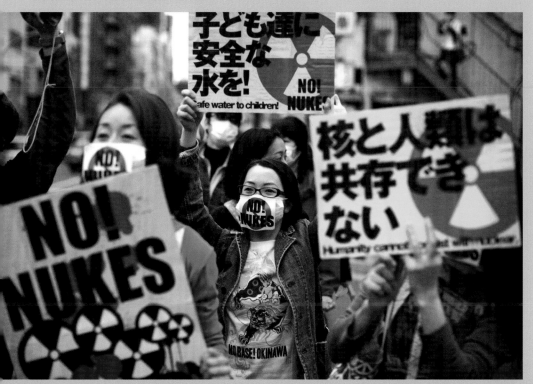

POSTWAR CONTINUITY Tokyo, 2005: Prime Minister Junichiro Koizumi of the Liberal Democratic Party (LDP) and opposition leader Katsuya Okada of the Democratic Party in Parliament. Since the end of the Second World War, the LDP, a catch-all party which encompasses differing political orientations, has ruled Japan almost without a break.

Keystone/Itsuo Inouye

USA

The American president is generally regarded as the most powerful man in the world. He is not only the head of state and head of government but also commander-in-chief of the most powerful armed forces in the world, head of one of the two political parties, the "voice of the people," and one of the leading figures in the world. He has considerable veto power over legislation and, owing to his central public role, can exert pressure through the media on Congress. Yet in reality, the power of the American president is less extensive than it appears. His power is limited through an extensive system of checks and balances and by a sharp separation of powers. The president is confronted with the strongest legislature in the world, to which even the constitution gives primacy, and with a very influential Supreme Court.

The strong separation of powers in the United States becomes particularly problematic when the two houses of Congress are not controlled by the president's party, as has been the case during more than half the last fifty years. In this "divided government," American democracy can function only if Congress and the president, after extensive negotiations, can find a bipartisan compromise. Given the increasing polarization between the two parties in the last few years, compromising has become increasingly difficult, however, with grave consequences for the ability of the American democratic system to function. Thus, shortly before Christmas in 1995, the federal administration had to shut down briefly because a Republican-dominated Congress was not willing to reach a compromise in budget negotiations with Democratic President Clinton.

The end of 2012, marking the end of President Obama's first term, saw a renewed showdown during budget negotiations between the Democratic president and a Republican-dominated House of Representatives. Only at the last minute could a compromise be found over the tax increases needed to reduce the deficit. With this, the fall off the so-called "fiscal cliff"–the automatic implementation of a series of fiscal measures and cuts, with unforeseeable economic consequences–could be, for the moment, prevented. The compromise was only a partial solution. Planned budget cuts affecting all governmental sectors, but in particular targeting military expenditures, were postponed. After fruitless negotiations between the adversarial parties and institutions, however, they nevertheless came into effect on March 1, 2013. Further conflicts between Congress and the president over financing the American government are preprogrammed, and a way out of the deadlock can be found only if the adversarial parties can pull themselves together and find cross-party compromises.

THE MOST POWERFUL MAN IN THE WORLD? Washington, D.C., 2012: President Obama in the Cabinet Room of the White House. The U.S. President faces a strong legislature, the Congress, and a powerful Supreme Court. If executive and legislature are not of the same party, compromises must be found; if not, government may be blocked from carrying out its policies. Getty Images/Pete Souza

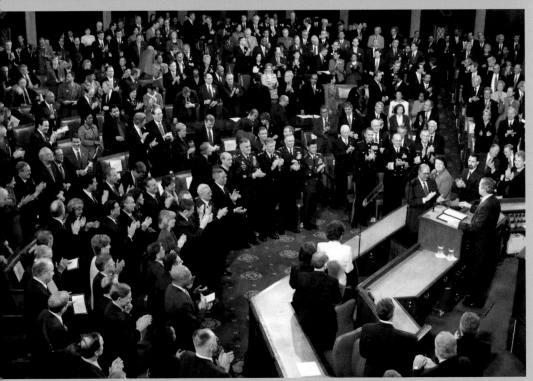

PRESIDENT AND CONGRESS Washington, D.C., 2001: President Bush presenting his tax reducation plan to Congress. Whether social expenditures should be increased or taxes lowered is an important and recurring point of contention between Democrats and Republicans. Reuters

SWITZERLAND

Switzerland, as currently constituted, came into being in 1848 after a short, bloodless civil war, in which modernizing liberals were victorious against Catholic conservatives. The two camps, after the end of the war, reconciled and created a central national government that was initially weak but that grew stronger over the decades. The cantons, the territorial entities in the country's federalist system, nonetheless remain to this day important counterweights to the power of the center. Switzerland also has a unique political system characterized by federalism, direct democracy, a consensual form of government, and neutrality in foreign policy. Switzerland is the prototype of consensual democracy, a form of democracy that divides and decentralizes political power to as great an extent as possible. For more than fifty years, Switzerland has been governed by a grand coalition that includes the four major political parties. It also has a unique hybrid government system that is unlike the more common parliamentary and presidential systems. The government, a seven-person council, is elected every year from among the members of the lower house of parliament, but once elected, they cannot be removed from office during their legislative term.

Switzerland distinguishes itself most from other democracies, however, in its direct democratic processes that give citizens the possibility of being directly involved in the law-making process at local, cantonal, and national levels. With the help of referendums, the Swiss can force binding plebiscites to be held on laws passed by parliament, and with the help of initiatives, can even suggest changes to the constitution, on whose enactment all citizens then can vote. Other countries have direct democratic procedures, but the form they take in Switzerland is particularly attractive because it allows for an interplay between direct and representative democracy. Unlike purely plebiscitary processes, Swiss democracy cannot be simply exploited by the political authorities. Unlike populist processes, as exist in some of the U.S. states, direct democracy in Switzerland also is not entirely outside the control of the parties and the political authorities.

A very strong form of federalism is also unique to Swiss democracy. Switzerland is the smallest of the federalist countries, and quite diverse political structures have developed over the centuries. While a highly developed decentralization has brought government closer to the citizens, it has the disadvantage in the Swiss case that the federalist structures no longer correspond to the current structure of society and they act to preserve traditional privileges that have long since been superseded.

CONSENSUS DEMOCRACY The Swiss government, the Federal Council, during its annual outing. Decisions made by the Federal Council are collectively supported by all seven of its members, even though they belong to quite different political parties. Adrian Baer

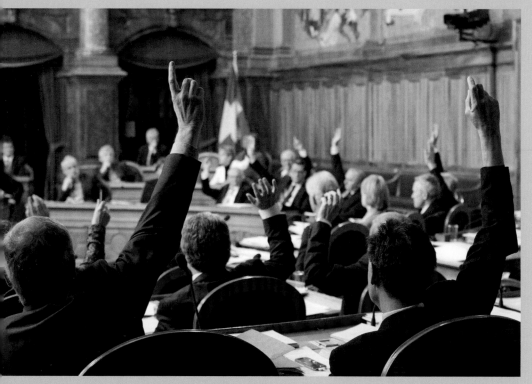

THE POWER OF THE CANTONS Bern, 2013: In the Council of States, the upper house of the Swiss parliament, each canton is represented equally. Small cantons thus have a disproportionate influence. Swiss federalism gives cantons considerable power. Keystone/Lukas Lehmann

TURKEY

In many ways, Turkey is a special case. Together with Indonesia, it is among the few functioning democracies in the Islamic world, though one with undeniable shortcomings. Though Turkey became a republic as early as 1923, it was a very long time until democracy prevailed. Until the end of World War II, Turkey remained an authoritarian single-party state, dominated and controlled by the Republican People's Party (CHP), a party created by the founder of the republic, Mustafa Kemal, known as Atatürk. Not until 1946 were other parties even tolerated. But even in the postwar era, democratic party competition could not develop unimpeded. The Turkish military intervened in civilian government three times (1960, 1971, and 1980), as it saw itself as the guardian of the principles of the founder of the modern Turkish state (which included, among others, a strident nationalism and strict laicism) and briefly assumed political power directly. The armed forces also indirectly controlled politics even after the politicians regained control over the levers of power: A "state within a state" was created, a "deep state" that retained control over politics. This "state within a state" first turned its attention primarily to putting down the uprising of the Kurds, led by the Kurdistan Workers' Party (PKK), a conflict that broke out in 1984 and still continues today. It also opposed left-wing extremist and Islamicist parties of all kinds.

In 2002, for the first time, the elections were won by an Islamic-leaning party: Recep Tayyip Erdoğan's Justice and Development Party (AKP). It has ruled Turkey since, increasing its share of the vote in both 2007 and 2011. The Kemalist CHP, a secular, nationalist, and social democratic party, has been the largest party in opposition. The AKP, which sees itself as representing conservative and neoliberal values, has increasingly moved toward becoming a party of reform and of the "new Turkish center," doubtless encouraged also by the prospect of joining the EU. The Turkish military remains wary of the party, though the AKP has taken decisive steps to modernize Turkey. When the AKP decided to name Foreign Minister Abdullah Gül president in 2007, there was a spectacular showdown, with the military making very clear that it would not accept a president whose wife wore a headscarf. But the AKP withstood this pressure, and when the constitutional court blocked the election, the party decided to dissolve parliament and call for early new elections. Its landslide victory not only made the election of Gül as Turkey's president possible, but also marked a milestone on the path toward curbing the political power of the military.

Turkey was officially recognized as a candidate for full membership in the EU in 1999. Official accession negotiations began in 2005, but have moved at a very slow pace, and with no end in sight. Various European countries, such as France under Nicolas Sarkozy, Germany under Angela Merkel, as well as the Netherlands and Austria have expressed strong reservations about Turkish membership, and have raised other possibilities of a "privileged partnership" for Turkey. The prospect of having Turkey—a large, relatively poor (as compared with Western Europe) and predominantly Muslim country—as an EU member has raised concerns across Europe. Turkey for its part wishes to be a full member and wants nothing to do with a "privileged partnership." Given the European reservations, Turkey's initial enthusiasm for EU membership has cooled markedly. The AKP regime was challenged in June 2013 by nationwide mass protests on the part of modern, secular forces in the country who rebelled against the increasingly authoritarian tendencies of Erdoğan's government. The government responded to this "crisis in growth," one comparable to the "May 1968" French protests, with repression rather than with reforms.

FOUNDER OF THE STATE Istanbul, Turkey, 2013: In justifying the removal of the occupiers of Gezi Park in Istanbul, the AKP-dominated Turkish government made references to Mustafa Kemal Atatürk, the founder of the modern Turkish state. Atatürk had called for a democratic and secular republic modelled on Western nation-states. Reuters/Yannis Behrakis

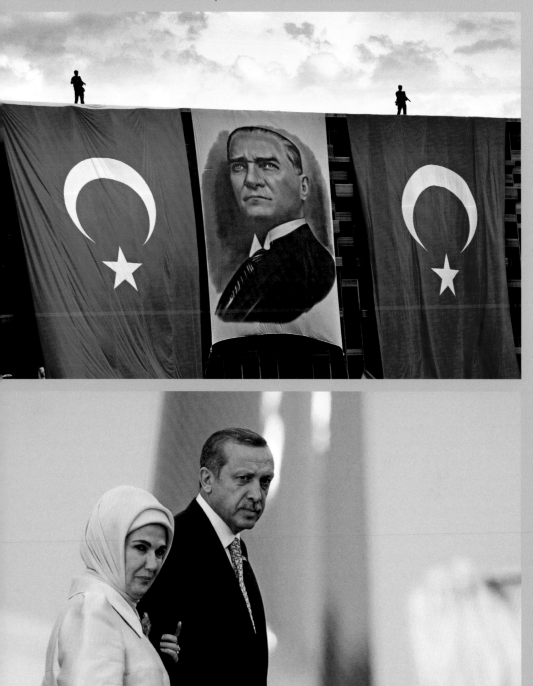

A CONTROVERSIAL PRIME MINISTER Prime Minister Tayyip Recep Erdoğan (AKP) and his wife Emine, 2013: The AKP was founded in 2001 and has dominated Turkey's politics for more than a decade. It has taken a stance against the strict laicism practiced in the country since Atatürk's day. However, Erdoğan has been accused of massively limiting the freedom of the press, and his authoritarian leadership style provoked numerous protests and demonstrations in 2013. AFP Photo/Fethi Belaid

BRAZIL

In Brazil, the transition to democracy in its present form was particularly long. In 1964, the military seized power in a coup, but the transition to democracy began only in 1974 with General Ernesto Geisel's presidency. During a transition period that lasted for sixteen years, the military regime gradually made concessions to the population. Finally, with the direct election of Fernando Collor de Mello in 1990, Brazil finally returned to being a genuine democracy.

Like all other countries in Latin America, Brazil has a presidential democracy. The Brazilian president is generally regarded as quite strong, as the constitution grants the president broad powers. Thus, the president can veto parts of laws that he or she disagrees with, and that veto can be overridden only by a two-thirds majority. The president can also make new laws by decree in practically all policy areas. However, while the president is formally quite powerful, the large number of political parties, weak party discipline, and federalism limit the exercise of that power.

The large number of parties is also the reason that the president cannot readily rely on a majority in parliament. During President Lula's tenure, for example, his Workers' Party had only about one-sixth of the votes in parliament. As a result, presidents need to forge multi-party coalitions. Owing to highly developed federalism, they also must pay attention to the strong regional interests in the country, which one can see in the selections made for ministerial and other high political offices. Dubious practices, including vote-buying, are often used to create parliamentary majorities in Brazil.

After two failed attempts in 1994 and 1998, in which he lost to his rival Fernando Henrique Cardoso, Lula da Silva was elected Brazilian president in 2002 and was reelected in 2006. Under pressure from Lula, his Workers' Party moderated its formerly quite leftist position and moved toward the center, and this was key to his victory. Lula was an extraordinarily beloved president, whose personal popularity far exceeded that of his party. Yet Lula, too, was reliant on corrupt practices such as buying the votes of members of parliament to get his policies enacted. This came to light in the so-called *Mensalão* ("big monthly payment") scandal in 2005, which almost brought down Lula's government. Under Lula's successor, Dilma Roussef, elected president in 2010 and also from the Workers' Party, the series of corruption scandals has not ended, though they were not of the magnitude of the *Mensalão* scandal. In June 2013, for the first time since the end of the military dictatorship, enormous popular protests erupted against this corrupt system. What began as local protests against price increases in the public transportation system soon spread and became a nationwide mobilization against a corrupt political system which allows the educational system and public services to decline while it wastes money on luxurious soccer stadiums.

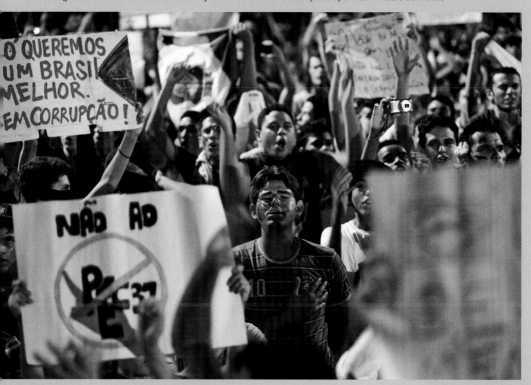

PUBLIC PROTESTS Fortaleza, 2013: Demonstrating against official corruption and irregularities as well as against the rising prices of public services. The latter was particularly aggravating as it took place at the same time as massive investments were being made in the infrastructure necessary for the soccer world championships in 2014. Reuters/Davi Pinheiro

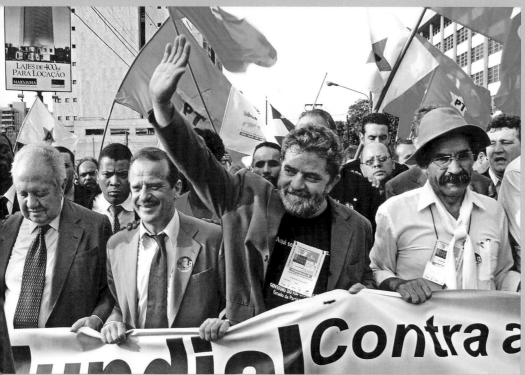

A BELOVED POLITICIAN Luiz Inácio Lula da Silva, known simply as Lula, was elected Brazilian president in 2002. His term in office was marked by successful efforts to reduce poverty while increasing economic growth at the same time. Lula was the most popular and beloved politician Brazil has ever had. Keystone/Vanderlei Almeida

More Appearance than Reality?

Wolfgang Merkel

The triumph of democracy at the end of the twentieth century was impressive. In 1989, Freedom House identified 69 nations as "electoral democracies," and by 2000 that number had nearly doubled. If it is minimally defined as involving regularly recurring and free elections, then one can find 120 democracies in the world. Since 2000, the number of electoral democracies has fluctuated between 123 (2005) and 115 (2010).

Yet such a minimal definition of democracy is problematic, as it encompasses quite varied ways of organizing political life under the rubric of "democracy." The examples of Finland, Sweden, and Switzerland on the one side, and Indonesia, Paraguay, Mali, or Turkey on the other (in 2010) indicate the breadth of such "electoral democracies" as well as the differences between them. In fact, many forms of political organization emerged during the wave of democratization at the end of the twentieth century, which, though they formally came about in free and moderately fair elections, nevertheless had considerable shortcomings in other central features of democratic political systems such as upholding the rule of law, checks and balances, and individual civil liberties.

Hence there has been a debate since the mid-1990s in political science focused on "illiberal," "delegative," or "defective" democracies. If one speaks of "defective democracies," then one must be able to show which areas are defective, what this means overall for democratic rule, and which basic model of democracy underlies such an analysis. In what follows, the basic model is an intermediate one that can be called "embedded democracy."

PRECONDITIONS FOR A FUNCTIONING DEMOCRACY: "EMBEDDED DEMOCRACY" AS A BASIC IDEA

The idea of embedded democracy is that stable democracies which adhere to the rule of law are embedded in two senses. *Internally*, the individual areas (partial regimes) secure their existence through functional interaction with the other areas, while *external* embedding means the partial regimes of a democracy are embedded within structures that provide the preconditions that make democracy possible. The areas are thus protected from external as well as internal shocks and tendencies toward destabilization.

The Partial Regimes of a Democracy

As one can see in Figure 1, five partial regimes define embedded, rule-of-law democracy: (A) A democratic electoral regime; (B) a regime of political participation rights; (C) the partial regime of civil rights and liberties; (D) an institutional guarantee of horizontal accountability; and (E) a guarantee that, both *de jure* and *de facto*, the effective power to govern lies in the hands of democratically elected representatives. This classification makes clear that the idea of embedded democracy goes beyond a minimalist understanding of democracy. Nevertheless it is "realistic," because it refers exclusively to institutional architecture and does not include outputs or desired political results in defining a rule-of-law democracy. The welfare state, fairness in the distribution of economic goods, or "social justice" may well be desirable policy results of a democratic decision-making process, but they are not constitutive of embedded democracy.

A. The electoral regime

The electoral regime occupies a central position in democracy because elections are the most visible expression of popular sovereignty. Beyond this, open, pluralistic competition for key leadership positions is what distinguishes democratic from dictatorial rule. A democratic electoral regime calls for universal active and passive suffrage as well as free and fair elections, but while this electoral regime is necessary, it is by no means a sufficient condition for democratic rule.

B. Political participation rights

The rights of political participation, which are the preconditions for elections and extend beyond the right to vote, round out the vertical dimension of democracy. They create the public arena as an independent political sphere of action in which organizational and communicative power unfolds. In that sphere, the collective processes of opinion-shaping and decision-making both determine and support competition for positions of political power. More specifically, these processes embody the unlimited

validity of the right to freedom of speech and opinion, as well as the right of association, and the right to demonstration and petition. In addition to public media, private media must also be accorded their weight.

C. Civil rights and liberties

Democratic elections and political participation must be augmented by civil rights and protections. As "negative liberties" asserted against the state, such civil rights help curb governmental claims to power. The protection of individual rights guarantees the legal protection of life, liberty, and property, as well as protection against wrongful arrest, exile, terror, torture, or invasion of privacy without just cause. These basic individual rights help tame majoritarian power cycles and prevent a "tyranny of the majority" (Tocqueville).

D. Division of powers and horizontal accountability

The fourth partial regime in a rule-of-law democracy consists of the rules governing the horizontal division of powers. This separation relates to the

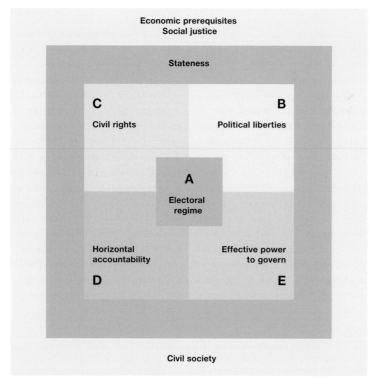

1 **THE CONCEPT OF "EMBEDDED DEMOCRACY"** For a democracy to function and be stable, multiple factors are necessary: Elections alone do not make a democracy. Rather, futher elements internal to that nation-state or to a "partial regime" are necessary, as are external factors, and only when they work together is a stable democracy possible.

structure of power and involves the lawfulness of government actions as well as checks on that action, in the interests of a balanced mutual dependence as well as autonomy of legislative, executive, and judicial functions. In this manner, the accountability and responsibility of a government are not just ensured periodically through elections, but are continually guaranteed through constitutional bodies that mutually control one another and limit the exercise of executive power.

E. The effective power to govern

The fifth partial regime stipulates that only those persons, organizations, and institutions which have been legitimated through free elections are empowered to make binding political decisions. This affects, for example, the military, but also powerful corporations, banks, or financial funds, which are not subject to democratic accountability. The effective power to govern possessed by democratic authorities is a necessary component of *embedded democracy*. This is particularly evident in many new democracies in Latin America, East, South, and Southeast Asia, where the military still (at least in part) retains autonomous competence over foreign and national security policy-making.

THE INTERNAL AND EXTERNAL EMBEDDEDNESS OF DEMOCRACY

The partial regimes described above cannot function with full effectiveness in a democracy unless they are mutually embedded. Democracy is thus understood not as a homogeneous regime but as an aggregate of partial regimes that both mutually reinforce and limit one another. Every democracy is also embedded in a surrounding environment, both stabilizing and making sure that democracy possible —or hindering and destabilizing it. This environment creates conditions of possibility or impossibility, and can improve or worsen the quality of rule-of-law democracies. The most important of these external embedded spheres are the socio-economic context, civil society, and international integration. Damage to, or under-development of, this external embedding often impairs democracy itself.

DEFECTIVE DEMOCRACIES

If a partial regime of an embedded democracy is so damaged that it changes the entire logic of that de-

mocracy, then one can no longer speak of an intact constitutional or rule-of-law democracy. From this perspective, defective democracies are democracies in which the partial regimes are no longer mutually embedded, and the logic of a rule-of-law democracy is disrupted. Defective democracies are characterized by the existence of a democratic electoral regime that functions, at least to a large extent. Yet because of disturbances in the operating logic of one or more partial regimes, that democratic electoral regime has lost the complementary and indispensable supports which ensure the three essential principles of a functioning democracy: Liberty, equality, and checks on the exercise of power.

TYPES OF DEFECTIVE DEMOCRACY

One can distinguish four types of defective democracy: Exclusive, enclave, illiberal, and delegative.

Exclusive democracy: Since the basic principle of democracy is popular sovereignty, this must be ensured through universal suffrage, implemented in a fair manner. If certain segments of the adult citizenry are excluded from the civic right of universal suffrage, this will not be the case. On the other hand, one cannot simply assume a dictatorship exists if 5 to 10 percent of the permanent residents in a country are excluded from the franchise or if there are minor electoral manipulations. This form of defective democracy has become rarer in the twenty-first century, since even dictators increasingly allow themselves to be elected. Particularly egregious examples in the second half of the twentieth century existed in the racist "democracies" of South Africa or Rhodesia. Far milder forms can be seen today, such as in Latvia, where the Russian minority, often born in Latvia, have found their rights to participate politically or to vote denied or bureaucratically blocked ever since the regime changed in 1991. A further, elite-oriented, democratic defect can be seen in Thailand: Only those citizens who have at least a bachelor's degree or higher education qualifications can be elected to the National Parliament.

Enclave democracy: If those who hold veto power—such as the military, guerrillas, militias, businessmen, large landowners, or multinational corporations—over certain political or economic domains deprive democratically legitimized representatives of access to them, then non-democratic enclaves will be created. Enclave democracy is a regionally specific

type found particularly in Latin America (for example in Chile immediately after Pinochet) and Southeast Asia (for example in Indonesia), in cases where the military often claims a political veto role for itself and evades civilian and democratic control. International financial actors or multinational corporations also become a problem for democracy in a globalizing era, because they increasingly influence the economic and financial policies of sovereign states.

Illiberal democracy: An illiberal democracy is found in incomplete constitutional states and damaged rule-of-law states in which the judiciary has little ability to limit the powers of the executive and legislative branches. The binding impact of the constitution on the actions of government and on lawmaking is low. Individual liberties and civil rights are partially suspended. Illiberal democracies are marked by a damaged constitutionalism, which affects the core of the liberal self-image, namely equal individual liberty. Illiberal democracies are the most common type of defective democracy, and can be found throughout the world: Examples include South Korea, Peru, Ukraine, and Turkey.

Delegative democracy: In a delegative democracy, the legislature and judiciary exercise only weak control over the executive. The binding impact of the constitution on governmental actions is low. The division of powers, which functioning democracies need to maintain through balanced political representation, is undermined. Governments, often led by charismatic presidents, circumvent parliament, influence the judiciary, infringe on the principle of legality, undermine checks and balances, and shift the balance or equilibrium of power in favor of the (presidential) executive. The voters, or the population at large, then "delegate" sovereignty to a charismatic or even demagogic leader, whether president or prime minister. Russia under Vladimir Putin, or Venezuela under Hugo Chávez and his successor are contemporary examples of such highly defective democracies.

REASONS FOR THE DEVELOPMENT OF DEFECTIVE DEMOCRACIES

Defective democracies often emerge from incomplete transformations of dictatorships into democracies, as in Russia, Nicaragua, Thailand, and Turkey. Less common is the decline of a once-functioning democracy, as in Venezuela or Israel (which have slight defects). There is no one factor one can point to as the primary cause for the emergence of defects in either newer or established democracies. Instead, it is usually a mix of causes that provide special opportunities for certain political actors to usurp power, suspend constitutional norms, or to dismantle checks on the exercise of power. Empirical research shows that particular developments may lead to serious deficiencies in democracies, as follows:

– *The path to modernity:* The likelihood that a defective democracy will emerge in a country increases if its path to socioeconomic modernization remains incomplete and produces acute power imbalances, and if the property-owning classes regard democracy as a threat to their economic and political interests. This has been, and continues to be, the case particularly in Latin America, Asia, and Africa.

– *The level of modernization:* The lower the level of socioeconomic development, and the more unequally resources (or affluence) are distributed, the more likely defective democracy will emerge. An asymmetrical distribution of economic, cultural, and cognitive resources promotes an unequal distribution of the political resources needed to act and exercise power. It further compli-cates the implementing of constitutional and democratic standards. Such inequality can be found particularly in Latin America and Africa.

– *Economic trends:* Economic crises provide incentives to institutionalize defects in unstable democracies. They are often seized upon as occasions for decreeing the need to have special powers or to issue emergency decrees, particularly in presidential and semi-presidential systems. Such special executive powers are usually extended beyond the end of the (alleged) emergency. One can find numerous examples of this even today in Latin America, but examples from the presidential systems of Eastern Europe, Ukraine, Russia, and Georgia also exist.

– *Social capital:* The likelihood that defective democracy will emerge is related to the type and extensiveness of social capital historically accumulated in a society. Social capital, which refers particularly to the trust citizens have in one another, often exists in societies that are ethnically or religiously segmented. Relations of trust between citizens who belong to differing religions

and ethnic groups occur only rarely. This favors the emergence of defective democracy as well as discrimination against minorities. Numerous African societies and the newer democracies in the post-socialist successor states are marked, or marred, by such defects.

– *Civil society:* A low level of trust between citizens makes it more difficult to develop an institutionalized system of political parties, interest groups, and civil society associations. Important pillars for exercising and guaranteeing political and civil rights are then absent. In a political and cultural context of this kind, a window of opportunity opens for charismatic and populist leaders who then rule by executive decree and bypass parliament, as has been true in Russia under Yeltsin and Putin, as well as in Asia and Latin America repeatedly over the last twenty years. Such behavior in weak civil societies is frequently more rewarded than punished at the ballot box.

– *Nation and state building:* The conditions for developing into a liberal democracy without serious defects are particularly poor when the transformational process is burdened by unresolved identity and statehood crises in the political community. Secession efforts and discrimination against minorities damage indispensable civil liberty standards as well as the right to participate politically, as has been evident in the Balkans, in Russia, and in the successor states to the Soviet Union in the Caucasus.

– *The type of authoritarian predecessor regime:* The longer totalitarian, post-totalitarian, or authoritarian regimes cling to power, and can hence put their stamp on political culture, the more likely it is that defects will exist in the democratic regimes that follow. Post-authoritarian societies have a tendency to bestow rewards in the electoral arena on executives who circumvent checks on their power, and who use "delegative" forms of rule. Russia, with its long authoritarian tradition, is a prime example.

– *Political institutions:* The more clientelism, patrimonialism, and corruption shape elite behavior vis-à-vis the citizenry, the more difficult it is for the new "formal" institutions to develop power, prestige, and effectiveness. Informal institutions threaten to distort and displace the function and functioning of the formal, democratically legitimized institutions. In key decision-making areas, democracy then operates following informal, unlegitimated, institutions and rules, while the formal democratic institutions degenerate into window dressing. This is partly the case for Greece, but in an intensified form it will hinder the democratization of countries such as Egypt or Tunisia.

– *International and regional context:* Where regional institutions such as the EU or the European Council are weak or lacking, and therefore cannot protect liberal and democratic institutions, broader scope for action is left open to governments to violate the rules governing such democratic institutions, because the cost of acting undemocratically has dropped significantly. This is less true of mature democracies such as Switzerland, but it exists among newer democracies whose institutions and democratic political culture have not yet stabilized or been consolidated, as in Asia, Africa, and Latin America.

CONCLUSION

Defective democracies are not necessarily transitional. They may be able to form a stable relationship with their environment and be regarded, by decisive segments of the population, as an appropriate answer to the extreme number of problems left behind by a predecessor's autocratic regime. Russia under Putin is a notable example, though something similar can be said of Indonesia, Bolivia, Ecuador, or Thailand, and will be a particular problem among the post-authoritarian regimes in North Africa. Defective democracies constitute about half of all electoral democracies at the outset of the twenty-first century. They often lack the socioeconomic preconditions that allow for a more rapid transition to a constitutional or rule-of-law democracy. Deficits in statehood, polarized ethnic diversity, and religious cultures with inadequate secular constraints, too, often prevent consolidation of democratic commonwealths. If one speaks of "democracies," then one needs to distinguish between embedded constitutional or rule-of-law democracies and defective democracies. The differences, for example, between how Russia and Switzerland are governed are surely no less significant than those between the Russian regime and the openly authoritarian regime of the People's Republic of China. Yet without the idea of a "defective democracy," it will be difficult to draw these important distinctions.

Vote!

Elections form the core of each and every democracy. In representative democracies, the citizens choose the representatives of the people and/or the government or the head of government, to serve for a specific term in office. In direct democracies, they can also vote directly on substantive issues.

As a basic principle, elections should be general (all citizens can vote), equal (each citizen has a vote, and each votes carries equal weight), free (the casting of a valid vote is not coerced), secret (no one can see for whom one votes), verifiable (voters can personally satisfy themselves that the specified criteria have been adhered to, and the election results), and fair (no arbitrary disqualification of candidates; equality in the means used to communicate with the voter).

A comprehensive infrastructure is indispensable to ensure there is compliance with these criteria and that the election results cannot be manipulated. All citizens must be guaranteed an opportunity to cast their votes—and only one vote per voter. Though elections and election advertising are mass events, voting itself stands in striking contrast. A citizen enters the voting booth alone and votes unobserved—each individual makes his or her own decision. The sum of all these individual decisions constitutes the result, in the end, and determines the winners and the losers of the election.

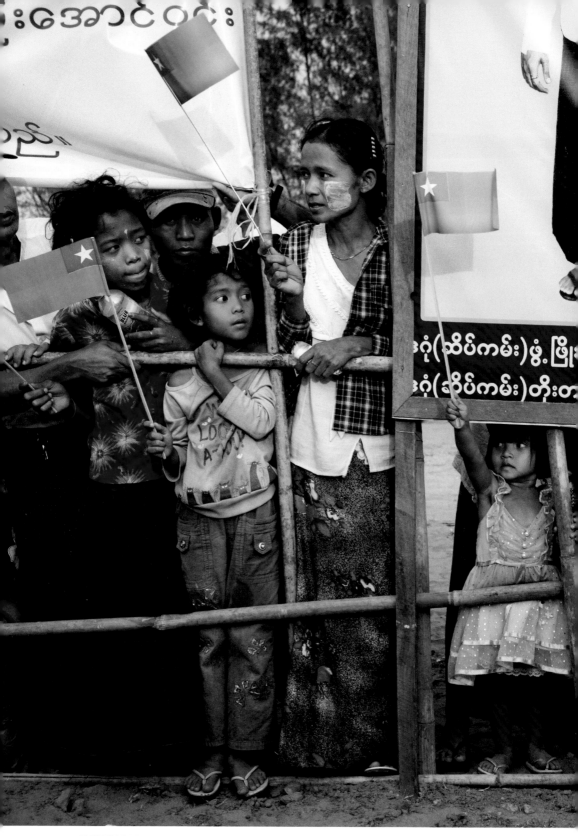

ELECTION CAMPAIGN

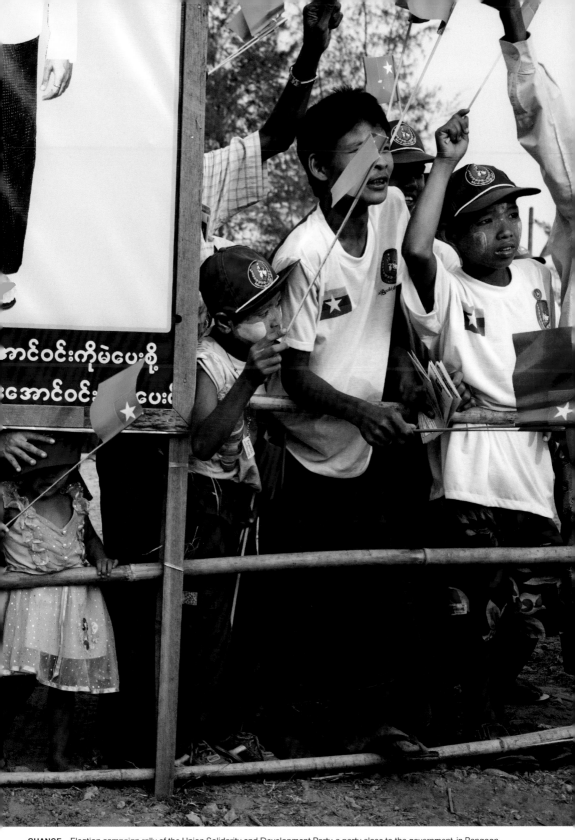

CHANGE Election campaign rally of the Union Solidarity and Development Party, a party close to the government, in Rangoon, Myanmar, 2012. Myanmar has been run for decades by a military dictatorship. In 2012, the oppositional National League for Democracy was allowed to participate in the elections for the first time since 1990. In fact, these were only by-elections to fill 45 of the 664 seats in the National Assembly, but it was regarded as a signal of a democratization of the country. VII/Adam Ferguson

FROM ONE TOWN SQUARE TO THE NEXT Finsterwalde, Germany, 2009: During her election campaign, Angela Merkel crisscrossed Germany. After the elections, which were held in the autumn of 2009, Merkel's CDU party was able to form a coalition with the small, liberal, FDP party. With this, Angela Merkel was confirmed in office as Chancellor. Panos/Stefan Boness

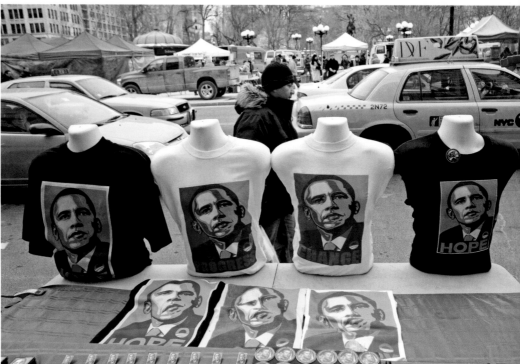

POLITICAL ICONS New York, New York, U.S. 2009: In American election campaigns, the person campaigning tends to be at the forefront more than the political program of their party. Panos/Natalie Behring

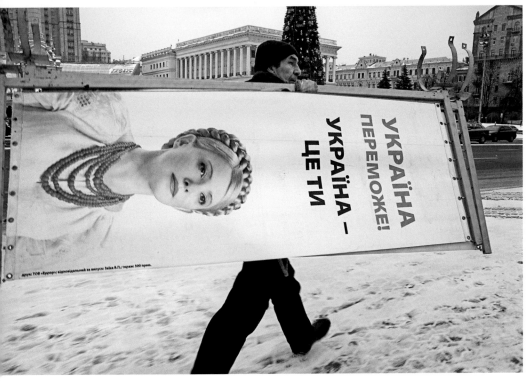

MEDIA ICONS Kiev, Ukraine, 2010: Prime Minister Julia Timoshenko, one of the key figures during the 2004 "Orange Revolution," made an unsuccessful bid for the presidency. As a result, Parliament declared it no longer had confidence in her government. In 2011, in a move regarded as politically motivated by both the EU and the U.S., Timoshenko was sentenced to a seven-year prison term for misuse of office. Panos/Iva Zimova

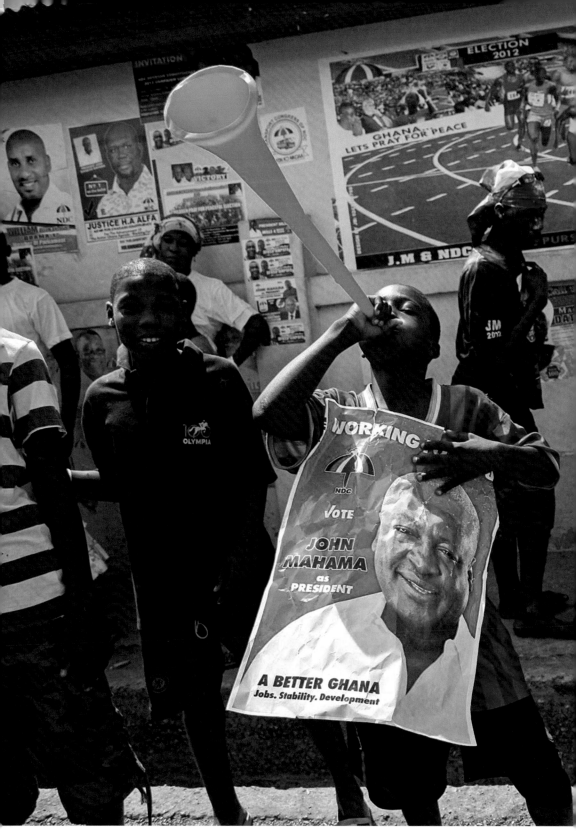

ELECTION DAY

VICTORY Accra, Ghana, 2012: Supporters of presidential candidate John Mahama celebrate his victory even before the official results are announced. Keystone/Legnan Koula

APPROVAL DENIED Penas, Bolivia, 2011: For the first time, Bolivians elect the supreme justices of their country. Evo Morales, Bolivia's first indigenous president and in office since 2005, had called for this election as part of a reform of the judiciary. Because the candidates selected by Parliament had no opposition representatives among them, this election became a political referendum. A clear majority of the votes were, in protest, submitted in forms invalidating them. Reuters/David Mercado

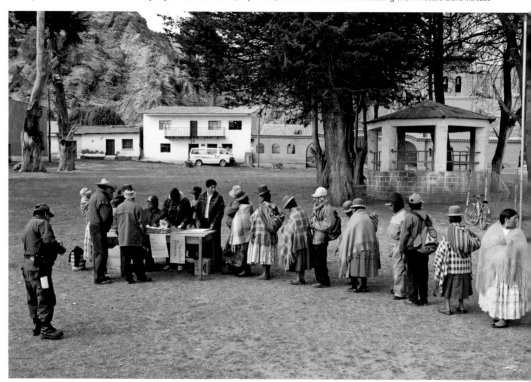

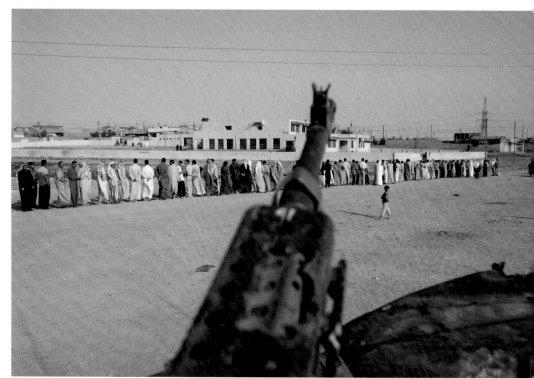

ENDANGERED BEGINNINGS Mosul, Iraq, October 15, 2005: The Iraqi people vote on the proposal for the constitution. The waiting line in front of the polling place is guarded by American soldiers. Noor/Yuri Kozyrev

FOR THE FIRST TIME Kabul, Afghanistan, October 9, 2004: In the first presidential elections in Afghanistan, there were separate waiting lines, as well as polling places, for men and for women. Hamid Karsai was elected President of Afghanistan.
Panos/Lana Slezic

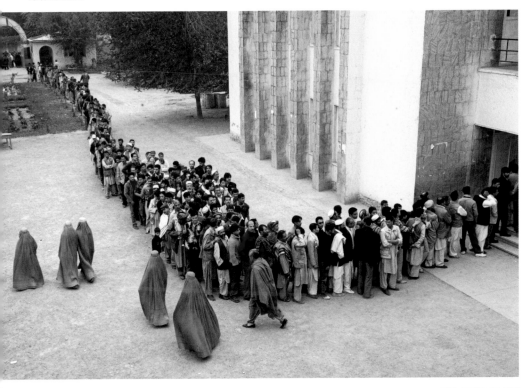

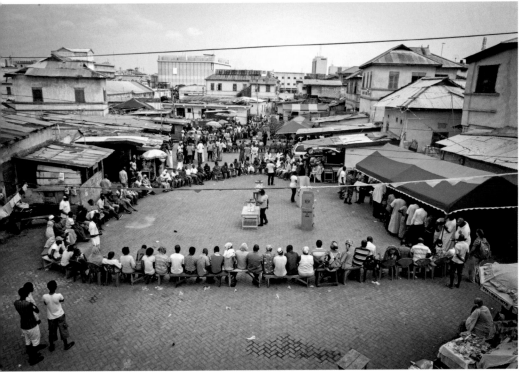

PATIENCE IS NEEDED Accra, Ghana, 2012: Long lines at the polling stations during the presidential election. Ghana is one of the few African countries that is regarded as a stable democracy. Keystone/Gabriela Barnuevo

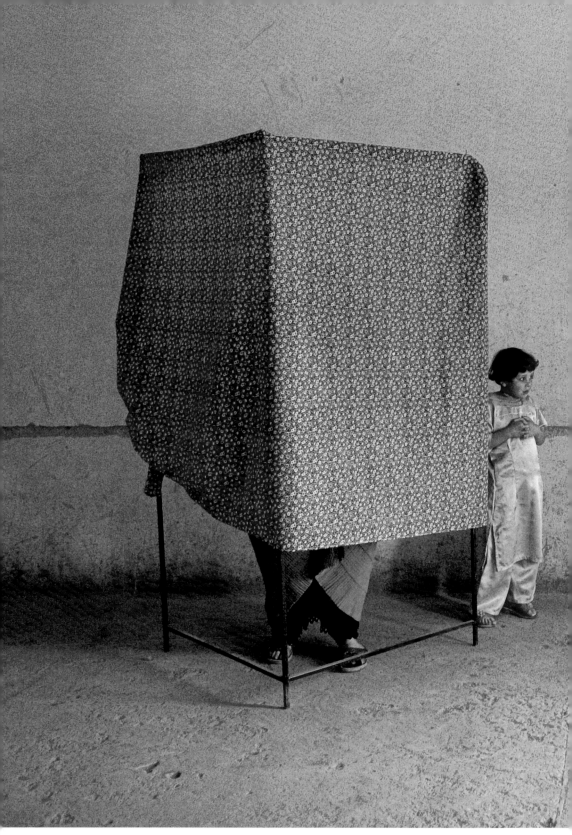

THE ELECTION

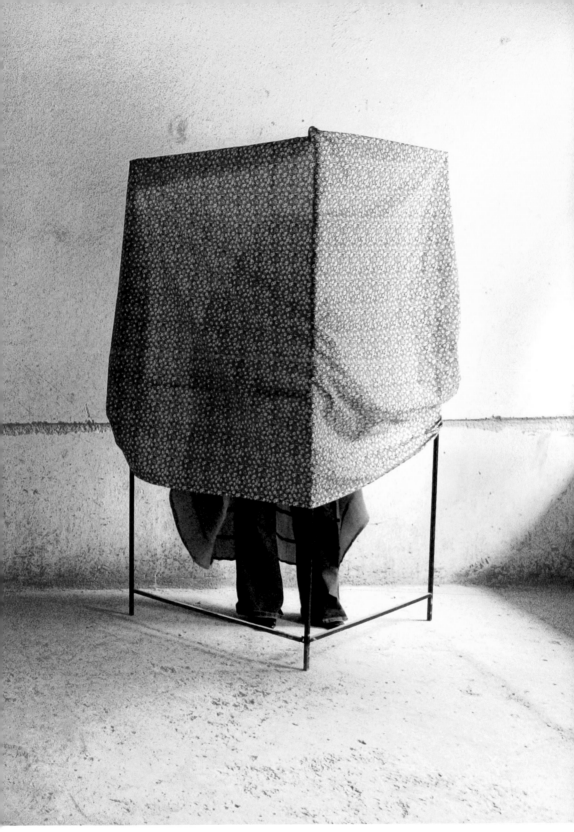

THE CITIZEN DECIDES Kabul, Afghanistan, 2004: Women in the election booths during the presidential elections.

Panos/Lana Slezic

IS DIGITAL BETTER? Columbus, Ohio, U.S., 2012: Some U.S. states use electronic voting machines. But the use of digital technology for elections has repeatedly led to controversy, since mistakes and manipulation cannot checked against existing ballot papers. Keystone/Darcy Padilla

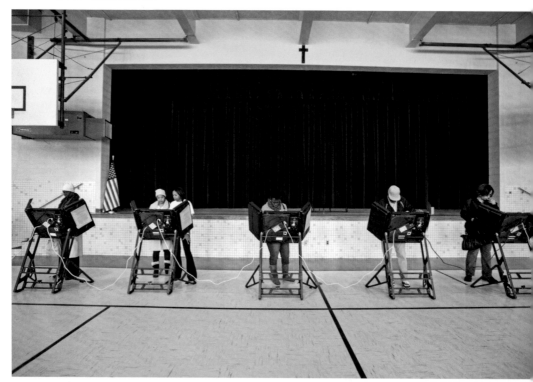

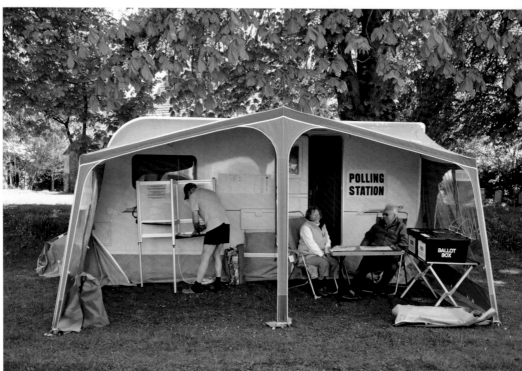

PRESENT EVERYWHERE Carlton, Great Britain, 2010: Mobile polling places for rural areas. Panos/David Rose

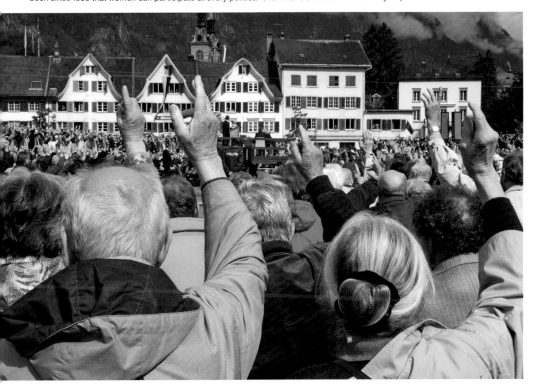

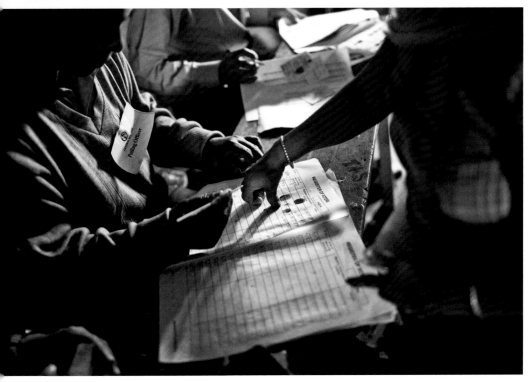

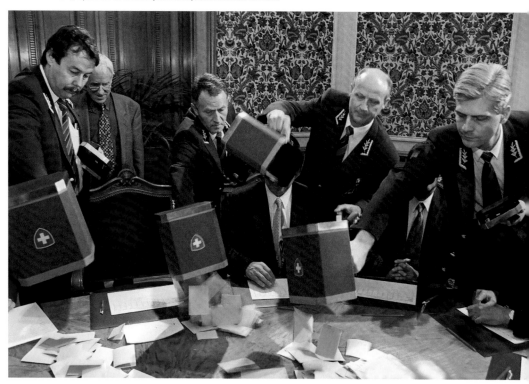

IN BLACK AND WHITE Bern, Switzerland, 1999: So-called parliamentary bailiffs (ushers) shown emptying the ballot boxes for a manual count in an election carried out by the United Federal Assembly. The vote counters, drawn from both House of Parliament, represent its various parties. Keystone/Alessandro della Valle

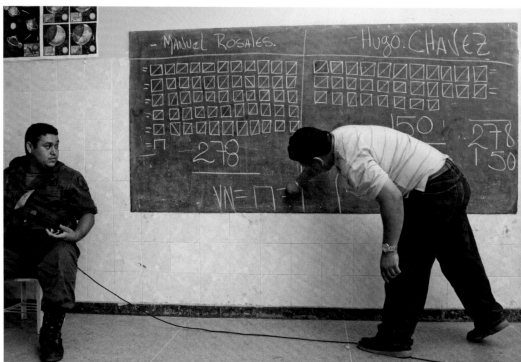

THE TOTAL DECIDES Maracaibo, Venezuela, 2006: A member of a polling station committee shown during an official examination of the cast ballots. Keystone/Leslie Mazoch

COUNTING THE VOTES

A LOGISTICAL CHALLENGE Kinshasa, Congo, 2006: The first democratic elections in the country in 45 years. A worker at a polling station watches over the ballot boxes. Having sufficient personnel and material is necessary in every election to make sure that all those eligible to vote can cast their ballots at the same time, as well as to protect the ballot papers from being manipulated and ensure they are correctly counted. Keystone/Michel Euler

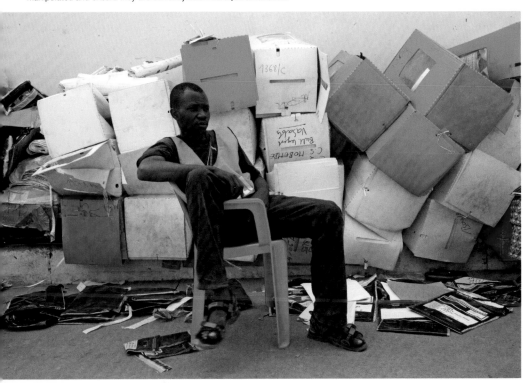

OFFICIAL PROCEEDINGS Chișinău, Moldova, 2009: When the ballot boxes are emptied, observers are always present to ensure that no manipulation of the votes takes place. Keystone/John McConnico

CONFIRMED IN OFFICE Chicago, Illinois, U.S., 2012: Supporters of re-elected President Barack Obama after his victory speech. Reuters/Kevin Lamarque

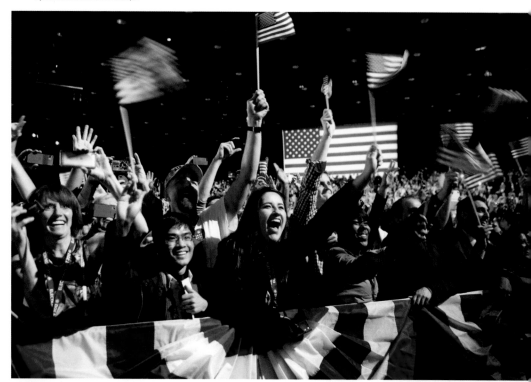

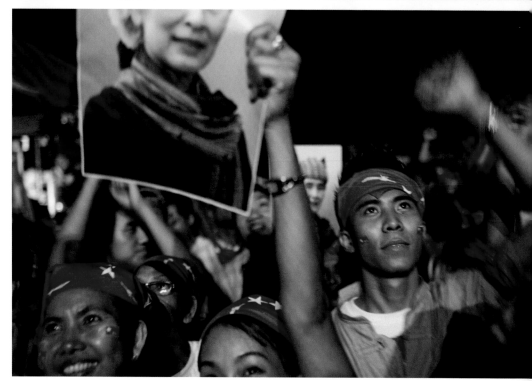

NEW EXCITEMENT Rangoon, Myanmar, 2012: Aung San Suu Kyi, daughter of the "Father" of modern Burma, and Nobel Peace Prize winner, was placed under house arrest by the military junta for twenty years. She won a seat in Parliament in the first partially free elections in the country since 1990. VII/Adam Ferguson

DEFEAT France, 2012: There is great disappointment among Nicolas Sarkozy's supporters as it becomes clear he has lost his re-election attempt. It is a mark of a strong democracy that the losers of an election accept and respect the results.
Laif/Ludovic

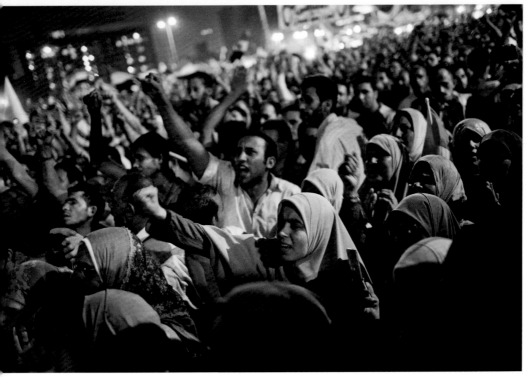

UNRULY TIMES Tahrir Square, Cairo, Egypt, 2012: Supporters of Mohamed Morsi celebrate his victory in the Presidential elections. A year later, and after days of popular demonstrations against his rule, he was removed from office on July 3, 2013, by the Egyptian army, and a transition government was installed. The future of democracy in Egypt remains unclear.
VII/Adam Ferguson

DEFEATED Paris, France, 2012: President Nicolas Sarkozy accepts his electoral defeat. Reuters/Yves Herman

THE VICTOR Tulle, France, 2012: François Hollande celebrates his electoral victory. Keystone/Guillaume Horcajuelo

In contexts beyond the classic definition of a Western form of government, can one still speak of democracy? Can one at least find elements of democracy in politically autonomous village communities uninfluenced by modernity? To answer this question, one needs to first provide a more abstract definition of democracy. Perhaps one can then identify structures that have at least some democratic aspects—even in village assemblies where collectively binding decisions are made, paternalistically, by the older men.

More specifically, can one ask whether the older men make and enforce binding decisions on their own, or whether, in that process, other members of the village participate sufficiently? Which decisions are made collectively in the village assembly, and which issues are settled in families, or bilaterally between families? Are decisions made based on existing majorities and minorities in the village? An examination of specific cases revealed that the younger men and the women, groups that are very little involved in decisions reached at village assemblies, nevertheless have direct influence at least over decisions reached within their own families. The village assemblies, by contrast, address conflicts—including accusations of witchcraft, claims of defamation, cases of adultery or theft, as well as questions of war and peace—that threaten the unity and social peace of the community. In such cases, the older men have the last word, and younger men as well as women can exert only indirect influence at best.

Even so, there are limits to the dominance of the older men in village assemblies. The heterogeneity of interests in village communities is not as extensive as it is in larger states, for the older men, in the end, also represent their own families. As such, they have to be concerned about balancing out interests and maintaining the ability of the village to act collectively. The power of leading personalities to make decisions exists only to the degree it is recognized by other villagers: Should a local leader misuse his authority, he loses it.

Finally, the collectively binding nature of decisions can be limited. Some men go on strike when a majority of the village decides to go to war, and a minority faction in the village can refuse to participate in a war as well—something not possible even in democratic nations. Minority factions even have the ultimate veto power to declare they will leave, and hence divide, the village—substantially weakening the majority that might like to go to war instead.

Traditional Forms
of Participation

Jürg Helbling

In many parts of the Third World, whether in East or Central Africa, Papua New Guinea, the Amazon basin, or Southeast Asia, village communities are (or are again) not under any effective control by a government, though they nominally belong to a nation-state. Papua New Guinea itself is a democratic state with a multitude of parties and regular parliamentary elections.

In Papua New Guinea, an electoral district consists of several dozen highland villages that send a representative to the national parliament. Practically every village tries to send its own candidate to the capital, Port Moresby, so the number of candidates is correspondingly high: It is not rare to have fifty or sixty vying for a seat. Each candidate tries to forge alliances between villages to increase his chances of getting elected. To obtain votes, candidates organize electoral events at which they pass out gifts in the form of food, beer, or cash.

A village often gives all its votes to a single candidate. Parliamentary seats are in great demand because the government makes a substantial amount of money available to representatives "to develop their electoral district." In the past, it was not unusual to have representatives then use this money primarily to improve the infrastructure either of the village they came from or of the village that helped them win the seat, while neglecting the other villages in that electoral district. Though the highland villages of Papua New Guinea formally belong to the larger political entity of the nation-state, the village population has minimal contact with the police, judges or bureaucrats, or in other words with those who officially represent the government. Villages reach their decisions largely autonomously.

Yet how do these politically autonomous village communities regulate their internal affairs and relations to neighboring villages? Can one speak of democracy in these societies, and if so, in what sense? Examining societies of a wholly different type forces one to develop a more precise conceptualization of what democracy is.

POWER WITHIN THE VILLAGE: THE SUPREME AUTHORITY IS AN ASSEMBLY OF OLD MEN

The typical political structure of such village communities, as among the Mai Enga people in the western highlands of Papua New Guinea, the Mangyan on Mindoro (Philippines), the Yanomami in the Amazon basin of Venezuela and Brazil, or the Turkana in northern Kenya, can be described as patriarchal. The older men, meaning those with children of marriageable age, have the say in the political life of villages, which usually have from 200 to 800 inhabitants. At village assemblies, the older men negotiate and regulate disputes that arise over claims of adultery, theft, defamation, and the like within the village. They decide over such "internal affairs" particularly when these disputes threaten the peace and cohesion

TWO EXAMPLES OF VILLAGE COMMUNITIES The Yanomami live in the Amazon rainforest, in groups of as many as 100 people. They live together in a traditional roundhouse and form a village community.

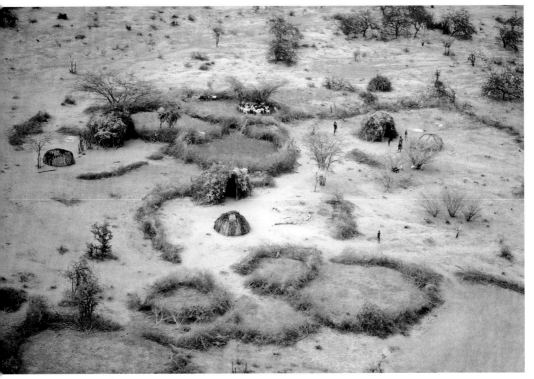

The Turkana, who live in Kenya, are nomads and herders. They erect new villages each time time they move to different grazing lands. Both images: Victor Englebert

of the village community. The older men also discuss and make decisions about "external affairs," which include whether to begin or end a war, and which allies to mobilize. In addition, they mediate conflicts with allies that arise in conjunction with gift exchanges and bride price payments, and conflicts with neighboring villages over land, as among the Mai Enga and the Mangyan, or conflicts over grazing and water rights, as among the Turkana.

The authority of the older men rests on patrilineal kinship models. Every village community consists of one or, more usually, many patrilineal ancestral kin groups. The patrilineal notion of social relationships provides the justification not only for the authority of those who are older over those who are younger, but also for the supremacy of men over women. Membership in a patrilineal ancestral kin group also regulates access to resources. Land, as well as water and grazing rights, are usually passed on from father to sons, whose sisters outmarry anyway.

The authority of the older men in the ancestral kin groups is based on ancestor worship. In their respective kin group, the older men are closest to the ancestors and therefore are their living representatives. They enforce the "law of the ancestors," a normative order that places the old men at the pinnacle of a hierarchical authority structure. The "law of the ancestors" sets out what is proper and what is not, or what one may do and what one may not do. The younger "charges" of the older men owe them respect and obedience, and if they behave in conformity with the normative order, they are rewarded by the ancestors with affluence, fertility, and health. But if they flout or break the law of the ancestors, they will be punished by bad harvests, infertility, and disease. Ceremonies reserved only to men, as well as initiation rituals that make men out of boys, and which among the Turkana take the form of an age-group system, round out these normative and cultural justifications.

Younger men, as well as women, are present at village assemblies, but rarely say anything unless they stand accused or are directly involved as witnesses to a conflict. If women do speak up beyond this, they are ignored or derided, or are cut short. Sooner or later, the younger men will become part of the village political elite, but the women remain in a weak political position not least because they have married into the village as a rule, and thus have no kin (father and brothers) in the village. The older men marry off their daughters, and marriage bonds primarily serve to cement political alliances between kin groups in different villages. The older men, in addition, also pay the bride price for their sons, in the form of pigs among the Mai Enga and cattle among the Turkana. Sons remain dependent on the older men until they marry, have children of marriageable age, and themselves become part of the village elite. As a result, marriage, but also adultery,

divorce, infertility, and problems in conjunction with bride price payments, are eminently political issues in such contexts.

Village chiefs and charismatic leaders can also be found in village communities. They have their positions owing to their success in recruiting allies to carry out armed conflicts, or due to their prowess as warriors, or because of their rhetorical skill and diplomatic abilities in resolving conflicts. These leaders play a prominent role in village assemblies, one comparable to that played by the political heavy-weights we are familiar with in democracies.

DEMOCRATIC ASPECTS DESPITE HIERARCHICAL POWER STRUCTURES: TO WHAT EXTENT IS THE POWER OF THE OLDER MEN LIMITED?

The question that arises is whether—despite these pronounced power hierarchies—democracy can exist at all in such politically autonomous village communities. To answer this, we need to think about the essence of democracy more abstractly and focus on three questions. First, how are the powers and decisions of the older men influenced by the other members of the village? Put differently, how do the latter influence the former, and how do other members participate politically in the collective decision-making process? Second, which decisions are made collectively, and which decisions take place within families, or between two families, that then do not need to be negotiated and decided at a village assembly? Third, how are decisions made at village assemblies? Are they made by a leader, or unanimously by the older men after long discussions, or are they based on existing majority and minority factions? The actual decision processes in village communities need to be investigated in greater detail here.

Political Leaders: Influential, but only up to a point

Let us first turn to the political leaders. The achievements of a local leader, called a "Big Man" in the New Guinea highlands, need to be recognized as such by other members of the village community. That may come through their skills at mediating conflict, their powerful rhetoric, their ability to organize warlike raids or generous feasts, or their success in external affairs, seen in their ability to win allies through gift transactions or bind other groups to the village through marriage.

The great influence such leaders have, however, lasts only as long as these qualities are honored. If these services are no longer recognized by other villagers, a leader loses his position. Villagers no longer follow him but instead give preference to other politically ambitious men whose accomplishments they value more highly. Local leaders who misuse their power, such as by acting too aggressively, harassing their own people, instigating unnecessary wars, or by only amassing but

EVERYDAY LIFE Communal life among the Turkana: The men take care of the animals. Here, they are watered at water holes that have been dug out.

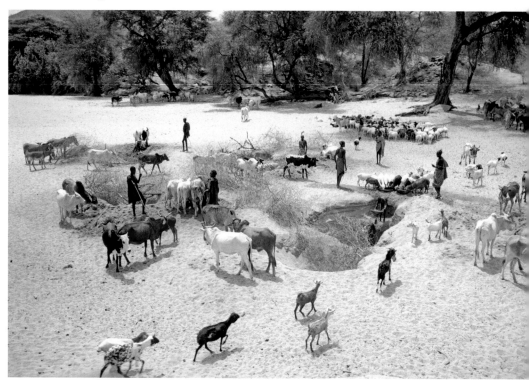

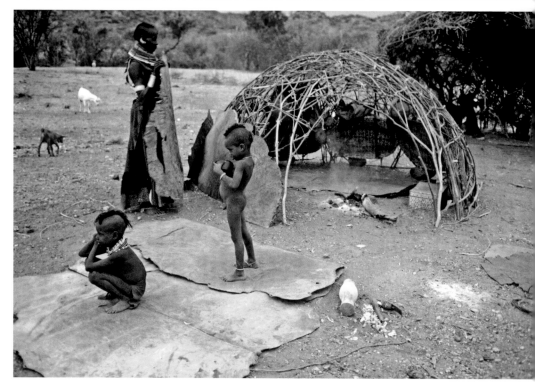

The women are responsible for building huts and carrying water.

Communal life among the Yanomami. Women gather termites for food and take care of the children.

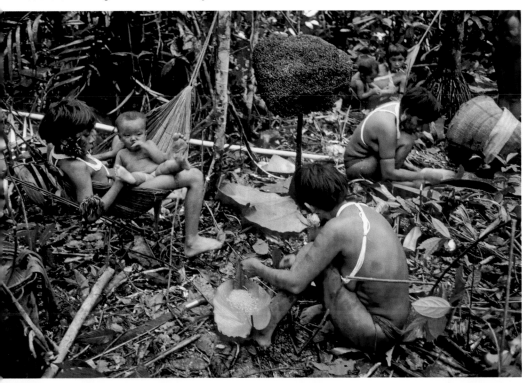

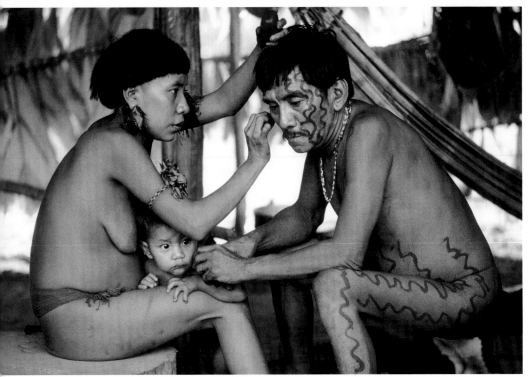

Villagers paint one another in preparation for a celebration. All images: Victor Englebert

not distributing goods may even be killed or accused of witchcraft (which comes to the same thing). Such measures are not often taken, but they do considerably limit the leaders' generally accepted potential for vainglory. More frequently, leaders who become too old to fulfill their duties lose their followers to younger and more adroit leaders. The peaceful "recall" in such cases occurs through followers "voting with their feet," while in the previous case, a leader is deposed through the secret consensus of conspirators who are responsible for his violent elimination.

Leaders have power thanks to their specific, and generally recognized, abilities and merits. Their power also comes from their kinship networks and from networks created through gift exchanges. This means leaders with such followers may have more of a say in village assemblies than other older men, but they cannot in the end overturn a majority opinion. Instead they often only represent the consensus opinion, shaped during what can sometimes be extremely long negotiations. The older men are just as involved in making collective decisions, so local leaders in the end are only *primus inter pares*, the first among equals. Yet what is the situation for younger men and for women?

Power Inequalities and Democracy:
The possibility of exerting influence from below

As we have already seen, the younger men and the women, politically speaking, only play second—or even third—fiddle. Pronounced power differences exist between the genders and the age groups, as can be seen particularly clearly in the village assembly, the key political institution, in which younger men and women cannot play any active part. In light of such a power hierarchy, it is questionable whether one can speak of a democracy here at all.

We must be clear as well about which conflicts and decisions even are the subject of public village assemblies. Within families, or between two families, decisions are made and conflicts resolved in conjunction with marriage, adultery and divorce, but also about exchange transactions, mutual assistance, and theft. Such matters are regulated either directly between the opposing parties or through mediation by a relative both parties have in common, without becoming the subject of a village assembly. In this household realm, women and younger men most certainly have a say, for example, about a marriage or the modalities of mutual assistance. Mother, son, and daughter can resist a politically motivated marriage plan the father may have. A daughter, for example, can elope with the man of her choice, and thus induce her father to relent because he has no interest in the difficulties that can result from a misalliance. There is thus a kind of subsidiarity, the result of which is that decisions are made primarily by those directly affected by them.

However, family disputes can certainly escalate when it is a matter of theft or defamation, when there are delays in paying the bride price, and in cases of adultery and divorce. They escalate in particular when kin groups in different villages are affected, or when such conflicts disturb the peace and cohesion of a village community, and thereby endanger the ability of the village to act externally. Such legal disputes must be negotiated and resolved in the village assembly. This is also the case when it is a political question of war and alliance, or when internal conflicts of interest between factions led by politically ambitious men are involved. It is here the older men have the say. They decide on measures and procedures in line with a normative order that puts the older men at the pinnacle of a hierarchical authority structure, but it is also one to which they too must hold. The old men orchestrate social pressure (to convict the perpetrator of a theft; to force an adulterer to break off a liaison). They admonish the adversaries and decide on penalties for adulterers and thieves, which can be either corporal punishment or compensation payments. The old men look for compromise and reconciliation between opposing parties, and restrain rivaling men if they try, in too heated and implacable a manner, to make their mark. One should not forget that the older men also represent members of their families, their "wards," and that there is a considerable commonalty of interests between the actors.

Yet even women can exert a degree of influence in village assemblies, though only indirectly through brothers, fathers, or husbands. Paradoxically, the exclusion of women from actively participating in village assemblies seems to increase the effectiveness of the collective decision processes, as can be seen among the Mangyan on the Philippine island of Mindoro. The Mangyan are of the opinion that women generally are emotional, unreasonable, quarrelsome, and uncompromising. Men, following this gender stereotype, are correspondingly objective, reasonable, diplomatic, and ready to compromise. This is despite the fact that most conflicts break out between younger men over marriage, adultery, and divorce.

However, thanks to the stereotypes, the older men can put pressure on the younger men by urging them to bring their behavior in line with their gender stereotype. Men who fuel conflicts in village assemblies by being emotional, aggressive, and uncompromising leave themselves open to being accused of not being "real men" but instead of "behaving like women." Only behavior that conforms to the norms and their gender ensures these men—to themselves and to others—of their masculine identity. In this case, the exclusion of women from public conflict resolution as well as from reaching decisions is a precondition for the successful resolution, by the older men, of internal conflicts.

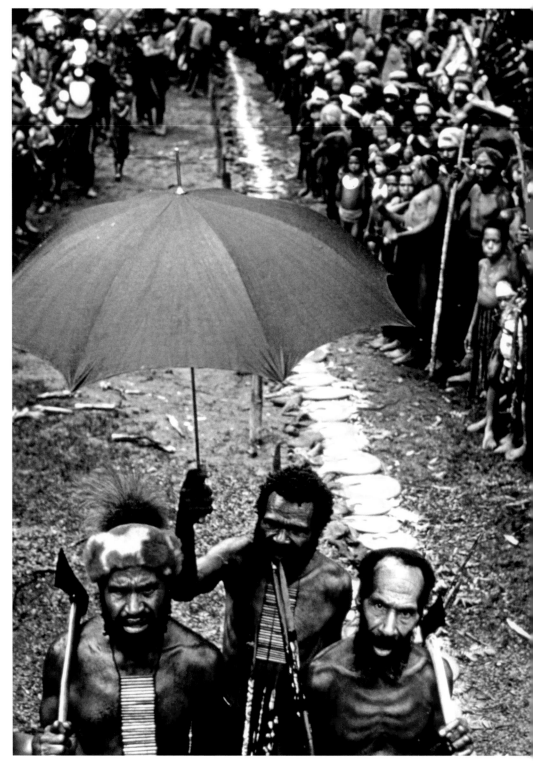

ORGANIZING FESTIVALS Papua New Guinea: Mai Enga gather to feast on pigs, which are a valuable good in this society. Organizing festivals in honor of alliances is an important function of the village chief. Magnum Photos/Burt Glinn

WARTIME LEADER Alto Xingu, Brazil: Kayapo warriors in full warpaint and armed with bows and arrows, clubs, and spears occupy the construction site for the hydroelectric plant at Belo Monte. Local leaders play a key role in external conflicts.
Noor/Yuri Kozyrev

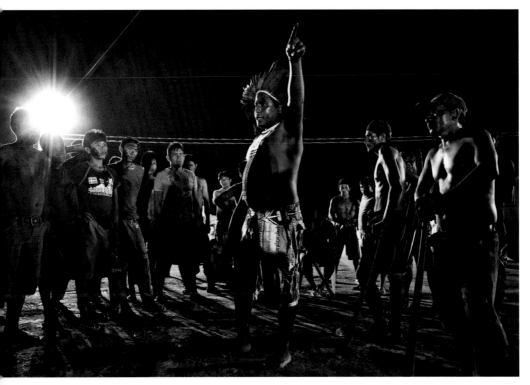

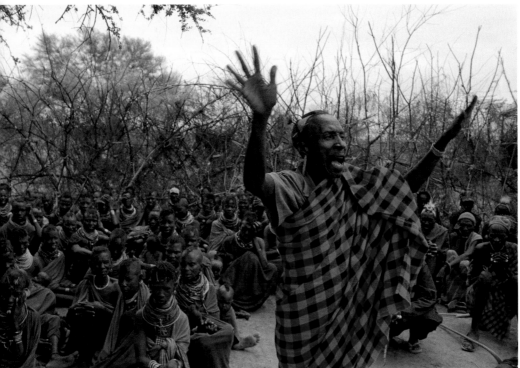

THE POWER OF THE VOICE A leader speaks to the village community. (Turkana) Magnum Photos/Chris Steele-Perkins

Decision Modes: How are decisions made?

So how are collectively binding decisions reached in village assemblies? A particularity of village assemblies needs to be noted here first. The village assembly is the central political institution in these societies, and there is no separation of powers in the form found in democratic nation-states. Village assemblies address not only "legal questions," which in a democracy would be decided by the judiciary in courts and on the basis of a legal code, but also political questions, which democracies resolve through systems of government, parliament, and elections. A village assembly is thus simultaneously responsible for two branches that are functionally separated in democratic assembly systems.

Village assemblies primarily discuss and make decisions about conflicts that threaten the cohesion and peace of the village community: Witchcraft, defamation, adultery and theft. This is also the forum for making decisions about external affairs, especially war and peace. Fundamentally, village assemblies are about finding quasi-unanimity, or put differently, about reaching a decision no villager has an interest in vehemently contesting.

Some disputes are over acts of a "criminal nature" such as adultery and theft. This means there are acknowledged norms about certain practices, and violation of these practices can lead to sanctions such as public humiliation, compensatory payments, or corporal punishment. Despite recognized legal norms, however, there are disputes over theft, witchcraft, defamation, or absent bride price payments in which the identity of the perpetrator remains unclear, or the parties involved dispute the specific circumstances. What one party calls theft, the other party characterizes as the repayment of a debt. What one side terms an unpaid bride price, the other side sees as the result of an unclear agreement.

Conflict resolution is even more difficult when acts of a "criminal nature" such as witchcraft, theft, and defamation are conflated with differences in political interests and resentment between rivaling men and factions. In such conflicts, legal norms, even if basically recognized by all, do not help much. Instead, village assemblies then "agree" on vague solutions. For example, the identity of witches and defamers is left uncertain because clear identification of the perpetrators and conclusive determination of the circumstances of the alleged offense would only escalate the conflict. Thus, every decision over a dispute remains provisional in the sense that one can, or must, return to it the next time the conflict breaks out.

These cases of conflict draw attention to a further characteristic of village assemblies. In this form of conflict resolution, the primary goal is to restore social harmony and avoid triggering additional resentment and future conflicts both legal and political. Unlike in the legal systems of democracies, the negotiation over

"legal matters" in village assemblies are not about applying abstract norms of right and wrong. There are no legal institutions supported by a governmental structure which could force adherence to laws, regardless of the consequences for those involved in a particular case. In cases that are of a "criminal nature," the village assembly does refer to generally accepted norms—the "law of the ancestors" passed on by oral tradition, for example—but this, as in political affairs more generally (including in democratic systems), is not about implementing abstract legal norms but is instead primarily about balancing interests and maintaining, or restoring, internal peace.

War and Peace: The scope for refusing to fight

Decisions about war and peace, which—unlike in democratic systems—are discussed and decided upon among the Mai Enga and the Turkana in village assemblies, are not about issues of a "criminal nature" but rather about the specific political interests of the individual kinship groups that constitute a village. In these cases, widespread consensus (with individual exceptions) is possible, as are decisions made according to majority and minority factions. Reaching agreement can become complex particularly when factions have differing external interests. This complicates making decisions about war, as this involves finding an opportune moment to engage in a war. At the same time, decisions over going to war admit of less delay than do disputes internal to the village. Unanimity and consensus in "external affairs" is desirable, because dissent means the village community in the end would be weaker militarily.

Still, the interests of villagers usually do not diverge as sharply as among citizens of a nation-state, and given the small size of villages, the individual consequences of collective decisions will be more immediately felt than in larger societies. Decisions themselves are for that reason easier to make in such a village than in nation-states. In addition, even if widespread village consensus exists, individual men can refuse to take part in a war—without being ostracized by the others. They may be reluctant to fight close relatives on the other side, or may refuse because of a bad omen, as among the Mai Enga. Such a "refusal to fight" option, even when a village is at war, is generally accepted. But if a war is regarded as unavoidable, the threat large, and the moment to attack opportune, then there will be broad consensus at the village assembly.

However, there are also cases where participants in a village assembly disagree whether a particular war is necessary, or whether the time for it is ripe. This is particularly true when there is no immediate threat from the other village and one faction does not want to start a war for that reason, yet a different faction sees advan-

Religious ceremony among the Yanomami in Brazil's rainforest. Magnum Photos/Chris Steele-Perkins

Older men prepare for a ceremony. (Turkana) Magnum Photos/Chris Steele-Perkins

tages in engaging in one, such as getting rid of, or weakening, a hated enemy at an opportune moment. The faction of the "hawks," even if they are in the majority, will not be able to have its way if the faction of the "doves" is strongly opposed. Even if the majority wishes to attack a neighboring village, the minority can refuse to participate in such a war. In that case, only one of the local kinship groups, usually allies of one of the main protagonists, will participate in the war while the other faction stays at home. If the faction of the hawks wants to incite a war on its own, and the minority refuses to participate, that will weaken the entire group, making the war riskier and putting the chances of victory in question. With this, too, the power relations between villages change, dampening the aggressiveness of the majority who are ready to attack, and making them reconsider their plans. In that sense, when it comes to questions of war and peace, the minority hold something like a veto power over the decision. On the other hand, if a village is threatened and attacked, all the villagers will stand together and take part in a war that is unavoidable.

Even if in the minority, the hawkish faction could—by engaging in small skirmishes—nevertheless try to provoke a war in the hope that if what results is a defensive war, the dovish faction will be forced to participate. Young men—perhaps egged on by an ambitious leader hoping for advantage over his village rivals that could result from engaging in a war—dash out, carry out smaller attacks, and thereby provoke counterattacks. Depending on the balance of power between hawks and doves in a village, the older men will then either try to stop the young warriors and restore peace with the village that was attacked or, after consultation, come to the conclusion that a war can, in the shorter or longer term, not be avoided anyway. For that reason, the war will be declared a war of the entire village. That such warlike *faits accompli* are not accepted with impunity is shown in cases where local leaders who have provoked wars regarded by most in the village as unwanted or too risky were themselves killed. That was the fate of Matoto among the Tairora in the eastern New Guinea highlands and of Fusiwe among the Yanomami in Amazonia.

If the conflicts of interest between the village factions over external affairs become too great, the minority can threaten to split the village, which means leaving it and joining another village. The hawkish faction will want to prohibit this from happening, as it means too great a weakening of the village's military strength: The hawks then will make concessions to the doves. If the conflict of interest is not reduced, then the minority faction will secede.

Such a division can also come about independently of differences of opinion over external affairs, particularly if the disputes become ever more frequent and

When the authority of the chief becomes too demanding, … individuals or families split off and create a new kinship structure that seems to be better led.

Claude Lévi-Strauss

Claude Lévi-Strauss (1908–2009) was a French anthropologist.

At a village meeting, news and current problems, including the increased frequency of droughts are discussed. (Turkana) Andrew Aitchison

DEMOCRACY IN AUTONOMOUS VILLAGE COMMUNITIES

Papua New Guinea: In a village of the Fore people, the upcoming national general election is discussed. Tobias Schwörer

Philippines: A Mangyan village assembly.

ever less peaceful. Tenacious conflicts are either ascribed to political conflicts of interest, and to rivalry between the leaders of the factions, as among the Mai Enga, or they are explained by adversaries being beset by evil spirits, which calls for shamanic rituals and pig sacrifice to fight off the spirits, as among the Mangyan. Yet in both cases, if the conflict between factions makes collective action increasingly difficult or even prevents it, then a division of the village becomes unavoidable. The frequency and the intractability of such conflicts increases with the size of a village community, so village divisions in these societies are both inevitable and not unusual. In each case, two new politically autonomous communities emerge: Within them, collective decisions and conflict resolution will be easier to agree upon, and there will tend to be more common interest when it comes to forging alliances.

CONCLUSION

So does democracy, as defined at the outset of this chapter, exist in politically autonomous village communities? Certainly there are no general elections, there is no party competition, no majority principle, and no separation of powers—and yet the ability to have a say is great. Decisions of the older men can definitely be influenced by the other villagers. Younger men and women can have a direct influence on decisions made in families, following the subsidiarity principle, though they have only an indirect influence on and in the village assemblies. But even there, interest heterogeneity is not as large as in the societies of nation-states, as the older men also represent the other members of their families. The prime concern of the village assembly, whether in "criminal" or in "purely political matters," and whether in internal or external affairs, is to find a balance of interests that allows the village community to continue to act as a viable political unit. The decision-making power of leaders, in addition, exists only to the extent to which it is acknowledged by other villagers, and if a local leader misuses his power, he may even be killed by his own people.

Both in resolving conflicts and in decisions of relevance for the community, it is a question of balancing interests. Majorities in village assemblies do play a key role, but individuals, even in a unanimously agreed-upon war, can dissent from participating. If only the majority in a village wants a war, the minority can refuse to participate in it. This is all the more remarkable because in nation-states with democratic constitutions, the electorate, as a rule, has no say at all about going to war or forging alliances, and even elected parliaments may follow such governmental decisions only when put under pressure. The ultimate veto power of the minority faction in a village is the option of dividing the community, which

weakens the remaining majority faction. A village division, which always takes place when the size of the village leads to an increase in the number and intransigence of the conflicts, as well as an increase in the heterogeneity of interests, is also the result of a structural particularity of such village communities: There is no overriding or controlling authority that, if needed, could compel political and legal decisions to be carried out.

The Yanomami invite a neighboring village community to a feast. Guests are fed soup until they have to throw up. Victor Englebert

Papua New Guinea: Conflict has erupted between two Fore villages. The armed men discuss what to do next. Tobias Schwörer

DEMOCRACY IN AUTONOMOUS VILLAGE COMMUNITIES

Kenya: A warrior of the El Molo tribe during a wedding celebration. The older men decide about marriages,
not least because they serve to reinforce relationships and alliances between village communities. Reuters/Boniface Mwangi

Democracy is defined not only by the act of voting, but also reveals itself in how people behave toward one another. Democratic values can be found in very different areas of life, but because they often seem so self-evident, they do not always strike us as democratic. However, they become more visible when one realizes that numerous behavioral norms that are now acceptable were not self-evident a short while ago. The force of democratic values quickly becomes clear when one considers longer-term societal changes, such as the reduction in power differences between groups, for example, between rulers and ruled. The central values associated with democracy were already summarized by the French revolutionary slogan "liberty, equality, fraternity." In the effort to live out these values, the power potentials change in many areas of social life. A democratization dynamic can also be seen in the changed relationship between employers and employees, men and women, parents and children, church authorities and parishioners, teachers and pupils, doctors and patients, or producers and consumers. In all these relationships, where the partners are more or less tightly bound to one another and influence one another, one sees a similar process at work: A reduction in inequality and in the lack of freedom between people. The process is long-term, and occurs sometimes faster, sometimes slower—and sometimes even with reverses—but it is one that unfolds and leads to an expansion in recognition, respect, and solidarity among a larger group of people. Democracy as a value then shows itself as a lived and cultivated norm, in quite varied areas of life, by how people behave toward one another. In that sense, it provides an important guide or orientation for the members of a society.

On a Smaller Scale

Erik Jentges

A democracy without democrats stands on shaky ground. The foundations on which a democratic society rests are the people themselves, how they relate to one another, and the values and ideals that are meant to guide and shape their communal life. Given this, it quickly becomes evident that democracy is not manifested just in politics and not just on Election Day. If it is to remain vital, it is important that democracy also has a place in everyday life. Democracy reveals itself in many perfectly ordinary situations, and we encounter it here and there, often without immediately recognizing it. Democracy is expressed not just in how people behave toward one another but also in the values that provide orientation for individual acts by the members of a society.

If one tries to investigate democracy as a value, it can be helpful to look more closely at certain transformational processes that have occurred in society. It has not always been the case that every person in a democracy had a voice that could be used to influence politics. Instead, a long period of development shaped the core values of democratic societies. The key was, and is, the mutual recognition of all members of society as equal beings, and that every citizen has one vote on Election Day reflects this value. No one can put two or three ballots into the box, because

THE MATURE CITIZEN Buenos Aires, Argentina, 2006: After a demonstration on the fifth anniversary of Argentina's economic collapse in 2001, citizens discuss with one another in the streets. Panos/Dermot Tatlow

everyone in an election has exactly the same share of power. This aspect of equality is deeply anchored in the constitutions of modern democracies, and it is a value people cherish. Any change to this rule would mean some people would gain more power and many others would have less power, and inequality would increase.

By now, it is regarded as self-evident in democracies that each person has individual dignity and is entitled to have his or her individual rights respected. Yet this is by no means self-evident worldwide, and is actually a relatively recent social achievement. Democracy as it is generally understood today essentially developed in the course of popular revolutions in Europe after 1789. The notion of the modern state was formed in this era, as was the ideal of the modern citizen. In the meantime, democracy as a value no longer connotes a purely Western understanding of government and politics, though this might seem an obvious observation. Democracy has become cosmopolitan and has found—and is still finding—a home everywhere.

If one takes a longer view of social processes, then it makes more sense to speak of democratization rather than of democracy. This can be understood by and large as a reduction in the power differences between rulers and ruled. The reduction

SCHOOL OF DEMOCRACY Bern, Switzerland, 2009: Schoolchildren, here in the National Assembly chamber in Bern, debate as part of the "Schoolchildren's Parliament" model game. Keystone/Peter Klaunzer

ordinarily takes place in stages through the institutional extension of the franchise, first to the middle classes as a whole, then to all adult men, and finally to all adults. The extension of the franchise has not proceeded uniformly around the world, nor has the franchise advanced equally far everywhere, but the sequence and direction is often similar. The sociologist Norbert Elias pointed out that the political institutionalization of democracy is embedded in longer and deeper processes of reducing power differences between various groups. Established authorities weaken, and once-weaker groups become stronger. Such processes sometimes can be seen between men and women, parents and children, and even between producers and consumers.

Democracy as a value is rooted in this belief of preferring a more balanced distribution of power among members of, and groups in, society. This value is anchored in national constitutions and thereby shapes political life. In addition, democracy is also evident in numerous facets of public and private space, and may be observed in many everyday situations.

DEMOCRATIZATION IN THE WORKPLACE:
CO-DETERMINATION AND EMPLOYEE RIGHTS

In modern societies, many people are involved in regular work relationships. They leave home in the morning, drive to work, engage in various activities that, in their unique ways, produce added value, and then they return home in the evening. Relatively few people are business owners and in a position to tell other people what to do or what not to do. Very few people are their own bosses. Most people are employees and only a few are employers, and the power difference can be seen in the relationship between employer and employee. A boss can lay off his employees—but at the same time he depends on those employees and what they produce.

With the advent of industrialization, this difference, found in nearly every factory and every business enterprise, became a great structural divide in all modern societies. A working class formed in cities that were rapidly expanding, and workers were unified primarily because they were all dependent on their employers. In this era, there was no protection against being dismissed from work, and no insurance coverage, so it was necessary to organize to try to ensure such protection. If orders for products dried up during an economic crisis, many employees could be laid off from one day to the next, and these were workers who supported families on their wages. If someone had an accident or was injured at work, he could not count on the support or solidarity of his employer. Understandably, workers wanted to change this situation, and demands to participate in workplace decisions (codetermination) were an important part of the democratization process.

Workers could fight for more rights particularly through the political associations, or unions, they founded. Even if workers were in a weaker position, they were never powerless. They could stop working and occupy factories. They could go on strike. The power differences between factory owners and factory workers were reduced in many countries over the course of industrialization. The workers of the world (proletarians), however, never united in the manner Karl Marx and Friedrich Engels hoped and called for in their 1848 *Communist Manifesto*. There was no large, centrally directed movement of the working classes wanting to free themselves from their chains. Nevertheless, this multilayered, decentralized, unguided process developed in the same direction in many places. The power differences between employers and workers diminished, and the relations became less arbitrary, more ordered, and more decent.

Distance between the various classes in society also decreased. With the exodus from rural areas and the consequent rapid growth of cities, the once-rigid social order eased in many places, and roles and positions began shifting. Propertyless workers and property-owning segments of the aristocracy and the middle classes began to converge.

TEAM SPIRIT Tegucigalpa, Honduras, 2011: Taxi drivers striking because of increased gas prices. In democracies which guarantee the right to strike, people can express their views about economic and work life. Reuters/Edgard Garrido

It is certainly also significant that labor leaders often became politically active. Nearly every democratically elected parliament today has a socialist party as a result, usually one that emerged from the labor movement. The career of Luiz Inácio Lula da Silva, president of Brazil from 2003 to 2011, is illustrative. He began his career as an assembly-line worker in an automotive supply company, and after holding various union positions, attained the highest political office in the country. In 1980, he helped found the Partido dos Trabalhadores, the Brazilian workers' party, and after three unsuccessful runs was elected president on his fourth attempt.

In everyday working life and in numerous arenas, one finds a functional, historically evolved democratization. Larger enterprises in many countries have works councils composed of employee representatives who consult with employers and managers about company decisions, ensuring that those who have less power in the structure nevertheless can have a say in it. These employee representatives sometimes need to address uncomfortable matters, but cannot be fired for doing so, as the government provides them with a degree of protection.

Democratization is not just a result of organized cooperation among workers in a country, but also results sometimes from targeted intervention and public pressure from other countries. There is a degree of global cross-border solidarity nowadays with the weakest members in the production cycle. Consumers in Europe, for example, began exerting public pressure on global enterprises as long ago as the 1980s. An example of this is the German automobile manufacturer BMW, which had been producing vehicles in South Africa since the 1970s. Under its apartheid policy, South Africa had institutionalized racial separation, thereby officially legitimizing enormous differences in power among the various groups in the population. Public pressure put on the company, which saw its image endangered by negative publicity, and fear for the consequences for its European market, contributed to BMW's improvement of the working conditions for its overwhelmingly black workforce in its South African factories.

A similar dynamic is at work today when unethical and exploitative working conditions in rapidly developing countries are criticized in newspaper and television reports or through new social media. Companies with global brand names and high recognition often appear in the headlines. Computer manufacturers have to justify the conditions of production in their Chinese supply factories, as well as improve them in a credible manner. Shoe manufacturers must answer for Indonesian production sites where child labor continues to be used. The increasing links in a globalized marketplace can favor such transnational solidarity and aid the democratization processes in the world of work.

THE WOMEN'S MOVEMENT AND EMANCIPATION:
EQUAL RIGHTS FOR MEN AND WOMEN

Two hundred years ago, relations between the sexes rested on quite different prem-
ises. Did a functional democratization also creep into the relationship between men
and women? That it is not just men, but women too who have recognized status
as legal entities and can therefore both inherit and possess property, seems self-
evident. Yet in some societies this is actually a quite new achievement and in oth-
ers it is a process that has not even properly begun. The extension of emancipatory
values, whose goal is the equality of the sexes, is a good indicator of the extent to
which the value of democracy is anchored in a society. Emancipatory values indi-
cate public opinion shows a preference for democracy. These values develop dif-
ferently by cultural region, including with respect to relations between the sexes.

The political demand for gender equality is not seriously challenged in modern
democracies. If one agrees with the argument Alexis de Tocqueville makes in the
introduction to *Democracy in America* (1835), then equality is the most important
value in a democracy. That means those who reject equality and equal status logi-
cally also reject democracy.

If one regards the development of modern societies as a generation-spanning
process, then it may come as a surprise that increasing the rights of women is a sig-
nificant constant in that process. The expansion of women's rights since the French
Revolution in 1789 has taken place both under pressure from women's movements
and thanks to a logically compelling interpretation of human rights. Moisey Ostro-
gorsky, a Russian historian and political scientist partly educated in France, sum-
marized this development as early as 1892 in a historical, comparative analysis of
the role women played in public life and the law: "Old Europe, in its turn, is shak-
ing off the secular dust of its codes. The perpetual tutelage which used to hang over
women is suppressed, the free disposition of their property and person secured to
them, and their capacity ungrudgingly recognized even beyond the private sphere."

The lawmakers in many European countries were influenced by the *Code
Napoléon*, the first modern pan-European legal code. It is a historical irony that
with its help, Napoleon, no democrat, laid a foundation in the countries of Europe
his troops stormed through on which modern nation-states later built. The *Code*
contains the ideal of *Rechtsstaatlichkeit* (the German version of "the rule of law"),
one premise of which is that all stand equal before the law. This idea has spread
throughout the world as part of the exporting of the European model of modern
statehood. The idea of the equality of the sexes also spread as a result.

Across the Atlantic in North America, the idea of putting men and women on
the same footing also arose from the political experiences of both men and women,

as well as from nineteenth-century efforts to emancipate slaves. Women, often from higher strata and middle-class households and with time to be politically active, worked hard to make the claim "all men are created equal" contained in the Declaration of Independence a reality.

However, the end of slavery and the recognition of voting rights for blacks were only the beginning of this democratization process, in the course of which women's rights came to be recognized and anchored in the catalogue of human rights. Since its beginnings, the movement for greater rights for women has been transnational, because its key protagonists were already exchanging ideas, concepts, and strategies across national borders by the end of the nineteenth century.

Eleanor Roosevelt (1884–1962) can be regarded as the driving force behind the development and elaboration of the UN's Universal Declaration of Human Rights (1948). This catalogue of basic democratic values not only anchors the rights of women, but also prohibits discrimination of any kind. The obligation undertaken by signing the agreement asks all countries—in the context of recognizing universal human rights—to also incorporate a gender equality policy in their respective legal codes. Yet the introduction of anti-discrimination measures

EQUALITY Utrecht, the Netherlands, 1970: "Dolle Mina" activists fight for equal pay and for the right to have an abortion. The slogan *Baas in eigen buik* (the boss of your own belly) is written on their stomachs. Laif/Jaap Herschel

depends in the end on the successful activities of those interest groups and individuals who agitate for women's rights. In Eleanor Roosevelt's case, it certainly helped that she had access to the right people and that her word carried weight in the media. In addition, her uncle Theodore Roosevelt (1858–1919) had been President of the United States from 1901 to 1909, and her husband, Franklin D. Roosevelt (1882–1945), held this office from 1933 until his death.

It is always a surprise to discover that many of the charismatic leaders, both women and men, at the head of these social movements came from educated, middle-class, and sometimes even quite rich families. They lived in households where servants did most of the daily chores, leaving "the lady of the house" time to engage in political activity. The invention and widespread use of washing-machines, vacuum cleaners, and other electrical household appliances reduced the burdens on women in less affluent and smaller households, similarly freeing them for political activity. This expanded the circle of women who could profit from these developments. The women's movement received greater support, and the pressure to change the social fabric increased, resulting in a gradual reduction of the inequalities between men and women.

In the West, many of the classic women's movements reached their self-appointed goals even before World War II. The right of women to vote was a widespread demand, and was anchored in law earlier in some countries and later in others. Still, a difference remains even today between what it says in a law or in a constitution and how that precept is actually lived out. That passages about gender equality exist at all in modern constitutions is often due to the work of a single individual, such as the author Simone de Beauvoir. Such women serve as models and may be stylized as heroines who demonstrate how women can shape their daily lives in a self-determined, self-confident manner.

A new, politicized feminist movement emerged in the West in conjunction with the student protests of the late 1960s. This new movement differed substantially in its goals from its predecessors, and argued, among other things, for a more radical feminism. At issue was bringing about full equality in both politics and society to give women more autonomy in matters such as abortion, divorce and sexuality. The goal was not only to increase women's opportunities but also to shift to a new way of thinking free of old clichés about sex or gender roles. Feminist activists were successful in moving into public spaces that until then had been dominated by men.

An additional goal was to rewrite the history of the relationship between the sexes. Official accounts had to that point largely been stories of male heroes, histories in which women seemed to have played almost no role at all. For centuries, the image of women had been shaped by the monotheistic religions which often

tarred women with negative stereotypes. It is thanks to the feistiness of the new feminist movement that the historical image of women has been permanently changed, and in the process the image and self-image of men has changed as well.

A decrease in power differences between men and women is not only due to the success of the women's movement, though. Economic interests have also favored this development. One example comes from the early years of European integration, when global equality norms played a part in the political interaction between the still-coalescing European community and its numerous member countries. "Equal pay without discrimination based on sex" was demanded already by Article 119 of the Treaty of Rome (1957) that founded the European Economic Community.

This policy, and formulation, goes back to a political compromise reached between representatives of the French and German governments. Compared with French women, German women were cheaper, as they were paid less than men. The French delegation had an interest in getting rid of Germany's competitive advantage, and was successful at the European level in pushing through the "equal pay for equal work" clause that had been part of the French Constitution since 1946. Differences in pay structures between men and women still exist today, and are well documented statistically, but they are far less large than they used to be. It is to be hoped, and expected, that pay scales will converge still further.

In other parts of the world, the idea of gender equality has been able to establish itself not so much in opposition to the state as a domain mostly dominated by men, but precisely because the state has seen such equality as a social value. However, that was not so much because equality was seen as a facet of democracy. In the Soviet Union and its satellite states, where socialism was exalted as the ideal form of the state, formal equality was official policy from the beginning. In the working class, everyone was a worker—regardless of sex. Admittedly, deeply embedded cultural traditions and gender roles were only very slowly influenced by political precepts, and in "actually existing socialism," a term first used officially in 1973 by East Germany's party leader Erich Honecker, women were rarely found in leadership positions. Nevertheless, this official policy created a different understanding between the sexes than in non-socialist Western European countries.

The historical view makes clear how these transformational social processes interacted. The reduction in power differences between men and women was not only due to a politicized women's movement. It was also due to the expansion of *Rechtsstaatlichkeit* (or the rule of law), the balancing of economic interests in the course of political negotiations, the expansion of a consumer society, and the electrification of households. And, of course, it was due to the improvement in opportunities for women, through schooling and university study. The decrease in pow-

er differences between men and women also had its effects in other areas, such as the notion of what a family is, the relationship between parents and children, and the influence of religion.

FATHER DOESN'T ALWAYS KNOW BEST:
MORE EQUAL RELATIONS BETWEEN PARENTS AND CHILDREN

Has there been democratization between parents and children—can a reduction in power differences be seen here too? If one looks far back in time, then the killing and abandoning of children was not a rare occurrence in the ancient world or during the Middle Ages. And if one looks back only two or three generations, then one can indeed observe that an authoritarian relationship increasingly has been replaced by a more egalitarian model of parent-child relations. Compared with other groups of humans, however, children are of a somewhat different order, an age group of small persons who are wholly dependent on their parents but are on a path to independence. In addition, children are recognized as a group in need of special protection by the UN, which has engaged in a number of campaigns to raise awareness of the rights of the child.

THE RELATIONSHIP OF PARENTS AND CHILDREN New York, New York, USA, 2005: The average number of children per family today is markedly smaller than it was two generations ago. As a consequence, each child is given more attention, and children have more possibilities to have a say than was the case in earlier eras. Magnum Photos/Thomas Hoepker

If one examines the parent-child relationship more closely, then it is noteworthy that parents generally have far greater opportunities to exert power than do their children, especially when those children are infants. It is gratifying when the relation between parent and child is marked by mutual deep affection, but that is not always the case. The notion that such affection should be present, or should be regarded as the "normal" state of affairs, is historically new. Aspects of a relationship of dominance were much more clearly evident in earlier eras: The word of the parent was law, the children did as they were told, and contradicting or opposing the parental will was punished. Obedience to, and respect for, the parents, and sometimes also fear of adults, were social norms to a far greater degree than is the case today. Modern societies have given children a larger scope for making their own decisions. Yet they did not have to fight for this the way the working classes had to: It is more the case that parents have civilized their own behavior.

Of the many reasons why this shift took the particular form it did, perhaps the most important is that families in earlier eras were often larger than they are today. Many more children were born, and many died in infancy. It was only with the development of modern medicine that child mortality began to rapidly decline. Nevertheless, in comparison with the number of adults, there were simply more children, lowering the value of each individual child. Owing to governmental social security systems in Western democracies, children today have become far less important in providing retirement security for their parents. And as families have become smaller, children have become more valued—and not infrequently are regarded as part of the self-actualization of the mother, the father, the couple, or the family as a whole.

Last but not least, producers have discovered children are an important consumer group. Precisely because their socialization is not yet complete, they are often more open to advertising than are adults. And the power of persuasion they can exert over their parents is enormous, as can readily be observed when one sees a whining child standing with its parent in front of the candy display rack at the supermarket checkout counter.

It remains unclear, though, which direction this process will take. While nuclear families are still common in modern societies, numerous alternative "family" forms have emerged as well. The frequent correlation of affluence and a declining birthrate will almost inevitably lead to an aging as well as a dwindling society. With an increasing scarcity of children, the power balance may shift again in the direction of the parents, or increasingly to the generation of the grandparents. Older people, just in terms of their numbers, will have a larger political impact, and this may set new political dynamics in motion with respect to democratization. At the

same time, dwindling societies run demographically counter to the global increase in population, which will trigger further social dynamics between child-poor and child-rich societies.

RELIGION IN COMPETITION WITH OTHER WAYS TO FIND MEANING

In comparison with earlier epochs, at least in Europe, the once-mighty Christian churches and the very influential religions around the globe have dwindled in importance. The slow formation of the modern state, which developed in surges and countersurges, led to a separation of ecclesiastical and secular power. The clergy was forced to come to an arrangement both in and with the state. In the vast majority of democracies, the churches are subject to the control of government, and they also accept the separation of church and state. Europe, with its stronger tendency toward atheism, is a global exception. The influence of Christian religions in North, Central, and South America, as well as in parts of Africa, is considerably larger; Hinduism is broadly anchored on the Indian subcontinent, and Islam is quite prevalent in populations of Arab countries as well as in many African and Asian nations. Religion therefore is not just a private matter: It also influences political life. The societal processes that have led to democratization in the realm of religion are well exemplified by Europe.

The development of the relationship between state and church, which also has a large influence on the relationship between clergy and believers, is associated with the "bourgeois revolutions" of those who would become the citizens of new nations. The year of the French Revolution, 1789, can be said to mark the birth of the democratic and secular nation-state. The process of secularization can be seen today, among other things, in the dwindling attendance at church services and the decreasing engagement with the church.

Urbanization was a particularly significant aspect of this development. That many people, pursuing a better life, moved from the countryside into the cities had an effect on the relationship between church and adherents. Cities grew so rapidly at times that an institution that rested on an infrastructure constructed out of stone, namely the church, could not keep up with the pace. Many of those newly arrived in the cities, willingly or not, no longer regularly attended services, and weaned themselves from the church.

In some parts of the world, meanwhile, and particularly where student protests of the 1960s led to a further break with authority, belief has come to be an option, as sociologist Hans Joas puts it. Church attendance and questions of faith have become matters of choice. Belief, in a sense, has itself become democratized, and one can pick and choose it freely. In secular nation-states, the options for religious

preferences have increased. Cultural cross-fertilization and encounters with those of other faiths (Moslems, Hindus, Buddhists) or contact with entirely new religions and sects have created something like a marketplace for faith, where religious communities vie with one another for adherents.

Gradually, secularization and the belief in progress have shifted certain aspects of authority away from the churches and toward the sciences. Many such social transformations stretch over several generations, and with every generation that is less tightly bound to religion, the influence of the churches weakens. Still, such shifts in power are nowhere fully complete, and in some countries bloody conflicts still rage whose outcome is uncertain. Other societies are deeply divided over the question which set of values should be regarded as right and proper. Thus, in the United States, the conflict between those who hold to Darwinian evolution and those who hold God to be the creator of all things rages on with great vehemence.

In Europe, relations between religious authorities and the members of a religious community generally have become more egalitarian. Elsewhere in the world, however, the developments are heading in a different direction, at least in some regions, and toward a still greater imbalance in power. There are complex explanations for this. The weakening of religion and growing affluence in society often go hand in hand. Those who do not profit from such prosperity and continue to live in poverty find themselves more dependent on processes they do not control. To make sense of those processes, a traditional stock of knowledge is drawn upon, and in such cases, religion remains of considerable significance: One sees a tendency to look for answers in religion, magic, and myth.

The authority of the clergy can also expand in poor and immiserating societies and milieus, because it is often the poorer segments of society, with their many children, who bring life to the denomination or religious community. Government policy is then exposed to increasing pressure from religious interests, which sooner or later leads to competition between politics and religion. In the end, this can also develop into a rivalry over the people's loyalty, one that astonishingly often turns on the question to whom the people are to pay taxes or levies.

In Europe, that exceptional case of secularization, church membership increased everywhere in the aftermath of World War II. However, this was followed by a new surge of "dechurchification" starting in the 1950s and accelerated by the advance of consumer society during the next several decades. These secularist tendencies were reinforced by the partial replacement of sacred doctrines by a civil religion (Robert Bellah), which was manifested in patriotic feelings associated with citizenship. This mix of differing processes was gradually strengthened in many European societies by displacing religion out of the public arena and into private life.

The churches lost their roles as institutions that provided guidance or orientation, a process explained by growing economic security and the higher educational levels attained by the population. The mass media delivered information and advice, from scientific, psychological, and medical experts directly into people's livingrooms and the moral authority of priests and pastors gradually weakened. As it was pushed out of the public arena, religion more and more became a private matter—as well as increasingly invisible.

Yet though religion in Europe was experienced less intensively in the population, and the churches lost a considerable degree of power, they have retained considerable residual influence. The wave of democratization that washed over Eastern Europe with the fall of the Iron Curtain would probably not have been possible without the contributions made by the churches, and would have doubtless taken a different course. The socialist and atheist experiment of the East German state between 1949 and 1990 resulted in extraordinarily strong modifications to the evolved structures of Christian religious communities, and led to a broad "dechurchification." Nevertheless, enough scope remained to the churches that it was possible in 1989 to discuss (and begin to practice) democratic options in them.

The peaceful revolutions elsewhere in Eastern Europe also began in the churches, with pastors and priests part of the intellectual elite and in leadership positions in what became sociopolitical citizens' movements. In East Germany, the oppositional Protestant movement of the *Kirche von unten* (the "church from below") was one of the key actors in helping to change that country's political system. Prior to this, Pope John Paul II had supported his fellow Poles in their Solidarność movement through repeated trips (1979, 1983, 1987) to Poland. The infrastructures and the numerous contacts between churches in the East and West repeatedly penetrated the Iron Curtain throughout the entire Cold War, creating opportunities for exchanging information and for peaceful dialogue, cooperation, and understanding.

As in the past, the churches remain important political actors in many European countries. In Latin American, African, and Asian countries where Catholicism is widespread, the Catholic Church also is an important political actor. In other religious communities, too, infrastructure and communication flows are significant resources on the path to greater self-determination, which could shift the balance between church and state. One sees again and again that countries profit from churches and from the institutionalized religious communities and welfare services they provide. This also has a conserving and consolidating effect on the relationship between clergy and believers, one that can contribute to a more stable development of society.

CRITIQUE AND PARTICIPATION IN THE CLASSROOM: FLATTER HIERARCHIES BETWEEN TEACHERS AND PUPILS

Regardless where in the world you visit a school to get an impression of the authority relationship between teachers and their pupils, you will discover that school instruction is similar. A teacher stands at the front of a classroom, between desk and blackboard, while the pupils sit at several rows of tables and look toward the front. Ordering the room this way gives the teacher the greatest possible control over what is going on in the class. Frontal instruction became established over the course of many generations: With the spread of Western educational institutions, it has become a global cultural good. Yet a few things have changed in the last decades.

For one, pupils in many places are no longer caned. This practice was still widespread in the mid-twentieth century, and it continues to exist in some countries. But a process was set in motion everywhere that gave pupils more rights and greater security from arbitrary or corporal punishment. Teachers are now encouraged to exert their authority not through physical superiority but through their mastery of knowledge. The respect shown to teachers is now of a different kind,

ELECTING A CLASS SPEAKER IN CHINA Still image from the film *Please Vote for Me* (2007), which shows the first election of a class speaker in China. Ordinarily, class speakers in China are selected rather than elected. Jifeng Guo

and much of the fear pupils felt in their encounters with their teachers has vanished. Why is this?

On the whole, both teaching methods and what is taught have become more modern and more in line with how young people learn. In many places, pupils are encouraged to participate, to help make decisions, and their dedication is demanded. Form and content are also oriented to training children and adolescents to become citizens in a democracy. Thus it is quite common that school classes elect a spokesperson from their ranks to voice the concerns of the class to teachers or the school administration. Many schools also have yearbooks or newspapers produced by the pupils. These publications are often supervised by the school administration, so only a constrained freedom exists in what is written in them. Yet they are nevertheless communication channels that allow for a discussion of the relationship between teachers and pupils—from the pupils' perspective. In far more authoritarian structures, this would not be possible.

Parents, too, have gained greater influence, for example through days set aside by schools as parent-teacher conference days, or through the election of parents' representatives. That too has contributed to a shift in the balance of power.

Court judgments have also influenced the authority structures in the classroom. The mass media repeatedly report on corporal punishment, sexual harassment, and other assaults by teachers on pupils. That these matters are publicized indicates that teaching personnel, given far greater and unquestioned power in the last century, no longer enjoy such an abundance of authority. A teacher's authority is strapped into a tight corset of civilized behavior. Overall, therefore, it has been possible to put the inevitably unequal relationship between pupils and teachers, one that has nonetheless become less unequal, onto a more trusting basis.

DEMOCRATIZATION IN MEDICINE:
INFORMED PATIENTS AND THE LOSS OF MEDICAL AUTHORITY

Around the world, doctors enjoy high prestige. They have knowledge at their command that places them in a position of power when they are in contact with patients. Their authority rests on thorough training. In addition, when they are in contact with patients, meaning with those in a weaker position, a habitus or a pattern of behavior develops that reaffirms the difference in power. Doctors learn to address their patients with a firm voice and great self-assurance. Therapies are prescribed and prescriptions handed out. And as a rule, patients follow their doctor's orders.

The doctor's advice carries great weight because it rests on scientific knowledge, gathered over generations, that continues to be expanded. Explanations based on magic and myth have been successively replaced by empirically ground-

ed insights. Successful therapies further legitimate this stock of knowledge again and again. The usefulness of modern medicine is not up for debate.

Nevertheless, there have been developments in the doctor-patient relationship that have led to a reduction of the earlier disparity in power. In many places, doctors are by no means "gods in white" anymore. Without difficulty, patients can inform themselves and know more than in the past about alternative treatment methods. They can enlighten themselves and become educated, responsible patients.

Other actors have also come between doctor and patient. Health insurance organizations have become an additional, relevant factor. Even though they have been established in many parts of the world, they do not yet exist globally. Overall, such organizations strengthen the position of the patients by weakening the position of the doctors. It is no longer the patient or the patient's family that pays for the doctor's services but instead a health insurance organization, and that change puts the doctors in a different situation of dependence.

Overall, the rights of patients have also become more extensive and can even be enforced by the courts if necessary. In the United States, for example, court decisions on medical malpractice have forced insurance companies to pay enormous sums as compensation, which drives up health insurance costs. The power balances have reversed here, and the educated, responsible patient is also a patient who demands his or her rights. This can help improve the communication between doctors and patients, if the dialogue is constructive, and can help reduce misunderstanding and increase trust on both sides.

CONSUMER POWER: MATURE CONSUMERS AND CONSUMER PROTECTION

Consumption is a key characteristic of globalization. The global consumer society can be found wherever advertised goods with price tags rest on supermarket shelves. Colorful bazaars, where haggling over the price is still part of everyday life, continue to exist in many countries, but they are being increasingly displaced by the successful supermarkets that can be found in practically every city. The global triumph of supermarkets marks a change from chronic shortage to a surplus in basic supplies. In affluent societies in particular, the relationship between producers and consumers has developed in a specific way.

The first supermarkets opened in the 1920s in the United States. The idea was picked up in Switzerland by the innovative entrepreneur Gottlieb Duttweiler, who founded the chain of Migros supermarkets before World War II. At least since the 1950s, governments in industrialized countries have pursued a vision of a consumer society that is meant to guarantee access and participation to all. The most striking slogan of this political and economic project was *Wohlstand für alle!* (Prosper-

ity for all!), a slogan popularized by German Chancellor Ludwig Erhard during the late 1950s. One of the sources for this lay in the geopolitics of the Cold War and the competition between the United States and the Soviet Union, and for that reason, at least in Europe, the development of a consumer society was often interpreted as Americanization. The result was to create a guiding principle of capitalism asserting that the consumer is king.

In capitalistically oriented affluent societies, the relationship between producers and consumers has resulted in an increase in the rights of customers. With the rise of modern mass consumption, rules for protecting consumers have also been developed, and they have been adopted in many places. One can find consumer protection—though in greatly varying degrees—in almost every society where standardized, industrialized production supplies consumers with goods. In fact, "the consumer" only became a term in the course of developing the modern consumer society. The citizen is not only endowed with rights in a democratic nation-state, but he or she also has rights as a participant in the market. In principle, every purchaser is treated alike and has the same rights—and not just in the supermarket.

CONSUMER PROTECTION Izsak, Hungary, 2008: Quality control in the production of sparkling wine. A democratic understanding of the relation between producers and consumers leads to situations in which consumers have guaranteed rights with respect to the quality of the product offered and can also demand this quality be maintained.

This has developed further into the concept of the educated or empowered consumer, a designation for the citizen in his or her role as market participant who wants to have free choice, under fair conditions, in decisions on what to consume. This demand is applied to just about everything that can be acquired with money: Foodstuffs, televisions, cell phone plans, airplane tickets, and so on. The idea of an educated consumer is by no means the result of a broad, pro-consumer, social movement. It is rather governmental actors that have insisted on and implemented guarantees and protections and broad rights. Consumer protection has become a cross-sectoral political task in which an attempt is made to take the interests of consumers into account across all market segments. The role of the government is then limited, however, to acting as referee and ensuring that the rules are upheld.

Generally speaking, the purchasing decisions of citizens in democracies are secured through legal guarantees. From a global perspective, enormous differences exist in this regard, but in Europe the relationship between producers and consumers is relatively clearly regulated and relatively advantageous to the consumers. Investigative journalism significantly contributes to the protection of consumer rights. Scandals in food production are disclosed time and again, the public

IS THE CUSTOMER KING? São Paulo, Brazil, 2002: Is having innumerable varieties of shampoo to choose from really democracy? An established connection does exist between the existence of a prosperous middle class and support for democracy. Magnum Photos / Stuart Franklin

is made aware of flagrant violations, and politicians are pressured to take action. It is in the producer-consumer relationship that democracy as a value comes repeatedly to the fore in the demand for equal and fair market conditions.

CONCLUSION

The values associated with democracy are to a large degree borrowed from the French Revolution, and can be summarized in its slogan *liberté, égalité, fraternité*—liberty, equality, fraternity. Even if we regard these notions as utopian goals, they nevertheless say something about the social realities in which we find ourselves and from which these longed-for utopias arise.

In the most varied areas of life, one can find a functional democratization. This often can be seen in reductions in inequality and as a response to a lack of freedom. It means the extending of recognition and of solidarity to wider circles of people. These experiences color the everyday and are noticeable in small things. This process is at different stages of development in the many different societies on the planet, and it often—but not always—develops in the same direction.

Democracy starts within the family, in everyday life.

Albert Schweitzer

Albert Schweitzer (1875–1965) was a Franco-German doctor, theologian and philosopher.

FAMILIY AT AN EARLIER TIME New York, New York, USA 1955: At the dinner table of a 1950s American family.
In this era, authority, patriarchal severity, and clear hierarchies were standard elements in family life. Magnum Photos/Elliott Erwitt

CHILDREN Sarnen, Switzerland, 1949: The average family today has fewer children than a 1950s family did. Correspondingly, children have more freedom to develop and more opportunities to have their say. Keystone/Theo Frey

Göttingen, Germany, 2005 Keystone/Sorge

DEMOCRACY IN ORDINARY LIFE

Volketswil, Switzerland, 2013 Christoph Ruckstuhl

Tai Chi Day in New York's Central Park, 2002 Laif/Edward Keating

RELIGION Zürich, Switzerland, 1945: Fewer and fewer people have a taste for sermons from the pulpit. For many, traditional churches seem otherwordly and outmoded. In the wide and diverse marketplace of offers to give meaning to life, the church is only one institution among many. It is not only in the U.S. that megachurches try to capture the "market of meaning-seekers" with media-driven spectacles and trendy aesthetics. Keystone

Palm Beach Gardens, Florida, USA, 2005 Panos/Robert Wallis

Keystone/Wolfgang Eilmes

Still shot from *Hermine und die sieben Aufrechten*, 1934: Clothing and consumption style used to clearly signal which social class one belonged to, but such differentiations have become less obvious now. While consumers continue to be defined by what they buy, individuals are much freer today in their consumer choices than they used to be.
Keystone/Scherl

Shoppers in Zurich, Switzerland, 2009 Keystone/Alessandro Della Bella

WORKING LIFE Workers in a Bicycle Factory: Traditionally, workers have been in a weaker position than their employers. Once organized into unions, they fought for, and won, rights including protection from arbitrary dismissals, accident insurance, paid vacations, and the right to participate in important management decisions. Yet even in the modern working world, employees remain vulnerable to arbitrary decisions by their employers. Keystone/Scherl

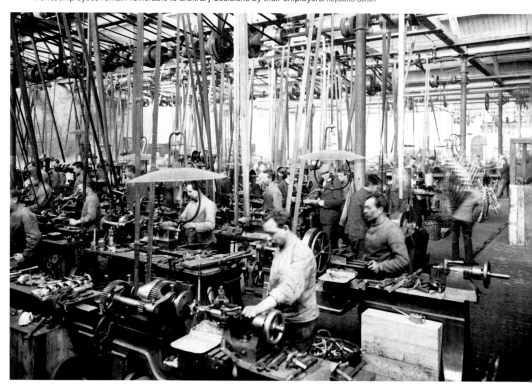

Call Center in Warsaw, Poland, 2011 Panos/Piotr Malecki

CONSUMPTION Zurich, Switzerland, 1925: With his mobile sales vans, Switzerland's Gottlieb Duttweiler, the founder of Migros, pioneered new methods of selling foodstuffs. Nearly a century later, the supermarket has become a fixed feature of modern life. The freedom to choose what one wants to consume is not an achievement of democracy, though a variety of products and competition serves the interests of consumers. Keystone

São Paulo, Brazil, 2011 Laif/Marta Nascimento

FAMILY TODAY Silver Spring, Maryland, USA, 2011: At the dinner table of a twenty-first century American family. Family life today is considerably less hierarchical and more egalitarian than it was half a century ago. VII/Stephanie Sinclair

Participatory Decision-Making in the Workplace

Flavia Fossati

Forms of democracy and democratic processes thrive when least expected. Sometimes mundane controversies and small-scale decisions can even have relevance for society as a whole. Thus, an event seemingly only of internal relevance, such as a vote taken by the rank-and-file workers in a company, can have consequences for a country's entire political process. Individual events connected to a similar set of issues can coalesce into a larger movement that takes the form of mobilization, demonstration, and strikes, ultimately encompassing the entire country in the debate.

CONFLICTS OVER WORKERS' RIGHTS IN THE CONTEXT OF A BROADER SOCIAL DEBATE

In Italy, the connection between varying forms of participatory democracy in "small" and "large" contexts, and the momentum basic social question can gather became especially evident in late 2010. In the context of the global banking crisis and a sustained recession since 2008, two key political issues emerged in the public sphere during the *autunno caldo,* the "hot autumn," and in both, Italy's future was at issue in one form or another. This process of forming political opinion, underscored by the media, resulted in a wave of nationwide protests, led by workers, students, political parties, and labor unions, that lasted for weeks and engulfed large Italian cities including Rome, Naples, and Bologna.

The first issue which would come to preoccupy large parts of the Italian public, emerged initially at a "micro-democratic" level in the context of votes taken at two Fiat automobile assembly plants, the Mirafiori parent plant near Turin and the Pomigliano d'Arco plant near Naples. Management had offered workers a deal that called for various concessions regarding wages and working hours on their part in return for job security: the goal was to increase the competitiveness of the factories.

The second issue that came to arouse public concern related to the impact liberalization measures and proposed cuts to education (the Gelmini reforms) would have on workers and apprentices who lacked job security. Among Italian industrial workers (labor market "insiders"), employment security is the rule. But since the introduction of flexible, temporary, and often precarious types of employment in 1997 and 2003 (the Treu and Biagi laws), and especially since 2008, women, young people, and low-skilled workers (labor-market "outsiders") have been practically unable to find stable, long-term employment. The latest figures show that in 2011, only one in three newly created jobs was permanent. In response, labor unions have drawn attention to the potential consequences for these labor market "outsiders" if labor market "insider" rights are curtailed.

What is interesting in the case of the Pomigliano and Mirafiori plants is that a decision modest in range was projected onto society as a whole. It shows that decisions made democratically on a small scale can lead to far-reaching consequences in a democracy, including igniting a process of public opinion formation, or leading to public protests that bring both outsiders and insiders onto the streets. Though the mobilization ultimately proved insufficient to block political decisions or reforms, it nonetheless served—particularly under Berlusconi's government, one that monopolized the media—to bring fundamental elements of democracy into play: the free and democratic formation, formulation, and expression of opinion.

RETAINING JOBS AT THE COST OF LOSING CONTRACTUAL RIGHTS: THE REFERENDUM AT FIAT AS AN EXAMPLE OF A DEMOCRATICALLY-CONDUCTED DISPUTE AT THE WORKPLACE

Debates over market liberalization have been a recurrent theme in Italy since the 1980s, because it has a labor market that suffers from a high degree of inflexibility, and has experienced falling productivity and rising unemployment. Though the Fiat automobile plants (*Fabbrica Italiana di Automobili Torino*) have long been among Italy's major and most prestigious employers, producing culturally iconic vehicles like the Topolino (1930s), the Fiat Nuova 500 (1950s), and the Fiat Cinquecento (1990s), they are no longer competitive—like many other firms in Italy.

That explains why Sergio Marchionne, Fiat's chief executive, informed the workforce in June 2010 that if they were not willing to give up certain privileges and increase their efficiency, he would move the entire manufacturing operation to Poland. Management then formulated a new labor contract that called for shift work, more flexible working hours, a reduction of work breaks by ten minutes, stricter controls on sick leave or absence, and a renunciation of the right to strike. In response, the labor unions, which since the 1993 reforms have been institutionally embedded in every factory in Italy in order to look after workers' interests directly or through labor-management negotiations, called for a vote by the rank-and-file workers about this new proposal. Workers, first in Pomigliano (in June 2010) and then in Mirafiori (in January 2011), were asked in a secret ballot referendum whether they were willing to accept greater restrictions and less-generous working conditions in exchange for preserving jobs in these plants.

In and of itself, the demand to increase production in Italy's factories and in the Italian labor market in general is legitimate and necessary to address, as the current Euro crisis demonstrates. Productivity has been low for a long time, so increasing it is necessary to develop the economy and keep jobs, especially as the country's southern regions (where Pomigliano is located) have youth unemployment

WORKERS PROTESTING Turin, Italy, 2009: Workers protest against layoffs at automobile plants. Referendums by the rank-and-file workers in which worker's rights were traded against guarantees of continued employment, led to discussions in Italian society and to week-long citizen protests against the government's position and attitudes. Dukas/Alessandro Tosatto

rates of more than 40 percent. One wonders, however, which incentives would most likely motivate workers to make such concessions. Therefore, and in light of fierce resistance, it is not surprising that Fiat sought to enlist a participatory decision-making mode so that the proposed measures would at least rest on a democratically legitimated basis—not that the workers were given any real alternatives.

The referendum on preserving around 5,000 jobs was necessary, though, not least because representatives from the three most influential Italian labor unions were of different minds. On the one side, representatives of the metalworkers' union, FIOM (*Federazione Impiegati Operai Metallurgici*), part of the CIGL (*Confederazione Italiana Generale del Lavoro*), Italy's largest union federation, strongly opposed the suggested new contract. They contended it was not only unconstitutional but would also lead to the "enslavement" of the workers. They invoked Article 1 of the Constitution, which states that the Italian Republic is based on the right to work, which it holds as an economic as well as a social value. They also pointed to Article 40, which institutionalizes the right to strike: The proposal would restrict this right. On the other side, the FIM (*Federazione Italiana Metalmeccanici*), part of the Christian and Catholic CISL (*Confederazione Italiana Sindacati Lavoratori*) union, the UILM (*Unione Italiana Lavoratori Metalmeccanici*), a union whose orientation is social democratic, and the Berlusconi government, supported the Fiat proposal so that jobs would remain in Italy.

To resolve this tricky situation and thus ensure democratic legitimation of the decision at least in procedural terms, the employees in Pomigliano were first called upon to vote for or against the proposal from Fiat's management. The participation rate was 95 percent, and 63.4 percent voted in favor. A similar result was obtained at the second plant, six months later, when 54 percent of the Mirafiori workers approved the plan in January 2011.

The flexibilization plans in Pomigliano and Mirafiori drew huge media response, not least because the case again highlighted the (near-constant) lack of unity among major union federations as well as defects in Italy's labor market policy. Yet this debate should not be seen only in strategic or labor market terms but also in terms of its relevance for democratic decision-making processes. The democratic aspect was quite prominent in the general public and media discourse during this time, for beginning with this referendum, and in response to the Italian government's support for Fiat, as well as due to a proposed reform of higher education, thousands of citizens protested and demonstrated (usually peaceably) for weeks on end, thus making their opinion regarding the Italian government and its objectives known.

EDUCATIONAL REFORM AND THE DEBATE ABOUT ITALY'S FUTURE: DEMOCRACY IN THE STREETS

The debate over "rights versus jobs" at Fiat was joined by a second debate over reform of the educational system. In addition to demanding the retention of jobs under fair conditions, preventing a scheduled reform of higher education policy was also at issue, as was how to make precarious employment and temporary jobs more secure. What needed to be improved, in particular, were not only job opportunities for young university graduates, but for women and the unemployed as well. Without them, social mobility would become impossible, and access, or re-access, to working life would be blocked. All these concerns were part of a social debate about Italy's future as a whole.

The legislature saw fierce debate over the Gelmini reforms proposed in the autumn of 2010. Named for Minister of Education Mariastella Gelmini, the reform bill envisaged massive cuts in education expenditures and a thorough reorganization of higher education policy: The state-run universities were slated to be downsized by 20 percent by cutting more than 1 billion Euros from the national budget and reducing the hiring of new professors. The reform was meant to be the last in a series of education reforms that had begun with restructuring the primary schools in 2008. In addition to cutbacks, the plans also called for liberalization and a greater market orientation in education, with individual universities to be given greater autonomy in curriculum planning and teaching methods as well as more financial autonomy. Through a new "privatization option," public individual institutions were to be given a choice and could become private institutions.

The criticism was correspondingly intense, and emphasized that this reform would only expedite

the formation of elites. The government countered by referring to new rules that would tie academic performance to giving students financial support, further noting that university degrees in their current form were of little relevance to what the labor market demanded by way of qualifications. Current higher education was too general and too oriented to the humanities. Among both faculty and students, this clear reorientation of Italian higher education met with an outraged response, not least because it was seen as concentrating power in the hands of tenured professors, private sponsors and foundations, all at the expense of the next, younger generation of scholars.

The debate was not only about how well universities were preparing students, but also about universities as employers, since the reforms would make the position of the young researchers who do most of the teaching in Italy's universities even more precarious. The reforms foresaw limiting their employment to a maximum of six years, and their heavy teaching load and working conditions would hardly allow them to concentrate simultaneously on pur-

suing a successful academic career. The academics and other educated workers who would then be forced to seek employment in other countries would be correspondingly large, hurting Italy's economy as well as its competitiveness.

The question was not just about job insecurity at Pomigliano and Mirafiori, workers' rights or austerity measures, but was a much more fundamental, *Che futuro per l'Italia?* (What future for Italy?), as one protester slogan put it. At the heart of the debate was the fate of the many students who once they had finished their studies, found themselves unemployed or doing only temporary work, the fate of researchers at Italian universities who had no prospects of further employment, and more generally, the fate of young people who feared for their long-term prospects, including for their pensions in old age. With slogans such as *noi la crisi non la paghiamo* (we're not paying for the crisis), *siamo tutti Brontolo* (we're all Grumpy [an allusion to the name of the seventh dwarf in Walt Disney's *Snow White*]) or *l'Italia che non si piega* (Italy won't buckle), workers (including Fiat workers), temporary

FOR ITALY'S FUTURE Rome, Italy, 2010: Students and lecturers protest against Berlusconi's educational reforms, which forsaw cutbacks at public universities. These protests led to a fundamental debate about Italy's future. Reuters/Tony Gentile

workers (known as *precari*), union members, leftist politicians, and many students took to the streets and protested. They demanded equality of opportunity in Italy, and thus took advantage of their democratic right to free expression. They opposed the Berlusconi government's plans to continue liberalizing the labor market and the educational system, and to make both more economically flexible.

CONCLUSION

Democracy is highly complex and not limited only to elections or referendums. It can become relevant at the micro-level, in a family or at the workplace, and at the macro-level, such as in the UN General Assembly. Between these extremes there are many different levels and forms of democracy that preserve and strengthen it, and they include strikes, protests, and other processes that shape public opinion.

It is therefore of great interest to analyze what kinds of democratic processes exist, where they originate and under what circumstances they become relevant to society. A referendum held among the rank-and-file who work at a company plant can become a metaphor in the public sphere and call attention to deficits in society. A simple issue in a limited context can almost imperceptibly become a symbol of special relevance to other people in larger contexts. The votes taken in the Fiat plants were not notably important or unusual, nor were they in any sense what sparked the protests. Instead, the point here is to emphasize that everyday democratic decisions can have many ramifications. The point is also to draw attention to how important public debate and freedom of expression are, particularly in systems where objectives vital to the welfare of the country are abandoned in favor of personal interests, as was the case under the Berlusconi government.

Democracy is an institution that organizes doubt, mistrust, and criticism. That is actually what makes it so successful.

Manfred Rommel

Democratic government can only be successful if it is supported by the democratic commitment of its citizens… We are not looking for admirers: we need people who think critically, who help in making decisions, and who share the responsibility.

Willy Brandt

Manfred Rommel (b. 1928) is a German politician and former mayor (1974–1996) of Stuttgart.

Willy Brandt (1913–1992) was Chancellor of the Federal Republic of Germany from 1969 to 1974. He made this statement upon taking office in 1969.

In long-established, stable democracies like the United States or Switzerland, certain aspects of democratic processes and institutions remain controversial. But these controversies are always about minor reforms—the democratic form of rule itself is not in question. By contrast, in many other countries of the world, including Egypt, China, Iran, Pakistan, Russia, and Vietnam, far more basic questions are put about the capabilities of particular types of government—and even whether democratic institutions on the Western model are desirable at all.

Can democracies, in fact, better meet the expectations society places on them, or can they solve problems better—as most readers of this book likely expect? If one looks at democracy less as a goal in itself or as a value and more as a means to an end, then one needs to define criteria to judge performance so that one can draw comparisons with other forms of government. Avoiding political violence, particularly war, and whether economic development is sustainable are among the most important of such criteria. Democracies, too, often inadequately resolve social problems. Yet when compared with non-democratic political systems, democracies do at least as well, and often better.

The Best of
All Governmental
Forms?

Thomas Bernauer

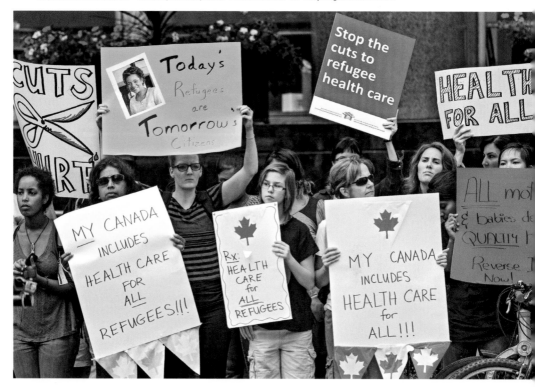

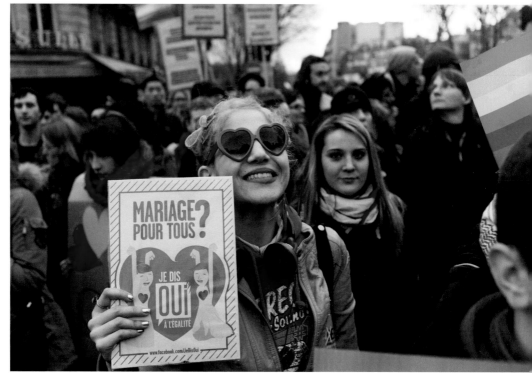

Paris, France, 2013: "Marriage for all? Yes!" Laif/Julien Chatelin

São Paulo, Brazil, 2013: "One Brazil for all!" Keystone/Nelson Antoine

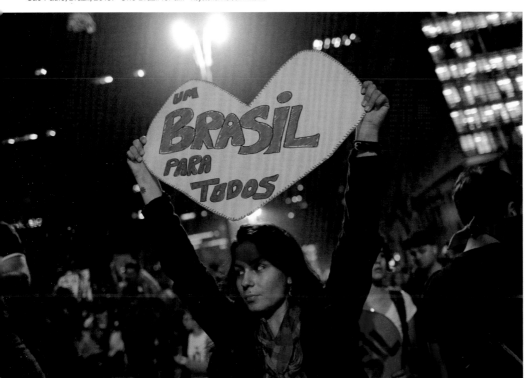

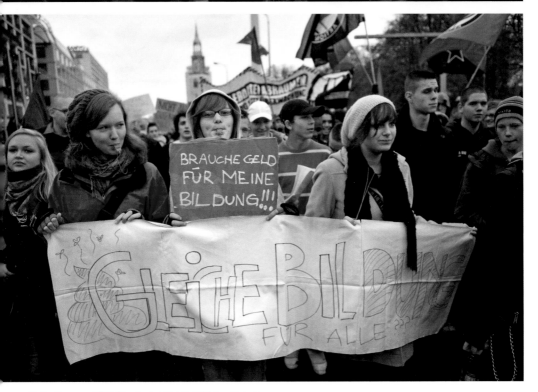

Berlin, Germany, 2009: "Equal education for all!" Panos/Stefan Boness

The Arab Spring has again made clear that the desire to participate in democratic decision-making processes can lead people to make great personal sacrifices. Democracy itself thus is an independent value for which people, at times, are even ready to die. But democracy can be seen not just as an end but as a means to an end as well. People want more democracy because they expect this form of government will help improve their material quality of life. That is because they expect democracy will improve their health care, educational opportunities, and the condition of the environment, and generally thereby increase their prosperity.

Yet are these expectations warranted, or are they an illusion? Are democracies generally better able to fulfill societal expectations and solve problems? The present chapter addresses these questions. Overall, one can conclude that though democracies inadequately address many societal challenges, and are sometimes wholly unable to resolve them, they are at least as good as, if not better, than non-democratic political systems. This observation supports Winston Churchill's well-known quip, uttered during a House of Commons speech (on November 11, 1947): "Democracy is the worst form of government, except for all those other forms that have been tried from time to time."

DEMOCRACY: MEANS TO AN END OR A VALUE IN ITSELF?

In highly developed established democracies such as Switzerland, there is, fortunately, no reason for most people to give their lives to achieve more democracy. However, it is also true that in such a country, democracy itself has a very high, independent value, and placing limits on existing democratic rights to participate in decision-making are practically taboo.

The high value placed on democracy can be seen in discussions about initiatives and referendums in Switzerland. The number of valid signatures necessary for an initiative (100,000) or a referendum (50,000) to be put to a popular vote should be seen in the context of a steadily growing population. The *de facto* hurdle for triggering a direct democratic plebiscite steadily lowers, which means the ability of citizens to directly participate in political decision-making steadily, if not near-automatically, rises. Demands to peg the number of signatories to a certain percentage of the eligible electorate, however, have virtually no chance of success. It seems the vast majority of Swiss citizens highly value their democratic participation rights, and they sharply reject even the smallest proposed curtailment of such rights. This can be seen as well in public discussions over whether Switzerland should join the EU. One of the most contentious aspects is that joining could mean limiting the rights of direct democratic participation—particularly if the plebiscite at issue is at odds with EU law.

This strong emphasis on democratic participation rights as an independent value can be contrasted to two other fundamental principles of modern democracies: The rule of law and efficiency. The rule of law stands as a corrective to a possible "tyranny of the majority," meaning there are limits to decisions reached by democratic majorities. Thus, the protection of fundamental human rights, or of the rights of minorities, can weigh more than the democratic will of a majority. Interestingly enough, Germany and Switzerland, both highly developed, established democracies, differ quite strongly on this point. In Germany, both basic rights and the rights of minorities can be protected, if need be, even against the will of government and parliament. Germany's Federal Constitutional Court can annul laws on such grounds either before or after they have come into effect. In Switzerland, majority decisions reached democratically carry more weight, as one can see from the passage of controversial initiatives such as those that ban the building of minarets, or call for the deportation of foreigners, or that address the detention of criminals.

In the tension between democracy and the rule of law, the issues primarily turn on the protection of basic rights and the rights of minorities. The tension between democracy and efficiency raises broader questions about the performance and capabilities of political systems. These questions are of considerable relevance not just to researchers but also to politicians, as political systems and decision-makers ultimately are legitimized not just through procedural aspects of the political system, such as democratic elections, but also by their ability to resolve problems.

DO DEMOCRACIES PERFORM BETTER THAN OTHER POLITICAL SYSTEMS?

The question whether democracies perform better than autocracies will seem nearly trivial to readers in highly developed, established democracies. Nearly all of them will likely answer with a resounding "Yes!" or point to North Korea's autocratic dictator, who rules over a poorhouse, and contrast it to a democratic South Korea that is a prosperous industrial nation-state. At most one can ask whether particular types of democratic political systems perform better than others. Does a consensual democracy like Switzerland perform better than a majoritarian democracy like Great Britain? Does a corporatist Austria have higher capacities and better performance than a pluralist United States?

However, a perspective focused on established democracies ignores that the question whether more democracy is useful and desirable remains highly contested in many of the world's countries. Pakistan provides a case in point. Since 2008, it has been ruled by a democratically elected government, but it is a country that has had a variety of military dictatorships as well as various shorter periods of

democratic rule. After a short surge in enthusiasm resulting from democratization, opinion polls now show considerable public distrust in democracy. In 2012, only 42 percent of the respondents regarded democracy as a desirable system of rule, 30 percent favored free, uncensored, media, and 20 percent free access to the Internet. But three out of five respondents preferred a strong political leader rather than democracy. A major reason for such findings is likely the disastrous economic situation of the country. In 2007, the last year the military dictatorship was in power, 59 percent of the respondents thought Pakistan's economic situation was good. In 2012, only 9 percent still thought so. It illustrates what Democratic strategist James Carville kept telling Bill Clinton to remember during his campaign for the U.S. presidency: "It's the economy, stupid." Similar responses can be found in other Muslim-influenced countries, where barely more than half (and at times only a third) of those asked think a good democracy is more important than a strong economy (see also Figure 1).

Bertolt Brecht, in *The Threepenny Opera* (1928), put the tension between democracy and a certain kind of performance, namely economic development, succinctly: "Food comes first, and only then comes morality."

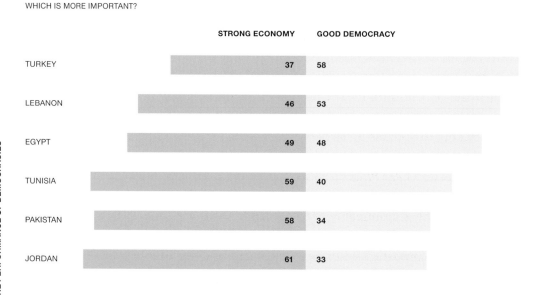

WHICH IS MORE IMPORTANT?

	STRONG ECONOMY	GOOD DEMOCRACY
TURKEY	37	58
LEBANON	46	53
EGYPT	49	48
TUNISIA	59	40
PAKISTAN	58	34
JORDAN	61	33

THE PERFORMANCE OF DEMOCRACIES

1 **WHICH IS MORE IMPORTANT, DEMOCRACY OR MATERIAL AFFLUENCE?** In a 2012 survey, the citizens of various nation-states were asked which was more important to them: a strong economy or a good democracy?

But the basic question whether democracies perform better cannot be adequately answered merely by making reference to particular countries. Rather, we have to first ask ourselves by which criteria we should assess the performance of democracy. Second, most of the world's countries are *not* economically highly developed, established democracies. The largest democracy in the world, India, is a comparatively poor and still-developing country. China, the world's most populous country, pursues a model of development, on the other hand, that the specialized literature calls authoritarian state capitalism. Questions about democratic performance thus need to be addressed in globally comparative terms.

Is there, in fact, a conflict between economic performance and democratic participation rights, as the example of Pakistan appears to suggest? When, and why, do countries and their citizens opt for more, or less, democracy in such a context? Existing research is not able to definitively answer such questions, though one can assume political systems legitimate themselves partly by reference to the quality of their political decision-making processes, and partly through their problem-solving abilities. Here legitimacy means citizens largely accept and support a country's institutions and decision-makers, as well as their decisions, laws, and governmental measures.

In what follows, we look at a broad catalogue of objectives and investigate whether democracy furthers these goals. We begin with the question whether democracy encourages the nonviolent resolution of conflicts. Subsequently, we turn to various other social goals that generally can be regarded as furthering sustainable development.

POLITICAL VIOLENCE: HOW PEACEFUL ARE DEMOCRACIES?

Ideally, democratic structures and processes should function in such a manner that they steer conflicting or different social interests onto orderly (institutionalized) paths that allow for nonviolent solutions. From this perspective, political systems can ultimately be regarded as capable (or able to perform effectively) when they are able to address and resolve social conflicts nonviolently (or nearly so). This criterion can be applied both to the international (between nation-states) as well as to the domestic (within nation-states) level. We limit our observations here to wars, because as a rule, they cause far more human suffering than other forms of violence (such as criminality or terrorism).

We can begin by looking at the global percentage of democratic nation-states over time and compare it with the number of wars (see Figure 2). Seen over the longer term, meaning since 1816, no clear relationship between democracy and war is identifiable. In the short term, particularly after the Cold War ended in 1991,

the percentage of democracies in the world has risen sharply, and the number of wars (both international and domestic) has fallen.

Conflicts Between States: Is democracy peace-loving?

The decreasing frequency of international wars since 1990–1991 and the simultaneous global increase in democracy is not yet tenable scientific proof that democracy promotes peace. This apparent connection could be spurious or have come about for other reasons, and many conflict researchers have addressed precisely this question. The German philosopher Immanuel Kant already addressed this possibility in his work *Perpetual Peace* (1795). It has only been in recent decades that modern political science has begun to more closely investigate, in both theoretical and empirical terms, a possible correlation between democracy and war.

The argument of "democratic peace," drawn by analogy from Kant's notion of "perpetual peace," is that democracies far more seldom go to war against one another than do other combinations of countries, such as democracies versus autocracies, or autocracies against each other. Numerous studies have come to this conclusion, and one can use World War II as an illustration. In that conflict, dictatorships (Germany, Italy, Japan) fought democracies (Great Britain, the United States) or other dictatorships (the Soviet Union). Yet none of the democracies in that conflict fought one another. However, this observation already strongly limits the democratic peace argument, since democracies do not seem to be fundamentally more peaceable at the inter-state (international) level, but only more peaceable with respect to other nation-states that have a similar (democratic) political system.

From 1945 to 2007, a total of 126 international wars were fought around the globe. This figure is generated by counting pairs of belligerents, with each pair participating in a war that involved more than two nation-states counted separately. Of these 126 wars, 15 percent were started by a democracy, and democracies were involved in 39 percent of the conflicts. In 19 percent of the cases, the war was started by a non-democracy, with non-democracies involved in 61 percent of these conflicts. The figures on initiators do not add up to 100 because many of these conflicts involved more than two nation-states and because a third nation-state initiated the war rather than either of the paired countries.

The obvious follow-up question (why do only pairs of democratic nation-states evince a less belligerent relationship?) has preoccupied researchers for many years. The focus has been on a series of questions. What mechanisms lead to democratic pairs of nations being able to resolve their differences without recourse to war? Why are democracies overall nevertheless not more peaceable

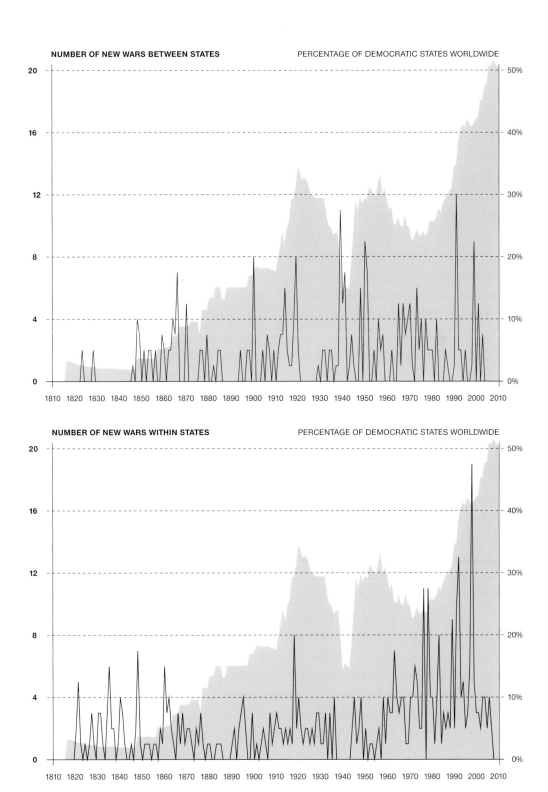

NUMBER OF NEW WARS BETWEEN STATES PERCENTAGE OF DEMOCRATIC STATES WORLDWIDE

NUMBER OF NEW WARS WITHIN STATES PERCENTAGE OF DEMOCRATIC STATES WORLDWIDE

2 **THE RELATIONSHIP BETWEEN DEMOCRACIES AND WARS** The figures show the percentage of democratic nation-states worldwide (minimal criterion: existence of elections for the executive authority) as well as the number of domestic and international wars that started in a given year, per country and conflict. One can note a clear increase in the number of democracies after the end of the Cold War and a simultaneous reduction in the number of wars.

than non-democracies (or autocracies)? Why is it that democracies in wars involving more than two nation-states very seldom find themselves on opposite sides in the conflict? Why do democracies win most wars, have fewer casualties, and become more engaged in efforts to resolve conflicts peacefully?

We focus here, by way of illustration, just on the first two questions. Research to date has provided three principal answers to the puzzle of democratic peace. The first is that democracies tend to be more strongly characterized by cultures which emphasize the peaceful resolution of disputes and which also place limits on political competition. However, this culture is primarily practiced vis-à-vis other democracies, and is understood in the sense of a common identity and a differentiation from political systems that are culturally different, meaning non-democracies.

Second, democracies face higher political barriers before the decision to go to war is made. The reason lies in the division of powers between legislature, executive, and judiciary, as well as in the barriers to war placed by citizens and the mass media. These hurdles have the effect that a democratic government will usually start a war only when it has good reason to believe it will also win this war. Research also indicates that a democratic government that loses a war is more frequently overthrown than a non-democratic government that does the same.

Third, democracies have both a stronger and a more transparent public arena. This means that when conflicts arise between two democracies, it is clearer to each, or rather, clearer to each government, how the interests and intentions of their adversary are developing. Misperceptions and political miscalculations that can trigger crises and wars are thereby made less likely.

If we turn to the second mechanism, we can assume that politicians are rational egoists primarily interested in their own political survival (e.g., maintaining power, being reelected). In countries where support by a cross-section of the population is necessary for politicians to exercise power—these countries are primarily democracies—political survival depends upon successful political activity which generates public goods that many in the population can profit from. In non-democracies, by contrast, the political (and sometimes even the physical) survival of rulers depends primarily on successfully providing a (numerically smaller) group of followers (than in a democracy) with private goods.

Public goods are those whose use is nonexclusive: No one can be prevented from enjoying them and they benefit the public at large. Examples of public goods include a system of public education or the provision of public health care. Private goods are those whose use can be limited to particular persons or groups. Decision-makers in democracies are thus more dependent on winning wars, though

IRAQ WAR, 2003: PRO AND CONTRA UN Security Council, New York, February 5, 2003: UN Secretary General Kofi Annan and other audience members listen as U.S. Secretary of State Colin Powell argues the case for intervening in Iraq. The information he presented was later shown to be largely inaccurate. This fraud and the ensuing conflicts claimed more than 80,000 human lives between 2003 and 2008 alone. Keystone/Elise Amendola

this is under the premise that victory in a war produces a public good or provides additional resources that can be used to generate further public goods.

In consequence, democratic governments that have decided to go to war invest considerable resources to win this war, and start a war only when the chances of winning are relatively good. Because a democracy knows another democracy will behave in precisely the same way, it judges its own chance of victory will be less, and that leads to fewer wars between democratic nation-states. Democratic peace can thus be explained by arguing that a war between two democracies would be very costly to both sides, and that the price to pay domestically in case of a defeat would be very high. Non-democratic governments, by contrast, invest fewer resources in waging war because they need to expend more resources to provide for their followers. They commence a war even when the chances of winning are unclear or even minimal.

However, because winning a war can bring domestic benefits (especially if one's own losses remain small), democracies may fight wars relatively often against weaker non-democracies. An extreme example of this was the one-week war the United States conducted against the Caribbean island nation of Grenada in 1983.

PROTESTING AGAINST THE WAR London, February 2003: The British reacted by mounting mass protests against Great Britain's participation in the war against Iraq. Prime Minister Tony Blair won re-election in 2005. Reuters/Peter Macdiarmid

For similar reasons, powerful democracies sometimes employ (a limited amount of) violence against much weaker democracies: The violence Israel has shown to Lebanon (1982–2006) is an example of this. However, in many cases the country under attack rapidly capitulates, and the conflict rarely escalates.

Conflicts Within States: Democratic debate rather than violent confrontation

In the last twenty years, the number and extent of domestic wars have increased in significance when compared to international wars. Here, too, one can see that democracy promotes peace or helps prevent war. True, democracy does create more space to carry out social conflicts, but it also helps reduce the motivation to carry out such conflicts violently. Social tensions often exist in dictatorships, and many under such regimes have an interest either in replacing the ruling elite with a different elite, or in replacing the dictator with a democratically elected government. But it is difficult to organize such interests in a dictatorship, as the apparatus of state repression can take action against a nascent opposition far more ruthlessly than is possible in a democracy. In democracies, it is far easier to organize a political opposition because there is far more space and freedom to do so. The repressive apparatus a democratic government has at its disposal is more tightly bound by the law and by democratic mechanisms. In democracies, groups in opposition to the government have far more opportunities to bring their views into the political decision-making process or to use the law and the courts. As a rule, political violence (including civil war) is thus not an attractive option for those in democracies who oppose the government. The exceptions—the Basque ETA or the Northern Irish IRA—where groups in opposition to the government have conducted minor wars that at the end of the day proved unsuccessful illustrate the rule. For these reasons, one should expect to find a nonlinear relationship between democracy and the risk of civil war. That risk is also low in repressive dictatorships, though it is somewhat higher in unstable, partly democratic political systems.

Integrative democracies, in particular, have a low risk of civil war. That is because they reduce conflict by more effectively transforming government expenditures into public goods that benefit broad segments of the population, and they reduce material risk through social safety nets (such as a welfare state) and the redistribution of income and wealth. They also guarantee individual liberties in cultural, religious, and other realms, and make the resolution of social conflicts more possible by using institutionalized and nonviolent mechanisms to do so. Costa Rica is a good example. The country is the oldest democracy in Central America, and did away with its army as long ago as 1949. Unlike its neighbors, it has not engaged in a civil war since.

What remains unclear is how to structure the process of democratization so as to limit the risk of a civil war. The risk of political violence in unstable semi-democracies can be quite high, particularly in the context of elections. Unrest in Kenya during the presidential elections at the end of 2007 is one of many examples. About 1,000 Kenyans lost their lives and more than half a million people were forced to flee as a result of conflicts between Mwai Kibaki's supporters and Raila Odinga's supporters, and because ethnic groups were mobilized against one another.

However, scholars have thus far been unable to establish at what point it is optimal to hold free elections in political systems that are democratizing. Many questions also remain open with respect to the effects of democracy and democratization on other forms of political violence, such as terrorism, as well as on non-political violence (e.g., criminality).

DO DEMOCRACIES HELP PROMOTE SUSTAINABLE DEVELOPMENT?

Avoiding or limiting wars cannot be the sole criterion for judging the performance of a political system. A further criterion is sustainable development, primarily interpreted as a broad catalogue of social achievements that are positively valued. These are summarized, for example, in the UN's Millennium Development Goals, which set out eight quite specific performance goals: Eradicate extreme poverty and hunger; achieve universal primary education; promote gender equality and empower women; reduce child mortality rates; improve maternal health; combat HIV/AIDS, malaria, and other diseases; ensure environmental sustainability; and create a global partnership for development. This catalogue has some gaps, and in part mixes means (promoting gender equality and developing a global partnership with developing countries) with ends (reducing child mortality rates and achieving universal primary education). But in the end, it points to a broad international consensus over the goals toward which nation-states and their political systems should strive. Here, too, one can ask whether democracy fosters reaching such goals.

INCENTIVES FOR MAKING PUBLIC GOODS AVAILABLE:
DOES POLITICS LIVE UP TO ITS PROMISES?

To understand how and why democracy might foster sustainable development, we need to begin with some abstract considerations about making public goods available to a community, as well as about what the ultimate or chief task of government is. Public goods are available to the general public, and they have particular benefits to those who use them. Examples include security, the rule of law, the public education and health systems, the welfare state, an intact environment, and the public infrastructure (which includes the rail and road network and the electric

grid). In societies that function well, the government either organizes such public goods and makes them directly available, or regulates the quality and price of such goods when they are provided by private actors.

If we regard democracy as a political marketplace, then we can also think of supply and demand processes. If we assume that in two nation-states, one a democracy and the other a non-democracy, there are identical problems to resolve in a particular realm (such as the health of the population or the condition of the environment), then one can expect that the public demand to find solutions will be greater in a democracy. At the same time, the political decision-makers will have a stronger incentive to meet this demand.

The reason to expect so is quite simple. Democratic systems make more space and freedom available to their citizens to become informed about a problem, for example, such as by publishing research reports or through investigative journalism. Such information spreads throughout society with the help of the mass media, and from this, demands are made, through political parties or through demonstrations, that the political system address the problem. This results in political pressure on decision-makers.

THE MINIMUM Loubao, Democratic Republic of the Congo, 2009: In its "Millennium Goals," the UN defined criteria for sustainable development, which were intended to apply to democracies as well. Aside from fighting extreme poverty and hunger, the goals included gender equality, ecological sustainability, and the existence of a functioning healthcare system (reduction in childhood mortality, improvement in the health of mothers). Panos/Frederic Courbet

On the supply side, the competition to obtain political posts, one regulated in democracies through general, equal, free, direct, and secret elections, plays a key role. To win a democratic election, a candidate must more convincingly promise to make at least as many (or better, more) public goods—such as a well-functioning health and education system—available to relatively large segments of the population than can his or her rivals. And once elected, that politician needs to at least partly implement such promises if he or she wants to be reelected.

But the incentives to provide private goods in non-democracies are stronger. To remain in power, what is especially necessary is to have the support of a relatively small elite. Examples of this might be the former Gadhafi regime in Libya, or the Assad regime in Syria. Both regimes invested little in their education and health systems or in the environment, and ran their countries like a family enterprise: The leaders and their close followers and supporters enormously enriched themselves. The burgeoning political opposition in non-democracies is pacified less through public goods than by government repression of oppositional activities—which is far easier to carry out than in a democracy.

Of course it is also true that some public monies wander into private pockets in democracies, or are spent for unproductive purposes that do not benefit the public at large. Yet one can generally expect that democracies invest more in activities or branches that benefit the broad public than do non-democracies.

This positive expectation with respect to the performance and capabilities of democracies when compared with non-democracies has led to criticism among researchers, however. One counterargument is that political decision-makers in democracies have short-term orientations because they want to get reelected and are mostly just thinking about the next election date. To maintain, if not increase, their political popularity they tend to support political measures that will demonstrate visible results to the electorate before the next election. Such measures, though, can be highly inefficient, often cannot solve complex, longer-term problems, or may even be counterproductive in the long run. One can think here of expenditures to stimulate the economy that in the short term lead to more economic growth but in the long term lead to more state debt and inflation, as well as financially burdening coming generations. Other examples include the lack of willingness to invest in the long-term stabilization of pension systems, or to invest in fighting climate change.

Another counterargument is that political decision-makers are often not primarily making decisions in the interest of the public at large but instead to serve politically influential interest groups—a preference that comes at the cost of society in general. Examples of this are subsidies to agricultural producers or mining

enterprises, tax breaks for the rich, or protection of specific domestic industries from foreign competition (which increases the prices to domestic consumers).

These critiques apply to democracies as such, however, and do not directly address what such a critique means when one compares democracies with non-democracies. A more pessimistic interpretation would be that critics expect democracies on average to show as many weaknesses in their performance as non-democracies. A more optimistic view is that democracies may not be able to solve social problems perfectly (for example, because they supply insufficient public goods), but nevertheless do a better job than non-democratic systems. Which of these arguments is sounder is an empirical question, to which we next turn.

WELFARE FOR ALL?
THE LINK BETWEEN DEMOCRATIC STRUCTURES AND
ECONOMIC PERFORMANCE

We begin with the economic performance of nation-states, since most other performance criteria, such as the quality of the educational system, the health of the population, and environmental protection are in the end connected to economic performance. This means nation-states that are more economically efficient and productive tend to also do better, over the longer term, with respect to other performance criteria.

The connection between democracy and economic performance is more complex than readers might think. On the one hand, economic growth, and thus also prosperity (usually measured as income per capita), is influenced by a multiplicity of factors whose effects, at least in part, are differently valued or assessed. On the other hand, effects and mechanisms can run in the other direction, as when democracy affects the economic performance of nation-states. Finally, democratization processes can be affected by the strength or health of a country's economy, as we saw in the example of Pakistan.

Welfare: Not only a characteristic of democracy

If we look at specific countries, it quickly becomes clear that the reciprocal effects of democracy and economic performance do not run in a straight line in one direction or another. Of the twenty richest countries in the world, sixteen are established democracies—the richest in per capita terms is Luxembourg, the "poorest" Finland—which would seem to support the proposition that "democracy leads to prosperity." Yet the richest country in the world today is Qatar, which, along with Singapore, Brunei, the United Arab Emirates, and Kuwait, is (by most measures) non-democratic. Some non-democratic nation-states such as China and Vietnam even achieve higher rates of economic growth than most democracies do, though (with a few exceptions, such as Singapore) they also started from a lower level of wealth. The world's largest democracy, India, is poor but is growing very rapidly as well.

Pros and Cons: The debate about the positive and negative influence democracy has on economic performance

And matters become still more complicated, because there are good arguments both for and against the notion that more democracy equals greater economic growth. Optimists argue that democratic institutions positively influence economic growth, and hence prosperity, primarily through three mechanisms. First, polit-

ical and economic freedoms reinforce each other, with the latter indispensable for growth. The protection of (private) property and legal certainty, among the usual concomitants of democracy, is just as indispensable. Investments on a grand scale are attractive only if the danger of nationalization by the government, or by private actors such as corrupt elites, is low. Second, democracies have more transparent decision-making processes. That increases how predictable or calculable the political and economic environment is, which in turn has a positive influence on economic growth. Third, democracies invest more in education. That encourages the development of human capital, and thereby economic development.

Critics, and pessimists, argue instead that democracy can also slow economic development. The average income of the electorate in democracies is usually lower than the average income of the ruling elites in non-democracies. The average voter in India, for example, has a far lower income than the average member of the Communist Party elite in China. The circles relevant for the political survival of a government in democracies also have different economic interests than those in non-democracies. Politicians in democracies thus tend to be confronted more with demands for higher wages and for a redistribution of income and wealth, such

LIMITS TO GROWTH?　In the past twenty years, China has experienced remarkable economic growth. Will its authoritarian system soon reach its limits? And will the ever-expanding middle class come to demand more freedoms and participatory rights? Art project by Alain Delorme

New York, USA, 2008: According to government data on poverty, 15.9 percent of the U.S. population—48.5 million people—were living below the poverty level in 2011. Panos/Martin Roemers

Singapore, 2010: The country has been run in an authoritarian manner, but is also one of the twenty richest countries in the world. The relationship between a government system and material prosperity is complex, and the influence democratic structures have on economic growth is difficult to show. Protection of property rights and legal certainty, however, are key to long-term economic growth. Panos/Tim Dirven

as through a proportionately higher taxation of higher incomes and assets. To be elected, they often answer such demands, even though in some circumstances it may slow economic growth. Additionally, democracies give more space and freedom to interest groups. They, in turn, create distributive coalitions that agitate for their own particular interests, without sufficient regard for the common good. Such observations lead to the expectation that the economic performance of democracies will be weaker, or at least no higher, than that of non-democracies.

Democratization, Dictatorships and Economic Growth: A mixed picture

If we use statistical methods to filter out alternate explanations for economic growth, and use growth (rather than per capita income) to judge a country's performance, then many studies show democracy does not seem to have a straightforward effect. When a very undemocratic country becomes somewhat more democratic, it accelerates economic growth. This positive effect democracy has on growth becomes progressively weaker, however, if the country moves from a moderate to a high degree of democracy. In other words, a small degree of democratization in a very dictatorial system such as North Korea's leads in the medium term to more economic growth than the further democratization of an already very democratic system such as Sweden. Partial democracies, or partial autocracies, like Singapore or Hong Kong show the greatest economic growth.

On the other hand, many studies also show that the effect of democracy on economic growth overall is weak. Instead, the development of human capital, as well as of legal institutions such as property rights or legal certainty (which may also exist in partial democracies or dictatorships), seems to be more important for long-term economic growth. In fact, they are more important than the specific form political institutions take, as demonstrated by the examples of Singapore, Hong Kong, Taiwan, and South Korea in the 1990s, or the example of Chile under Pinochet. Countries like these seem to first overcome poverty through efficient economic policies that are directed by autocrats. After that, a democratization process ensues. Taiwan and South Korea, for example, are ranked nineteenth and twenty-fifth in terms of prosperity and both can be called democratic. Hong Kong, however, has found itself in a precarious political situation since it was handed back to China more than a decade ago, one that could lead to rolling back the partial democracy practiced there under British rule. Political liberties in Singapore are also limited. It should come as no surprise that such models are of considerable interest in China and in Putin's Russia. However, in light of what one sees in established democracies, it is unlikely a high degree of affluence will be compatible in the long term with severely limiting the opportunities for political participation.

FIGHTING POVERTY: A CHALLENGE FOR DEMOCRACIES AS WELL

Strong economic growth of the kind seen in China, India, or Brazil is often associated with an increasing disparity in income. The rich become richer, while the proportion of people living below the poverty line does not fall and may even rise. The performance of democracy should thus be evaluated not just in terms of its effects on economic growth in the country as a whole but also with respect to what effects it has on poverty or on the poorest segment of society.

For a long time, it seemed clear a positive correlation existed between a reducation of poverty, and democracy. Because democratic governments tend to act in the interest of broad segments of the population, in two equally prosperous countries we should observe less poverty in a democratic than in a non-democratic country. The voices of the poor are heard more clearly in a democracy, the argument runs, and the poor thus receive more government support there.

But there are two critical issues here. The first is that available data about the extent of poverty, or the progress made in fighting it, are relatively poor. Poor countries, but even some rich non-democracies such as the Arab oil-producing countries, often lack reliable data on poverty. The absence of such data can strongly distort the results of statistical analyses. The second is that while one can assert democracy has an influence on the extent of poverty, poverty can in turn influence democratization processes. Because the effects may work in both directions, they complicate making a reliable assumption about the "democracy-poverty" effect.

Newer studies show that older research results also may have been too optimistic. Better data about the degree of poverty, measured for example by child mortality rates, as well as improved statistical methods, suggest a more sobering conclusion: With respect to poverty reduction, democracies on average do no better than non-democracies. If one regards democracy more as an end than as a means, such a conclusion is not necessarily bad—at least there seems to be no contradiction between democracy and reducing poverty.

Yet the question we posed earlier using the example of Pakistan—do people seem to want more democracy or do they seem to want better economic performance?—seems problematic. Or put another way, there is no systematic evidence that it would be worthwhile to pay the price of having less democracy in order to make greater progress in fighting poverty.

That democracies do not perform better in fighting poverty is connected to the fact that the poorest segments of the population participate at below-average rates in democratic decision-making processes. Those in the middle and upper classes are usually much more politically active: More likely to vote or seek political office, and they participate more frequently in interest groups. As a result, they

THE QUEST FOR DIGNITY

Wole Soyinka

[…] Considerations of this intangible bequest, human dignity, often reminds me of a rhetorical outburst in the United Nations by a Nigerian representative–no, that desperate rhetoric did not lead to hysteria […], except one chooses to remark the barely suppressed hysterical laughter in the hallowed halls of the General Assembly. The occasion was the nation's arraignment before the General Assembly on charges of violations of human rights and the denial of democracy to the people. In what he must have considered the definitive argument on the subject, he challenged his listeners to combat in more or less the following words:

"What exactly is this Democracy that we're talking about? Can we eat Democracy? The government is trying to combat hunger, put food into people's stomachs and all we hear is Democracy, Democracy! What exactly is this democracy? Does it prevent hunger? Is it something we can put in the mouth and eat like food? "

I felt bound to come, quite unnecessarily, to the defence of the United Nations and wrote an article in response. I remarked I had dined in the cafeterias and restaurants of the United Nations on a number of occasions, and had never seen Democracy on the menu, or indeed on any menu in restaurants all over the world. So what, I demanded, was the point of that statement?

Well, Democracy as such may not be on the UN restaurant menu, it is nonetheless on its catering agenda. So is Human Dignity. Needless to say, both are inextricably linked. Indeed, Human Dignity appears to have been on everyone's menu from the most rudimentary society, recognized as such by philosophers who have occupied their minds with the evolution of the social order. […]

Wole Soyinka (b. 1934) is a Nigerian playwright, poet and writer. He was awarded the Nobel Prize in Literature in 1986.
Excerpt from "The Quest for Dignity," The Reith Lectures, 2004

also exert more influence on political decisions than do poor people. Politicians in democracies thus have an incentive to enact public measures or engage in investments that primarily benefit the middle and upper strata. The poorest thereby tend to get passed over.

THE RESPONSIBLE CITIZEN: DEMOCRACY AND EDUCATION

Most established democracies, following the principle of equality of opportunity, regard education as a public good. Regardless of income and wealth, every citizen should have access to a comprehensive range of educational offerings, in order to be able to sensibly take advantage of the economic, social, and political liberties in their society. In addition, if we also think of the abovementioned incentive to make public goods available, then we should expect democracies to do more for the education of their citizens than non-democracies do.

In reality, the connection between democracy and education is more complicated. Those who have higher levels of education are usually economically more productive and for that reason also usually have higher incomes. They and their children, in turn, have better educational opportunities because they can afford private schools, for example. Voters in a democracy should on average therefore have a stronger interest in a public education system financed through public tax revenues than the members of elites who support the regime in non-democracies. The reason is that with respect to average incomes, the latter group is usually richer than the former.

In addition, education generates benefits for the economy of the respective country overall. Countries with a more highly educated population are more innovative and economically productive. This creates jobs and income, which leads to more economic growth and a higher average level of affluence. One can therefore expect that democratic countries have better public education systems than non-democracies.

As with combating poverty, however, differing interests in democracies may thwart one another. It is the lower income levels that could profit from an expansion and improvement in what is offered in grade schools, yet this is the segment of society that usually participates less in political life than do the middle and upper strata. Presumably, therefore, the interests of the lower classes are given less consideration. The middle and upper classes, however, are more likely interested in improvements at the secondary and university level than in spending more for grade schools. Since these strata are more politically active than the poorer strata, politicians tend to have an incentive to invest more in higher rather than in lower grade levels.

The quality of educational opportunities in a country is very difficult to measure. As a result, analysts usually fall back on figures that are relatively easy to measure. Thus, the degree of democracy is assessed by average years of schooling (which is an indicator of the "scope" of education). Statistical analyses taking into account that more education can lead to more democracy have shown that democracy tends to positively influence the educational offerings in a country. Pupils in democratic systems have a greater scope of education. Studies using additional measures of the educational system, such as illiteracy rates or state investment in various educational areas, have come to similar conclusions. Democracies therefore invest more in the education of their population.

OPPORTUNITIES SOS Hermann Gmeiner International College, Tema, Ghana, 2012: This school gives children from disadvantaged families the opportunity to complete their secondary education. While democracies invest more in education than non-democracies, educational opportunities for children tend to depend on the social background they come from.

Christian Bobst

OUT OF SIGHT, OUT OF MIND?
DEMOCRACIES AND ENVIRONMENTAL PROTECTION

In terms of democracies and environmental protection since the 1970s, most politicians in established democracies are of the opinion that economic development should not come at too great a cost to the natural environment. However, nearly all economic activities burden the environment, so environmental problems are practically unavoidable. Yet the goal should be to limit the environmental impact in such a manner that future generations may be guaranteed an environmental quality comparable to the one that currently exists. This goal is usually described as "sustainable development," meant in an economic and ecological sense. Here, again, the question is whether democracies can manage to strike a balance between trying to achieve more economic prosperity, yet also protecting the natural environment, and doing so better than non-democracies.

Let as assume that individuals who are extremely poor want to first satisfy their material needs for food, shelter, and basic medical care. In countries where the majority of the population is very poor, governments should as a rule also take this view. Once the worst poverty has been eliminated, though, and a larger middle class formed, and where the damage done to the environment through economic development has become visible, we should expect that both the people and the government should turn more to addressing these environmental problems.

For simplicity's sake, let's compare a democracy and a non-democracy, and assume both countries share the same level of prosperity and the same environmental problem. Under these conditions, one can expect that both the demand for, and the governmental supply of, measures to address the particular environmental problem will be greater in the democracy. For environmental problems tend to be diagnosed more quickly, more precisely, and with greater transparency in democracies, and they are more openly discussed and more readily transformed into demands made of the politicians than in non-democracies. A broad cross-section of the population also profits from better environmental quality (meaning better air, better water quality, less noise). For that reason, politicians in democracies have a stronger incentive to respond to these demands than do politicians in non-democracies. As in all the aforementioned performance criteria, this does not mean democracies always resolve environmental problems effectively. It only means, in a pessimistic reading, that they at least do no worse than non-democracies. The more optimistic view holds that they resolve environmental problems both better and faster. Empirical comparative research, covering long time periods and including many countries, has tried to establish whether the putative positive effect of democracy can actually be found. The results of this assumption appear

GLOBAL Weisweiler, Germany, 2010: With respect to global climate problems, democracies perform only barely better than non-democracies. Laif/Paul Langrock

LOCAL Bern, Switzerland, 2012: In combating local environmental problems that voters can see for themselves, democracies generally do markedly better than non-democracies. Keystone/Lukas Lehmann

to be borne out: Democracy does seem to have a positive influence. This positive effect of democracy, however, primarily applies to environmental problems that are local or regional in nature and therefore visible and evident to voters (examples include cleaner air and water as well as trash removal). For larger or even global environmental problems, the picture is more mixed. With respect to global climate change, democracies are more cooperative when it comes to adopting political measures. With respect to their own burdens that they place on the environment (greenhouse gas emissions, for example), there is little difference between the performance of democracies and non-democracies.

CONCLUSION

The performance of democracy can be assessed in relation to the value inherent in it in terms of a goal—meaning the esteem in which a particular form, and practice, of democracy is held by the respective population. It can also be assessed, as this chapter has shown, with respect to criteria that lie outside of democracy itself.

We have focused here on two criteria that are probably among the most important for assessing the performance and capabilities of democracies: The avoidance or limitation of political violence, and sustainable development. The list of criteria one could use to measure the performance of democracies, though, can be extended almost at will. We could ask whether public administration is more efficient in democracies, and so as a result have less evidence of clientelism, corruption, and abuse of office. We could ask whether democracies attract more foreign investment or whether they weather currency crises better than non-democracies. We could also ask whether particular types of democracies (for example, majoritarian versus consensus democracies, parliamentary versus presidential systems, corporatist versus pluralist systems) do better with respect to particular performance criteria. These are all questions political scientists pursue, by now with considerable intensity and energy. But generally speaking, when it comes to the performance and capabilities of political systems, the fundamental difference between democracies and non-democracies has proven to have more explanatory power thus far than finer differentiations within the group of nations that, by current conventional measures, encompasses the established democracies.

THE AMERICAN DREAM California, USA, 1967: Steak and road cruisers for all? Things a little a smaller would be just fine, too… Democracies, more so than non-democracies, tend to provide for the satisfaction of basic material needs in the population. Conversely, with growing prosperity, the acceptance of democracy increases. Dukas/Robert Landau

HALE AND HEARTY IN OLD AGE Männlichen, Switzerland, 1999: A healthy environment, a good healthcare system, and a functioning social welfare state–all are common goods more likely to be available in democracies than in non-democracies. They help ensure older citizens will remain active for many years. Keystone/Juerg Mueller

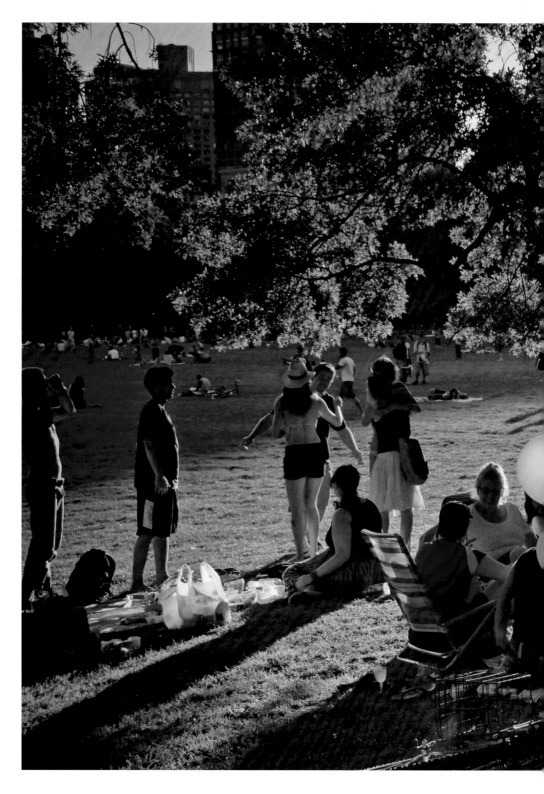

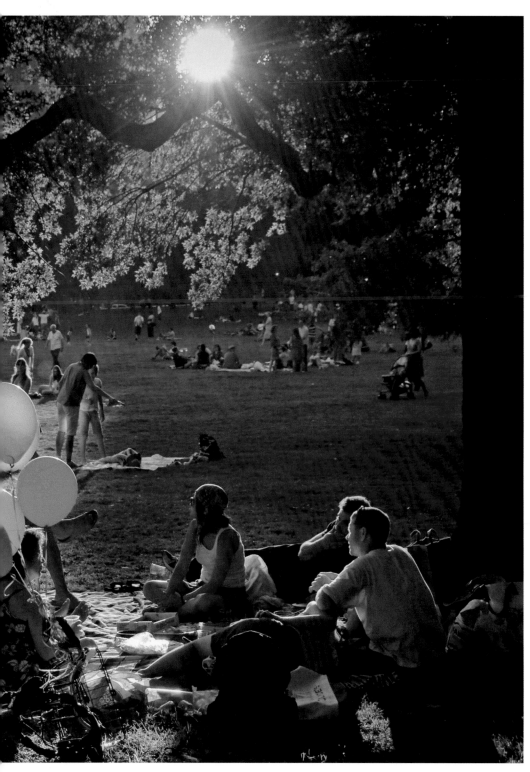

LEISURE TIME A pleasant afternoon in New York's Central Park: Even though conditions differ greatly from country to country, everyone in democratic countries has a right to ample leisure and recreation time. Juanjo Gaspar

The mass media play an extremely important role in modern democratic societies. The information the media provide is indispensable for citizens' freedom to form political opinions and express political will. Politics, too, depends on open communication to have any legitimacy at all—elections and plebiscites are of no use if voters are uninformed about the topics at hand, the content of proposals, and the differing political stances.

But journalists and politicians do not pursue the same goals, and the media sometimes lose sight of the demands placed on them, as they too pursue their own interests. Politics, in contrast, has shown an increasing tendency in recent decades to become "mediatized." By that, one means the accommodation, partly voluntary and partly forced, to the rules of the media business. When the media do not (or cannot) fulfill their role as a critical voice and a "fourth estate," it can mean the public arena no longer works properly, and that can put in question the ability of a democracy to function at all. Independent and critical journalism performs an important controlling function, one in the interest of all, and ensures efficient transmission of the programs and solutions politicians have to offer. If politicians go too far in their efforts to mold the media to their own ends, it will lead to critical responses by journalists. Both politicians and journalists seek the attention of the public, and thereby must walk a tightrope in their mutual efforts to deal responsibly with the demands made of a functioning, democratic public arena.

THE MEDIATIZATION OF SOCIETY

A Challenge
to Democracy?

Frank Esser and Florin Büchel

German Chancellor Angela Merkel depends on her good rapport with the media, and that explains her choice of Steffen Seibert—formerly the anchor of *heute,* the ZDF TV network's evening news broadcast—as her government spokesman in 2010. Seibert is a media insider and understands how journalists work. He does not do his new job alone. As head of the Federal Press Office of the German Government, he has 550 communications experts and an annual budget of 90 million euros at his disposal. The Federal Press Office's job is to regularly inform journalists and the general public about government policies, primarily through press conferences, organized programs, brochures, and publicity campaigns. Its functions also include keeping government workers abreast of media coverage and the climate of public opinion—and for this purpose, assessments of news reports and surveys of the general public are used.

All democracies have established such entities. In the United States, for example, they occupy offices in the west wing of the White House. For the U.S. president, communication with the media and the members of the public is a key instrument of power. By winning over the mass media and the general public, he can exert strategic pressure on the Senate and House of Representatives to obtain approval for his agenda. Bill Clinton, however, repeatedly used this machinery for damage control, notably in his efforts to head off the Lewinsky scandal.

In England, immediately after Tony Blair won election in 1997, his New Labour government drastically altered how government communicated. Newly organized strategic communications units kept a close eye on media reporting, and former journalists were appointed to positions in government departments. Many of these changes were so radical that they came under scrutiny by select committees of Parliament and were the target of critical reports in the media.

In Switzerland, the gradual expansion of communication efforts and bureaus at the federal level raised so many concerns that a popular referendum in 2008 sought to prohibit the Federal Council, and parts of the federal administration, from engaging in campaign and propaganda activities in the run-up to Swiss national referendums. The Federal Council, along with both houses of the Swiss Parliament, recommended rejection, a suggestion that voters in the end followed. To achieve that outcome, however, Swiss voters first had to have the broader relationship between the media and politics clarified. This is the objective of the present chapter as well.

COMMUNICATION ON ALL CHANNELS: WELCOME TO THE MEDIA SOCIETY

Modern democracy relies on communication between politicians and citizens, and the mass media proffer themselves as an effective and independent medium for just that purpose. Mass media infrastructure is capable of giving politicians oppor-

tunities to address broad segments of the population, but niche and specialized media also allow them to address their proposals to specific voter groups. Mass media are important for the voters, too. The media make it easier for voters to inform themselves about politics, and at the same time voters can choose among various media, depending on how serious or entertaining, how liberal or conservative, they want the reporting to be. By now the media have proliferated so much that we can speak of a media society or a media democracy.

The media society is characterized by a constant evolution of new types of media, and they increasingly pervade society. Moreover, the dissemination of information has greatly accelerated and been amplified. Owing to this penetration, the media can demand the attention and recognition of society as a whole, and citizens and politicians alike are increasingly dependent on the media for their information needs. As is true of a long-distance relationship, both the public and the politicians also depend on communication. As long as the medium in question is e-mail, Twitter, Facebook, blogs, or a telephone, the exchange of information is mutual. Yet exceedingly few citizens have such a close, direct exchange with politicians. Most citizens get their information through journalistic media, meaning

Chappatte

through newspapers, radio, television, and the websites these media maintain. Regardless whether journalists report on the concerns of politicians or the concerns of citizens, news reports always go through an editorial process that transforms reports into a "story." Interviews are usually edited as well. A journalist typically gathers statements from several sources, weaves a selection of those statements together with other material to construct a news story out of it, and retains control over the key message and interpretive framing of that story until the end. This conforms to the principles of media independence and freedom of the press in a democracy. As noted above, however, federal chancellors, presidents, and other politicians are unwilling to completely relinquish control over communication. Political parties, industrial firms, and Hollywood actors, too, each have their own communication staff and PR experts, who help them to proactively place their messages in the media as well as react to topics and media reports unfavorable to them.

A professionalized approach to communication is especially important in politics. In a democracy, those in positions of power are legitimized only as long as they show responsiveness to the public and provide accountability. Politicians are eager to appear in lead stories and on TV to publicly demonstrate how responsive they are. That is, they want to show how deeply committed they are to the interests of the public and how greatly they therefore deserve the support of the citizens in elections and referendums. Politicians use the news media to learn what concerns the public (and expect journalists to research those issues and present them in a pluralistic fashion), and they use the media to present proposals from the various parties that offer remedies for these concerns (and expect journalists to report fairly on the substance of these proposals). During this process, politicians must also hold those responsible for the success or failure of the various proposed solutions accountable. Only then can the citizens who are motivated to participate make informed choices as to who best represents their interests or who should continue serving as their political representative. There is also an expectation that journalists disclose fiascoes and name those responsible for them—and not just at election time, but throughout the political cycle.

MASS MEDIA AND POLITICAL COMMUNICATION TODAY

Various media functions meant to encourage responsiveness and accountability in a democracy have emerged, and over time have affected how journalists interpret their roles. These functions can be roughly broken down into four activities: Communication of information, analysis, control, and advocacy.

The Tasks and Functions of the Media: Information, analysis, control

The first task of the media is to provide information. The media make society visible to its members by reporting on important issues like terrorism, the national debt, or alternate energy sources. Only through the media is this possible on a scale beyond the limited horizon of an individual's direct experience. This, ideally, expands the individual knowledge consumers (meaning the recipients of mass media) possess. For example, if the various political parties disagree about how to handle the national debt, then citizens will follow this debate as it is transmitted by the media. Specific demands are thereby placed on the media: They are to present key issues in detail, from multiple perspectives, and in an objective manner.

The second task of the media is to offer analysis that goes beyond the scope of just providing information. Here journalists see their mission as not only communicating facts (as transparently and objectively as possible) but also as providing an understanding of the background. Reports on important events, therefore, are augmented by material embedding them in a larger context. If we return to the national debt debate, then journalists are expected not only to convey, in purely neutral terms, what arguments the various parties to the debate have offered, but

Chappatte

also what background research has revealed about how the discussion came about in the first place and what effects it might have on the daily lives of the citizens. Here, too, demands are made of the media. The background information must be correctly researched and presented in an appropriately complex manner.

Criticism is the third task of the media. This role, often called investigative journalism, is developed to varying degrees in different countries—endorsement of this role is particularly pronounced among reporters from English-speaking countries. The journalist considers him or herself in a watchdog role, keeping a sharp eye on political and economic powerbrokers and exposing failures. This critical role often means the media comes to be seen as a "fourth power" in addition to the executive, legislative, and judicial powers in a democracy. Interpreted this way, the role of the media extends beyond merely communicating information and embedding events in their specific contexts to include critically scrutinizing incidents and shedding light on the intentions of key protagonists in order to (perhaps) reveal inefficient or even illegal practices. In the case of the public debate about the national debt, therefore, it may be possible for a journalist to discover, through detailed research, that one of the actors involved represents a particular economic or social interest. Even corruption may be at play. An investigative journalist then sees it as his or her job to inform so that members of the public can come to their own opinions in light of full information.

A journalist's responsibility is even greater when in this investigative role. The power of the media to damage reputations by making unfounded accusations is enormous, so research must be done painstakingly and arguments must be based on facts—though this often, unfortunately, is not the case. The better-known examples in which the U.S. media played an outstanding investigative role include the Watergate revelations, the disclosures of the My Lai massacre, and the abuse at Abu Ghraib prison. In Germany, they include the *Spiegel* revelations surrounding the Barschel affair (in 1987), the Flick donations to political parties (in 1982), and the CDU (Christian Democratic Union) party donations scandal (in 1999).

The journalistic role of advocacy for a specific group or cause, finally, is often listed as a fourth task. Here, the media mission is to give voice to certain issues or groups that are (purportedly, perhaps) felt to be disadvantaged. At stake are viewpoints that involve arguments for or against, but about groups that lack the power to make their own case. Thus the media take the side of underrepresented interests, such as of minorities, but also side with powerless majorities such as women or workers. As a rule, the respective journalists are concerned to generate a standpoint that runs counter to mainstream public opinion. Journalists who take sides in a political debate (for example, on reducing the national debt) wittingly give up

a neutral position, which in turn also carries its own responsibilities. It should be clear that the advocacy-driven articles published fall into the category of opinion journalism.

These four journalistic roles require reporting that is informative and contains ideas based on systematic reasoning. This does not mean entertainment and emotions have no place to play in journalistic products! Entertaining elements can help journalists, in some circumstances, to present politics in an understandable, attractive manner. What remains decisive is that the reports are factually correct. Entertaining elements should be used as a stylistic device to enrich and broaden readers' experience, not as mere ploys to briefly grab their attention.

The Mass Media and the Marketplace

One should also delve into the role of the media as commercial enterprises. The models noted above describe ideals or desired values. In daily practice, however, journalists are subject to certain pressures, above all with respect to the need to produce for profit. Private media enterprises such as those owned by Axel Springer and Rupert Murdoch must keep costs low and earnings high in order to meet the profit expectations of shareholders. Public broadcasters must appeal to as wide a range of users as possible to justify compulsory television and radio license fees. All are under pressure with regard to circulation and ratings, and journalists are not given unlimited resources to conduct research or to write. The prerequisites for time-consuming, serious (and costly), investigative journalism therefore are not necessarily always present. Some media make do with inexpensively produced pseudo-revelations that generate attention but have little social relevance and only lead to artificially inflated controversy. They respond, for example, to the collective amusement at the dramatic fall from grace of once-acclaimed figures (such as "celebrities" and their private problems) or seek to goad communities into shared anger (over gasoline and electricity prices, or to promised but not delivered prize payoffs, for example) through sensationalist reporting.

Substantive political journalism that wants to give its consumers more than just voyeuristic amusement and superficiality requires initiative and costs money. In this respect, journalism faces a certain contradiction between aspiration and reality. These frictions result in part from the quite different tasks politics faces. Many politicians want the media to act as a kind of junior publicity agent—and then are disappointed. When politicians enter the media arena, they want to present themselves publicly as persons who represent the citizens' interests. In how they communicate issues, they try to stir interest in their work and mobilize voter groups to support their concerns. Politicians depend on functioning flows of

information if they are to assess the actions of other parties and institutions and follow what the government and the opposition are doing. Only then can the opposing views among the many participants in an increasingly complex democratic world be reconciled. Finally, politicians want to exert influence through the use of strategic communication, by articulating interests according to their own lights, defining problems in their own terms, and "selling" their own proposals for solutions. But because the media insist on their autonomy and pursue their own economic and journalistic goals, they do not always participate in these processes as politicians might wish.

The Role of Marketing in Political Communication

Like the media, politicians are also subject to constraints. The growing number of swing voters means an increasingly large role for campaigns, in which the image and charisma of the candidates as well as the rhetoric and clarity of their message are key elements. For this purpose, increasing use is being made of political communication experts, pejoratively sometimes called spin doctors—meaning manipulators who slant messages to give them the right "spin." This is a cynical way to

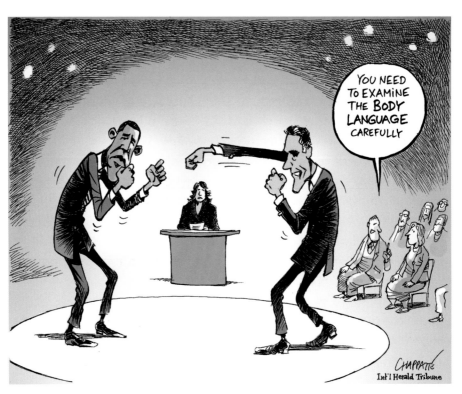

Chappatte

describe the legitimate efforts made by governments and parties to communicate and try to assert themselves in today's media society. That is why, in politics today, professional communication management is no longer a questionable prop but a core business essential for political survival. Rhetoric that appeals to emotions, or is even sometimes aggressive, can certainly help make a factual issue more comprehensible to the public, differentiate a politician more sharply from his political opponent, and broaden the ordinary citizen's horizon of experience—but only if such stylistic elements ultimately contribute to a better communication of a political program rather than cheapening or exploiting the moods of voters. And in the popular referendum mentioned at the beginning of this chapter, Swiss voters also allowed themselves to be persuaded there were legitimate grounds for allowing politicians to provide substantive information.

FRICTIONS BETWEEN MEDIA AND POLITICS: WHERE ARE THERE CONFLICTS?

There are a number of tensions between the media and politics due to their divergent goals and modes of operating, which include the differing understandings of consensus, negotiation, methods, and time.

Exaggeration, Simplification, Abbreviation: The medium channels the message

While politics means reconciling many interests to find a consensus, the media are more interested in conflict and rivalry. While political negotiations often require isolation so that concessions can be made to opponents without a public loss of face, the media insist on transparency and disclosure. From the conflict-oriented standpoint of the media, willingness to compromise is regarded as caving in and weakness. While effective politics consists of procedural rules, staggered participation, and a collective process of harmonizing differing stances, the media are more interested in charismatic individuals who pitch in, take action, and stir things up. While politics needs long-term horizons to address complex problems, the pressure in the media world to come up with what is new and thus newsworthy is so great that insisting on political timescales is interpreted at times as sitting things out or ignoring citizens' pressing concerns.

Of course, these are sweeping statements, but they are meant to show that the presence of the media can place great pressure on politics and politicians. Among the potential consequences is an increased emphasis on conflict, or on symbolic acts and on the personality of politicians, which makes cooperative, realistic solutions harder to achieve. Under the pressure of permanent media expectations,

politicians might, in an extreme example, attach less significance to the long-term ramifications of their decisions so that when they address problems they look less to political alliances and more to shifting opportunities in the media and in public. The temptation can be to conduct a politics oriented to short-term solutions, whose effects prove misguided over the longer term. Furthermore, politicians might be induced to sidestep the time-consuming procedures used by political institutions and make policy "through the media" instead. Thus, Gerhard Schröder, Tony Blair, and Bill Clinton frequently made firmly-worded statements in front of TV cameras in an effort to speed up the formation of opinion in parliamentary committees, or to guide opinion in a certain direction.

Whose Rules are Being Followed? The mediatization of politics

But there is not only pressure to bow to media rules and constantly anticipate what the media public wants. There are also new opportunities for politicians to employ the media and new communication platforms for their own ends—that is, to make their own efforts to exert influence on the media. This combination of adaptation, anticipation, and exploitation is summed up in the term "mediatization of politics."

There are indications that the mediatization of politics has intensified of late. Politicians appear receptive to the needs of the media, seek contact with influential journalists, make confidential rounds of talks possible, undergo coaching for media appearances, arrange for systematic evaluation of any coverage that deals with them, entrust staffers with PR work, expedite setting up communications units in parties and other organizations, assign these units to top management, and, in external communications, simplify and tailor issues and arguments to orchestrate them for the media. At times, the influence of the media extends to the very heart of political decisions about both personnel and factual issues. Basically, the media are very often taken into consideration nowadays when it comes to deciding which political problems have priority, how they are articulated and defined, what the reaction to alternative proposals will be, how the implementation of a decision will be justified, and how public criticism is to be dealt with.

The question whether and how the media will react is no longer an adjunct of political considerations, but has become an integral component of political processes. In 2005, in a survey of the German Bundestag (national parliament) and Landtag (state parliament) representatives, more than one-third stated that the media had more influence on setting the political agenda than they themselves did. And almost half of the politicians surveyed expressed the opinion that a complex issue that was not suited for the media had less chance than in earlier times of getting into the legislative process in the first place. Not surprisingly, the results of the

survey were published under the title *Nur noch Bild, BamS und Glotze?* ("Only *Bild,* the Sunday edition of *Bild,* and the Tube?" – a reference to statement allegedly made by former Chancellor Gerhard Schröder that these popular media were all he needed to govern Germany).

In light of these developments, many wonder to what extent the mediatization of politics diminishes its quality. Media skills may replace subject-matter expertise as the key element in a politician's success, the increasing number of political talk shows on television might hasten the decline in the importance attached to parliaments, and mediatization could lead to a phase of symbolic politics and populism and, by the same token, make it harder for consensus-based and substantive politics to prevail over the longer term—because such politics lack media appeal.

By now, politicians have learned to adjust to the new conditions and to make use of the media for their own ends. Anticipating the media's logic can also be seen as a way to retain power, increasing the prospects for exploiting the media. Ronald Reagan and Barack Obama are good examples of politicians who adroitly manage communication to win the media over to their side—both men mastered the art of stage-managing events, images, issues, and states of mind.

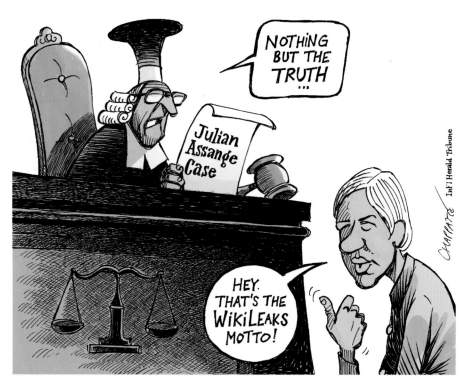

Chappatte

In wartime, this approach takes on a steering aspect, when the opportunities for journalists to report can be limited. Wars remain prime examples of manipulation and propaganda—though the means for doing so have been sharply modernized: A popular catchphrase here is embedded journalism. Government policy for reporting made critical background accounts difficult during the 2003 conflict in Iraq, and led journalists to uncritically accept the U.S. government's allegation of the existence of weapons of mass destruction as a reason for war, though this claim later proved false. The tendency of the media to adopt the views of the established political elites in times of crisis has been repeatedly documented in the United States, where it is referred to as *indexing*.

Italy's former Prime Minister Silvio Berlusconi may have especially relished a media democracy controlled in such a manner as well. He tried repeatedly to translate his experiences as an entertainer and media entrepreneur into political successes. Conversely, he was also concerned with using his political power to make sure the influence of the media companies he owned would increase. This is further evidence that adaptation to the logic of the media helps secure political power. It also is due to the current crisis-driven developments in the media system. Many newspapers are in economic straits, partly due to the increasing importance of the Internet for readers and advertising customers. In light of the growing economic pressures and the dwindling resources for researching stories, journalists have become increasingly dependent on their sources in politics and the business world (which are easy to acquire and thus require no large financial outlays)—and thereby potentially lose both influence and journalistic independence.

CONCLUSION
THE SIGNIFICANCE OF MEDIA QUALITY FOR DEMOCRATIC PERFORMANCE

Do the processes described here improve or worsen the quality of democracy? Without doubt, the growing omnipresence of the media gives the public easier access to political information. Yet the image of politics in the mass media is heavily influenced by the news value attached to reports about notables and celebrities, to harm that has been done, to negativity, to personalization, to the potential for visualizing a story, to controversy, and to "human interest." Therefore, mediatization does not necessarily promote political commitment and political participation. Many citizens feel that classical mass media political reporting no longer speaks to them at all. The reporting that presents politics as a game dictated by strategic maneuvers and a calculus of political power seems to especially encourage public cynicism. Blame for this should by no means only be laid at the door of the media—politicians' opportunism and how distant political parties are from

ordinary citizens contributes to citizens feeling alienated from politics. At any rate, a wide gap can be found between educated citizens interested in politics, who successfully use the media as a source of information, and poorly informed segments of society who have little interest and who use the media primarily for entertainment. The extent to which this tendency is counteracted or exacerbated by the Internet is currently of considerable interest. The question whether an altered media environment helps increase the responsiveness and accountability to the public by the political system is also of key importance.

To a large degree, that responsiveness depends on whether journalism that is focused on substance remains economically viable. It also depends on whether substantive journalism remains present in heavily used media channels and can present politics in a way that speaks to broad segments of the population. This requires enormous journalistic resources. If the media succeed, under the new conditions, in encouraging as many different groups of players as possible to participate in communication, deliberation, and participation, then democracy will be alive and well. If the effectiveness of journalism decreases, then the quality of democracy will suffer.

Name me a country where journalists and politicians agree, and I tell you there's no democracy there.

Hugh Carleton Greene

Hugh Carleton Greene (1910–1987) was a British journalist. From 1960 to 1969, he was Director-General of the BBC.

9/11 New York, USA, 2001: The attack on the World Trade Center was broadcast live around the world. An event and its mediatization were now simultaneous. Magnum Photos/Thomas Hoepker

WAITING FOR THE NEW ONE London, Great Britain, 1997: Journalists waiting for Tony Blair, the newly elected
Prime Minister. Journalists not only broadcast such news but also interpret, analyze, and provide critiques on such events.

Getty Images/Tom Stoddart

XXL Berlin, Germany, 2011: Banner on the occasion of the Pope's visit on the side of the building that houses the Springer media enterprise. Large media firms influence the perception of politics, and at times politicians are of course also influenced by media reporting. Keystone/Geilert

VOICE FROM OFF-STAGE Refugee camp in Ngara, Tanzania, 1994: The mass media can greatly influence public opinion. In the Rwandan genocide, radio played a disreputable role, where it was used as a tool to spread messages of hatred.

Panos/Witold Krassowski

LIVE AND IN COLOR Kostroma, Russia, 2011: Vladimir Putin, then prime minister, in a live TV interview with a journalist from a state-run TV station. Heads of government worldwide are well aware of the great power television can play as a stage for presenting their views. Keystone/Alexander Ryumin

JUST FOR SHOW 2003: On a surprise visit to Iraq at Thanksgiving, President George W. Bush presented a U.S. soldier with a traditional turkey. The picture was staged for the press: The turkey was made of plastic. Keystone/Pablo Martinez Monsivais

THE MEDIA MOGUL Rome, 2009: Italy's longest-serving prime minister was also the country's biggest media entrepreneur. Silvio Berlusconi's Mediaset broadcasting group was successful primarily because of its entertainment shows. The entanglement of political with media power, which he repeatedly tried to strengthen by changing the laws, led to numerous controversies. Keystone/Pier Paolo Cito

THE DEPUTY Moscow, 2011: President Medvedev before a press conference. His presidency was heralded as "open and transparent," but his policies were not fundamentally different from those of his predecessor and successor Vladimir Putin, who was prevented by Russia's mandatory term limits from running for a third consecutive term as president. During that time Putin served as prime minister instead. Reuters/Ria Novosti

THE MOB Paris, France, 2011: A member of France's Socialist Party giving news-hungry journalists an explanation in the context of the scandal surrounding politician Dominique Strauss-Kahn. Reuters/Philippe Wojazer

THE CITIZEN AS JOURNALIST New York, USA, 2011: "Occupy Wall Street" demonstrators being filmed. The scene spreads worldwide almost immediately via digital media. Digital media have played a key role in all the rebellions of recent years, including those of the Arab Spring. Such media allow citizens to compare and contrast their own images with official reports, and to reveal falsehoods or counter tendentious official reporting. Noor/Nina Berman

WHISTLEBLOWER U.S. soldier Bradley Manning secretly passed on classified documents to users of the WikiLeaks webiste, where they were publicized. They included a video showing an American combat helicopter attacking and killing Iraqi civilians and Reuters journalists. As a result, Manning was sentenced to thirty-five years in prison.

PRESS CONFERENCE Washington, USA, 2009: President Obama signing an executive order. The image-building visualization of politics is one of the key tasks of the public relations departments of political institutions. Such symbolic acts "for the camera" are among the classic tools of modern political communication. Reuters/Larry Downing

"EMBEDDED JOURNALISM" Ad Diwaniyah, Iraq, 2003: In wartime, politicians intensify their efforts to control reporting. The United States has used the notion of "embedded journalism," a euphemism for having journalists work in a context predetermined and controlled by the Army. Under these conditions, independent reporting is virtually impossible.
Keystone/Laurent Rebours

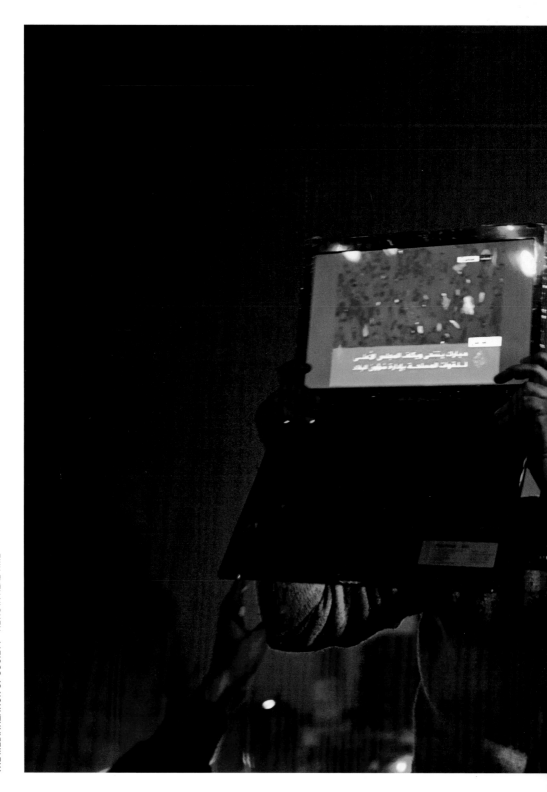

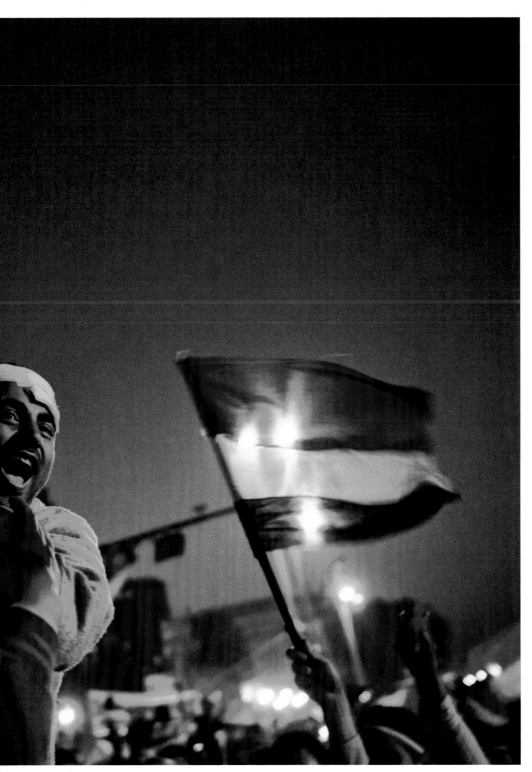

AN EVENT INTERSECTS WITH ITS REPORT Cairo, Egypt, 2011: A demonstrator at Tahrir Square holding a laptop on whose screen Hosni Mubarak's resignation is being announced and shown. Digital media have played a major role in popular protest movements. They provide immediate information about events and enable opposition groups to feed their point of view into the media cycle. Panos/Guy Martin

The Power of the Better Argument

André Bächtiger and Marco Steenbergen

Nowadays, good democracy is also deliberative democracy. Deliberation can be defined as a reasonable conversation whose core is good argument, not power and interests. An ideal deliberative process looks as follows: Participants justify their positions and views in detail and with an eye to the common good; they weigh different arguments against each other, treat other participants and views with respect, and are ready to be convinced by better arguments. Deliberation also makes egalitarian claims. All those who will potentially be affected by a decision should be able to participate, and additionally, disadvantaged groups in society, such as the lower social strata and cultural minorities, should be specifically targeted for inclusion in the deliberative process. The goals of deliberation are increases in knowledge, changes of opinion oriented to the common good, greater understanding for differing positions, and reaching consensus. Theorists of deliberation, such as the German philosopher Jürgen Habermas, regard deliberation as a sine qua non for reaching broadly based decisions, especially in modern societies that no longer possess common religious or moral frames of reference. Many deliberation theorists expect that it will improve the quality of political decisions and will make people both better informed and more committed citizens.

DELIBERATION IN POLITICS: OBJECTIVE ARGUMENTS WITH RESPECT TO STRATEGY, POWER AND THE REPRESENTATION OF INTERESTS

A long philosophical tradition stresses the significance of deliberation in politics. The English philosopher John Stuart Mill, for example, felt elected representatives should be guided by the better argument when they made decisions. Many political scientists, however, think that what has priority in politics is not deliberation but power, strategy, and the assertion of interests. But does this mean that deliberation is absent in politics? The answer is clearly no. For one thing, politicians are fully aware of the concept of deliberation as an ideal of political communication. For another, the political context and the political system play a very important role in the deliberative quality of political debate. Consensus systems like those in Switzerland, where all the important political actors are integrated into the work of government, are conducive to deliberation, and as a result, electoral competition plays a smaller role. In a consensus system, there is a need to negotiate, which means the positions of the actors involved can only be ignored at high cost. In a competitive system like that of Great Britain, by contrast, government and opposition face each other as fierce opponents, and as a rule, the opposition has no avenues by which to influence the policies of the government in power. Thus, the seated British government can not only ignore the arguments of the opposition, but the constant contest between government and opposition makes respectful and constructive discussions impossible.

The Example of Switzerland: Respectful treatment of the arguments of the minority

One example of strong deliberation in politics could be seen in the discussions in the Swiss Parliament during the 1990s about revising the language article in the Federal Constitution. The revision went back to a motion made by the Rhaetian Martin Bundi in 1986, who had wanted to see the position of the Romansh language in the country strengthened. The Bundesrat (or Federal Council, the nation's executive), then drafted an article intended to anchor two principles in the Swiss Constitution. One was linguistic freedom—meaning the right to speak one's

mother tongue everywhere—and the other was a territoriality principle intended to regulate precisely which language would be spoken in a canton. The idea was that by explicitly mentioning linguistic freedom in the Constitution, Rhaetians were to be ensured more flexibility in using their Romansh language.

Yet this government proposal met with considerable resistance on the part of French-speaking and Italian-speaking politicians, as they feared the result would be Germanization. German-speaking Swiss could then demand German-language schools in French-speaking cantons or in the Italian-speaking Ticino canton, and could then even force such schools to come into being through judicial action. In the parliamentary debates over the proposal, many representatives from the German-speaking majority were very respectful of the arguments made by those who belonged to the minority language groups, and great willingness was shown to find an optimal solution for all minority language speakers, whether they were Rhaetians, Ticinesi, or Romands. Not only did some parliamentarians

change their mind in the course of the debate, but the debate was one often conducted at an academic level. This can even be seen from a quantitative analysis of the speeches made: 54 percent provided elaborated justifications, 26 percent were oriented to the common good, and 70 percent were explicitly respectful. These values are significantly higher than in ordinary parliamentary debates, where the proportion of explicitly respectful speeches only reaches 12 percent.

After debating for a number of years, and after carefully weighing the various arguments, the parliamentarians came to the conclusion that explicitly mentioning the freedom of language use and a territoriality principle in the Constitution was neither feasible nor viable. As a result, two French-speaking members of the Ständerat (the Council of States, or upper house) suggested setting aside the debate over a constitutional article and just concentrating on the problem of the Rhaetians. The new language article would only contain provisions to financially support threatened linguistic minorities. The compromise suggestion was broadly welcomed in both

DISCUSSION Bern, Switzerland, 2005: Federal Councillor Eveline Widmer-Schlumpf and National Councillor This Jenny in conversation. Extensive and objective debate which considers the arguments brought by the opposition is essential elements in modern democracies that wish to come to decisions acceptible to and supported by society. Keystone/Peter Schneider

the Nationalrat (the National Council, or lower house) and the Ständerat, and was approved in a popular plebiscite without difficulty. Though the media derided it as "bones without meat," it was nevertheless the product of high-level deliberations whose outcome was marked by respect for the concerns expressed by the linguistic minorities and by insight into the complexity of the topic.

The Example of Ethical Questions: Finding compromises to resolve complex questions

Further examples of deliberative behavior in politics can be found in moral and ethical discussions of topics such as abortion. Though the issue of abortion strongly polarizes, one repeatedly finds politicians who try to mediate between abortion advocates and abortion opponents. The German debates on the subject during the early 1990s are exemplary. Horst Eylmann, a representative of the Christian Democratic Party, put it as follows: "This is ... a debate over personal avowals and about moral appeals that involve decided stances, and at times grand words, but it is also a debate that involves a critical and doubting thoughtfulness." Discussions were conducted respectfully and at times very constructively, especially in the "Protection of Unborn Life" select committee. Uta Würfel, a representative of the Free Democratic Party, summed up the discussions by saying: "We members of the select committee ... genuinely weighed, without prejudice, the arguments of those who thought differently, and we struggled with one another to find the best way to protect the life of the unborn." The result was a complex compromise. On the one hand, abortion was morally proscribed, but it was nevertheless permitted within a specific time period. At first glance, this was an inconsistent solution, but it allowed both proponents and opponents of abortion to save face.

Two aspects made it more possible to conduct respectful and constructive debates in this select committee. First, party discipline was eased, thereby opening up the rigid and normally very competitively oriented government and opposition system in Germany. Politicians did not have to toe the party line but could remain open to arguments that came from their political opponents. Second, discussions were held behind closed doors, which lessened public or voter pressure. That, in turn, made it

easier for politicians to show respect for other positions and arguments or even to change their minds. In the public debates in the German Bundestag (the lower house), on the other hand, loud and vociferous altercations took place over abortion. Many politicians wanted to publicly show their voters where they stood and where their commitments were. Public political speeches are often speeches to the gallery: The point is not to convince other politicians but rather to speak, convince, and mobilize one's clientele.

Even if deliberation overall is seldom encountered in politics, it does exist. If the right political institutions—such as consensus systems or relaxed party discipline—interact with the right topics, then politicians are certainly able to discuss reasonably among themselves, as the examples of the Swiss language article and the German abortion debate clearly show.

CITIZEN DELIBERATION:
INVOLVING THE POPULATION IN THE DEBATE

Citizen deliberation has developed into a cottage industry in the last few years. The reason for this is a perceived malaise in the established world of politics. Not only has voting participation steadily fallen over the last decades, but citizens themselves have become increasingly critical of political parties, governments, and parliaments. To many observers, a way out of this is to strengthen citizen participation and citizen deliberation.

A prominent form of citizen participation is the deliberative opinion poll begun by James Fishkin, an American political scientist and philosopher. Europolis, a pan-European deliberative poll in which 348 citizens from all 27 member states of the EU spent a weekend discussing migration policy and climate change, is an example of this. The participants were randomly selected citizens, and though only about 30 percent of those selected actually took part, they were not too different from the average population. Put differently, participants were not just the educated or those materially well off, but came from lower social strata.

The participants were informed in as balanced a manner as possible about migration policy and climate change, with experts of various persuasions available to answer questions, and facilitators made sure that group discussions proceeded in a civilized

manner so that no participant dominated the discussions. Participants were asked their opinions at the beginning and at the end of the deliberations. Many changed their minds after the Europolis event. With respect to migration policy, many participants who held extreme views moved to a more centrist position, while the topic of climate change showed a distinct shift of opinion in the direction of more climate protection. Citizen deliberations very frequently result in changes of opinion among the participants. Additionally, the participants' fund of knowledge increases and their faith in democratic decision-making processes becomes more robust.

Yet critics and psychologists are fundamentally skeptical about how well citizens can actually deliberate, because the demands deliberation places on ordinary citizens are high. Citizen participants must not only be able to justify their views factually and in a manner oriented to the common good, but must also be able to recognize better arguments and adjust their original opinions accordingly.

Europolis, belying the skepticism of the psychologists, showed that normal citizens are quite able to deliberate at a good level. Nearly 37 percent presented a complex argument at least once in the discussions, just about 50 percent argued at least once in a manner oriented to the common good, and 55 percent, at least once, were explicitly respectful of other arguments.

The following example from a Europolis discussion on immigration nicely illustrates how differentiated and constructive citizen deliberation can be. Participant A first argues for sealing the EU's external borders:

"In my view, the EU needs to see to it that its external borders are closed, it needs to check that no illegal immigrants slip into the individual nations and—well—perhaps even take away jobs from natives."

Participant B counters by noting there were humanitarian aspects of immigration too:

"Yes, I too am of the opinion that it isn't necessarily the job of the EU to seal off the countries and the borders, because we have to see this all a little more globally, we're after all one world and the world

CO-DETERMINATION Citizen meeting in Pueblo, Colorado, U.S., 2009. An increasingly critical attitude that citizens have toward established modes of politics and political institutions make new forms of political participation necessary. In them, citizens try to find solutions that serve the common good, yet do so in ways that lie outside standard party political modes. Getty Images/RJ Sangosti

consists after all of many other countries, and we also have to see to it that the remaining population and the other people whom we have exploited for all these years are somehow doing well."

In response, Participant A then offers a more differentiated argument:
"That isn't quite what I meant by sealing the borders, instead I'm of the opinion that a targeted immigration is certainly reasonable. It's just that, among other things, we have to focus on (…) getting those people into the countries who have the corresponding work experience so that the lower income classes don't find their work being taken away from them (…) the people, those—the poor countries where they say that enough was already done to them in the colonies, one should give them the possibility of building up something in their own country and not as refugees—there where you see those terrible things on television—that should not be, but they should be able to develop in such a manner at home that they wouldn't need to do something like coming here and then drowning."

At the same time, cultural and class-specific differences existed in the Europolis discussions. Eastern and Southern Europeans from the working class had far lower levels of deliberation than the other participants, and they participated less often in discussions.

Though citizen deliberation is not able to involve all participants equally well, it still functions better than the harshest critics of deliberation fear. A U.S. study found that regularly participating in deliberative processes distinctly increases interest in politics, voting frequency, and other political activity.

Citizen Deliberation as a Political Instrument: Citizen-generated solutions

Over the last decade, citizen deliberation has increasingly become a regular part of politics. In Canada, citizens' assemblies were created in British Columbia (2004) and Ontario (2006) as part of efforts to reform each province's electoral system. The creation of citizens' deliberative bodies in both cases was to fulfill campaign promises, and the suggestions these assemblies made were subsequently put to a referendum.

In the end, neither province voted in favor of the suggestions of their assemblies. However, 57 percent of the votes cast in British Columbia were in favor: The referendum failed because it did not obtain the required approval by 60 percent of the votes. This shows that citizens who have not deliberated nevertheless do trust the decisions reached by their deliberating fellow citizens. This is especially true because citizens' assemblies need not follow any particular party's tenets and can hence more readily support what is in the common interest. By contrast, parties—particularly when they are working out electoral systems—will carefully check to see how well a given suggestion serves their own party's interests, and may therefore not necessarily choose the option best serving the interest of the largest number of citizens.

China: Involving citizens at the local level

Citizen deliberations increasingly are being undertaken in non-Western countries at the local level, most notably in China. The focus there is on local projects, such as traffic planning or water supply, and citizens determine which project is most important and which should be first implemented. In this, the Chinese Communist Party (CCP) is interested in hearing feedback from its citizens through deliberative processes—without having to carry out democratic elections. Still, one should credit the CCP for, at least at the local level, quite often carrying out the recommendations emerging from citizen deliberations. In terms of citizen participation and citizen deliberation, Latin America plays a key role (see pp. 245–6).

CONCLUSION

Overall, however, the greatest difficulty is the direct effect citizen deliberation has on political processes. While there are individual cases, as in China, where the input from citizen deliberations is taken up by the established political institutions, most citizen deliberations remain without any political effect. The reasons for this are often the lack of political and party support as well as insufficient media coverage. That was the case in Europolis. Although the EU Commission had financially supported Europolis, the results of its deliberations were largely ignored, both by the Commission and in European politics.

FURTHER DEVELOPMENTS

In the last few years, several blind spots have become visible in deliberative theory. Critics have found fault with the fact that reasonable, common good-oriented, and respectful argument can discriminate against disadvantaged groups, such as cultural minorities and the lower social strata. As we saw in Europolis, Eastern and Southern Europeans from the working classes did, in fact, display a lower level of deliberation than other participants. To better involve disadvantaged groups in the deliberate process, deliberation itself is now being more broadly defined. Good deliberation now is seen as also including telling stories, bringing in one's own experiences, and not least, drawing on emotions. Self-interest, or private interests, should not be subverted, in deliberations, to the benefit of an orientation to the common good and to values held in common. Deliberation is increasingly coming to be regarded less as a respectful, consensus-oriented dialogue. As psychologists have shown, confrontational and competitive debating can help participants acquire better knowledge and in the end lead to better decisions.

A further blind spot is the one-sided view of deliberative processes, and their results, that can be found in specific institutions and arenas such as parliaments or in deliberative polls. A new, systemic approach has tried to instead emphasize the interplay of different institutions and arenas among the citizenry and in politics. A central question here is how input coming from the citizens is received or absorbed in politics, and how it is then processed. A systemic perspective posits as well that no one arena can realize all deliberative ideals. Thus, for example, Switzerland's Ständerat has considerable potential for engaging in differentiated and respectful argument, but it falls short when it comes to including the lower social strata. Nevertheless, the interplay of political and civil society arenas helps take a variety of deliberative ideals into account. If, for example, Switzerland's Ständerat would accept the input coming from civil society groups representing the disadvantaged (which the Ständerat itself could not have articulated in that way), and would process it in a deliberative manner, then, from the systemic perspective, an optimal deliberation would have been established.

How Should I Vote?

Regula Hänggli

Referendums demand of citizens that they both decide whether to participate in them and that they form an opinion about the proposals. From research on political behavior, we know that these processes are shaped by
- the individual characteristics of the citizens themselves (e.g., age, level of education, or political orientation)
- aspects of the issue(s) being voted on (e.g., complexity, familiarity with the subject)
- features related to the political context of the election (e.g., the intensity and degree of conflict in the preceding campaign, the prevailing political culture)

PARTICIPATION IN REFERENDUMS: WHAT INFLUENCES PARTICIPATION AND WHO SHOULD BE MOBILIZED?

In every referendum, voters must make a variety of decisions (see Figure 1). The first is to decide whether to participate at all. The (expected) closeness of the result influences participation: The closer the expected result, the more efforts campaigners will make to mobilize those groups whose votes they expect to receive. In addition, the anticipated financial consequences to an individual of a particular outcome are also important: Participation rates will be higher the more is at stake. Controversial, significant, or emotionally laden topics also draw more citizens to the polls. Finally, the politically ill-informed and those uninterested in politics participate less in referendums than do those who are well-informed.

OPINION FORMATION PROCESSES IN REFERENDUMS: DECISION-MAKING POSSIBILITIES

If voters have chosen to participate in a referendum, they then need to form an opinion. There are two paths individuals take, one heuristic and the other systematic. Both are regarded as suitable behavior for voters.

Heuristic and Systematic Decision-making

In the former, decisions are made by simplifying choice through a heuristic, a term for a problem-solving method. In direct democratic referendums, at least four heuristics come into play: The status quo, the emotional, the trust-based, and the political party heuristic.

In the case of the first, a citizen rejects innovation and sticks to the status quo. This strategy does not require any foreknowledge and is for that reason an easy one to follow. It can be explained by the risk-averse behavior of individuals who want to avoid insecurity as well as potential losses. The stereotype of the (chronic) naysayer who out of principle initially simply rejects all that is new corresponds to a status quo heuristic. In the emotion heuristic, the emotions are decisive. In the trust heuristic, voters follow the recommendation of persons or institutions they deem trustworthy and knowledgeable, and ignore what others have to say. This simplification in decision-making is often used with reference to the government. If a voter trusts the government and regards its information as competent and informed, there is a good chance that voter will follow the government's recommendations on how to vote. The opposite is of course also possible: Voting against such a recommendation because one does not trust the government.

The political party heuristic also depends on the information made available by the elites, inasmuch as voters follow the recommendation of the party they feel most closely aligned with. Here, a voter's basic political orientation is activated and strengthened by the preferred party, and this is like-

ly the heuristic voters most commonly use in referendums.

The emotion, trust, and party heuristics presuppose minimal cognitive effort, as a voter needs certain information from the political actors (those engaged in the referendum campaign) to form an opinion. If voters want to cast their ballots in accordance with their preferred party, for example, they also need to know what their party's position is. Owing to the positions they take on the proposals at hand, as well as to the information they prepare beforehand, political actors—and the government in particular—have special significance in referendums.

In the systematic path, it is the arguments that are decisive. In taking this path, voters weigh the pros and cons of a proposal and assess which arguments are more convincing.

The Systematic Decision-making Path

The choice between heuristic and systematic paths depends on an individual's motivation and competence, and the more motivated and competent someone is, or feels him/herself to be, the more likely that person will choose the systematic path. In addition to such individual characteristics (e.g., motivation, competence), the choice of the systematic path also depends on aspects specific to the campaign itself. The intensity of a campaign plays a particular role, as intense campaigns signal to voters that the referendum issue is important. If someone regards the referendum topic as important, he or she will be motivated and more likely to choose the systematic path. Familiarity with the proposal to be voted on is also important, for the greater the familiarity, the more competent a voter feels and the more likely the systematic path will be chosen.

The Heuristic Decision-making Path

The heuristic path is a viable alternative way of making a decision, because voters can make reasonable decisions based on these four heuristic strategies and thus simplify their choice. It is a path, however, that can also lead to making misjudgments. A misjudgment means not noticing that one's actual vote does not correspond to one's true preferences. For

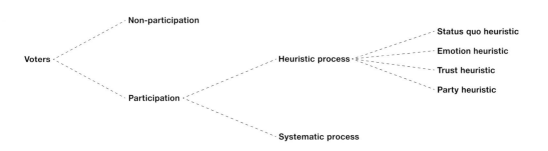

1 **DECISION TREE FOR THE OPINION-FORMATION PROCESS** The motivation for making a decision in a referendum can have quite different justifications. For that reason, referendum campaigns try to convince and speak to citizens in a variety of ways.

example, if your father had a small business and you felt warmly toward such enterprises, you would vote in favor of a tax reform that benefitted small businesses. Yet you may well not benefit from that proposed tax reform, and had you considered the facts, you likely would have voted against it.

Such misjudgments occur under the following three scenarios. First, you might automatically or unconsciously follow a heuristic and fail to consider whether that heuristic is in fact suitable: You simply do what your preferred party recommends. Second, you might lack the necessary knowledge of the context to be able to intelligently apply a heuristic. You could intelligently apply the party heuristic, for example, if you did so in a manner dependent on the unity among the party elites. If the party elites speak with one voice, then you can forgo informing yourself, while dissension in the ranks would indicate the issue at hand is not so clear. Party elites are united when there are no dissenting opinions at the subnational level or within associations or unions. In such a case, for example, the government, economic associations, and center and right parties might

be for a particular proposal, while the left and green parties, unions, and NGOs might be against it. In addition, no subnational party would hold a different opinion. Third, it might be that citizens follow their party even though they would actually hold a different opinion based on other arguments. This possibility gives rise to concern if a group of voters adjust their arguments to fit the party's views. In other words, this would mean following the party heuristic leads to using the arguments the other way around. Reasons this can happen might include an unwillingness to grapple with the proposal, or an emotional response to the issue itself, and because the emotion heuristic reinforces the party heuristic, it distracts from the actual content of the proposal.

SUPPORT FOR DEMOCRATIC OPINION FORMATION

Government and media can support the democratic opinion formation process by ensuring that the information they provide is of good quality. Here it is not the absolute amount of information that matters but rather that the flow of information is

OPINION FORMATION IN REFERENDUM CAMPAIGNS

SYSTEMATICALLY FORMING AN OPINION? Bern, Switzerland, 2012: Looking at the fine print? Referendum campaigns try to court voters in various ways. Some use objective arguments while others try to appeal more to the emotions.
Keystone / Peter Klaunzer

provided in as balanced (or not one-sided) a manner as possible.

Similar Means: A bilateral flow of information

One can speak of a bilateral information flow if a similar amount of information appears in the media and in the referendum documents from both political camps. If information is largely unilateral, then one camp has a distinct advantage in terms of "volume" (extent, intensity), which has negative consequences for the opinion-formation process. The less politically involved citizens are, the stronger the effect an unequal information flow has on their forming a political opinion. A less politically involved citizen in this case will follow those arguments most prominently, and one-sidedly, presented in the referendum campaign. In this case, it would actually even be better if the person would use a heuristic.

In reality, the bilateral information flow from the government is encouraged by an informational pamphlet that is sent, together with a postal ballot, to voters a few weeks before a referendum is held.

In that pamphlet, the proposal to be voted on is described and proponents as well as opponents state their most important arguments. In some cases, political parties, unions, associations, or other interested parties make recommendations on how to vote, and the actions government or parliament have taken on the proposal(s) may be included. Such informational brochures are standard in Swiss national referendums, and are used in some U.S. states as well.

In the European context, and particularly in Switzerland, the government (or rather, the constitution) promotes such a bilateral information flow also by drawing other actors—associations, unions, NGOS—into the process: Their arguments also become part of the public debate. In the United States, the government has less control over the direct democratic process and thus also has less control over the flow of information. In California, for example, direct initiatives are placed before the voters without the legislature giving its opinion beforehand. In this case, the flow of information is to the disadvantage of the government. Plebiscites in the

NOT THE MOST SUBTLE APPROACH Zurich, Switzerland, 2007: In their controversial poster promoting a popular initiative "to deport criminal foreigners," the Swiss People's Party tried to appeal particularly to negative emotions among voters. The poster, and the referendum campaign, created a stir internationally, with many regarding both poster and campaign as racist and xenophobic. Panos/Mark Henley

United States should thus be seen as an instrument for minorities not represented in the legislature.

Media behavior is decisive in providing a balance between the differing arguments. In Switzerland and in other countries in Western Europe, such as Germany or the Netherlands (when they hold referendums), the media rely on the preparation and efforts political elites undertake, and report on the arguments elites have prepared and about the actors involved. Journalists favor reporting on the more powerful actors and members of government, but also provide balance. That means should one side be more active than the other, then its arguments are accorded relatively less weight than are the arguments from the less active side. Put another way, the media make efforts to provide balance and want to give both sides an opportunity to be heard. This positive assessment does not apply, however, to the free newspapers, where the quality of information provided is worse than in other media. In such free newspapers, far fewer arguments are provided about referendums, and less effort made to explain them. A further displacement of commercial newspapers by free newspapers would be problematic for providing referendum information to voters.

Less discussion of opposing standpoints exists in the United States. In California, for example, up until 1992 popular initiatives could rely on the fairness doctrine, which guaranteed balanced coverage in radio and TV on both sides in plebiscites. Since 1992, however, this doctrine no longer has a legal basis in the case of popular initiatives. The state-provided voter pamphlet is today the only source that guarantees coverage of both sides and still provides a bilateral flow of information.

Information about the Means:
Transparency about the origins of campaign financing

In addition to balanced information, another factor that can encourage democratic opinion formation is information and transparency about where the money spent on campaigns is coming from. Transparency enhances the quality of democracy because one can identify the interests of those who are providing funding, and thereby indirectly obtain information about the proposal itself. In numerous U.S. states, including California, both the amounts and the names of major donors to a referendum campaign must be made public. Since referendum campaigns are conducted highly professionally in the United States, much money is involved and transparency is correspondingly important. In 1998, for example, a record amount of money was spent on popular initiative and referendum campaigns—$400 million in the entire country—with $250 million of that spent in California alone.

The costs of television advertising form a major part of this expense, but costs are also generated from collecting signatures, which is done by private groups contracted and paid for this purpose. No such practices exist in Switzerland, a country that generally has little transparency when it comes to how its politics are financed. However, political advertising on Swiss television is forbidden, and the collection of signatures is often voluntary, so as a result, less money is in play. Nevertheless, more transparency about the role money plays in its politics would help increase the quality of democracy in Switzerland.

DEMOCRACY–A DREAM?

Max Frisch

[...] DEMOCRACY–A DREAM

I remember being a high school student and having to stand next to the teacher's desk and read the verse: *Majority is irrational.* And continuing: *Understanding has always been only among the few.* I was indignant, German classic or not, and was informed by the teacher that it wasn't Friedrich Schiller saying that, the writer who bequeathed us *Tell,* so powerful on the stage, no, it was a prince who spoke that way, a courtier in attendance at the court of the tsar. I had to accept that, but such verses violate a taboo within me, and when I was allowed to return to my seat, the indignation I felt as a Swiss did not go away.

MAJORITY IS IRRATIONAL

Why, in fact, does the numerical majority decide? Nowadays I think that a fair question. Why is the majority right?–assuming, for the moment that it is the majority that actually decides about military armaments or economic matters in general: Does the majority really know what it is making decisions about? Who instructs the majority, that is, who owns the media corporations that inform the majority? [...]

On the one hand:

Dethroning the majority, even if done only theoretically, namely by doubting whether the majority makes better decisions in the general interest than a minority does, naturally leads to balancing on a dangerous knife-edge, with an abyss both left and right, I know: to the left, a unity party in the name of the people, one that robs it of its mature responsibilities; to the right, all kinds of military juntas.

On the other hand:

By forbidding ourselves from harboring any doubts about the political competence of the numerical majority and simply watching from afar, do we protect ourselves from the failure of our parliamentary lobby-democracy?

I'm eager to hear your open responses.

[...] And to what end, really, do we act as if we believed the majority decides?–as if we didn't know what the majority in the country, the people who for that very reason no longer go to vote, take for granted: de facto, but if possible in the guise of democratic folklore, it is power that makes the decisions anyway, and in the free world, that means capital. Why can't we admit that? Kings and princes used to flaunt their power. What we have in its place is not liberté-fraternité, but a consti-tutional apparatus in all its perfection, which, with some shrewdness, can be manipulated in such a way that the exercise of power appear democratic every time.

What is understood by politics here:

shrewdness;

the way you manage to get hold of a numerical majority;

in order to exercise your control;

without the voters figuring it out.

To start the conversation at last: Do you see in the fact that there are still popular referendums in abundance (in which the competing positions have very different advertising budgets) and the fact that the numerical majority makes the decisions both in parliament and in the government commissions–do you see that as a guarantee of democracy?

Max Frisch (1911–1991) was a Swiss playwright and novelist.
From: Walter Obschlager, ed., Max Frisch–*Schweiz als Heimat? Versuche über 50 Jahre,* Frankfurt am Main, 1990, pp. 489–92

While in some parts of the world people are celebrating the arrival
of democracy, in many of its established heartlands there are signs that
democracy might be becoming "tired," that perhaps an election result
might be less important than the performance of the stock exchange. Parti-
cipation in voting is declining in many countries. This does not mean that
democracy is disappearing; its formal institutions remain fully functioning.
We might however say that we are on the road towards something called
"post-democracy," a situation where, although elections, parties, debates
and all the apparatus of democracy keep going, the energy and strength
of the political system is no longer found there, but in small circles of political
and business elites. One reason for this is that our main parties still bear
the marks of the conflicts and identities of the periods when they were formed:
Civil wars of the nineteenth century, religious conflicts, divisions between
town and country, the struggles of industrial workers for citizenship.
The populations of post-industrial society, whether in hi-tech and scientific
activities or low-paid jobs in the service sector, find it hard to make sense
of such parties.

Meanwhile, democracy remains largely national, while the economy is
becoming global. Many aspects of the conduct of the great transnational
corporations are beyond the reach of democratic governments, and
have sometimes developed political power over them. As politicians become
out of touch with their publics, they become increasingly drawn towards
the representatives of that global corporate power, on which they
become increasingly dependent, forming the small elite circles that are
becoming the real heart of politics. The 2008 financial crisis and its
consequences in the Eurozone have shown us this at work, as democratic
institutions were largely excluded from the deals made between banks
and public authorities. But the way in which that crisis has been handled
has produced waves of protest and critical citizens' movements in many
parts of the world. Do these campaigns mark a revival of democratic energy?

Democracy's Fatigue

Colin Crouch

In 1994, black South Africans, after a long struggle, won the right to vote for the first time. They arrived at polling stations in vast numbers, standing in line for many hours in the blazing African sun. Similar signs of enthusiasm in using a hard-won democratic right could be seen in the early 1990s across central Europe as Soviet communism released its hold. These are scenes from the springtime of democracy. Do democracies then have an autumn? Do they become tired? If the proportions of the electorate bothering to turn out and vote serve as evidence, the answer would seem to be yes. In almost every country with long-established parliamentary democracy, there has been a long-term decline in voter participation (see Figure 1).

A particularly poignant moment, when democracy seemed to have become tired, occurred after the 2000 presidential election in the United States. The race between George W. Bush, the Republican Party candidate, and Al Gore, his Democratic Party opponent, was exceptionally close, and everything depended on the result in one state, Florida, of which Bush's brother was governor. Defective voting machines resulted in thousands of votes being declared invalid, the great majority of which were in areas where Gore's support was strongest. Florida officials declared Bush had won the election and Gore's supporters launched a series

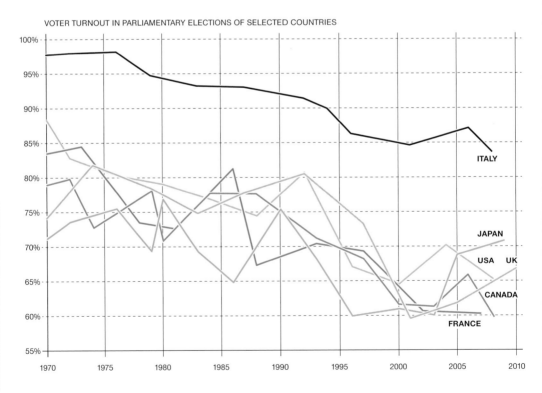

VOTER TURNOUT IN PARLIAMENTARY ELECTIONS OF SELECTED COUNTRIES

1 **FEWER AND FEWER VOTERS** In the course of the last decades, there has been a decline in voter turnout in so-called "mature" democracies of the western world. (In the case of the U.S., and for better comparability, only the values of the second congressional elections are given—which coincide with electing the President. Voting participation then is typically higher than during midterm congressional elections.)

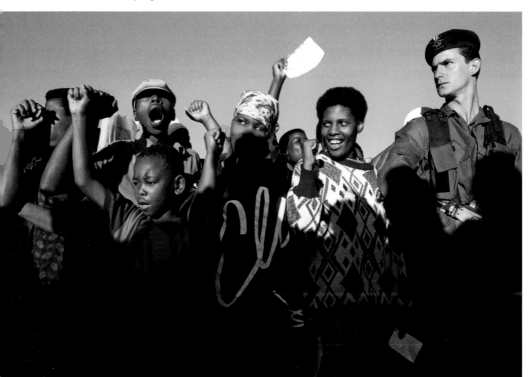

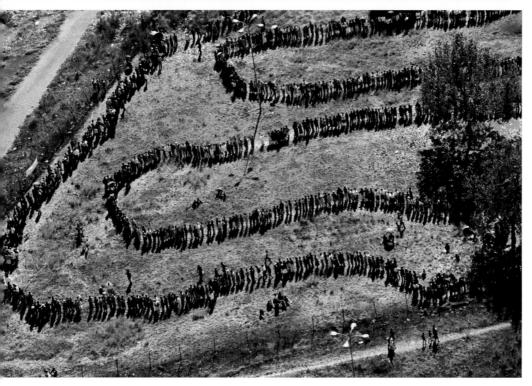

South Africa, 2004: Township residents wait in long lines to be able to cast their vote. Keystone/Denis Farrell

A TIRED DEMOCRACY? New York Stock Exchange, November 20, 2000: Presidential candidate Al Gore can be seen on a screen next to stock market tickers. Uncertainty about who had won lasted for weeks after the polls closed. Yet the country seemed more concerned with the effects this uncertainty would have on the stock market than on what its political consequences might be. Keystone/Doug Kanter

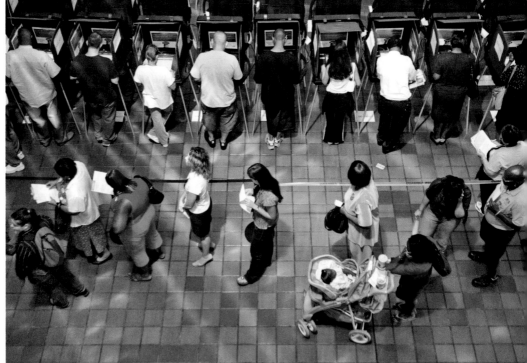

Polling place in Florida: In the 2000 elections, there were questions about the methods used to count votes in Florida. In addition, its governor Jeb Bush was the brother of presidential candidate George W. Bush. Due to the results from the other states, the outcome in Florida was decisive in determining who would be elected president in 2000. Reuters/Marc Serota

of legal appeals, which were eventually resolved in Bush's favor by the U.S. Supreme Court. George W. Bush became President of the United States. During the days of waiting for the outcome, as different levels of law courts made conflicting decisions, the predominant anxiety in the U.S. media was not whether U.S. democracy was functioning correctly or whether there had been dishonest practice, but whether uncertainty over the result of the election might damage the stock exchange. It really did seem that U.S. democracy was becoming tired and cynical; that the actual outcome of a presidential election and whether it had been achieved fairly were less important than temporary damage that might affect share prices.

Or were the cynics right? Has it become unimportant who wins elections? Are we moving away from societies that are truly democratic, toward something that would more accurately be called "post-democracy"? By post-democracy I do not mean an absence of democracy, a dictatorship. I mean rather a situation in which all democratic institutions, like elections, function as before, but where the results do not seem to matter much, because the energy, the vital force, of the political system has gone elsewhere. It has disappeared into the more or less closed circles of political and economic elites. Elections would then increasingly become spectacles managed by professional communicators, who have learned their skills advertising products.

I therefore use post-democracy in the same way that we use the idea of "post-industrial" economies. When we say that an economy is "post-industrial," we do not mean that all its factories have disappeared, or that people no longer use industrial products. These things live on and remain important, but the energy, innovation, and dynamism of that economy have gone elsewhere—in this case into the service sector. So it is with post-democracy.

Also, I do not say that, in the established democracies of the Western world, we are already living in such a state of post-democracy. There is too much life and contestation in our politics for that. But I do claim that we are on the road toward post-democracy, and should not be complacent that, just because we have elections that can sometimes lead to changes of government, our democracies are in good health.

I see three main reasons why democracies might be becoming tired in this way.

DO PEOPLE KNOW WHO THEY ARE (POLITICALLY) ANYMORE?

First, our party systems still mainly reflect the political and social divisions of a bygone age. In European countries we have parties whose names and primary symbols represent the struggles of the nineteenth and early twentieth centuries: Christian, Catholic, Protestant, lay parties; farmers' parties; parties of property

CLASSICAL OCCUPATIONS BEFORE THE POSTINDUSTRIAL SOCIETY EMERGED Shipyard worker in Gdansk, Poland, 2007: After the Iron Curtain fell, industrial work was relocated, in grand style, from the established Western European countries to Eastern Europe. Panos/Piotr Malecki

Workers at the VW automobile plant in Wolfsburg, Germany, 2008: Since the second half of the twentieth century, the proportion of those who work in the secondary or manufacturing sector in Western democracies has steadily fallen. Panos/Stefan Boness

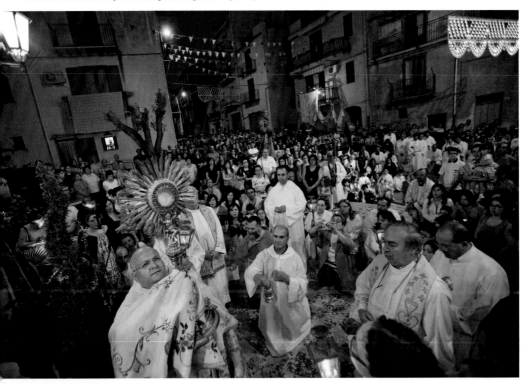

Catholic Mass in Corleone, Italy, 2009: In most postindustrial societies of Western Europe, the role of religion is declining. There are alternative ways for finding meaning, and they compete with the churches. Panos/Robin Hammond

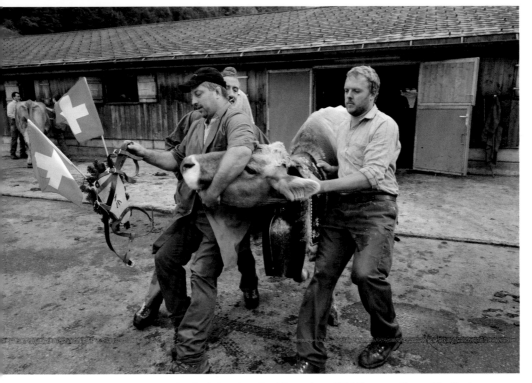

Swiss farmers decorating a cow prior to leading it down from the alpine pastures, 2007: The occupation and identity of farmers were clearly defined. In the nineteenth and twentieth centuries, this identity was reinforced and promoted by specific interest groups and political parties. Panos/Mark Henley

POSTINDUSTRIAL OCCUPATIONS Pizza chef in Sodertalje, Sweden, 2007: Today, numerous but often poorly paid jobs exist in the service sector of Western countries. Panos/Jacob Silberberg

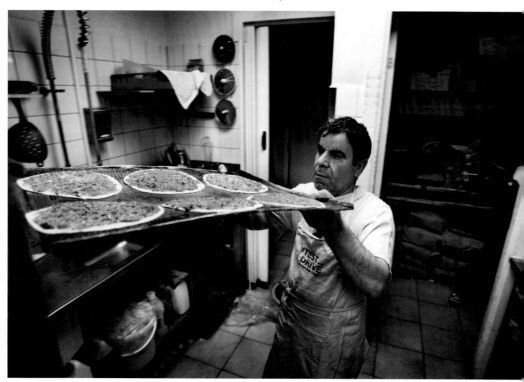

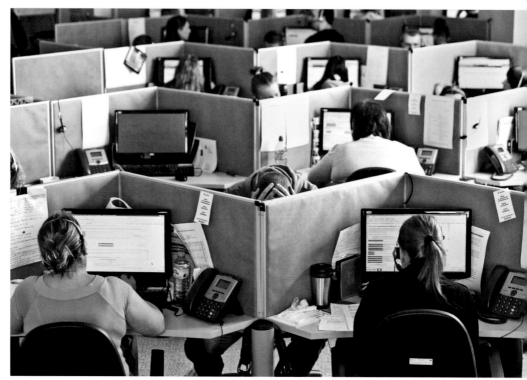

Call center in Warsaw, Poland, 2011: In the last decades, IT has been a growth industry. The activities that have emerged as a result are not of a kind that carry strong identifications wtih them. As a result, there are also no political parties that represent the interests of those who work in such service jobs. Panos/Piotr Malecki

Nurse in a clinic in Wigan, Great Britain, 2004: Jobs involving providing care for others are often poorly paid even though they involve much responsibility. These professions also have no political lobby. As Western societies age, however, there will also be an increasing number of people in such professions and occupations. Panos/Steve Forrest

owners; parties of industrial workers. The two parties of the U.S. system originated in the winners and losers of the Civil War in the 1860s. In nearly all these cases, parties developed to represent groups that were at the time being denied access to citizenship—or to represent those trying to exclude others. Parties defined a social identity that people could understand, and defined it politically, because those identities were rooted in conflicts that centered around who was to have the right to vote or otherwise participate in shaping society.

The last great group to struggle for citizenship based on their rights were women, excluded for so long in many countries from the right to vote. However, they did not follow the rule and form separate feminist parties. This was probably because, as women mainly live in families alongside men, the conflict of separate parties representing the genders would probably have been too big to manage. Today, immigrant groups might still fight for citizenship, but they are too small to launch major new parties.

In general, once universal adult citizenship has been obtained, any new identities that develop in society neither can have, nor need to have, a particular political expression. In today's already industrialized societies, many new occupations have emerged, such as those using information technology (whether as high-powered operators or as call-center staff), or many new professional occupations. At the same time, other occupations that have existed for a long time—such as restaurant work, school-teaching, health care and other forms of care—have grown considerably in size and importance. But as citizenship no longer has to be struggled for by such new groups, they have no reason to link their occupational identity to a political one. Meanwhile the old party bases make little sense to them, and they feel that the political world has little to say to them.

But do people need an occupational or religious identity to shape their political concerns? Today, for example, many people are concerned over the future of the environment, and green or ecological parties have developed in most countries. The way in which they have been able to challenge the existing political system certainly demonstrates that we are not yet living completely in a post-democratic age. But, not being based in a particular social identity, these parties tend to remain small; they address us in terms of issues we might care about, which is important, but not as important as issues that define who we are.

Perhaps we do not find it easy today to develop strong identities; so much around us changes so fast. For many working people there is no such thing as an occupational identity, and fewer and fewer Europeans (though not Americans) have a religious identity that is important to them. The very fact that we so often define our period in terms of "post-" suggests this: Post-industrial, post-modern,

post-democratic. We think we know who we used to be, and we are aware that we are leaving it behind, but we are not at all sure who we are becoming.

GLOBAL MARKETS, NATIONAL GOVERNMENT: IMBALANCE OF POWER

Second are the political consequences of globalization. Our national democracies became established at times when economies were also largely—though never wholly—national. Nationally owned firms employed workers within the country to produce goods, many or even most of which were bought by consumers also within the same country. This does not mean that national governments controlled their national economies; that happened only in communist lands. But firms and governments both mainly existed at the same level. If governments wanted to regulate a particular economic activity, they could do so mainly within their borders. Today large corporations operate across a wide range of countries; some of them have even ceased to have a particular national pattern of ownership. They employ workers, often working in local supplier firms, across many parts of the world, and they market their products globally too.

Meanwhile, government has remained firmly national. If the activities of large firms require some kind of regulation, this usually has to be done through international deals involving many countries. This sometimes takes place, but if so, it happens at a level of politics rather remote from national democratic debates. At the same time, global corporations have some scope for playing governments off against each other, claiming that they will concentrate their investments in those countries where they are treated most favorably in terms of taxation, labor laws, or planning requirements. This intervention in what governments can do may pre-empt the demands of voters, further limiting the reach of democracy. It is therefore not surprising if people start to believe, rightly or wrongly, that it does not matter for whom they vote, or whether they vote at all.

THE NEW ELITES OF POST-DEMOCRACY

Finally, as a consequence of all these developments, politicians and voters become increasingly estranged from each other. Politicians would like to feel that they can rely on their party memberships to keep them in touch with voters, that party members are a microcosm of the parts of the electorate to which the politicians want to appeal. But party members today often represent the declining occupational and religious identities that were important in the founding of the party but which no longer touch the great majority of voters. The politicians therefore no longer trust their parties to represent the people, and increasingly use market research methods to discover what voters want. This is expensive, and party

Nescafé factory in Dongguan, China, 2004. The multinational manufacturing company Nestlé is the world's largest producer of foodstuffs. Panos/Mark Henley

Google's China headquarters in Beijing, 2007: This Internet company seeks out its locations primarily with economic conditions in mind. The company's tax burden is low, for example, because it only has its offices in countries which keep their business taxes low. Panos/Robert Wallis

Moscow, Russia, 2003: Press conference announcing the founding of TNK-BP, a subsidiary of BP. This international energy company is often in the headlines due to ethical concerns, which include environmental degradation and human rights violations. Panos/Anatoliy Rakhimbayev

Colombo, Sri Lanka, Facination garment factory, 2004: This company produces items for internationally well-known firms such as Nike or Columbia. The garment being displayed will fetch $45 when sold–the company in Sri Lanka will only receive $2 for making it. Panos/Fernando Moleres

memberships—which provide parties with funds—are declining everywhere for the same reasons that electoral participation is declining. In some countries parties have access to state funding to help them finance their activities; in others, like the United Kingdom and United States, they have nothing other than members' contributions. But parties can supplement their incomes if they can attract funds from corporations. Those same firms that have become rich by becoming global often have money to spare for political donations, often in several different countries.

This can solve parties' funding problems and enable politicians to afford market research and advertising techniques to try to connect with an electorate from whom they are otherwise becoming remote. But this comes at a price.

Firms do not usually give money to parties out of pure kindness. They want something in return: Policies that favor their interests. Increasingly politicians find themselves drawn away from close interaction with voters—whose interests they find it hard to understand, partly because we voters often do not realize what our interests might be. Instead, they are drawn ever closer to corporate leaders—who know exactly what they want from governments, who can get easy access to communicate their demands through their "lobbyists," who can offer much-needed finance to parties, and who can decide to invest in a particular country or go elsewhere.

When large, global corporations develop privileged relations with the political world in this way, we can see signs of post-democracy. This does not mean at all that corporate political power did not exist before; it certainly did, and has long been a problem for democracy. What is changing is the global scope of the lobbying, and the inability of existing party systems to challenge it.

We can see this most strongly in the forces that led up to the financial crisis of 2007–2008. Particularly in the United States, the big banks had acquired great political power, funding politicians' campaigns, lobbying to stress the value of their activities to the U.S. economy, and inserting their personnel into government posts. The firm of Goldman Sachs became particularly noted for the number of employees who obtained key posts in the U.S. Treasury, but it was not alone.

During the 1990s and the early years of the present century, the banks used their lobbying power to achieve a deregulation of the U.S.—and therefore the global—financial system, enabling them to take far higher risks in their lending activities than had been possible since U.S. legislators had imposed some rules on the system following the collapse of the 1930s. The banks took the risks; by 2007 things had already gone badly wrong. And so, after just a few years of deregulation the biggest collapse of the banking system since the 1930s took place. It was then

agreed by governments in virtually all countries that, although the banks had brought the crisis on themselves, they were too important to be allowed to fail. Public money would have to be used to guarantee their survival. Ordinary citizens would have to bear the cost, through increased taxes and reduced public services. Because only bankers understand how to fix a financial system, governments are now even more dependent on them than before.

WHAT CAN BE DONE?

The financial crisis provides the best example so far of how we are moving toward post-democracy. An extraordinary concentration of business power led to the deregulation that created the crisis; the absence of any effective democratic response to the crisis has made it possible for the same concentration of power to govern the way in which we are trying to emerge from the crisis. It is, however, not the only example. In the energy sector, too, global concentrations of business power can have important political consequences. Sometimes the same can happen with the food industry, pharmaceuticals, and others.

The general inability of political parties to cope with this phenomenon is evidence that we are on the road to post-democracy. But evidence that we have not traveled far along that road can be seen in the protests and critical campaigns that these developments have attracted across many countries. The financial crisis in particular unleashed a wave of anger in the United States, many parts of Europe, and elsewhere. It is a characteristic of democracy—not always a good one—that governments are blamed for problems even if they are not their fault. A significant feature of the new protest movements is that they target corporations as well as governments. It is as though citizens understand that, on the road to post-democracy, corporate leaders share responsibility with politicians for public policy.

The criticisms have spread from the financial crisis itself to the way in which cuts in public services have been required to pay for it, especially in the countries of Southern Europe where the financial crisis produced a general collapse of confidence in the national economy. The crisis has also drawn public attention to growing inequalities between extremely rich people and the rest of the population—including a new sensitivity to the ability of wealthy people to avoid paying taxes.

These campaigns probably do not affect the majority of people, but they serve as important warnings that in the crisis, and more generally where public scandals affect the relations of politicians to large corporations, our formal governing institutions are unable to manage crises with the fairness that the citizens of democracies might expect.

THE PROXIMITY OF POLITICS TO ECONOMICS Washington, D.C., 2010: Lobbyists talking with U.S. Senators to bring about changes to a planned bankruptcy law. The close meshing of elites in the political and the economic worlds is one of the characteristics of post-democracy. Laif/Paul Hosefros

World Economic Forum in Davos, Switzerland, 2013: Anshu Jain, Co-CEO of Deutsche Bank, seated next to Pierre Moscovici, French Finance and Economics Minister. Every year, the elites of the political and economic worlds meet in Davos for discussions. Keystone/Laurent Gillieron

Traders at the New York Stock Exchange, 2009: The 2008 financial crisis would not have happened had the U.S. banking sector not been liberalized. These changes were pushed through by lobbyists and allowed banks to take higher risks than in the past. Reuters/Chip East

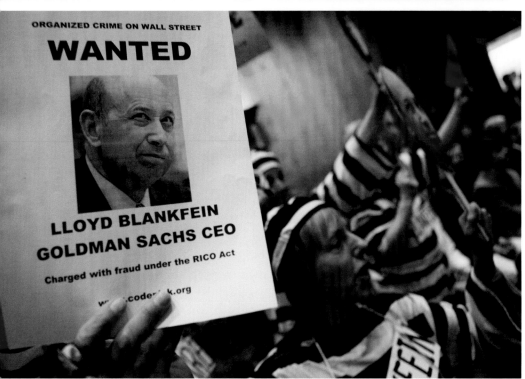

Photo of Lloyd Blankfein, Goldman Sachs's CEO, used during a demonstration. This investment bank played a controversial role during the banking crisis. Keystone/Evan Vucci

Campaigns often focus on single issues, but the extension from anger about the conduct of banks to protests about taxation and public services suggests the building of wider movements. This perhaps goes furthest in the international group Attac, which is an organization engaged in financial, taxation and green issues, moving toward the development of an entire political program.

A logical next step for such groups would be to enter the formal political arena, turn themselves into parties, and stand for election. Some have done this, most notably the Piratenpartei in Germany and the MoVimento 5 Stelle (M5S) in Italy, both of which campaign directly on the basis of the unresponsiveness of the conventional parties. Both parties make use of humor to ridicule the existing state of party democracy—M5S is led by a comedian, Beppe Grillo. In both cases, however, they have so far not gone far beyond this to develop positive policies across the full range—far less in fact than movements like Attac and Occupy, which have not stood for election. The Piraten are mainly concerned with information technology issues. M5S actually held the balance of power after Italian national elections in 2013, and had the opportunity to make demands for reform from the main parties. But it chose not to do so, and preferred to remain as a protest party.

The situation is developing rapidly, and movements and parties might morph into each other in the coming months or years. However, it is not easy for any of them to become major parties, for the reasons already given, showing how existing parties have reached their present problematic situation: The new occupational and other social identities are no nearer to finding political expression; globalization continues to remove many issues from the reach of national and of course local politics; and corporate elites have acquired a position of political influence from which it is difficult to dislodge them, when we are all so dependent on the goods and services they produce. Maybe the leaders of the Piraten and M5S understand this and know that they stand little chance of becoming anything more solidly rooted than a protest movement, and so they do not try.

It is indeed likely that the populations of today's advanced societies will never fit easily into the mould we have inherited of twentieth century parties and their relations to governments and to voters. That mould assumed that people accept rather solid blocs of identity, and large, mass-membership organizations. Sometimes older politicians see the lack of interest of young people in organizations of this type as evidence of a lack of interest in social questions. But people from this same young generation are highly active in many campaigns and movements, and volunteer to work for many valuable causes. Increasingly they do this through social media and the Internet rather than through formal movements. The change

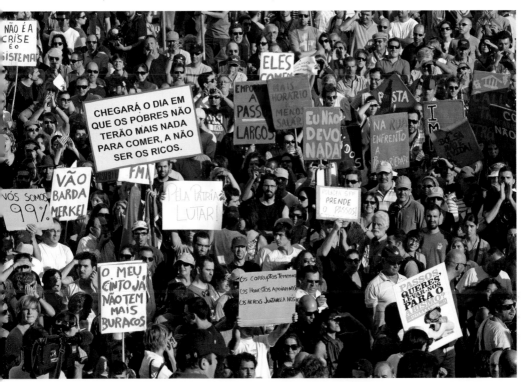

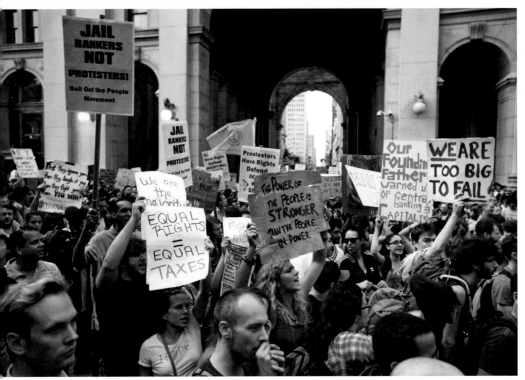

"Occupy Wall Street" protesters in New York, 2011: This movement is against the unequal distribution of burdens as a consequence of the financial crisis. VII/Stephanie Sinclair

Vienna, Austria, 2013: Protests by the group Attac against laws favoring tax fraud and money laundering. The group calls for fair taxation of all for the benefit of the commonwealth. A core demand is for the international taxation of profits from stock market transactions. Keystone/Helmut Fohringer

may be one of means, not of ends or values. Perhaps the Piratenpartei is right to try to construct politics around information technology.

This image fits well with the idea of a post-modern society, where actions and identities are highly flexible and never remain fixed for long. To some extent the contemporary financial system seems very much like this too. Investors hold shares for very brief periods, sometimes just a few seconds if they are making computerized share purchases. Entire companies can change ownership in a similar way. Financial value created in the secondary markets is a value based on fluctuating share prices themselves rather than on some estimate of what shares might be worth in an increasingly elusive "real" economy. It was this elusive nature of financial value that caused the financial crisis.

So is a flexible, lightly organized, social media-based politics the entirely appropriate response to the new economy? Possibly. But we must remember that, while stocks and shares and the values associated with them can seem as light and easy-going as a Twitter message, behind them stand enduring realities of extremely and stably wealthy individuals and corporations. Wealth and income are today more unequally distributed in most advanced economies than has been the case for many years. And the power that such wealth can wield has considerably more reality than a fluctuating share price. This is both cause and consequence of the problems of democracy. Post-democracy may well be post-industrial; it is not very post-modern.

Democracy as we know it today developed in the context of the nation-state. To what degree can democracy continue to exist in an era when societal processes are globalized and politics increasingly internationalized? Can democracy develop outside the confines of the nation-state, in international organizations or in bodies like the EU? To what degree does globalization contribute to the dissemination of democratic principles? What role can international organizations play in the democratization of authoritarian states?

The increasingly transnational scope of social processes challenges a political order that thus far has been nationally based and democratically legitimated. The ability of such a political order to solve problems is put into question by a world that calls for greater international cooperation. Yet though politics has internationalized, the *demos* has chiefly retained its national character. The development of a boundary-crossing public arena for politics in Europe, let alone a transnational European identity, has been very slow. Nevertheless, one can detect democratization trends in the international context. Parliaments or parliamentary bodies have been introduced in international organizations, and the transparency and accountability of international bodies have increased. What is key here has been the interplay between international institutions and the democratically legitimated organs of the nation-state, the latter of which retain central monitoring and control functions even in a global(ized) order.

While the internationalization of politics challenges and alters national notions of democracy, it also provides an opportunity to spread democratic principles throughout the world. Thus, many international organizations are committed to promoting democracy in authoritarian states. Such organizations support democratic forces in the respective civil societies and exert pressure on authoritarian regimes through incentives and sanctions. By binding them into common activities or policies, international organizations seek to change the orientation of authoritarian regimes and to move them toward democratic principles—though these efforts meet with varying degrees of success.

On the Right Track?

Sandra Lavenex

Globalization, understood as the increasing global intertwining of societies, has a mixed relationship to democracy. In established democracies, globalization severs an established congruence between the power of the state and its citizens, between rulers and ruled. The increasingly transnational nature of societal problems leads to situations where many such problems—be they the protection of the environment, the stability of the financial system, or control over international migration—can no longer be resolved by an individual nation-state alone. At the same time, the political solution an individual state arrives at often has immediate consequences for other states and societies. The problem-solving ability of democratically legitimated nation-states is thereby rendered increasingly meaningless. Only globalization—the creation of international political institutions and greater international cooperation—can restore the ability to solve problems. In that sense, globalization means many political decisions are no longer made within nation-states or through established domestic, democratic, legislative processes. The challenges that arise for the functioning of democracy are the subject of the first part of this chapter.

The second part turns to the potential globalization holds for spreading democracy throughout the world. While the abovementioned processes challenge the way established democracies function, globalization simultaneously brings about a diffusion of democratic norms and procedures around the globe, even when such democratizing processes often remain incomplete and conflict-laden at times. In this section we examine various strategies and instruments democratic states and international organizations use to support and promote democratization processes around the globe.

I. GLOBALIZATION AND THE TRANSFORMATION OF DEMOCRACY

Modern democracy developed in tandem with the consolidation of the Western nation-state. The distinguishing characteristic of this process was the relative concordance between territory, people, and governmental authority inside a defined national boundary. Globalization severs this concordance and challenges established norms of democratic rule.

Internationalization: The drifting apart of rulers and ruled

The most fundamental challenge globalization poses for democracy is the drifting apart of rulers and ruled. At heart, globalization threatens the fundamental principle of democracy: The political self-determination by the people. Internationalization, meaning the transfer of political authority to supranational institutions, transgresses the territorial demarcation of people organized into nation-states and deprives them of the opportunity to participate in central decision-making processes. That raises the question how the *demos* can continue to be involved in the exercise of rule in the absence of participation by elected representatives. At the same time, the internationalization of politics also calls for a new definition

EUROPEAN UNION "Europe would work better without those Europeans." The transfer of political authority to supranational insitutions eliminates the people as participants in basic decision-making processes. Chappatte

of the *demos*. The new constituting of political processes and networking between political decision-makers has advanced rather more rapidly than the formation of transnational political identities, and developed more quickly than has the emergence of a transnational political space, along with the political parties, media, and associations to occupy it.

The internationalization of the right to rule has been realized most fully thus far in the European Union (EU). Not only does the EU have responsibilities in numerous policy areas, but with the European Commission, European Parliament, and European Court of Justice it also has supranational organs that are independent of national governments. Additionally, EU law, which is formulated with the agreement of a majority of the national representatives in the Council of Ministers and the representatives in the European Parliament, takes priority over national law and is directly applicable in the member states. It is therefore not surprising that the question of a *demos* that transcends national boundaries has been discussed primarily in the context of Europe's integration. Thus, the EU has a parliament directly elected by the citizens of the member states, and over the years, that parliament has achieved the status of a legislative organ with rights and powers equal to those of the Council of Ministers of the member states.

Yet there are still no genuinely European political parties, and candidates for a seat in the European Parliament remain members of national parties. Party politics and political campaigns for election into this parliament remain primarily national rather than supranational, and a transcendent, fully European political space barely exists. Citizens of EU member states continue to cling to their respective nationalities as their primary identity. Only very haltingly have any signs of a European identity developed, even though all EU member states have issued nearly identical EU passports since the 1980s.

As long as national identities and national political spaces dominate, democracy in the European Union and beyond must continue to be thought of, and shaped, with reference to a national *demos* and its institutions. For that reason, what is crucial to the internationalization of politics is for decision processes in international bodies to be linked back to domestic democratic processes, and to be supported, as well as controlled, by national citizens. This demand, in turn, is connected to other factors such as the possibilities for political participation and involvement, the transparency of political processes, the responsiveness of governmental actors, and the responsiveness of an internationalized politics to the demands and issues raised by national citizens.

International Institutions without Legitimated Political Representatives: The problem of participation

The internationalization of politics has made political participation more difficult, however. The winners in internationalization are often government executives, cabinets, and ministerial administrations: They represent nations externally, and take the national seats at international meetings. Governmental executives establish direct contact with their counterparts in other nations, coordinate policy in international organization and policy networks, and hammer out common solutions. Yet participation problems exist both for individual states and for the citizens of these states and their elected representatives. The United Nations (UN) is the only international institution with universal membership, as all sovereign and internationally recognized states are members. In the UN General Assembly, the most significant consultative and decision-making body after the UN Security Council, each country has one vote. This distinguishes it from the powerful and exclusive Security Council, which has only five permanent and ten non-permanent members, the latter of whom serve two-year terms. The five permanent members, China, France, the United Kingdom, Russia, and the United States, each have the right of veto.

UNITED NATIONS New York, U.S., 2010: Secretary General Ban Ki Moon speaking before the UN General Assembly. Membership in the UN is open to all internationally recognized countries. The Assembly's decisions are not binding under international law. However, the decisions of the UN Security Council, which has five permanent members, are binding on all UN member states. Keystone/Justin Lane

Theoretically, every country also can participate in the international financial institutions of the International Monetary Fund (IMF) and the World Bank, but not every country's vote is equal, since voting power is proportionate to the number of shares a country holds in these institutions. In addition to these international organizations that in principle are open to all nations, more selective clubs have gained influence in recent years, including that of the G7/G8 nations (the group of the most important industrialized nations/plus Russia) and more recently, the G20 nations (the twenty most important advanced and developing nations). Not only are numerous states excluded from these core circles of international policy-making, but the exclusive meetings have no link to directly elected representatives of the people, either in national or international parliaments. Since the 1990s, the exclusivity of these power circles has led to strong protests from non-governmental organizations (NGOs) and other civil society actors, which have regularly staged demonstrations against G7/G8 and G20 summits.

Unlike the representatives of governments, directly elected and thereby legitimated representatives are far less internationalized. International agreements are negotiated by the respective national ministers, and then signed by heads of states

G8 SUMMIT Camp David, U.S., 2012: Organizations such as the G8 or the G20 exclude many states and lack democratic legitimacy. Their decisions nevertheless often have far-reaching consequences for the world. Getty Images/Pete Souza

and governments. There is hardly any direct representation of the people at the international level, and in the context of ratifying international agreements, national parliaments as a rule can only accept or reject such agreements *in toto*.

Nevertheless, one can observe a slow development of popular representation over time in the course of this internationalizing of political decisions. A precursor can be found in the Inter-Parliamentary Union (IPU), founded as long ago as 1889. Initially, the organization was meant for individual parliamentarians, but it developed into an international organization of the parliaments of sovereign states. Today, the national parliaments of 157 countries are members of the IPU, and the organization, which functions for its members only as an advisory body for international questions, has had observer status at the UN since 2002.

Some international organizations founded after World War II, too, championed parliamentary assemblies early on as a way to augment their intergovernmental structures. This was true of the Parliamentary Assembly of the Council of Europe (since 1949), the EU's European Parliament (since 1952), and NATO's Parliamentary Assembly (since 1955). The European model served as exemplary for other regional alliances, including the Latin American Parliament (1964), the Andean Parliament (1979; it is associated with the Andean Community of Nations), the Mercosur Parliament (2007; Mercosur is a common market founded by Argentina, Brazil, Paraguay, and Uruguay), and the African Parliamentary Union (1976). It should be noted that the EU's European Parliament is the only such parliament directly elected by the people, and is also the only one that can participate in the legislative process or in decision-making. Other international "parliaments" are meetings of delegates from national parliaments and only have consultative functions.

Beyond such regional political and economic institutions, there are increasing calls within global organizations such as the World Trade Organization (WTO) to increase "parliamentarization." A first meeting of parliamentary representatives from the WTO's 157 member states took place on the margins of the Seattle WTO Ministerial Conference in December 1999. Participants there decided to create a permanent committee of parliamentarians, with the goal of exchanging information about WTO negotiations that were underway, and of overseeing WTO activities. A first Parliamentary Conference on the WTO was convened in March 2011, organizationally supported by the IPU and the European Parliament. The approximately 400 members of parliament who participated took the opportunity to engage in direct dialogue with participants in the WTO negotiations.

Efforts in the UN to also create a parliamentary assembly to complement the General Assembly have existed since 1945, though it was only in the 1990s that this

idea began to find broader support. In the meantime, an international network of NGOs and members of national parliaments have together launched a "Campaign for the Establishment of a UN Parliamentary Assembly," a goal supported by the European Parliament in June 2011.

To some degree, efforts at "parliamentarization" are attempts to transfer familiar national elements of representative democracy to the international level. Yet organizing a representation of the people at an international level is far more difficult than at the national level. The model of universal elections, the standard, established form for politically representing a nation's citizens, does not readily transfer upward. This can be seen in the EU, where as a rule, elections to the European Parliament are "second-order" elections, meaning they are dominated by national debates rather than international issues. Since it is difficult in international parliaments to achieve direct representation through elections, some states have increased the role their national parliaments play vis-à-vis their own national executives. Thus, a national parliament can control the actions representatives of their government take in international negotiations by granting limited, defined mandates. On the other hand, this presupposes a high level of information, transpar-

AFRICAN UNION Addis Ababa, Ethiopia: This building, which houses the headquarters of the African Union, was completed in 2011 with Chinese funding. The African Union includes almost every state in Africa. The African Union's organizational structure was modeled on that of the EU. Keystone/Kyodo

ency, and good communication, as well as good relations between those who represent a government and parliamentarians.

Similar challenges exist for the inclusion of other civil society actors such as the "social partners," which usually means union and employer peak associations that work together on labor-related issues. On the one hand, the domestic influence of such representatives of labor and management declines the more national politics is determined through international negotiations. On the other hand, internationalization also opens new opportunities for interest groups to participate politically. Thus, the European Commission and the European Parliament have established close contact with numerous social partners and NGOs with which they regularly consult. The integration and involvement of NGOs has by now become routine in other international organizations and negotiations, such as over global climate issues or world trade. To some degree, one can regard the opening of international bodies to NGOs as an alternative to popular participation through direct or universal elections, though one both more limited and less legitimate(d). This has led to coinage of the term "association democracy," which, in contrast to representative democracy, is a form of democracy that does not represent the people through parties and elections but instead sees them represented by organized interests.

Behind Closed Doors: The problem of transparency

Every type of political inclusion and participation presupposes transparency and access to the necessary information. As a rule, internationalization means an increase in the complexity of the problems and an increase in the number of actors involved in finding solutions. This increase in actors only increases the problem of transparency. Traditionally, debates in the context of international negotiations or within international organizations also have not been made public, so that national parliaments and citizens are presented with a *fait accompli*, the end-product of an already decided agreement.

During the last few decades, however, most international organizations have become more open to the public and have made their documents available or published them on the Internet. The WTO is a good example, as it has for some years now published the position papers of the WTO states online during a given negotiation round. The documentation for issues raised in EU institutions, as well as minutes of meetings of the Council of Ministers and of the European Parliament, the EU's legislative organs, are also readily available today. Still, it is not always clear from such documents what the respective negotiators' positions are, so that one cannot trace specific decisions back to the representatives of particular nations

or to individual actors. Those who wish to gain access to the relevant information also need a substantial degree of expertise in the material.

With decreasing degrees of formality, as a rule, the transparency of international institutions also decreases. As a result, many international bodies and networks of policymakers are wholly unknown to the public, or rather, so little information is communicated about their decision-making processes that they are all but publicly invisible. A good example is the Basel Committee on Banking Supervision (located at the Bank for International Settlements). This committee is composed of representatives of national central banks and is not based on an international agreement, as an international organization would be. Its members are not states but banking supervisory authorities and banking governors. Together, these experts make key decisions about stabilizing the financial, and especially the banking, system. For a long time, the existence of the Basel Committee was known only among specialists, and the committee remains unknown among broad segments of the public even today.

The transparency problem in international politics affects not only citizens but their representatives in national parliaments as well. National parliaments are responsible for ratifying international agreements and transforming them into national law. To avoid being confronted with just the end product of an international negotiation, and to gain greater insight into the course of the preceding negotiations, national parliaments have adopted various measures. Among them, one finds the creation of specialized committees, the demand for regular reporting by the government, or the requirement for access to the documents of the involved international organizations.

A Lack of Oversight and Control at the International Level:
The problem of accountability

The challenge the internationalization of politics poses for the inclusiveness and transparency of political processes also carries consequences for another fundamental principle of democracy: Responsible government action. The principle of responsible government action states that decision-makers must justify their decisions, and that those who are the recipients of these decisions must have the opportunity to call the decision-makers to account for their actions, whether through judgment or sanction. Representative democracy has developed a host of institutions to ensure the control of the government by citizens. The classic instruments to ensure this responsibility are recurrent free elections. Elections, along with a vocal opposition, guarantee that decisions-makers remain oriented to the will of the people, or put differently, if they do not show such commitment, then they will

not be re-elected. Such control and dismissal options are missing in the international system. The interrelations among decision-makers as well as the lack of transparency in decision-making processes make it far more difficult to identify who is responsible for particular decisions.

It is for this reason that international organizations, as well as the representatives of governments engaged in international negotiations, are given a limited mandate set by their respective national parliaments. Such mandates are meant to ensure that the international solutions reached remain limited to those areas which cannot be efficiently addressed at the national political level.

This "subsidiarity principle" exists in the EU as well, since it too faces the problem of responsibility. National parliaments cannot call their own governments to account for decisions made in the Council of Ministers, since twenty-six other representatives of the other EU member governments have also worked on a particular decision. Not only that, but owing to majority voting rules that are usually used, it is possible that one's own government was on the losing side in a particular decision. Second, the European Commission, the EU organ most comparable to a governmental executive, does not make its decisions on the basis of a political program decided by a particular national parliament. For that reason, the Commission, too, cannot be made politically responsible for the implementation of this political program. Furthermore, the European Parliament can exert only limited control over the Commission's actions. So, for example, if this Parliament loses confidence in the Commission, it can only dismiss it as a whole, but it cannot sanction individual commissioners. Not only that, but the commissioners are elected by the heads of states and governments of the member states and the European Parliament can only signal its approval. The Council of Ministers, the chamber of the states, can be called to account as a collective actor neither by the European Parliament nor by the national parliaments.

National parliaments can respond to this problem of clear assignment of responsibility in various ways. Relative to their own national governments, they can use the instruments that are well known in domestic politics: Put parliamentary questions to government, introduce motions, conduct critical plenary debates, or if absolutely necessary, withdraw their confidence in the government. However, these last two options in particular are very seldom used.

Outside of representative democracy, direct democratic instruments provide opportunities to exert control in, and over, international politics. In Switzerland, a governmental plan to join an international organization for collective security or to join a supranational community triggers a mandatory referendum, and the Swiss citizenry must approve such membership. Prominent examples of the power

of this direct democratic tool can be seen in the Swiss refusal to join the European Economic Area in 1992, or in a national referendum held in 2002, when Swiss citizens voted to approve Switzerland becoming a member of the United Nations. Swiss citizens can also vote to approve or deny other international agreements, as long as the referendum petition to do so is signed by 50,000 citizens, or if eight of the twenty-six cantons call for such a referendum.

Some EU member states also have direct democratic instruments available to them which they can use to steer at least some aspects of foreign policy. A growing number of member states have allowed their citizens to vote on whether they are willing to accept changes to EU treaties. Negative referendums, such as Denmark's "no" to the 1992 Maastricht Treaty, the rejection by France and the Netherlands of the EU's Constitutional Treaty in 2005, and Ireland's rejection of the 2008 Treaty of Lisbon, have led either to special provisions for these nation-states or to new negotiations, as in the case of the failed Constitutional Treaty.

Does International Politics Care about Citizens?
The problem of responsiveness

The question how an internationalized politics is able to respond to the needs and issues of citizens is the fifth and last of the challenges addressed here. The effort to respond to the needs of society is both a motive for internationalization as well as an important measure of the legitimacy of international politics. At heart, this is a question of the performance of international politics, or as described on pages 358–87, of its capabilities, sometimes called its "output-legitimacy."

The problem with responsiveness (or output-legitimacy) is that it is often in some conflict with "input-legitimacy," or rather, to demands for participation in international governance. Fundamentally, decisions can be reached more rapidly the fewer participating actors there are. This is also a likely reason why "clubs" like the G8 or G20 that operate parallel to open international institutions such as the UN, IMF, or the World Bank have increasingly arisen in the last years. The question of performance is also difficult to answer as soon as one moves away from more technical questions such as how to improve environmental quality, and instead turns to areas in international politics concerned with decisions about political values or the redistribution of wealth.

However, such political questions are in turn often the consequence of earlier and seemingly technical and uncontroversial decisions. For many years, nation-states found it relatively easy to remove barriers to trade through market liberalization measures, and thereby realized increases in wealth. The same is true for the liberalization of capital flows and the concomitant international interconnection of

global financial markets. Only later was it realized that a liberalized international economy also needs international regulation to avoid systemic risks and to ensure that gains from liberalization are distributed in a more or less balanced manner. However, it is far easier at the international level to agree on dismantling particular national rules and regulations than to agree on the content of new rules that need to be enforced by all. This can be seen very clearly in the unsuccessful efforts thus far to more strictly regulate financial markets, despite the global financial crisis.

A FIRST CONCLUSION

Politics responds to globalization challenges by going beyond the national boundaries of societal problems and addressing them instead by internationalizing decision-making processes and institutions. Simultaneously, an increasingly internationalized politics itself generates challenges to democracy.

These challenges are diverse and multilayered. The question to what extent internationalization undermines democracy in individual nation-states clearly depends on how far international politics moves away from simple questions of regulation and instead begins to ask questions about values and redistribution. But it would be too simple to make international organizations or international agreements, detached from the level of the national, responsible for decision-making processes and their substantive consequences. It is far more the case that internationalization connotes an increasing interweaving of government and of decision-making at a level beyond that of the nation-state. Intertwined at that level, one finds, in addition to representatives of one's own state, representatives of other states and institutions, all of whom take part in the decision-making processes.

Though the possibilities for individual citizens to directly participate are dwindling, given the distance, complexity, and lack of transparency in these interwoven and international decision processes, some scope still remains for optimizing cooperation between elected representatives in their roles as parliamentarians, and representatives of the government who sit in ministries and cabinets. But as long as there is no sense of community, in the sense of an emergent European or even cosmopolitan *demos*, and as long as citizens continue to identify primarily with their national institutions and national political spheres, international politics must remain tied to national politics and find majority support there. This does not exclude the possibility that political interconnections over time may also bring about a transfer of political loyalties, or that the internationalization of politics will bring about an internationalization of the *demos* and hence a transformation of democracy.

ENVIRONMENTAL PROTECTION Global warming conference, Kyoto, 1997: The Kyoto Protocol, in effect since 2005, for the first time established targets, binding under international law, for greenhouse gas emissions in the industrialized countries. Yet the United States never endorsed the agreement, and Canada withdrew from the protocol in 2011. Another challenge is restraining developing countries, which until that time had not been bound by any agreements. Reuters

Greenpeace activists during a protest against the overfishing of the oceans, Port Lincoln, Australia, 2012. Keystone

NATO headquarters in Brussels: NATO, formed during the Cold War as a collective defense alliance of Western nations, modified its strategic concepts in the wake of the collapse of the Eastern Bloc. Aside from defense, the prevention of conflict and intervention in troubled areas were also defined as components of the mission to provide collective security. In a globalized world, there are almost no purely 'local' conflicts any more. Keystone/Virginia Mayo

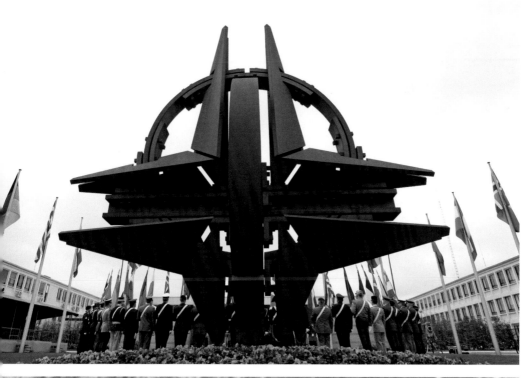

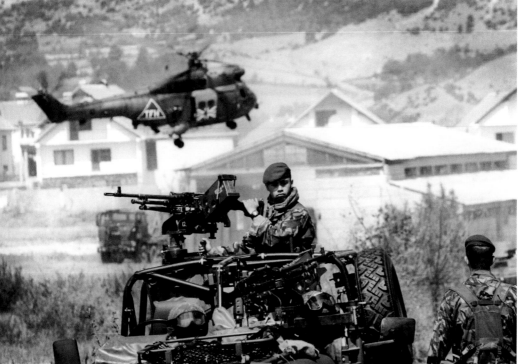

British NATO soldiers in Macedonia, 2001. Panos/Andrew Testa

European Court of Human Rights, Strasbourg: Citizens of contracting states could turn to this Court if they thought their rights had been violated by their own country or by another contracting party to the European Convention on Human Rights. Keystone/Ruffer

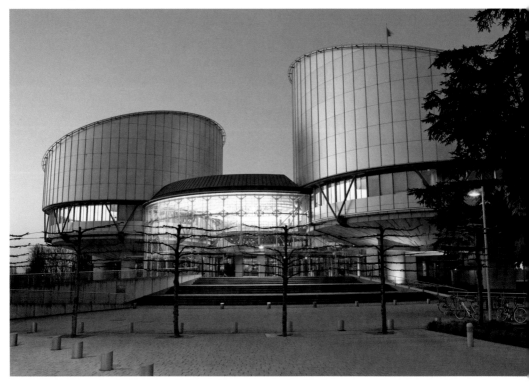

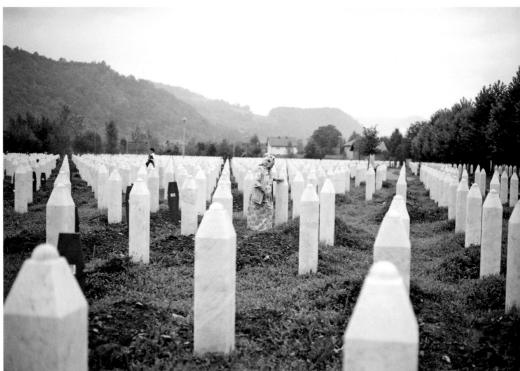

Cemetery in Srebrenica, 2010: "Mothers of Srebrenica," a victims' association, lodged a plea in Strasbourg as Dutch UN soldiers hadn't intervened in 1995 when the Army of Republika Srpska commited a massacre of Bosnian civilians. The organization's first appeal against the Netherlands and the UN was unsuccessful. Panos/Andrew Testa

DEMOCRACY IN THE AGE OF GLOBALIZATION GLOBAL PROBLEMS–GLOBAL SOLUTIONS?

476

REFUGEES Angelina Jolie, UNHCR special envoy, in a refugee camp in Pakistan, 2005: The refugee problem is international. The UN's refugee agency, the UNHCR, estimated there were 45.2 million refugees worldwide in 2012, including "internally displaced persons" who were driven from their homes in their own countries. Of that number, however, only 15.4 million met the definition of refugees under international law. Keystone

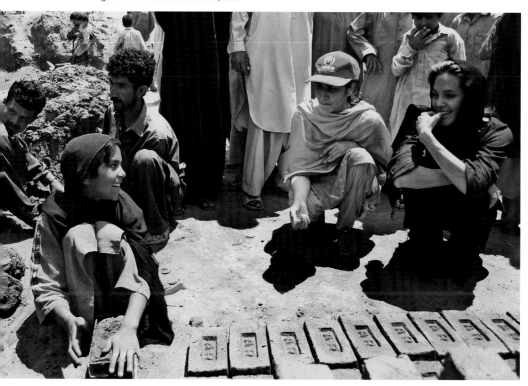

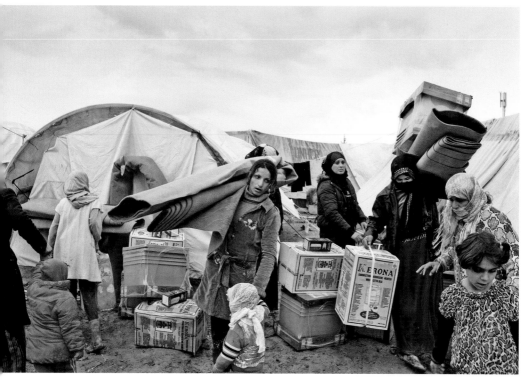

Syrian refugees in Iraq, 2012. Panos/Ivor Prickett

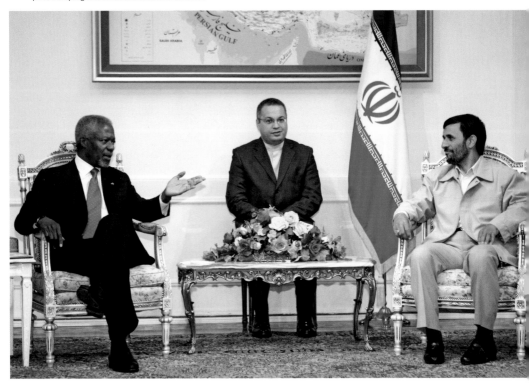

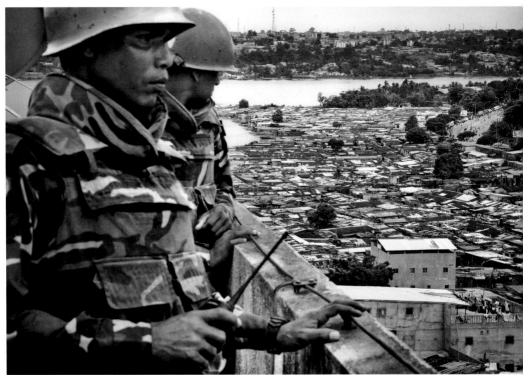

UN peacekeeping forces in Abidjan, Ivory Coast, 2011. VII/Stefano De Luigi

MIGRATION European Parliament, Brussels: Migrants want to relocate to a different country for various reasons: Persecution, poverty, environmental disasters, and so forth. According to the UN, there were 213 million migrants in the world in 2010, of whom 15% were illegal immigrants. Europe has had to deal with migration problems on a massive scale. The EU has made numerous joint policy decisions regarding migration. Reuters/Thierry Roge

Migrants in Patras, Greece, 2007. Giorgos Moutafis

Meeting of the International Monetary Fund and the World Bank in Tokyo, 2012: In a globalized world, economic crises often also have international causes or effects. After Argentina's economic crisis in 2001, its government had to accept the IMF's conditions for restructuring the country's debt. Citizens' bank accounts were frozen, and the population was hit hard by the crisis. Keystone/Stephen Jaffe

Looters in Buenos Aires, 2001. Keystone/Daniel Luna

Critics of globalization in Geneva, 2003. Oliver Vogelsang

II. GLOBALIZATION AND THE DIFFUSION OF DEMOCRACY

The international integration of societal processes and the internationalization of politics as characteristics of globalization are not just grave challenges to established democracies. They can also contribute to the democratization of authoritarian systems and thereby contribute to the global diffusion of democracy as a model of governance.

The three waves of democratization were presented earlier, on pages 27–62. Globalization contributes, in differing ways, to the diffusion of democratic ideas and principles—if often only fragmentarily and insufficiently. The explosion in boundary-crossing communication brought about by the Internet, satellite television, and expanding social media such as Facebook or Twitter means few areas on the planet remain wholly cut off from Western ideas of human rights or political participation. These new media give democratic oppositional groups and human rights activists in authoritarian states opportunities to rapidly and efficiently spread information, to forge alliances with the like-minded abroad, to look for support from international organizations, democratic states, and NGOs, as well as to organize domestically. The satellite television channels Al Jazeera and Al Arabiya

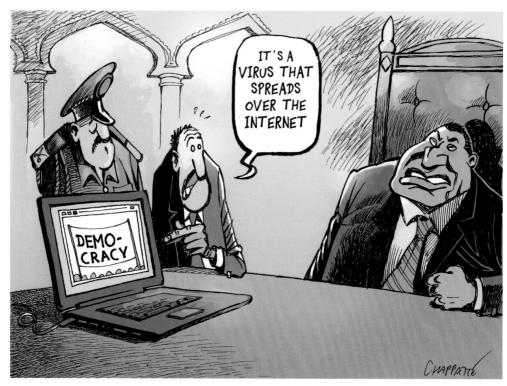

New media play an increasingly important role in the political process. Chappatte

reported exhaustively on the protests and demonstrations in Tunisia and Egypt, and thereby encouraged a wave of solidarity through out the entire Arab world. The diffusion of democratic revolts from North Africa to the Middle East was substantially aided by technological innovation as well as the use of new media. The stubborn efforts on the part of the Chinese government to hamstring domestic protests that spread through the Internet also demonstrate the potentially transformative power of new media.

Beyond the potential for democratization of an increasingly globalized civil society, Western states and international organizations also work to spread democracy. Three basic strategies are employed: Support for democratization "from below" through economic aid, education, cultural exchange, and backing given to democratic forces in society; democratization "from above" through a mix of incentives and pressure put on authoritarian regimes; and democratization at a more horizontal level by involving authoritarian states and their administrations in international networks and cooperative forums.

Supporting democracy "from below" and horizontally through integration can be regarded as indirect forms of democratization, while democratization "from above" works directly and uses explicit incentives or sanctions. A further direct way to encourage democracy, though one more discredited in the last few years, has been military intervention coupled with violently toppling authoritarian rulers. How little military power and the toppling of dictators alone is sufficient to support democratization can be seen in Afghanistan or Iraq.

Support for Citizen Engagement:
Democratization through development and support for civil society
The most widespread form of support for democratization is indirect support given to social and economic change in the target country, as well as the help given to democratically-minded civil society actors. Starting with the United States and the Netherlands, all Western states have by now made the promotion of democratic principles, human rights, and good governance into goals of their development policy. The "democratization through development" approach is based on the assumption that an increase in wealth, education, and modernization in a society will also lead to demands for greater democratic participation rights. Growing affluence and modernization lead to the creation of a middle class that has an interest in shaping the political future of their country and may question the established authoritarian system. This middle class provides the foundation for an active civil society through a multitude of organizations, associations, and parties, which help organize civil society interests and which come to demand a role in the political process.

As this form of democracy promotion operates only very indirectly, and is further-more aimed at bringing about profound changes to society, its success is difficult to measure. A very indirect confirmation of the effect of social, economic, and cultural exchange on democracies can be seen in their geographic spread. Statisti-cal studies have shown that as a rule, democratization waves spread regionally, so geographic proximity to a (new) democracy has a positive effect on political transformation processes, likely due to news about the changes under way in the neighboring state.

Explicit, though indirect, promotion of democracy through trade, economic development cooperation, and help provided to democratically minded groups in society needs to overcome various political hurdles, however, and such outside involvement can quickly lead to tensions with an authoritarian regime. For that reason, this path rarely is consistently pursued. Investigations of EU efforts to pro-mote democracy in North African states, for example, particularly through the "Euro-Mediterranean Partnership" and the "Barcelona process," both of which began in 1995, have shown that such initiatives all too often shy away from conflict with those in power. Help provided to civil society groups as a rule could only be provided with governmental approval, so in these cases, the lion's share of such help ended up going to non-political service-providing organizations. The EU's ambivalence was further heightened by broad skepticism shown toward Islamist groups that might be the ultimate beneficiaries of democratic reforms. Such ambivalence was starkly demonstrated in the early phase of the Arab Spring as well, when French President Nicolas Sarkozy first supported the hard-pressed Tunisian dictator Zine El Abidine Ben Ali, or when Italy's former Prime Minister Silvio Berlusconi supported his Libyan friend Muammar Gaddafi. The hesitant Western stance vis-à-vis the Arab world arises from what one might call the "democracy stabilization dilemma," a fear of the destabilizing effects democratic reforms might have.

Carrots and Sticks: Democratization through incentives and sanctions

Beyond strategies intended to encourage democratization "from below" and from the people themselves, international actors also have more direct means, particu-larly that of "political conditionality." This is applied "from above," when particu-lar favors or benefits can be tied to carrying out reforms.

Political conditionality was first introduced in the 1970s in international devel-opment cooperation, when nation-states began to tie development projects to obligations to respect human rights. Both the United States and the EU, as the most important donor countries, in using instruments designed for economic

development, foresee the imposition of financial sanctions, or the cessation of cooperation, for severe human rights violations. The EU has repeatedly used such measures in African countries, including Togo, Niger, Guinea-Bissau, the Comoros, the Ivory Coast, Liberia, Zimbabwe, the Central African Republic, Guinea, and Mauretania, and also in Haiti and Fiji. As a rule, such sanctions divert aid away from economic development and instead give it to civil society actors. This was true in Belarus in 1996 after there was backsliding in its democratization, in Russia in 1999 in response to the war in Chechnya, and in Uzbekistan after severe violations of human rights became known in 2005. But there are also just as many cases where political conditionality was not employed. Good examples for this include the response to Israeli policies in the occupied territories or in the restraint shown toward Algeria and Vietnam.

A different kind of political conditionality began to be employed in the 1990s, in which financial aid was linked to cooperation in the areas of "good governance." It is by now standard that countries wishing to qualify for World Bank or IMF credits are held to certain basics, including transparency in administration, efficient government action, participation of civil society actors, administrative and politi-

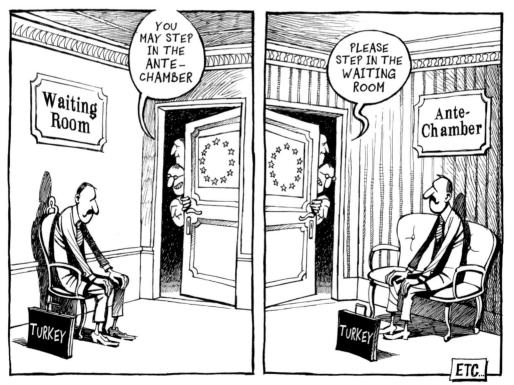

"TOP-DOWN" PROMOTION OF DEMOCRACY High democratic standards are among the criteria for EU membership. Turkey was officially recognized as a candidate country for EU membership in 1999, but the negotiations have been difficult, with no end in sight. Developments in Turkey were not the only cause for delay, however–differences between EU member states played their role, too. Chappatte

cal responsiveness, as well as justice and adherence to the rule of law. While "good governance" avoids referring to "democracy," as that would extend the catalogue to include free and fair elections and popular sovereignty, there is an overlap between the two notions.

Further ways to promote "top-down" democratization are provided by the conditions that go with membership in international organizations, a form particularly well developed in Europe. Thus, Council of Europe statutes state that only pluralistic democratic states that practice the rule of law and respect human rights may join. Still, such strictures did not prevent Russia from joining in 1996, despite widespread misgivings about the path that country had taken. In the eyes of some, Russia's accession was too early, though the overall assessment is more mixed. On the one hand, the Parliamentary Assembly of the Council of Europe reacted to the ongoing Russian aggression in the Chechen war by suspending Russia's vote in the Assembly and by recommending Russia be excluded from the Council. Though a political solution was found for this disagreement, a degree of pressure remains on Russia through the implementation of the European Convention on Human Rights and the right Russian citizens thereby acquired to appeal to the European Court of Justice in Strasbourg. By now, cases brought by Russian citizens represent more than one-fifth of all pending cases before this court.

But the organization that has most consistently promoted democratization as a condition for joining has been the EU. Since the mid-1980s, when it accepted Greece, Portugal, and Spain, countries that had freed themselves from dictatorships or military rule, the EU has tied expansion in its membership to compliance with democracy. This formally became part of the conditions for membership in the Copenhagen criteria of 1993, and was subsequently applied to the candidate member states in Central and Eastern Europe. The consolidation of liberal democracy became a condition for starting negotiations about full membership, and insufficient progress in democratization was the reason why negotiations with Slovakia could not begin in 1998, as they had begun for other Central and Eastern European states. The real prospect of membership, as well as the systematic and rigorous review of progress toward democracy undertaken by the European Commission, is generally regarded as the reason why the political transformation of these Central and Eastern European states proceeded as rapidly as it did. Despite this generally positive assessment of accession conditionality, it is worth emphasizing that such a "top-down" strategy does little to change the socioeconomic preconditions for democracy in a particular society, and also does nothing to help develop an active democratic culture and civil society.

It is interesting that regional organizations outside of Europe, too, have dedicated themselves to the principle of democracy. Thus, Latin America's Mercosur economic community and ECOWAS, the West African common market (Benin, Burkina Faso, Ivory Coast, Gambia, Ghana, Guinea, Guinea-Bissau, Cape Verde, Liberia, Mali, Niger, Nigeria, Senegal, Sierra Leone, and Togo) both have contractually committed themselves to upholding democracy. These international agreements also call for sanctions in case of undemocratic developments. After a military junta toppled the democratically elected government of Mali, ECOWAS imposed economic, financial, and diplomatic sanctions on its member state in early 2012. This conflict over the democratic order in Mali, however, was soon overshadowed by military action taken against Islamist rebels in the northern part of the country.

All Sitting at the Same Table: Promoting democracy through involvement

Finally, democracy can be indirectly promoted when authoritarian states that are members of international institutions come into contact with the democratic principles, norms, and procedures these institutions use. Such governments can learn

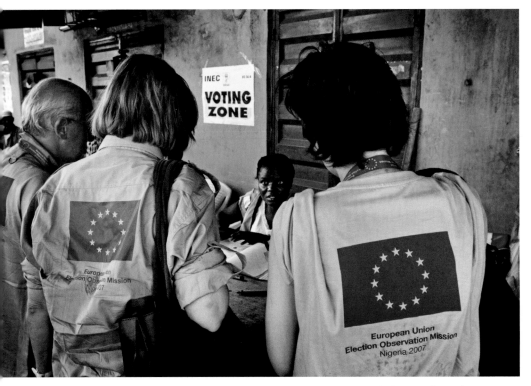

INTERNATIONAL ELECTORAL COOPERATION Lagos, Nigeria, 2007: Election monitors from the EU at a polling station during the presidential elections. The presence of international observers made it possible to record and publicize voter manipulation and irregularities. Panos/Jacob Silberberg

from example and adopt these processes and norms, and in that sense globalization serves democracy though the internationalization of politics. International institutions in which representatives of both democratic states and authoritarian states work together have a socializing effect on their members, and in the best case, strengthen identification with democratic processes. This is particularly true when the legal instruments these organizations use themselves contain elements of democratic principles such as transparency, participation rules, or guides to good governance.

CONCLUSION

Globalization brings both risks and opportunities for democracy. In established democracies in the Western world, the increasingly transnational nature of political problems, as well as the delegation of decisions to international organizations and bodies, weakens the domestic basis of political participation and the democratic control of power. At the same time, globalization serves to diffuse democratic ideas and institutions around the globe. Our understanding of democracy and the forms it takes in the Western world need to accommodate a multilevel constellation of politics and policy-making that goes beyond the nation-state. At the same time, many of the newly democratizing states copy the Western model of liberal democracy only incompletely and add their own nuances to it. Both as a value and as a goal, democracy is thereby subjected to constant change.

Democracy cannot be forced upon a society, and neither is it a gift one can take possession of once and for all. It must be earned anew every day and it must be defended.

Heinz Galinski

Heinz Galinski (1912–1992) was President of the Central Council of Jews in Germany from 1954 to 1963 and again from 1988 to 1992.

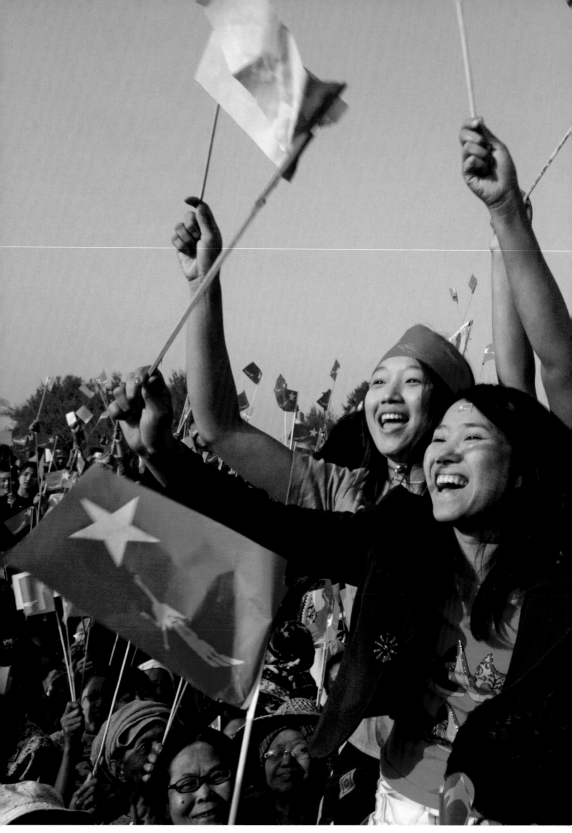

DEMOCRATIZATION

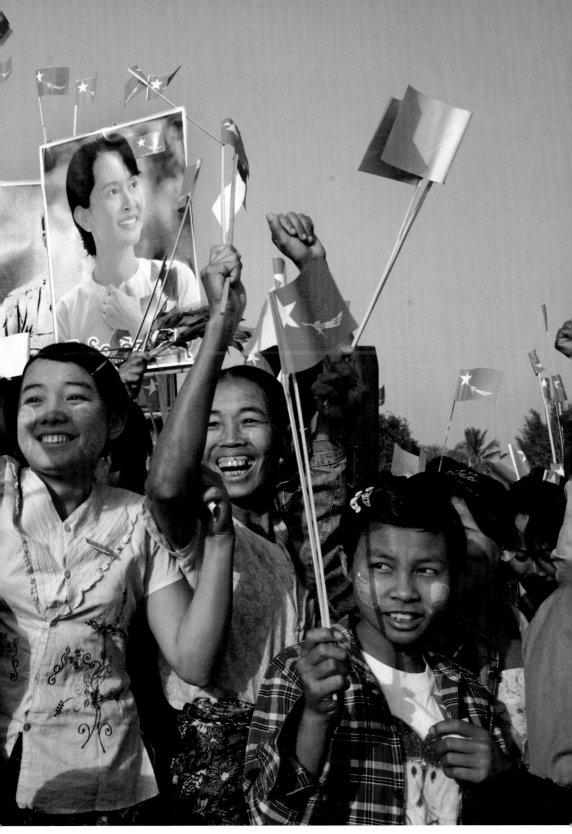

SOMETHING IS ON THE MOVE Naypidaw, Myanmar, 2012: As a result of international pressure, Aung San Suu Kyi, the leader of the opposition and a winner of the Nobel Peace Prize, was freed after fifteen years of house arrest. Panos/Adam Dean

The Democracy of Democracies

Francis Cheneval

"DEMOICRACY" INSTEAD OF "DEMOCRACY AND FEDERALISM"

Though federalism and democracy are often mentioned in the same breath in Switzerland, they not only differ, but are even at odds with one another. This is because federalism in its origins was an idea that emerged from leagues and alliances created between states or princes. Such alliances could be forged without involving or even having a notion of (let alone democratic rights for) "the people." The agreements themselves were negotiated between representatives of territories or estates, but how such representatives were chosen, and to whom they were accountable, is an open question in federalism.

Federalism and democracy also stand in opposition if "democracy" means rule by one single people. Taken strictly, federalism contravenes the democratic principle that all citizens are politically equal. Conversely, the idea of a single people violates the multiplicity notions inherent in federalism. "Demoicracy," by contrast, is a way to designate the common rule of multiple peoples (*demoi* is the plural form of *demos*). The constituting and union of multiple peoples is ensured through the political participation of citizens both internally and at the common level.

TWO IMPERFECT EXAMPLES OF DEMOICRACY: SWITZERLAND AND THE EU

One can distinguish between two types of demoicracy. The first is exemplified by Switzerland (a federal demoicracy), the second by the European Union (a multilateral demoicracy).

No Exit or Veto Rights: Federal demoicracy

The Swiss federal state includes numerous peoples, and these peoples, as well as the citizens as a whole, are represented in the political institutions of the two chambers of parliament (e.g., the Federal Assembly). The participant peoples (e.g., the cantons) in the federal state have their own constitutions and broad political competencies, but as individual political units, they lack veto power over the federal constitution and generally have no right of secession. The Civil War in the United States, in fact, is a historical example of what it can mean if a member state or group of member states lacks the right to secede, and this lack is coercively enforced by the federal government. The difference between a federal and a multilateral democracy is thus anything but insignificant.

In the EU, member states do formally possess both veto power and a right to withdraw from the union. As examples, Sweden decided in a popular referendum not to adopt the euro, and both France and Holland rejected the EU's Constitutional Treaty in national referendums. However, these formal rights are in the process of being politically and economically undermined. Merely for economic reasons, for example, Greece today is in no position to exit the euro zone, which means the EU is moving towards becoming a federal state, though without this having been adequately cleared, in a demoicracy sense, with the peoples or citizens of the EU.

In classic international relations, there is a legally regulated, side-by-side coexistence of independent peoples. To speak of a demoicracy in such cases would not be appropriate, because these independent peoples deal with one another only on a case-by-case basis, do not engage in common government activity, and impose no binding common institutional constraints on one another that are determined by the political acts of citizens.

There has been a discernible drift, globally, away from the classic forms of international relations, as

there are increasing numbers of so-called multilateral organizations based on common and binding rules, the member peoples of which recognize as an independent superordinate institution (such as the UN, WTO or EU). One can then speak of a demoicracy if all member states of a multilateral organization are governed democratically domestically and the common institutions are run following the principles of democratic rule. Put differently, demoicracy exists if the common institutions are accountable to the citizens and if the operation of such institutions can be co-determined by elections, initiatives, and referendums citizens participate in.

In its current form, the EU comes closest to approximating the multilateral type of demoicracy. Only democratic nations may become members. They retain veto power over treaties and have a right to withdraw from the union. Member states therefore have parallel and overlapping political orders and are not hierarchically subordinated. All citizens have a claim to see their human rights protected, and they enjoy political rights as members both of their individual states and as EU citizens. As such, citizens are also directly represented in the European Parliament; the nations are represented collectively in the European Council. That legislation is adopted in the EU by majority vote in Parliament and Council does not contradict multilateral demoicracy, because this rule by majority does not apply to treaties and is limited to particular responsibilities assigned to the EU in the treaties. Such responsibilities are expanding, which can be taken to indicate the EU is moving towards becoming a federal type of demoicracy.

Exit and Veto Rights: Multilateral demoicracy

In a multilateral demoicracy, the peoples remain sovereign. This means, more specifically, that member nations have both a veto power over the treaties which lay out the organization's principles and institutions, and a right to withdraw. In a demoicracy, what applies to the member state applies to citizens in every democratic country: The right to withdraw and the right to participate. Governing competencies are relinquished to joint or superordinate institutions, but the right to withdraw, as a national people, from these institutions is not. In this model, the right of veto is intended to guarantee, to the greatest extent possible, the non-domination of the population. They need not submit to any fundamental rules to which they have not consented. In addition, they do not have to yield to the rule of the majority in specific areas unless they have agreed in advance, when approving the basic contract, to using such a rule. On the other hand, popular sovereignty is perceived positively to the extent the peoples unanimously and jointly adopt binding and basic rules, and in these rules also introduce organs that pass laws by majority decision. When it is a question of rejecting a new constitutional provision, each people in a multilateral demoicracy is sovereign (veto right). When a new constitutional provision is to be introduced, then it can only be by all, and in common (e.g., a unanimity principle for new basic rules or for modifying them). Put differently, each people individually can control the existing basic rules, but amending them can only take place by common approval.

The multilateral type of demoicracy is a democratic structure that falls somewhere between an international organization and a state. On the one hand, it signifies a transformation of the state and of the international order built on states. That order can be traced back to the pressure to resolve problems through joint governmental activity. On the other hand, demoicracy stands for the principle that political integration between national peoples should not lead to the dissolution of nations against their will, because this would amount to violating popular sovereignty norms. Local or national collective identities should not be denied but instead recognized, and the endeavor by national peoples to remain independent—to the extent such an endeavor is present—should be accommodated. One can assume that democratic states which share common basic values, and which decide within a general political framework to engage in joint governmental activity, will also want to tie such activity

Demoicracy types	Right of member nation to withdraw	Right of member nation to veto basic constitutional rules
Multilateral	Yes	Yes
Federal-level	No	No

VISIBLE DIVERSITY The flags of all of Switzerland's 3,089 communities, displayed at the 1964 national exposition in Lausanne. Switzerland is an example of a federal demoicracy: Its constituent peoples, meaning the citizens of its cantons, have no exit or veto rights. Keystone/Jakob Braem

SOLIDARITY? Athens, Greece, 2011: The EU is the best example we have of a multilateral demoicracy, as its member states possess both exit and veto rights. However, the recent debates about the EU's bailout package for Greece make clear that contentiousness accompanies trying to achieve a solidary community of peoples. Often, the various donor nations do not really want to see it fully realized. Keystone/Petros Giannakouri

back to the will of the citizens. Moreover, mutual recognition comes easier to democratic peoples, as does the confidence that joint institutions can be run lawfully and democratically: It rests on the domestic democratic structure of member peoples.

DEMOICRACY AS RULE BY THE PEOPLES

It is valuable to examine aspects of "democracy" that are masked by its literal meaning. Thus, "democracy" means "government of (or by) the people," as though there were invariably only one people. Often, however, there are many peoples rather than just one. And these peoples do not just co-exist side-by-side, but are frequently institutionally intertwined as well. "Demoicracy," or "government of (or by) the peoples" expresses the thought that peoples can jointly establish state authorities and jointly exercise political authority.

Democratic theory suppresses this aspect of multiple peoples. One talks of "the people" as if it were a unit existing in empty space. In reality, different political peoples may be linked to one another by institutions and procedures, and such associations are in fact fairly common. A city with a town council and a government, one that holds elections and referendums and in which citizens engage in common political action, has a people, in a democratic sense. This "people" is not sovereign in the sense of a people who establish a political state, but it does have political autonomy and acts as the sovereign within its jurisdiction.

A member state of a federal state—in Switzerland, these member states are the cantons, the sovereign political entities—that has a constitution, a government, a parliament, courts, and whose citizens engage in common political action through elections and referendums and all their related activities, has a sovereign people. The "people" function here as the authority that establishes the state. A nation-state in which member states are treated as sovereign, and in which participating peoples and citizens act in common politically through elections or referendums, has numerous "peoples" engaged in the exercise of state authority. In reality, such a democracy is a demoicracy, a form of state and governing brought about and exercised by a multitude of peoples—who for their part should not be thought of as self-contained units—who are interwoven with one another. Under some circumstances, therefore, the term "democracy" obscures this multiplicity of peoples and misleadingly suggests that "the people" are a self-referential, unique unity.

The concept of popular sovereignty envisions that the people institute the state and determine its structure, including what limits, boundaries and responsibilities that state has. Democracy is therefore not only a form of governing but invariably also a form the state takes. When a body politic contains several member peoples, it affects both the activities of governing itself and the structure of the state as well. A democracy can of course have only one people that constitute it, and in this strict sense, a democracy then has a single popular sovereign and several governmental powers. A demoicracy, by contrast, exists when there are numerous peoples that institute the state, not just one.

PRINCIPLES OF FAIRNESS IN DEMOICRACY

One can ask which principles a demoicracy of the multilateral type, like the EU, actually would have to consider binding. We have already listed the power member states have to veto and the right they have to leave as key basic conditions: These legal claims are based on popular sovereignty. They are maintained in a demoicracy, though it also means sovereign peoples have the sovereign authority to delegate the tasks and powers of the state, and to engage in governing jointly. Are there any other positive principles a demoicracy would have to fulfill?

The principles here should be specific to demoicracy, or applicable only to it. In addition, they should not be derived from a particular national democratic model, but should be acceptable to all potential member peoples. If we compile a list of such principles, some principles of democracy will be missing, not because they do not apply, but because they pertain to all democracies or are general principles in international law. Human rights, the separation of powers, general accountability, minority rights, the rule of law, civil rights, and so forth, are all elements that exist in a demoicracy, but they are not specific to a demoicracy and apply to a democracy as well. Likewise, we can say that a people's right to defend themselves, or their subordination to international humanitarian law or other basic principles, are not specific to democracy but are

part of general international law—and apply to non-democratic states as well.

We must regard freedom, and legal and political equality of the member peoples, as prerequisites for demoicracy. Admittedly, that qualifies the political equality of citizens in the individual nation-states, but this is legitimate if these citizens have agreed, as separate constitutive peoples, to enter into the demoicracy. Without these two preconditions, one cannot imagine demoicracy as a fair association of peoples. Because a demoicracy is made up of sovereign peoples, the issues of joining and leaving a demoicracy, as well as its basic rules, must be decided by each member people. A demoicracy therefore depends on the involvement of the citizens among the individual member peoples in building the institutions of demoicracy through a constitution. A demoicracy can be governed only by involving the citizens, and furthermore, it must also be demoicratically constituted.

This principle also means that member peoples and citizens have a right to equal treatment in the common demoicratic legal order, and may not be discriminated against. Further, one will expect all member peoples to recognize transnational rights, that is, individual rights, which then apply not only to their own citizens but to all citizens of all other member peoples too. And in addition, to qualify as fair, such a structure must arguably include conditions that enable the least well-situated member peoples to increase their prosperity to a greater extent than would be possible outside the federation.

Demoicracy thus is to be understood as a solidary community of peoples, without needing to stipulate here which individual means are needed to making a disproportional growth in the prosperity of member peoples who are worse off possible. One can assert that the violation of one or more of the rules listed can give cause to speak of a breach of "demoicracy," because arbitrary rule over a people or its citizens would then be exercised, and the fundamental principle of an equality and freedom of the peoples would be violated.

The Twenty-first Century Challenge

Daniel Kübler

URBANIZATION:
OPPORTUNITY AND CHALLENGE

As of early 2008, more people on the planet live in cities than in the countryside, and by 2050, the percentage of city-dwellers will have risen further. By that date, according to estimates, two-thirds of the world's population will live in cities and only one-third will still live out in the countryside. In the course of the twenty-first century, in other words, mankind will have become a city-dwelling species.

So is this good or bad news? The urbanization of the planet and the growing number of megacities have created many problems. But urbanization and megacities also hold new opportunities, not least for further democratization. In fact, the history of modern democracy is inseparable from the history of cities. Democracy itself was invented in the *polis* of ancient Athens. Legal principles (the rights and duties of citizens) and representative institutions (councils), important cornerstones of modern democracy today, were first articulated and established in medieval European cities.

What happens in cities has been and continues to be important for democracy. Thus, political science research has been able to show that the urbanization of a country is an important prerequisite for the stability of its democratic order. So it makes sense to ask how and whether increasing urbanization will affect democracy in the twenty-first century.

THE MEGACITY AS THE CITY
OF THE TWENTY-FIRST CENTURY

Urbanization has been especially pronounced in developing and newly industrializing countries. Former villages have become cities, as in China's Shenzhen. In 1950, Shenzhen had only about 22,000 inhabitants, but by 2010, there were more than 10 million. Even existing cities have grown, and some

have become megacities. In 1950, Delhi had 1.3 million residents, but by 2011, it had 22.6 million, making it the largest city in India and the second-largest city in the world. Urban growth has been impressive in industrialized countries as well. Tokyo, the largest city in the world, grew from 11.2 million in 1950 to 36.9 million in 2010. During the same sixty-year period, the population of New York increased from 12.3 million to 20.1 million. This trend did not go unnoticed even in Switzerland: The Zurich agglomeration grew from just around 500,000 residents in 1950 to 1.2 million in 2010.

Megacities, defined as cities with a population in excess of 10 million, mark a turning point in mankind's history. Cities have never been this big before. The population of ancient Rome is estimated to have been 1 million at most. The most significant city in the pre-Columbian era, Teotihuacan (in today's Mexico), had about 250,000 inhabitants at its peak. Significant medieval cities such as Florence or Venice had only a little more than 100,000 residents. Megacities are a recent phenomenon, and have existed only since World War II, when Tokyo and New York crossed the 10 million mark for the first time.

According to UN calculations, 23 megacities existed worldwide in 2010. It is projected there will be fourteen more by 2025 (see Figure 1). Megacities are the result of a new migration of peoples triggered by modernization, liberalization, and globalization. Owing to their links to the rest of the world, the large urban agglomerations in industrialized countries increasingly are becoming market hubs and attracting people both from the countryside and from abroad. In developing and newly industrializing countries, people migrate from the countryside into the city in hope of more income and a better life. In China, though, such migration was not allowed

Urban area	Country	2010 Population (millions)	Estimated 2025 population (millions)
Tokyo	Japan	36.93	38.66
Delhi	India	21.94	32.94
Mexico City	Mexico	20.14	24.58
New York	USA	20.10	23.57
São Paulo	Brazil	19.65	23.17
Shanghai	China	19.55	28.40
Mumbai	India	19.42	26.56
Beijing	China	15.00	22.63
Dhaka	Bangladesh	14.93	22.91
Calcutta	India	14.28	18.71
Karachi	Pakistan	13.50	20.19
Buenos Aires	Argentina	13.37	15.52
Los Angeles	USA	13.22	15.69
Rio de Janeiro	Brazil	11.87	13.62
Manila	Philippines	11.65	16.28
Moscow	Russia	11.47	12.58
Osaka	Japan	11.43	12.03
Cairo	Egypt	11.03	14.74
Istanbul	Turkey	10.95	14.90
Lagos	Nigeria	10.79	18.86
Paris	France	10.52	12.16
Guangzhou	China	10.49	15.47
Shenzhen	China	10.22	15.54
Kinshasa	Democr. Rep. Congo	8.41	14.54
Chongqing	China	9.98	13.63
Bangalore	India	8.25	13.19
Jakarta	Indonesia	9.77	12.82
Chennai	India	8.78	12.81
Wuhan	China	9.16	12.73
Tianjin	China	8.53	11.93
Hyderabad	India	7.56	11.65
Lima	Peru	8.95	11.53
Chicago	USA	9.55	11.43
Bogotà	Colombia	8.50	11.37
Bangkok	Thailand	8.23	11.24
Lahore	Pakistan	7.35	11.20
London	United Kingdom	8.92	11.26

1 **URBAN REGIONS WITH MORE THAN 10 MILLION INHABITANTS, 2010 AND 2025 (ESTIMATED)** A megacity is defined as an urban region with more than 10 million inhabitants. There were 23 megacities in 2010; by 2025, it is estimated there will be 14 more.

at all until economic reforms were promulgated during the 1990s. Since then, hundreds of millions of Chinese migrant workers have left their villages for the cities. By the end of the twenty-first century, even poorer countries will be as urbanized as industrialized countries are today.

PEOPLE DENSELY PACKED TOGETHER: THE PROBLEMS OF MEGACITIES, THE PROVISION OF NEEDED PUBLIC GOODS, AND CIVIL SOCIETY INVOLVEMENT

Seen globally, life in the cities is better. Poverty, hunger, and infant mortality are less widespread there than in the countryside. Incomes are higher, and both medical care and education are available. Why? Because in the city context, the provision of public goods apparently functions better, meaning infrastructure and services exist that are available to all: A health system, schools, water supply, roads, public transportation, and so on. These public goods do not arrive like manna from heaven, but are instead the end-product of a long political process. At the outset, demands and needs are articu-

lated by various groups in society. This is followed by a debate over whether there is general interest in satisfying these needs, and where public resources (such as taxes) should be expended, or whether forms of behavior should be generally regulated (for example, through governmental legislation). Finally, the corresponding services need to be organized and appropriate rules enacted.

Special conditions or frameworks exist in megacities for such processes. Their tremendous population growth has also brought enormous problems in its wake. Permanently clogged streets and hopelessly overcrowded buses and metros are not just an annoyance for commuters. They also become a problem for the urban economy if it means goods no longer arrive on time or employees have difficulty getting to their workplaces. Poverty and a lack of prospects are not just regrettable problems for those who live in the slums, but create a breeding ground for social conflicts that explode into city riots, criminality, and looting, thereby becoming problems that threaten an entire urban community. The sheer scale of such problems in megacities

MIGRATION Guangzhou, China, 2005: There are 230 million migrant workers in China. They live and work in the cities but have no political rights there. During the Chinese New Year, many of them return to their families who live in rural areas.
Andreas Seibert

increases the likelihood that these problems will be recognized as relevant by the public at large, and corresponding public goods made available to try to resolve or ameliorate them.

In democratic countries, the right to vote gives the dissatisfied citizens of megacities important leverage. City governments are removed from office if they show themselves incompetent—or unwilling—to effectively resolve urban problems. As a result, city governments make an effort. Conditions in megacities also provide favorable conditions for political mobilization outside representative institutions. It is easier in big cities for social movements to recruit people to their causes. The concentration of people in a relatively small area makes communication easier, distances are shorter, and the number of adherents potentially larger. This is particularly significant in non-democracies. It was already true in the storming of the Bastille during the French Revolution, and true of the protests at Tiananmen Square in Beijing. And it was also true of the Arab Spring, when the availability of new

communications technologies, especially in the cities, played a decisive role. Megacities provide favorable conditions for staging uprisings against autocratic rulers.

Yet "apolitical" mobilization in cities, especially the megacities, has long been much more common than revolutionary uprisings, and is almost more important for democracy. Conflicts between poorer parts of the population and city authorities flared already in the 1960s and 1970s in the big cities of many developing countries. Because they could not afford "normal" housing, those newly arrived in the cities improvised by putting up dwellings on undeveloped land, including on steep slopes, empty sites, and under street or railway bridges, thereby creating slums, barrios, favelas, and shantytowns.

The city authorities were largely powerless to prevent this development, and they had no choice other than to tolerate such "wild urbanization." Because slum or barrio residents began to divert water and especially electricity from the city grid, the authorities gradually began to supply these new

PUBLIC GOODS New Delhi, India, 2012: To address a summer water shortage, the government has provided the population with a water tanker. The supply of pubic goods is usually better in big cities than in the countryside. Still, urban agglomerations are often breeding-grounds for social conflicts. Keystone/Kevin Frayer

neighborhoods with a minimal infrastructure. This was less out of kindness than to prevent the collapse of supply networks to the rest of the city. The authorities in the growing megacities, particularly in autocratically governed countries, were always less than eager to get involved in slum areas.

Given the gap between unmet needs and the lack of commitment by the public authorities, slum residents had little choice but to organize themselves. Slum self-organization initiatives, particularly in Latin American megacities, have been well documented in social science research. Such initiatives range from starting up soccer clubs to creating neighborhood self-help groups, and even to creating community centers with soup kitchens, family advisory services, and medical care. The church often played an important supportive role, but so did foreign development aid workers who preferred to work with local self-help groups rather than providing money to autocratic governments.

Since the 1970s, the number of local NGOs in the big Latin American cities has multiplied, and their activities are no longer confined today to helping city residents with their daily problems. Also, these NGOs are increasingly politically active and dedicate themselves to promoting human rights, environmental protection, and greater democracy. Today, there are tens of thousands of Latin American NGOs, most of which, parenthetically, are run by women. Many of them emerged, during eras when autocratic governments ruled, from self-help efforts in large urban agglomerations. Nowadays, these NGOs form a dense weave of stable civil society structures and help existing democratic institutions function better, thus ultimately helping to stabilize Latin American democracies, particularly in Brazil and Mexico.

DEMOCRATIZATION AND DECENTRALIZATION IN CLOSE QUARTERS: ADMINISTERING MEGACITIES

Local NGOs have also been an important cornerstone in the global trend, observable since the mid-1980s, toward the decentralization of governmental

THE POOR QUARTER Rio de Janeiro, Brazil: The poor in Brazilian cities live in favelas. These are often lawless places in which governmental authority barely exists; a drug gang controls the favela called Chapadao. Noor/Kadir van Lohuizen

power. Responsibilities and resources have been transferred from the national level to lower levels of government not only in Europe and North America but also in many developing and newly industrializing countries. Particularly for administrators of the large cities, the situation has changed dramatically, and thanks to decentralization, they now have greater scope for action. At the same time, pressure on them from civil society actors to actually address the many urban problems has also increased.

Decentralization has also definitely brought political conflict to the major cities, over the provision of public goods to help resolve societal problems. The organization of these goods has also engendered conflict. The local authorities in many countries have been equipped not only with responsibilities and financing, but also with new democratic elements, including direct election of mayors or new direct democratic procedures, such as budgeting processes in which ordinary residents participate. The latter have been particularly practiced in the larger Brazilian cities (for an example from Porto Alegre, see pp. 245–6) and are known from other

Latin American countries. They have begun to be introduced on other continents as well.

Thanks to democratic processes, civil society actors can better articulate their needs and demands to the city authorities. And thanks to decentralization, these authorities now also have more means at their disposal and better opportunities to actually respond to these needs. This, in turn, ensures them voter support and strengthens trust in the functioning of democratic processes. Decentralization and democratization thus go hand in hand and mutually stabilize each other, and it is especially the megacities that have profited hugely from this development. It is not just that the available resources have increased: The political scope for action has grown, too.

However, one challenge to the ability of democracy to function in megacities arises from the increasing incongruity between urban sprawl and institutional organization. Megacities cover enormous areas, as one can see when standing on the observation platform of the Edificio Italia, the tallest skyscraper in São Paulo. A seemingly endless sea of houses stretches as far as one can see in all direc-

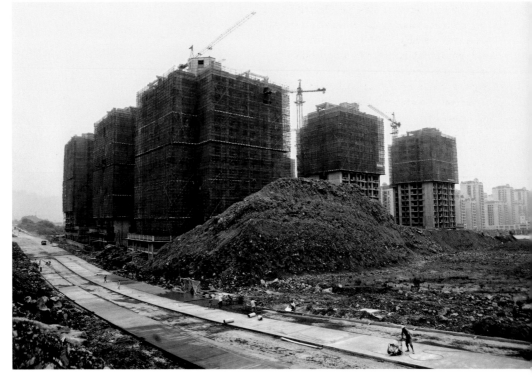

URBANIZATION Chongqing, China, 2007: Rapid urbanization calls for enormous increases in building. The Chinese Urban Planning Ministry projects that an additional 300 million citizens will move to the cities by 2025. In addition to Shanghai, Beijing, Shenzhen and Guangzhou, it is likely that three additional urban areas will achieve the status of megacities.

Panos/Mads Nissen

tions. About 20 million people live here, but only about half of them are actually residents of the city of São Paulo itself. The rest live in the thirty-eight communities that form the regional metropolitan area of São Paulo. Urban sprawl did not halt at the boundaries of individual communities, with the result that these various communities increasingly lie athwart the city landscape. This creates difficulties for taking official action, such as trying to coordinate public services for the entire residential area, or in allocating tax revenues between richer and poorer communities. The higher the number of communities in a metropolitan area, the greater such difficulties: The topic is one of ongoing interest in political science.

OVERALL, MEGACITIES AS THE KEY TO FUTURE WORLDWIDE DEMOCRATIZATION?

The twenty-first century will be marked by global urbanization, in the course of which the number of megacities will continue to increase. Megacities provide access to work and income for many people, and help to expand the middle class. They are incubators for a network of civil society structures with whose help people can aid one another in resolving the problems of daily life. Megacities also require efficient governmental institutions that make public goods available, including, in particular, residential space, drinking water, transportation, wastewater treatment and waste recovery, and education. Megacities create enormous challenges but also contain great opportunities for spreading and stabilizing democracy.

On balance, and taken as a whole, development in the world's megacities can certainly be evaluated positively, because it is precisely the big cities that profit most from the combination of democratization and decentralization. However, one should note important counterexamples. The two biggest cities in China, Shanghai and Beijing, as well as the huge cities of Chongqing and Tianjin, are administered directly by the Chinese central government: There can be no talk of decentralization here. A strict regulation of residence status, additionally, has made the estimated 230 million migrant workers who people China's biggest cities largely into subjects without rights. Their political influence ought therefore to be zero, yet migrant workers have nevertheless begun to organize themselves in Chi-

na's biggest cities. Increasingly, city residents launch protests, some violent, against their authorities, and it is becoming increasingly difficult for Chinese governments to ignore the demands and needs of the country's migrant workers. In China as well, one suspects, the key to democracy will lie in its biggest cities.

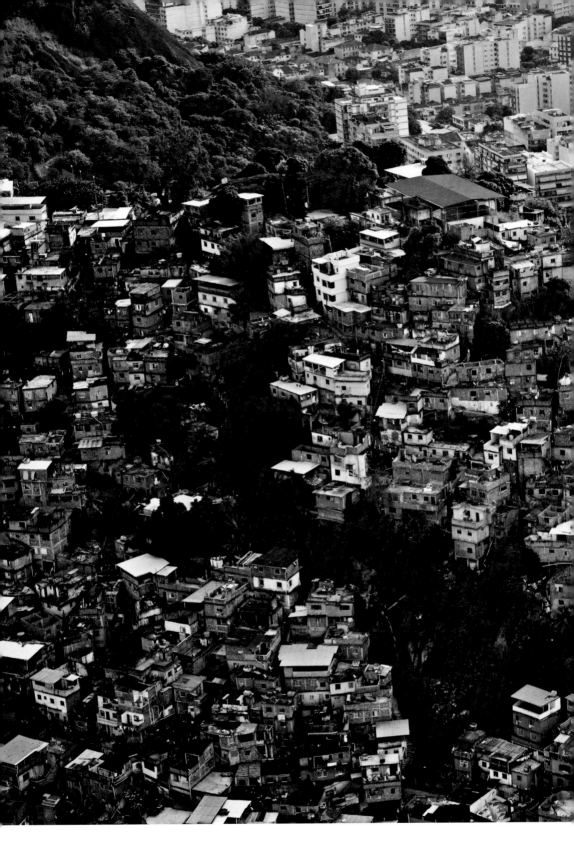

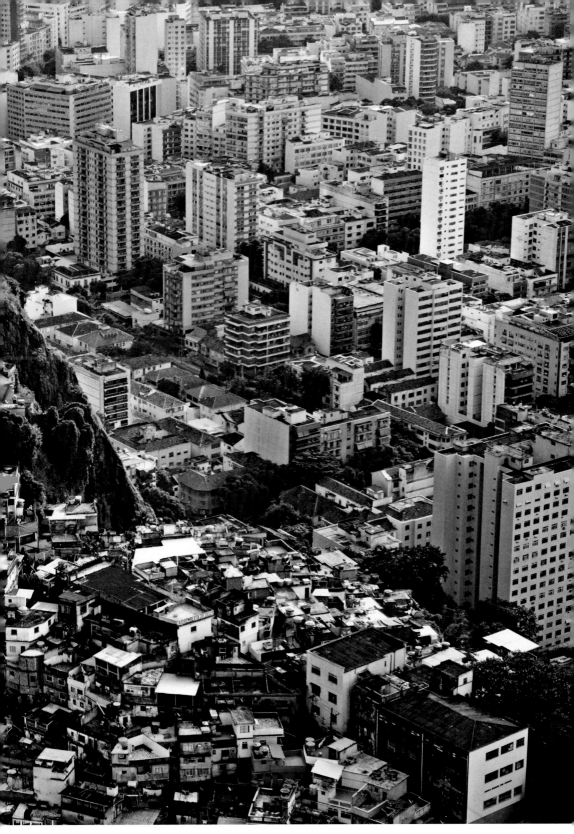

SOCIAL INEQUALITY Rio de Janeiro, Brazil, 2012: In Brazil, rich and poor are very close to each other, and not just geographically. An autocratic form of government in many Latin American countries has meant little has been done for the poorest parts of the cities. Numerous NGOs have been formed in response, and they play an important role in democratizing the cities today. Noor/Francesco Zizola

THE VIEW FROM ABOVE Houses as far as the eye can see. Urban areas with more than 10 million residents are called megacities. These agglomerations pose special logistical challenges, though they also give their residents particular opportunities for social and political renewal. São Paulo, Brazil: 19.7 million residents (2010)

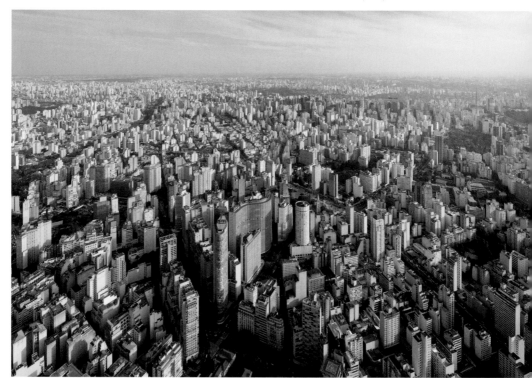

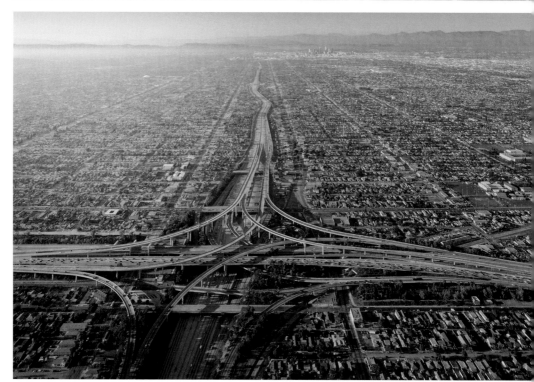

Los Angeles, California, USA: 13.2 million residents (2010)

Tokyo, Japan: 36.9 million residents (2010)

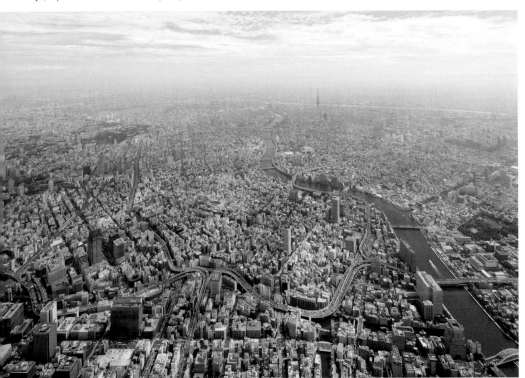

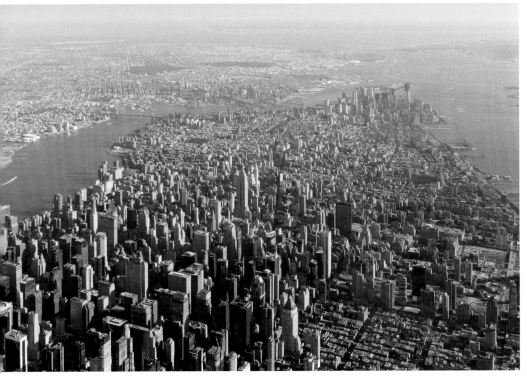

New York, USA: 20.1 million residents (2010) All images: Iwan Baan

RESIDENCES Hong Kong, China, 2012: The city lies on the Pearl River delta, an area of 120 million residents, including the two megacities of Guangzhou and Shenzhen. Hong Kong is one of the most densely inhabited places in the world, so many people live here in extremely tight quarters.

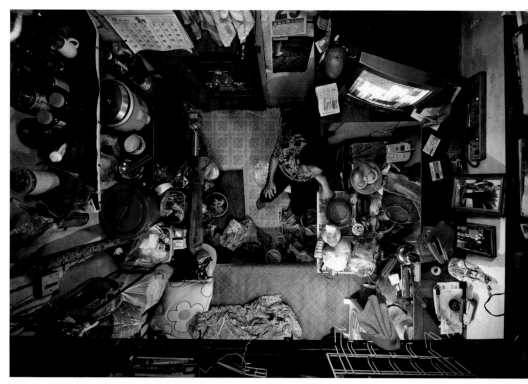

All images: Rex Features/Benny Lam

POOR AND RICH The close proximity of extreme poverty and enormous wealth in big cities gives rise to social tensions. For example, slum dwellers tap into the electric and water lines that run to the richer neighborhoods. To prevent the infrastructure from completely collapsing, the authorities then provide the poorer areas with at least a minimum of resources. The solutions found for such problems can help support democratic structures. Jakarta, Indonesia

Bangkok, Thailand: According to official estimates, this city will become a megacity by 2025.

Calcutta, India

Shanghai, China All images: Keystone/Peter Bialobrzeski

TRANSPORTATION Rental and living costs vary enormously in a megacity, which leads to huge numbers of people commuting to work each day. That in turn creates special challenges in how to deal with a large volume of traffic in a very small area. Moscow, Russia

Karachi, Pakistan

Manila, Philippines

Cairo, Egypt All images: Panos/Martin Roemers

513

THE MASSES London, Great Britain, 2007: London will likely have more than 10 million residents by 2025. Megacities, with their large labor markets, provide considerable opportunity for pursuing the most varied lifestyles. Such cities correspondingly attract people from around the world, creating a dynamic that can be quite different from that of the country in which the megacity is found. Since continued urbanization is a global tendency, one of the important questions

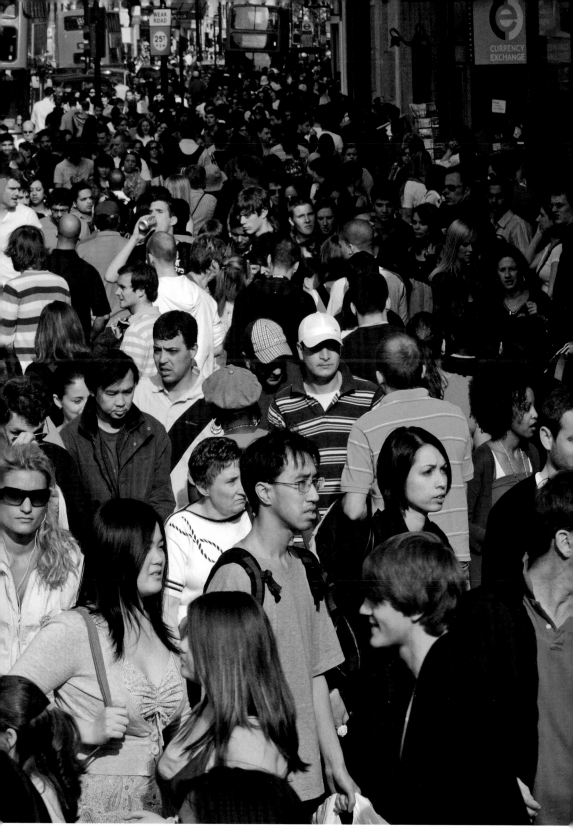

for the twenty-first century is how it will be possible to democratically govern such large urban agglomerations, with all their challenges. Panos/Mark Henley

AUTHORS

André Bächtiger
Born 1971 in Bern, Switzerland. Since 2010, he has held a Swiss National Science Foundation assistant professorship at the University of Lucerne. He is the author of various publications in the field of deliberation studies, including *Deliberative Politics in Action* (Cambridge University Press, 2004) and *Mapping and Measuring Deliberation* (Oxford University Press, 2014).

Thomas Bernauer
Born 1963 in London, Ontario, Canada, he studied political science in Zurich and Boston and has published widely on issues of international environmental and economic policy. He has been a professor of political science (international relations) at the Swiss Federal Institute of Technology (ETH) in Zurich since 1995.

Daniel Bochsler
Born 1978 in Bern, Switzerland, he obtained his Ph.D. in 2008 at the University of Geneva, and has had research stays at the University of Tartu, University of Belgrade, University of California at Irvine, and the Central European University in Budapest. He is assistant professor of democratization at the National Center of Competence in Research (NCCR) Democracy, University of Zürich. His research interests include elections in areas where ethnic conflict exists.

Florin Büchel
Born 1985 in Vaduz, Liechtenstein, he is a Ph.D. student and research assistant at the Institute of Mass Communication and Media Research (IMPZ), University of Zurich. His main research interests are international comparative aspects of political communication, journalism cultures, political and media systems, and cultural industries.

Francis Cheneval
Born 1962 in Bern, Switzerland, he studied philosophy and political science in Fribourg and Georgetown (USA). He has held the chair of political philosophy at the University of Zurich since 2011, and his most recent publication is *The Government of the Peoples. On the Idea and Principles of Multilateral Democracy* (New York, 2011).

Colin Crouch
Born 1944 in Isleworth, United Kingdom, he is external scientific member of the Max Planck Institute for the Study of Societies, Cologne, and an emeritus professor of the University of Warwick. He also taught at the London School of Economics, the University of Oxford, and the European University Institute in Florence. His books include *Post-Democracy* (2003), *The Strange Non-Death of Neoliberalism* (2011), and *Making Capitalism Fit for Society* (2013).

Frank Esser
Born 1966 in Korschenbroich, Germany, he is professor at the Institute of Mass Communication and Media Research at the University of Zurich, and co-director of the NCCR Democracy, a national competence center for research on democracy. His publications are mainly in the area of international comparative research on journalism, news, and political communication.

Flavia Fossati
Born 1983 in Sorengo, Switzerland, her studies have been in political science, sociology, and international law. Since 2009, she has been a teaching assistant and Ph.D. student at the Institute for Political Science (IPZ) in Zurich. Her research interests are active labor market policy and attitudes toward welfare state policies in Europe.

Regula Hänggli
Born 1979 in Brugg, Switzerland, her research focus is on political communication, the process of opinion formation, and the interplay between democracy and the media. She studied political science and economics in Bern and Bergen (Norway), and obtained her Ph.D. in Zurich after a period of research in Chicago. From 2011 to 2013, she was assistant professor of political communication in Amsterdam, and since November 2013 is professor of social science methods in Fribourg.

Jürg Helbling
Born 1954 in Uznach, Switzerland, he is a tenured professor of ethnology at the University of Lucerne. He has published numerous books and articles on political and economic anthropology, including *Tribale Kriege: Konflikte in Gesellschaften ohne Zentralgewalt* (2006) and *The Mangyan's Survival Strategies: A Case Study of Mangyan and Lowland Filipino Interaction in Northeast Mindoro* (2004).

Erik Jentges
Born 1978 in Berlin, Germany, he studied various social sciences in Berlin and Paris. He has held teaching positions at the University of Zurich and Humboldt University, Berlin, and his research and publications in communication studies and sociology include *Die soziale Magie politischer Repräsentation* (2010).

Hanspeter Kriesi
Born 1949 in St. Gallen, Switzerland, he holds the Stein Rokkan Chair in Comparative Politics at the European University Institute in Florence. He previously taught at the universities of Amsterdam, Geneva, and Zurich. He has wide-ranging research interests, including the study of direct democracy, social movements, political parties and interest groups, public opinion, the public sphere and the media. From 2005 to 2012, he was director of a Swiss national research program on the challenges to democracy in the twenty-first century.

Daniel Kübler
Born 1969 in Heidelberg, Germany, he completed his undergraduate and graduate studies in Lausanne, and his political science *Habilitation* in Zurich. He is currently a professor of democracy and public governance at the University of Zurich, and publishes on topics in public policy, democracy, and urban politics and governance. Since 2012, he has been director of the National Center of Competence in Research (NCCR) Democracy, and since 2013, director of the Center for Democracy Studies in Aarau (ZDA).

Andreas Ladner
Born 1958 in Zurich, Switzerland, he is professor of institutional policy and public administration at the Swiss Graduate School of Public Administration (IDHEAP), University of Lausanne. His numerous publications have focused on political communities and local politics, parties, and information websites for voters (Voting Advice Applications, VAAs), as well as on the reform of political institutions.

Sandra Lavenex
Born 1970 in Milan, Italy, she is professor of political science and international relations at the University of Lucerne and a regular visiting professor at the College of Europe. Her research and publications have focused on questions of public policy and democracy in the global age, and on Europeanization.

Wolfgang Merkel
Born 1952 in Hof, Germany, he is director of the Democracy and Democratization research unit at the Social Science Research Center Berlin (WZB), and professor of political science at the Humboldt University, Berlin. He is a member of the Berlin-Brandenburg Academy of Sciences and Humanities, and his research and numerous publications have focused on political regimes: democracy–dictatorship, democratization, political parties, social democracy, and social justice.

Lars Müller
Born 1955 in Oslo, Norway, he is a publisher and graphic designer. Apprenticeship in Switzerland 1975–79, studies in the United States and the Netherlands. Established his design studio in Baden, Switzerland, in 1982, and one year later his own publishing house, which moved to Zurich in 2012. He has produced numerous titles on typography, design, art, photography, architecture, and society. Lars Müller has taught at various universities in Switzerland and Europe and currently is a guest lecturer at the Harvard University Graduate School of Design.

Frank Schimmelfennig
Born 1963 in Marienberg, Germany, he is professor of European politics at the Swiss Federal Institute of Technology in Zurich. He has published widely on questions of European integration, in particular EU enlargement, differentiated integration, democracy and democratization in the EU, and the promotion of democracy by the EU.

Marco Steenbergen
Born 1963 in Apeldoorn, the Netherlands, he is professor of political science, in particular political methodology, at the University of Zurich. He has authored numerous articles and books in political psychology, deliberative democracy, and statistical methods. His latest book, *The Ambivalent Partisan*, has won two awards.

Manuel Vogt
Born 1981 in Winterthur, Switzerland, he studied political science in Zurich and is currently a Ph.D. candidate at the Institute for Conflict Research, Swiss Federal Institute of Technology in Zurich. His research and publications focus on democratization and ethnic conflicts, primarily in Latin America and Africa, and he has conducted fieldwork in Guatemala, Ecuador, the Ivory Coast, and Gabon.

Democracy means getting involved in one's own affairs.

Max Frisch

Max Frisch (1911–1991) was a Swiss writer.

EDITORS' ACKNOWLEDGMENTS

This publication has only been made possible due to the dedication and work of many people. We would like to express our special thanks to them:

René Schwarzenbach, who provided the initial impetus for this project.
The authors, who set themselves the task of translating their research results and specialized knowledge into more generally comprehensible language.
The members of the Lars Müller Publishers team, in particular Michael Ammann, Nadine Unterharrer, Helena de Anta, Esther Butterworth, Martina Mullis, Nicole Aeby, John Bendix, and Miriam Cias, whose commitment and close collaboration with the authors made this volume possible.
Yvonne Rosteck, who with word and deed supported this project throughout all its phases.

Democracy: An Ongoing Challenge is a project that transcends its initial medium. The printed version will serve as the basis for electronic applications and teaching material.
This project would not have been possible without the trust and support of the following foundations and institutions:

SWISS NATIONAL SCIENCE FOUNDATION

nccr democracy

LANDIS & GYR STIFTUNG

**LOTTERIEFONDS
KANTON ZÜRICH**

SWISSLOS
Kanton Aargau

SWISSLOS
Lotteriefonds
Kanton Bern

SWISSLOS-Fonds
Basel-Stadt

SWISSLOS
Basel-Landschaft

KANTON LUZERN
Kulturförderung
SWISSLOS

Mit Unterstützung der

Loterie Romande

DEMOCRACY: AN ONGOING CHALLENGE

Edited by NCCR Democracy, Hanspeter Kriesi, Lars Müller

Picture research and selection: Nicole Aeby, Nadine Unterharrer
Editorial coordination: Michael Ammann
Editorial assistance: Miriam Cias
Copyediting: John Bendix, Oliver Jarvis, Kathleen Luft
Translations: John Bendix, Kathleen Luft; Jennifer Taylor (Index)
Copyrights: Helena de Anta
Art Direction: Lars Müller
Design: Integral Lars Müller/Lars Müller and Nadine Unterharrer
Typesetting: Esther Butterworth
Lithography: Ast & Fischer, Wabern
Paper: Hello Fat Matt, 135 g/m²
Printing and binding: Kösel, Altusried-Krugzell, Germany

Lars Müller Publishers
Zürich, Switzerland
www.lars-mueller-publishers.com

ISBN 978-3-03778-396-2

Printed in Germany

German version also available:
Herausforderung Demokratie
ISBN 978-3-03778-296-5

VISUAL READERS BY LARS MÜLLER PUBLISHERS

FOR CLIMATE'S SAKE!
A Visual Reader of Climate Change
René Schwarzenbach, Lars Müller, Christian Rentsch,
and Klaus Lanz (Eds.)
ISBN 978-3-03778-245-3

"With over 300 illustrations, texts and case studies,
this abundant visual reader equates to a meteorologic
journey through the earth's climate system."
Greenpeace Magazin

THE FACE OF HUMAN RIGHTS
Walter Kälin, Lars Müller, and Judith Wyttenbach (Eds.)
ISBN 978-3-03778-017-6

"The editors have done justice to the issue in an
outstanding manner. Their encyclopedic work illustrates
the full story of human rights more vividly than this
has ever been done before." *Der Bund*

WHO OWNS THE WATER?
Lars Müller, Klaus Lanz, Christian Rentsch,
and René Schwarzenbach (Eds.)
ISBN 978-3-03778-018-3

"It is an aesthetic book, filled with pictures, and
a fascinating read at the same time…. The aptly chosen
texts and ecovatice illustrations convey factual
and visual information in a refreshing way that is also
amazing and frightening." *Quell*

FAITH IS.
The Quest for Spirituality and Religion
Lukas Niederberger and Lars Müller (Eds.)
ISBN 978-3-03778-144-9